Y[...]

You[...]

in the V[...]

Carolyn Street La Fond - 4/3/2002

The
Painter's
Daughter

CAROLYN
STREET
LaFOND

The Painter's Daughter

The Story of Sandro Botticelli
and Alessandra Lippi

Frederic C. Beil
Savannah

Copyright © 2001 by Carolyn Street LaFond

Published by
Frederic C. Beil, Publisher, Inc.
609 Whitaker Street
Savannah, Ga. 31401
http://www.beil.com

LIBRARY OF CONGRESS CATALOGING-IN-PUBLICATION DATA
Carolyn Street LaFond, 1951–
The painter's daughter:
the story of Sandro Botticelli and Alessandra Lippi/
Carolyn Street LaFond
p. cm.
ISBN 0-913720-78-x (hardcover : alk. paper)
1. Botticelli, Sandro, 1444 or 5–1510. Fiction.
2. Lippi, Alessandra, 15th cent. Fiction.
I. Title
PS3569.T69236P35 1999
813'.54—dc21 99–22016
 CIP

First edition

All rights reserved

This book was typeset by SkidType, Savannah, Georgia;
printed on acid-free paper; and sewn in signatures.

Printed in the United States of America

Contents

People in the Story

Botticelli, Sandro (Filipepi), fifteenth-century Florentine painter

Buti, Lucrezia, Augustinian nun painted by Fra Filippo Lippi; mother of Filippo and Alessandra

Buti, Spinetta, Alessandra Lippi's aunt; Augustinian nun

Cattalani, Cortesia, Florentine courtesan and model for Sandro Botticelli

Ciardi, Ciardo di, Giovanna's older brother; husband of Alessandra

Ciardi, Giovanna di, daughter of a Pratese wool merchant; Alessandra's best friend

Diamante, Fra "Dido," Carminian cleric and Fra Filippo's first assistant

Lippi, Alessandra, daughter of Fra Filippo Lippi; Sandro Botticelli's god-daughter

Lippi, Filippino, son of Fra Filippo Lippi; later Sandro Botticelli's student

Lippi, Fra Filippo, early fifteenth-century Florentine painter, a "worldly" cleric; Sandro Botticelli's first master teacher

Medici, Giuliano, Lorenzo's younger brother; assassinated in Florence's great Duomo

Medici, Lorenzino di Pierfrancesco de', younger cousin of Lorenzo Medici; patron who commissioned "The Birth of Venus"

Medici, Lorenzo ("Il Magnifico"), fifteenth-century Florentine banker and patron of numerous artistic works

Medici, Semiramide d'Appiano de', wife of Lorenzino; correspondent with Alessandra

Poliziano, Angelo, fifteenth-century Florentine poet and tutor for the Medici family

Savanarola, Fra Giralamo, Dominican monk who transforms Florence spiritually and economically

Vespucci, Amerigo, member of affluent Florentine family; Sandro's neighbor; Medici agent and later a navigator to the New World

Vespucci, Simonetta Cattaneo, Amerigo's much-loved cousin; "Queen of Beauty" in Florentine society

Vincenza, the faithful servant of the Lippi household

Vincetti, Niccolo dei, student of Filippino Lippi; escorts and befriends Alessandra

Acknowledgments

MY GREATEST THANKS GO TO DR. GINO CORTI, paleographer for the Harvard Institute of Renaissance Studies in Florence, Italy, for his friendship and assistance; Ronald Lightbown, biographer and former keeper of the Victoria & Albert Museum in London; the friends who supported me in this seemingly endless endeavor; and to my daughters, Madeline and Anna, for their patience while I was "lost" in the fifteenth and sixteenth centuries.

The
Painter's
Daughter

Introduction

*I*N THE LATE NINETEENTH CENTURY THE EN-glish art scholar Herbert Horne took an avid interest in the painter Sandro Botticelli, whose acclaim during the early Renaissance of Italy had faded into relative obscurity. Horne moved to Florence to study the painter's works and life, and aroused a fervor among the Victorian elite for Botticelli's lyrical depictions of women. The best loved, of course, was the radiant *Venus Arriving on the Shore*, which was duly renamed *The Birth of Venus* or, in Italian, *La Nascita di Venere*.

The panel, once considered "profane," is now housed behind protective glass in the Botticelli Room at the Uffizi in Florence, Italy. More reproductions of this painting are sold than any other prints from the museum's collection. Along with Michelangelo's *David*, Botticelli's graceful and melancholy goddess is one of the most-often-used symbolic figures of the Italian Renaissance. It is also considered to be "one of the few works of Western art that creates obsessions"—as it did with me when I was a young art student, twenty-seven years ago.

Prologue

—Villa of Castello, Tuscany, March 1537

COSIMO I DE' MEDICI WAS MUCH TALLER IN STAT-
ure than his ancestor, Il Magnifico, and his great uncle, Loren-
zino de Pierfrancesco, from whom he had, indirectly, inherited
Castello. As the son of the great Florentino soldier Giovanni delle
Bande de Nere, the young Cosimo was about to be declared duke of
Tuscany, although he had not yet reached his majority. Still, his return
to Florence and impending influence over the city-state would mark
the first, true, civic power of the Medici since Lorenzo Il Magnifico
had taken his last breath at Careggi in 1492.

The numerous villas of the Medici had passed in and out of many
hands, some related, some not, in the course of the first years of the
new century. Castello, Cafaggiolo, and Trebbio had remained in the
Pierfrancesco branch, and Lorenzino's sons and nephews had contin-
ued to maintain the adjoining farmlands to the benefit of the family
ledgers. However, the inventory of many of the villas' furnishings had
been lost and in some instances altered for the protection of the Pier-
franceschi. Among these was the designated ownership of an exquisite
canvas panel that depicted the arrival of the goddess Aphrodite, or the
Roman Venus, emerging from the sea on an immense shell and blown

to shore by two ancient figures of the wind. A maiden awaited her on the land with a billowing, floral cloak. It was said by all who saw this painting that the goddess was so radiant in her beauty that "she hath no mortal face."

The painting had recently been transported to Castello from the villa of Trebbio, where it had been in storage for many years. Before that, it was believed to have been at Cafaggiolo, where it had been hidden to avoid confiscation by the *piagnoni*, the more zealous followers of Savanarola. Here the "pagan" and "obscene" canvas escaped the flames of the Bonfire of Vanities. But before her death, Semiramide, wife of Lorenzino de Pierfrancesco, had asked that the painting be transferred to Trebbio with her—"so that I might be reminded of a rival and a friend and the bitter sweetness of youth." It was through Semiramide's carefully kept letters that young Cosimo I de' Medici learned of his great uncle's patronage of the Florentine painter Alessandro Botticelli. And it was through one of the sons of the late painter Filippino Lippi that Cosimo was able to locate the very frail Alessandra Lippi, Filippino's sister and the model for so many of Botticelli's now forgotten goddesses and Madonnas.

Cosimo and three of his retinue left Castello early that morning in May to travel to a small villa outside the town of Prato. The road from Castello traversed the Tuscan countryside northwest to Prato. It was a well-traveled road on account of the shipments of raw and finished wool transported on it.

The wife of Alessandra Lippi's eldest son now presided over the Villa Tavolo. Alessandra's husband, Ciardo, had been dead for many years. She welcomed young Cosimo and his men with as much aplomb as she had demonstrated in her fairer years. Although her face was now weathered and aged, her eyes still glowed a radiant glow, one said to be attributed to her long-deceased mother, Lucrezia Buti. Alessandra introduced all the members of her family to Cosimo. He was pleased to find her so lucid and alert, although her hearing had begun to fail.

"The painting has returned to Castello," Cosimo began eagerly as he took the chair closest to her in the little garden.

"Which one?" Madonna Alessandra appeared confused at first.

"Why, the one that 'bears no mortal face' . . . You know, the one by

4

Sandro Botticelli. I believe it was called 'Venus Landing on the Shore.'"

"Ah, yes." A reflective smile moved across her face. "The one that caused all the trouble . . ."

"You mean, with the Savanarola's followers?" Cosimo had been a good follower of recent history.

"Oh, even before that. I suppose every sitting I did for Sandro was troublesome." A sad reminiscence filled her eyes.

"He was your godfather, was he not?"

Allesandra nodded. "And I his namesake. Did you know, the maiden on the shore is the profile of Simonetta Vespucci? She was Queen of Beauty, and I could never quite do justice to her."

Alessandra's digression aroused Cosimo's curiosity all the more.

"There were many rumors about Botticelli and his studio and you, if you'll pardon me. I mean no disrespect by mentioning this, Madonna Alessandra. It is because the painting of the Venus fascinates me, now that it is installed in its rightful place. I want to know more. I want to know its history."

"Ah, then you must know about Sandro, and my parents, my brother, Filippino, and me; and there is not enough time in my life to tell it all." Her laugh was musical.

"But could you try, Madonna? Many have even forgotten that Sandro was one of the great maestri of Florence. Other artists are glorified now—Titian and Pontormo and, of course, the aging Michelangelo, who has made his mark in Rome."

"Sandro knew Michelangelo, as did my brother. But Michelangelo, for all his genius in marble, could not quite master the female form in painting."

"And somehow Sandro Botticelli did?"

"He made all women divine."

Cosimo nodded in agreement. "Tell me your first recollections of Sandro Botticelli, Madonna Alessandra. He was an apprentice in your father's bottega in Prato when you first knew him?"

"Yes, he is part of my very first memories and my last."

"Then begin with the first."

"But I was so little . . ."

"Whatever it is you remember. Tell me your first memory."

1

The First Farewell

MY FIRST MEMORY OF SANDRO BOTTICELLI was the first memory of all that I ever knew—the crowded piazza, the long cloaks of the men, and the flowing mantles of the women curtaining my view of the cathedral. I strained to see the man in the pergamo, the rounded pulpit built on the outside wall of San Stefano. Prato's Cathedral was known throughout Italy for this pergamo, and Prato was known for its possession of the sacred relic of the Virgin's girdle, which was displayed from the pergamo every spring. The man who stood there so high above the crowd was very familiar to me—a familiar face in vestments now enclosed within the carved frieze of prancing children. Those carvings came alive to me then with their chubby faces and well-formed curls of hair. They were the playmates I never had as a small child. I wished to run as they did on the frieze, but the citizens of Prato closed me in.

I had been aware of my mother's presence, but then suddenly I was not. There was a confusion of noise and the voices of people all looking up towards the familiar man who tried to speak. He was shaded beneath the hood of the pergamo and appeared as if he were some fanciful creature standing beneath a mushroom. For me it was a pleasant distraction, and I recall how my father had once said, "Distractions

give life its dearness." Indeed, his family had been a large distraction for him and his work. But now, the distraction before me had caused me to lose sight of my mother and my brother, Filippino. I was lost; a cold panic filled my veins, and I cried out.

Soon I heard another voice, "Sandra! Sandra!"

The voice was loud and bold. It was not my mother's voice, for at a time such as this she would have called me Alessandra.

Suddenly two, large, warm hands lifted me up inside a long, woolen cloak. I saw the kind face of my godfather, Sandro, who was also my father's best assistant or garzone.

"Sandra mia! Here we are!" He chuckled as though pleased to be the one to rescue me.

I clutched him tightly about the neck, and his thick hair tickled my hands where his cloak was tied. He held me carefully as he carried me through the crowded piazza to my mother, Lucrezia, and to my brother who stood beside her.

"Here we are, little Sandra!" My brother pinched my leg beneath my linen gown where the wind had blown it up.

I was now safe in the cluster of my family, and the carvings of the dancing children were no longer so delightful. My mother then reached out for me, but Sandro touched her lightly on the sleeve beneath her mantle.

"I can hold her, Madonna Lucrezia. I am pleased to hold my god-daughter, and she shall be pleased to see the better for it!"

And I was.

The man in the pergamo was Fra Diamante, my father's senior garzone. I had seen him often in my father's workshop near the Piazza del Mercatale, and he was a frequent guest who supped at our house on the Via delle Tre Gore near the cathedral.

"Do you see Dido?" *Dido* was the way I pronounced the name *Diamante*. Then Sandro bounced me a little, as though the jostling might improve my vision.

"Say *Fra Diamante*," Mother corrected him, for such family names were not to be used in public, especially during this official blessing of the New Year.

For me, however, *Dido* was not the chaplain of the nearby convent

of Santa Margherita, but rather the man I had always seen painting beside my father or mixing pigments next to Sandro. Yet here he was, in his church vestments, praising the Holy Virgin of the Annunciation and the Incarnation of Christ Our Lord. It was now the year 1467 by the Florentine calendar.

Diamante spoke loudly from the pergamo and leaned over to bless the crowd and to pray for the prosperity of Prato in the New Year. He spoke different words, different from his discourses with my father in their workshop or during visits to our house. Of course, now I realize that he was using Latin, the language of the Church and of the poetry I would later study. The words tumbled from his lips like a foreign song, and I seemed to know it, to grasp its message as one does music.

The crowd became silent with this Latin, and around me I could hear only whispers in our native Tuscan. I pressed my face close to Sandro's, because I liked his smell. He smelled of the pigments and glues that lingered on his hands, and he smelled of the leather thongs that tied his cloak. His face was smoother than my father's, and he nuzzled me gently as we waited through the blessing of the Florentine New Year.

"Happy New Year, little Sandra!"

The babble of voices rose up from the crowd. Diamante was no longer in the pulpit.

"Where's Dido?" I remember pointing up at the empty pergamo.

"Diamante must walk in the procession with the Abbess Jacopa and the Proposto and the canons of Santo Stefano," Mother explained.

Sandro led us towards the procession of city and church officials. I recall that my mother stared at them strangely. Diamante walked beside the abbess and behind the others. We watched them pass through the piazza of the cathedral, and I remember that I waved at Diamante, who smiled cautiously but did not wave back.

"You shall see Dido later tonight," Sandra said to calm me.

We moved over the bricks of the piazza, further from the procession and closer to my house on the side street of Via delle Tre Gore.

"There will be a special supper for us tonight, Sandra mia!" Mother took my hand and put it to her mouth to kiss it. "Aunt Spinetta will be there, and Sandro, of course. He is always our favorite guest! And Vincenza is making ravioli and little jellies for sweets." She was smiling

as she spoke, and the crowd from the piazza seemed to part for her as readily as it had for the procession. They must have recognized her from all of father's paintings.

Then there passed a series of carts, each with a different decorative theme. One portrayed the planting of the crops. Another depicted the fulling mills on the river Bisenzio, in tribute to the oldest mill in all of Tuscany, where newly woven wool was shrunk and pressed. On another cart was built a replica of Prato's old and new fortressed castles, united by the double wall called the *cassero*. From beneath this mock-*cassero* there spilled several cloves of raw wool to illustrate an old saying about the town.

"Look beneath the foundation of the city wall and find there a tuft of wool!" Sandro laughed a little as he quoted it.

I was too young at the time, however, to appreciate this clever tribute to my city. And later, while still a child, whenever I would see those double walls where they came closest to the original field (or *prato*, for which the town was named), I would look down along the ground for those famous tufts of wool. But they were never there.

My favorite cart that day, and ever since, was filled with beautiful maidens holding the first flowers of spring. Their hair was yellow from the use of lemon juice and saffron, and it was braided and twisted beneath a garland of the same flowers. Flowers were even woven into the harness of each mule that pulled the cart, and this was a splendid sight to see. It was only later, as a woman, that I came to understand what a confusion the Florentine New Year was to the rest of Italy, as opposed to the charming event it seemed now. Still, all Tuscans reveled in their uniqueness: the purity of their language, their love of finery tempered by a devotion to frugality, and this, their celebration of the angel Gabriel's visit to the Holy Virgin on the twenty-fifth of March.

"One more occasion for good eating and drinking!" I heard Sandro saying at our table that evening.

"As if the other holidays were not enough." Dido had a way of smiling and frowning at the same time.

"Ah, but the soul needs to rejoice after a long winter."

My father smiled most certainly, and I remember leaning up against his leg and feeling the texture of his hose against my arm.

"Yes, a winter of eating and drinking!" Dido continued, although he himself was not much of an ascetic.

What was so wrong with eating and drinking? I wondered. My elders had always taken joy in it, and so did I.

My mother and Aunt Spinetta were busy helping our servant, Vincenza, and did not engage in this banter. They set the long table with our best crockery and Venetian glassware. I was particularly intrigued by the two-pronged, silver serving fork. I later learned that it was a Tuscan invention, as were most ingenious Italian devices. Vincenza laid a plate and goblet each for Sandro, Diamante, Spinetta, and my brother, Filippino. Then there was one large plate and goblet that my mother and father shared. When I was very little, my mother fed me from this, but later I acquired my own plate and cup.

"You shall be pleased to see the sweets I have made for you!" Vincenza scuttled by and pinched my cheek as she spoke. Then Sandro cleared his throat in an alarming way and Vincenza corrected herself. "And *everyone!*"

I recall how I worried that there might not be enough for me, but after I had set my little teeth upon the larded capon, herbed pork, and cheese ravioli (which were soft and chewy and big enough to hold in each hand), followed by the sweet, broad Lucca beans and the drink of diluted malmsey, I had barely enough room for more than one of Vincenza's molded jellies. They were sweet and yellow, colored with saffron or quince. Some were made of fruit, and some were made from goat's milk boiled with honey and left to harden. Vincenza had shaped them into little birds and rabbits and, for Filippino, a horse. There were others made of figs and dates with sweetened pine nuts, but Mother feared I might not chew them as well. Of course that made them my favorites.

Mother held me on her lap as I savored each sweet, while Father and Diamante and Sandro talked about my father's painting and a trip he was going to take. I did not understand it all, nor did I try to. My father's work was the usual topic of conversation. Sometimes he would complain about the patrons who were angry with him over a delay but did not realize the difficulty in obtaining certain pigments. Or sometimes the complaint would be of a garzone who could not diligently

finish an assignment, such as gluing a panel, preparing the gesso, mixing the pigments, or transferring a cartoon to wood or plaster. Yet I never heard him complain of any of these with Sandro.

Often father would grumble about not acquiring the proper gold leafings for a frame. Gold leafing was a sensitive subject for Sandro, as this was the trade through which he had met my father. Sandro, however, was patient with him and would only answer when father had finished with his grievances against demanding patrons or lazy assistants. I never understood the complexities of their relationship until much later. At the time my father would talk and talk, while Dido would nod in agreement or interrupt to argue. But Sandro would sit quietly with his dark eyes sliding back and forth beneath their heavy lids. Then, just at the moment when one might have thought the arguing to be finished, Sandro would say something very clever, which made the principle of the argument unworthy of the discussion it had provoked. Of course, to a child, it was all a flurry of hands and words ended by laughter. But on this night of our New Year's Feast there was no arguing about patrons, other than the Fathers at Santo Spirito who had wished the altarpiece ready to be hung.

"I told them they were sure to have it before I left for Spoleto and *after* the balance of payment!"

Father enjoyed his final swallow of wine. He and Mother drank the sparkling white Carmignano, which was a "sin" to dilute with water.

Where was Spoleto? I recall wondering. Was it close by? Was it part of Florence? Father had spoken a good deal of his home in Florence and his days in the monastery of the Carmine. But I had never heard of this "Spoleto."

Then Sandro spoke, as he was inclined to do at the end of one of father's or Diamante's diatribes.

"I trust that the Fathers of Santo Spirito shall value the panel even more for its well-rendered hands."

Hands? I wondered, but then I remembered. My father had praised Sandro often for his ability to draw and paint both hands and feet, those awkward human appendages. Now he nodded in agreement.

"Surely the most difficult part of the anatomy!"

"All the more reason to master it, to have the hands and feet direct

the posture of the head and body rather than merely yielding to it."

"Yes, Sandro. And let us pray that your exquisite hands in this altarpiece shall make the Fathers *yield* to paying us!"

I moved to sit upon Sandro's warm and ready lap, and he seemed to welcome me. Because he was on the subject of hands, Sandro placed one of his fingers against my palm, and I clutched it. Then he bounced my little fist up in the air in a playful yet significant gesture. I remember laughing while my mother chuckled lightly in her musical way. I did not appreciate the painting of which they spoke, *The Presentation of the Infant Christ in the Temple*, or my part as the model for the Christ Child. My mother had played the doting Virgin Mary, holding out her hands to me.

My mother had modeled for many of my father's most famous paintings. She had figured as his Madonna in almost everything he painted after his arrival in Prato. He had been so taken by her beauty. Indeed, this "distraction" made its mark on the artistic and religious world, which in those days were one in the same. My brother Filippino and I were at the center of a ripple that had a very passionate source. But the ripple was unknown to me then. Being safe and warm in our house on Via delle Tre Gore on that New Year's night, or any night, was the only consummate happiness I would ever know. Without a conscious pleasure, I enjoyed my mother's gentleness, my father's well-earned pride, the comfort of Aunt Spinetta and Vincenza, and the occasional companionship of Filippino. And in the same way, I came to know the affection of my godfather, Sandro Botticelli. It was an affection I would seek for the rest of my life.

Not long after this, my mother took me to father's workshop or bottega near the convent of Santa Margherita, where my mother had once lived.

"We need to say farewell to Sandro, for he is going home." I recall her tying the little white cap about my head. I was told that "home" for Sandro was Florence and not Prato. "He is going to work with another maestro in Florence." Of course I could not know the complexities of an apprenticeship.

But later I did understand how Sandro had been referred to one of

father's friends and fellow artists, the sculptor and painter Antonio Pollaiuolo. He would finish his training in Pollaiuolo's bottega, while Father would work in Spoleto on a new commission.

We walked down a narrow street until we came to the busy bottega, in which both Sandro and Diamante also lived. Sandro was sitting next to father, putting sheaves of vellum into a leather binder. On this parchment were some of his earlier drawings along with his later studies to show to his new maestro.

"Ah, but you are nearly a maestro yourself!" I heard my father say.

"Would that my purse could show it!" Sandro shrugged his broad shoulders.

"A painter's purse never shows what he is worth." My father laughed, but then he became more serious. "Be of good cheer, Sandro, for you shall quickly become accustomed to Antonio's ways. He is the best anatomist in Florence. He has even dissected cadavers to study the muscles and bones."

"Filippo!"

My mother wished to quiet him. The mention of *dissection* and *cadavers*—words I did not yet know—was offensive to her.

"Then he shall surely appreciate my *hands!*"

Sandro reached out to squeeze my fingers. This made me giggle, which dispersed the immediate discord of my parents.

Diamante worked quietly in one corner, packing jars of pigments and the renderings for glue. The powdered lime for gesso was in the largest jar I had ever seen. It appeared he was helping Sandro to pack. But soon I learned that he, too, was preparing to depart. He was to accompany my father to Spoleto to decorate the cathedral there.

Dido barely smiled at me, although he saw me standing next to Mother and tugging at her skirt. Here he was no longer chaplain, but Fra Filippo Lippi's faithful assistant. Dido did not seem to mind the favoritism that my father showed to Sandro. Perhaps he felt no threat in it because of Sandro's air of independence. Sandro never pandered to father in the course of his apprenticeship. According to Mother, who was most observant, he had such confidence and passion in his work that it transcended the personal conflicts of a bottega.

Later I learned that Sandro had loved my father for his artistic guid-

14

ance and spiritual generosity. But he did not possess the same ardent devotion to him as the less talented and less confident Diamante, who had regarded his partnership with father to be ecclesiastical as well as artistic. As I recall that time, it seemed that Sandro was always a better companion. And Mother always spoke of him as the youth who had grown to manhood in Prato and who had offered Filippino and me much more affection than father's other pupils did. I did not understand what it would mean for him to be gone, any more than I would understand my father's departure.

Sandro hid his melancholy, if there was any, while Diamante sulked in the background. There was a certain sadness present, but I did not know why. I always wondered if Diamante had envied Sandro for the position he had found in our family. After all, I was his namesake. Or perhaps he envied Sandro's artistic promise, as he set off for the workshops of Florence and its circle of elite masters.

According to Mother, Diamante's clerical duties were not terribly gratifying to him. He had already changed Orders after his Carmelite superiors had imprisoned him for refusing to divulge the truth of my father's "indiscretions" at Santa Margherita. He was now a Vallombrosan. I later found it ironic that Diamante should succeed my father as chaplain of that convent from whence such scandal had arisen. Sandro told me he believed the appointment had been to honor Diamante's loyalty to my father, the greatest painter ever to work in Prato.

Diamante's loyalty did not go unappreciated. Father had included his portrait in his final fresco in Santo Stefano: Diamante appeared as one of the mourners at *The Funeral of St. Stephen*. Sandro's face was also among them, but much more obscure—perhaps because my father knew that Sandro would be quick to immortalize himself in painting when he became master of his own bottega.

The thing I recall most vividly that afternoon we went to bid farewell to Sandro was a drawing he had made. He held it up for me in the warm glow of the new spring sun. Father had opened every shutter and thrown back the oil cloths on every window, for he had not wished to invest in the expense of glass. The brightness of this natural light illuminated Sandro's drawing in a way I shall preserve forever. It was a study for his first *Adoration of the Magi*, which he had begun for the

Epiphany of 1465. I recall the graceful profile of my mother as the Holy Virgin and myself as the Christ Child on her lap. I was just an infant in the picture, with barely any hair, and yet I could recognize my own face. Even at the age of three, I had already seen many sketches of myself. Such was the illustrious fate of a painter's daughter: to be studied from every angle, to be the subject of her father's (or his pupil's) genius. Still, I was only one of many figures that might appear on parchment, panel, or fresco. Except for the self-importance felt by any child, I was no more significant at that time than any other model whom father or Sandro might use in their work. Certainly, I could not match the role my mother had played in the paintings of the quattrocento. At least, not yet.

2

Prato

I RECALL THE DAY SANDRO BADE US FAREWELL. His new maestro, Antonio Pollaiuolo, had sent an escort on horse to Prato to accompany Sandro and his belongings safely to Florence.

"Meseems you shall have a generous employer," Father said to Sandro that morning as he mounted the horse. Everyone laughed, I suppose, because Father's frugality had long been a source of jesting with Sandro.

I remember asking Mother why a man had come to travel with Sandro. She explained that, although Florence was only a few hours' journey on a well-traveled road surrounded by a string of hamlets, the threat of attack by brigands was still a possibility.

"I trust you shall reach the Porta al Prato by midday," Father added, while the servant secured Sandro's supplies to the side of another horse.

(The Porta Prato was the city gate closest to Sandro's parish of Ognissanti. I would pass through it often in my later years—a rather dark, dreary church that would eventually entomb both Sandro and Simonetta Vespucci, the woman he loved. But all of Florence loved Simonetta.)

Father held me up to Sandro on his horse, in front of our house on Via delle Tre Gore, so that I might kiss him farewell.

"Sandra mia." He caressed my face with one hand. "One day, perhaps, I shall paint you." I had no idea then of the significance of that remark.

The night of Sandro's departure, Father was careful to speak so that Diamante would not hear.

"The bottega will seem empty without Sandro."

"Even more empty without *you*," my mother replied.

At the tender age of three I did not truly recognize Sandro's absence until "Babbo," as I called my father, and Filippino had departed also. I recall trying to ask Mother if they had gone to visit Sandro. She said they would be in Florence for only a night and would continue on to another city called Spoleto.

"Babbo and Filippino and Dido are all going to Spoleto, which is much farther away. Almost to Rome! Many days shall pass before they reach Spoleto, and there Babbo shall work in the cathedral. He is going to paint the walls, and Dido shall assist while Filippino watches and learns."

"To paint?" I remember asking.

"One learns much by watching, just as you learned to eat and wash and put on your little gown."

She laughed gently and lifted me up close against her breast. I could smell the familiar scent of her hair and neck and feel the lingering moisture of her breath. It was sweet from the fennel that she often chewed after meals. What I could not feel was her emptiness without Father and Filippino. It was an emptiness she had known before and had endured by faith and prayer. Now, she declared, she had her little Sandra to comfort her, and so she saw to my needs and wants with special care and affection. And I believe I did profit from her attention in a way that Vincenza feared might spoil me.

My life with Mother and Vincenza was pleasant during those two years that Father and Filippino were away, but three females made a sorry household. Because of this, Father arranged for our friend, Ser Piero di Vannozzo, to see to our comfort and daily affairs. Ser Vannozzo was the procurator of the little convent of Santa Margherita and

also acted as its notary. He was not investured and lived outside the church, not far from our house on Via delle Tre Gore.

Our house stood between the piazza of San Stefano and the river Bisenzio, near the junction of three streams. We were not far from the closest fishing spots, and from our tiny garden we could see the carts of freshly caught tench and pike roll by. I recall once seeing the resilient tench flipping over the sides of one cart and how this both frightened and amused me.

Ser Vannozzo often brought fish for Mother and Vincenza to prepare, as he was inclined to purchase an abundance for the convent. He was a frequent guest at our table as a result, and Mother would make jest of the fact that she was still "supping with her fellow Augustians." This was especially true whenever Aunt Spinetta joined us. She had retained her vows and still resided at Santa Margherita, but the new Abbess Jacopa had allowed Spinetta to take advantage of breaking closure for the purpose of visiting her family. And Mother was the only member of her family that Spinetta cared to see, as both had been forsaken by their brother in Florence.

Mother had said that, by allowing Spinetta's frequent visits to Via delle Tre Gore, Jacopa was extending the kindnesses first conferred by the good Abbess Bartolommea. This kindness was especially noble, considering that our house had once received both my mother and Spinetta at a more questionable time. Bartolommea had died before the scandal of my brother Filippino's birth, but Jacopa certainly knew of it. I believe, from all Mother ever said about Bartolommea, that she would have forgiven Mother her indiscretion.

Thus Spinetta and Ser Vannozzo supped at our table on numerous evenings and filled the space that Father and Filippino had left behind. Ser Vannozzo brought news of Florence or nearby Pistoia, while Aunt Spinetta bade us hear about the less colorful life at Santa Margherita. In due time we were joined by Vincenza's betrothed, Riccardo. He was one of the *contadini*, or country peasants, who worked for a vintner outside the walls of Prato. We then heard much about the harvesting of grapes, a process that brought the only interruption to the continual fulling and dyeing of wool on the Bisenzio. Such an interruption in work brought merriment to the exhausted fullers and grumbling to the

cloth merchants, whose profits were postponed. Both parties would then drown their joys or sorrows in the vintage that ensued.

I shall never forget going with Mother and Vincenza to visit Riccardo, as this was my first trip to the countryside. The air smelled sweet and new, and the hills were green and dotted with yellow poppies and blue cornflowers. We went in early spring when the grape vines were just beginning to shoot out beyond their twisted, peeling trunks. They reminded me of rows of little gnarled men reaching out to one another with their new, green fingers.

Riccardo resided within the vintner's servants' quarters. It was a humble house with simple furnishings, but Mother cheered it with her linen tablecloth and basket of provisions. Riccardo spoke much of his eagerness to join us at Via delle Tre Gore. Mother explained that Ser Vannozzo had arranged for him to enter our household so that we would not lose Vincenza to the vintner when she married. Riccardo would remain with the vintner until that year's harvest had passed, and then wed Vincenza in the fall. He spoke eagerly of overseeing "a respectable garden" at Via delle Tre Gore, although there was little land for one.

At that age I soon wearied of my elders' discourses and was happy to go running beside those "little gnarled men." On one visit I wished to join the children I saw beyond the rows of vines. They were the children of the *contadini* who worked in the fields with their parents or even in the fulling mills in town. When Ser Vannozzo saw how eagerly I had approached them, I heard him tell Mother, "Meseems Fra Filippo would smile to see his daughter frolicking amongst the peasant children!"

Mother's reply was quick and strong. "Sandra is fain to frolic with almost any children, as long as they are kind."

Indeed, with my protected upbringing, I had not many playmates; certainly not like the *contadini*, whose children mingled often in both work and play. Eventually I would find friendship when I began to be tutored with a small number of girls whose fathers could afford the luxury of educating their daughters.

On one of my visits to the country, I recall going close to the green marble quarries outside of Prato. They were almost as famous as

the quarries of Carrara, and the unusual green marble supplied decorative façades and interiors for many of the great buildings in Florence and beyond. One afternoon, I overheard Riccardo tell Mother of some encounter he had had near these quarries. He had met some stonecutters who had been assigned to cut a piece of marble for the sculptor and painter, Antonio Pollaiuolo. Mother gasped with recognition, becausethis was Sandro's new maestro in Florence. She implored Riccardo, if he were to see the stonecutters again, to inquire on her behalf about "Sandro Filipepi." A few days later, Riccardo came to Via delle Tre Gore with what little news he had gleaned from his next encounter.

"The stonecutters say Sandro Filipepi is known to them as 'Sandro Botticelli.'"

"That is the name he took after his oldest brother, who has always been round as a barrel. Giovanni was called 'Botticello,' and because Sandro was the youngest, he became 'the little barrel'—Botticelli." I remember giggling in the background and then covering my mouth.

"The stonecutters say that Sandro has left Pollaiuolo's bottega to study under an artist name Verrocchio."

"Ah, yes, Andrea del Verrocchio. He is a painter and sculptor and was once a goldsmith—a good match for Sandro after his background in goldsmithing. And how fares Sandro in his employ?"

"They did not say. I explained that he had once worked here in Prato with Fra Filippo Lippi and that I was about to enter into Lippi's household, where Sandro is fondly remembered."

"I wonder if he has matriculated yet into the Speziali." Riccardo looked perplexed, and I was too. "The Speziali is the guild of apothecaries, doctors, painters, and goldsmiths, as they all use similar elements for their work."

Mother then spoke of Sandro for the remainder of the day, and Vincenza nodded in accord with all that she had to say. They were very merry in these reminiscences, while Riccardo, who had never known Sandro, would shrug and busy himself in our little garden. Mother had always maintained that Sandro was the most memorable of Father's students, not only for his wit and talent but for the exceptional interest he took in Filippino and me. After this episode there seemed

21

a certain melancholy again in my mother, and I, too, could feel the void of Father's and Filippino's absence.

Thus began that most visceral and vicarious link between mother and daughter, a connection of which I was not aware until later, when I would seek my rightful independence from her. For now, I was a mere child whose moods and inclinations were dictated by my mother. At any time, my playfulness could be tempered by her introspection, her quietness in prayer, or her restrained sorrow. There was only Vincenza to distract me, to force me to relate to things less subtle and complex than my mother's moods; but Vincenza had always been more than a servant to us. She acted as Filippino's mother when he was but an infant and my mother returned to Santa Margherita to renew her vows. This may seem strange, but a scandal had surrounded Filippino's birth, and Mother could no longer bear the uncertainty of life with Father. She felt that by returning to the convent to do her penance, she might be able to cleanse it.

They had "eloped" years before. Eventually there was a citizen denunciation of my father, made anonymously to one of the magistrates of Prato. It even implicated Ser Vannozzo, as he would often bring Filippino to Santa Margherita so that Mother might hold him in secret for a while. By then, Filippino was four.

When the truth was discovered, Mother left Santa Margherita and Father sought a formal dispensation for her from Pope Pius. But he never used it. The scandal had lost its flame. And Father was always so busy painting. . . .

My father was commissioned to decorate the Cathedral of San Stefano in 1452, the same year that my mother and Aunt Spinetta came to Santa Margherita. They entered as boarders, each paying fifty florins, thanks to their selfish stepbrother, Antonio, who had refused to invest in the public dowry fund. A female slave may be purchased for fifty florins! Imagine selling one's youth for that! Ah, but many a convent or monastery is filled with women and men who come to their vocation by chance and not passion. Father himself entered the Carmine as a youth after his parents died and his aunt could no longer afford him. Perhaps this is why they were so well

suited to begin with; neither had ever fully embraced the vows of chastity.

My father first saw my mother as a young Augustinian novice when he purchased his house on the Piazza del Mercatale across from Santa Margherita. Later he bought the house on Via delle Tre Gore and made the first house his bottega and lodging for his garzoni. He hastened to approach the Abbess Bartolommea to request the fair Lucrezia as his model for a painting of the Virgin Mary commissioned by a rich Florentine merchant. The merchant had requested that it be a tondo, or round panel, in which my father was most accomplished. Although the request was unrelated to his commission at San Stefano, the abbess honored it, as Fra Filippo Lippi was so esteemed a painter and a candidate for the chaplaincy at Santa Margherita. Father had long embraced the ancient Greeks' notion of divinity in beauty. He believed that our Holy Mother would have been as radiant and comely as she was humble and pure. Thus, my mother was captured as a very human and graceful Madonna many times over at my father's hand. While he drew his preliminary studies for each work, my mother enjoyed the wit and observations of a man who had managed to continue participating in the world she had been forced to leave. There was much he knew of her life in Florence: her parish church, the members of her father's silk guild, the carnivals before Lent, and the great jousts on the piazza of Santa Croce. I am certain she found herself able to laugh as she had not done since her arrival in Prato. She also found herself confiding in this worldly friar, who was old enough to be her father but seemed more youthful than she.

Much of what I know about my father came through my later discussions with Sandro. My mother was hesitant to speak about the ambiguities of my father's past and his many shortcomings as a man of the Church. At the time he came to Prato, he had found himself in disfavor with his superiors for neglecting his parishioners in another part of Tuscany. And then there was the matter of his inquisition, which he never spoke of in my presence. The wounds from the rack had left him with a constant reminder of his folly for having employed an undisciplined garzone, who accused him of refusing payment through a forged note. The garzone's family had great influence with the

Church and insisted on Father's imprisonment. According to Sandro, he was subjected to the Carmine's "most eloquent of inquisitors, and bore it bravely."

As I began to construct the puzzle of my parents' lives, I could see a pattern of concurrence in which each event propelled them, ultimately, into each other's arms. Their romance was not the passionately sudden liaison that people entertained it to be. Rather, it blossomed gradually from a mutual comfort and trust to the glimmer of attraction kindled by such fulfillment. I have often wondered, had my father been a successful painter without the cloak of the Church, and had my mother been a maiden of more means, if they might have found each other anyway in Florence. In that case, however, he would not have painted her as he did under these less fortunate circumstances, and the century might never have known its most gracious Madonna.

3

Florence

T HE NEXT TIME I SAW SANDRO WAS SOON
after the marriage of Lorenzo Il Magnifico, in 1469. I was still
very small, but there was much to impress a child my age.
Mother and I were on our way to Spoleto, to see father and Filippino.
Ser Vannozzo had written to Sandro of our passing through Florence,
and he responded in haste that we should stay with his family at Via
Nuova. It was a larger house that could accommodate not only guests
but his older brother's gold-leafing workshop on the ground floor.
Sandro was still with Andrea del Verrocchio and enjoying the fruits of
his labors on the banners for Il Magnifico's wedding. He was now a re-
spected journeyman whom Verrocchio trusted with any illustration,
and he was celebrated for having rendered very flattering likenesses of
the groom Lorenzo and his Roman bride, Clarice Orsini.

Imagine entering that great city in the wake of such festival and pag-
eantry as few cities have ever seen. I believe the wedding had been only
a few months earlier. And because Sandro had found favor with Lo-
renzo through Verrocchio's bottega, he was able to arrange for an es-
cort to accompany us from Prato all the way to Spoleto. Il Magnifico,
on behalf of his ailing father, provided us with one of the Medici's
most faithful bodyguards "to insure the safe passage of Madonna

Lucrezia Buti, her child, and any household servants." I remember Mother's reading the pronouncement, and the introduction of our escort, a massive young man named Giuseppe, "sent in the employ of Palazzo Medici with gratitude for those great works done by the hand of Maestro Fra Filippo Lippi."

I'm sure Sandro had informed the Medici that my father was ailing in Spoleto. He had been invited to the wedding but had been unable to attend. I didn't know myself about my father, althoughI knew that something was not right, and I recall the courier who brought a letter from Filippino earlier that summer. Mother consumed its message hungrily with eyes of alarm. Vincenza had inquired, 'Is all well with Maestro Filippo?' And Mother had answered, "His rupture is worse. I must go to Spoleto."

Vincenza had just delivered her first child with Riccardo, who now lived with us. Mother decided to wait two months, until the child proved to be thriving, and then depart with me to Spoleto. I am sure she knew this would be my last chance to see my father, whose memory was already growing dim in my small brain.

The remainder of that season was filled with preparations for our departure. Mother spoke often of father's health to Vincenza or Ser Vannozzo. The canons of Spoleto had provided my father with a phy-sician, and she thought this very generous. But Ser Vannozzo was more cynical and told her it was only to insure that their frescoes would be completed. My brother had written that Diamante was transferring to plaster father's cartoons for the topmost fresco, *The Coronation of the Virgin*.

This was his last painting of my mother, but Diamante did most of it. It is very gaudy, which was Dido's style, and a verypoor tribute to the woman my father loved.

Mother prepared me for the journey by describing the road to Flor-ence and the countryside that I would see along the way. She spoke of the many buildings I would see—houses much grander than the house of Prato's great merchant, Francesco Datini, and churches much greater than Prato's San Stefano. We could cross the bridges over the Arno, a river much wider than our Bisenzio, and pass through city gates much grander than our own *cassero*.

The night before our departure, Mother helped me to undress and wash. She gave a quick prayer for our safe return instead of the usual recitations of Vespers. But in spite of my fatigue, I could not sleep. I stood up at the end of my bed and threw back the oil cloth shades and shutters. I looked into the starry sky above Via delle Tre Gore and thought of Florence and the thousands of candles that flickered through real glass windows.

Our escort, Giuseppe, was a formidable man: tall and broad with a noble countenance. It was difficult to believe he had once been a peasant from Fiesole. I remember standing close to him and wrapping my arms around his slender legs, an act for which I was swiftly reprimanded. But he had an easy manner and said, "I am grateful to take a journey with such a delightful charge." Then he turned to Mother, "And I am even more privileged to escort the Madonna of the tondo that Fra Filippo Lippi painted for Leonardo Bartolini. I have seen it and it is surely you."

"Mamma is famous! Her pictures are in San Stefano, too!"

"Filippo painted the frescoes for the main altar with his garzone, Sandro Botticelli of Florence. Do you know him?" She continued to gather our belongings together.

"Ah, yes, I recall the name. He did the banners for Lorenzo's wedding."

"Sandra was named for him and he is her godfather," Vincenza added.

"He spent five years with us and was Filippo's favored pupil. He had a gift for painting hands and hair."

The subject of hair compelled me to fetch my doll, Caterina, and hold it up for the tall Giuseppe to inspect.

"Babbo sent her for last Christmas. She has real hair and a pearl!"

"She has the hair of a noblewoman." Giuseppe pressed his fingers carefully against the high crown of the doll's head. "A beautiful child such as you should have such a lovely thing, Sandra." He stroked the doll's hair and then my own. It seemed odd for a man of his vocation to be so gentle and to take delight in a small girl and her doll.

Later, as Mother and I mounted our mule, Bello, and Giuseppe secured the rest of our supplies on his fine black horse, he inquired

about my father's health, which was the reason for our journey.

"He has an old injury which has been aggravated by climbing the scaffolding to paint a very high fresco," Mother explained softly. "It has troubled him often, but, according to Filippino, never like this."

"Is Babbo hurt?"

Mother held me closer. "Babbo has a bad stomach ache."

"He needs Vincenza's broth!" I was recalling the home remedy for my own childhood ailments.

Giuseppe chuckled gently. "Methinks he needs his daughter's laughter."

We stopped only twice in the three hours it took to ride to the outskirts of Florence. As we neared the hills above the city, Giuseppe pointed to the distant houses of Fiesole to the east. When we descended into the meadows of poppies and cornflowers, we were truly quenched by the view of the valley below and the fragrant smells of earth and flowers. Meanwhile, Giuseppe readied himself for entering through the city gates as a respected servant of the Medici.

We came upon clusters of vendors who had set up their carts outside the old fortresswalls. When Mother inquired why there were so many, Giuseppe explained that there was no tariff on goods sold outside the gates. Mother recalled that shopping outside the walls was often a bargain.

"Ah, but without the market patrols, the vendors are tempted to cheat!" he warned her as she approached a woman selling oranges.

"But these are a delicacy and a boon to health." She cradled the rare, bright fruit in the palm of her hand. "Some believe these to be the *palli* of the Medici. You know, the red balls on the Medici coat of arms."

To this, Giuseppe held up the staff that sported the arms of his employer. "And many believe the heraldic *palli* to be a symbol of the Medici's gold florins rather than any medicinal fruits!"

Then he approached the vendor and purchased four luscious oranges as a gift to Mother and myself.

"You mustn't." I remember her blushing from his overture.

As a child, I had quickly dismissed any flirtation I might have witnessed between a man and my mother. I had no concept, then, of how

28

rare her beauty was, even while entering a city full of coarse and unsavory faces.

Mother accepted the oranges for my benefit, and Giuseppe quickly turned his attentions to passing through the massive arch of the city gate before us. He declared to an inspector that we had no wares to sell within the city and had only to flash the arms of the Medici on his staff to win our uninterrupted passage.

"This is the Porta al Prato," Giuseppe announced. "I was instructed to enter this way in order to reach Sandro's house."

"Indeed! Indeed! This is the way to the Borgo Ognissanti. It has been many years, but this quarter of the city remains unchanged!"

Mother's eyes were bright with anticipation as we beheld the tangled meadow of rough grass stretching before us. We could not know what feelings had risen up in her heart as she gazed upon the city she had left so long ago. On one side of the field we saw a cluster of boys throwing and kicking something. As we approached them, we could see there was some structure to their playing, and Giuseppe explained that they were engaged in the celebrated game of "gioco del calcio," a kind of football.

As we passed closer to the canals of the Borgo, our nostrils were hit with the horrible stench of refuse in an area called "Sardigna Island." It was worse than the dumping areas in Prato that were often used as latrines. The air improved for a while until we reached the fulling mills of the Borgo.

Bello was a bit daunted by the noises and obstructions as we encountered mule trains and carts of wool. I saw children not much older than myself emerging from the fulling houses, and Giuseppe explained that they worked there, literally walking on the wool to compress it. As we plunged into this world of sweat and dirt and dyes, I did not appreciate the gentle childhood with which Filippino and I had been blessed.

We soon approached the section of the quarter with large city houses on the left side of the Borgo. To the right, near the river, were more dyeing and weaving houses and the shops of tanners, all benefiting from the waters of the Arno. In the distance we saw the church of Ognissanti, but it was dwarfed by the much larger companile of

Florence's great cathedral farther ahead, towards the center of town. Santa Maria del Fiore towered above every building in Florence. The massive dome of Brunelleschi was the largest in all of Italy and Europe. As we gazed upon the legendary skyline, Mother recalled a story father had enjoyed telling about the construction of the dome some years earlier.

The great artist and architect, Filippo Brunelleschi, had entered the contest to design an impressive dome for the cathedral of Florence and had arrived with other architects to present his plan to a committee appointed by the Masons' guild. When asked to show his design, the petulant Brunelleschi declared that it was secret and he did not wish to have it examined "by untrained busybodies." The committee was about to dismiss him when he produced, from his pocket, a hen's egg and asked all the men present if they could stand the egg upright on a table and keep it there without it rolling on its side. When no one produced a solution, Brunelleschi took the egg, smashed one end of it, and firmly set it upright on the surface.

"But any of us could have done that!" the other artists and members of the committee had declared.

But Brunelleschi was more clever. "Indeed. And if I showed you my plans, you would say the same of me!"

Needless to say, the committee was so impressed by his confidence that he was awarded the commission.

We all laughed at the tale, while marveling at the great dome. Near it, but closer to the river, rose the tall tower of Palazzo della Signoria with its distinctive turret. It was more imposing than our own town hall, the Palazzo Communale, in Prato. I believe my mother was at once inebriated by the sights of her old city, the city I would visit often as I grew to womanhood.

We finally passed the church of Ognissanti and turned in to our left on the following street. This was the Via Nuova, and I was pleased to see the well-kept houses. Giuseppe explained that it was one of the cleaner streets in Florence, as it had been among the last to comply with the ordinance against pigs.

"Pigs?" I had not spoken a word since we had entered the Porta al Prato.

"When pigs were allowed to roam about, they ate most of the refuse. Street cleaners with no wages!"

We stopped at a narrow doorway, where Giuseppe dismounted and knocked twice. I could hear a muted din of rhythmical pounding and tapping. Giuseppe knocked on the door again and finally the latch was pulled open. A large, amiable looking man with heavy eyelids, much like Sandro's, answered. He went immediately towards Mother and clasped her delicate shoulders between his large, broad hands.

"Madonna Lucrezia! You are here. Come in! Come in! I will call for Smerelda. I see you have brought your littlest angel with you." He reached down and touched my hand, and I recall the gold dross on his fingers that was transferred to mine.

The man directed Giuseppe where he should lead Bello and helped him unpack our belongings. They went to a modest livery in a rear courtyard behind the house. Then Giuseppe took his leave, saying that he would return in two days, when we would depart for Spoleto.

"We are most fortunate to have a pleasant escort."

Mother then introduced us to Mariano Filipepi, Sandro's father.

We stood at the foot of a dark stairway leading to the living quarters of the house. On the ground floor was a large workshop in which Sandro's two older brothers engaged in the trade of goldbeating. Sandro would eventually set up his bottega here.

Mariano called out to Giovanni, the eldest and heaviest—the "barrel" from whom Sandro had acquired his new name. The other brother, Antonio, continued to demonstrate some technique to an apprentice. Both hovered deep in concentration over a sheet of gold leafing.

"Welcome! Welcome!" Giovanni rushed towards Mother while wiping his hands on an already-soiled apron. For him, work seemed a form of celebration.

Mariano introduced us. "Giovanni's wife, Mona Nera, and Sandro's mother are upstairs preparing the meal. Go up and we shall follow. Sandro is still at Verrocchio's bottega, but I know he will not miss supping with us today!"

We mounted the stairs to the first level, where Mariano deposited some of our belongings. As with most Florentine houses, the kitchen

was on the top floor, and there two women, one old and one younger, labored among two children. The older woman, Sandro's mother, called out to the boy, who was my age.

"Amide! Come here and meet Sandro's goddaughter. You remember Filippino. This is his sister."

The boy smiled shyly and held out a small wooden ball to me. I took it, thinking it was mine. A pleasant little girl, slightly older, appeared. She was his sister, Fiametta, and Sandro's niece.

"Our brother Benincasa is at his lessons. You will meet him later." She quickly took my hand. "You look like your mother, Alessandra."

"But she has her father's nose!" Mona Nera interjected.

"One is very observant when there is a painter in the family."

Mother offered to help in the preparation of the meal, but Sandro's mother and Mona Nera insisted we be shown our room to rest. Alone in the little bedchamber with Mother, I was now comfortable enough to sleep. She had taken off her mantle and removed my little gown and stockings. As I lay beside her, I recall the scent of oranges and the sweat that clung to her in sweet familiarity. I could hear the muted percussion of hammers and metal below as I drifted off to dream.

I awoke to many voices and a thin stream of autumn sunlight filtering through the shutters of the room. I was alone on the bed and could hear my mother talking in the room above. Without thinking, I wandered upstairs in only my camisole. A tall, familiar man held out his arms to me and lifted me up.

"Sandra mia! What a beauty and look at all your hair!" Sandro marveled as he pulled his fingers through it again and again.

Mother explained that when last he had caressed my curls, they were "only short tufts of gold."

"Now there is a lovely cherub for you, Sandro. Perhaps she can sit more still than Amide." Giovanni rubbed his son's already rosy cheeks.

"You forget she is a painter's daughter. It is in her blood to sit." As Sandro placed me on a little stool, I was filled with the recollection of that moment when he had held me high above the crowd in front of the Prato Cathedral.

I sat with the other children on one side of Mother when we ate. The oldest boy, Benincasa, had returned from his lessons but took no

interest in me or his siblings. Sandro talked to Mother about his work with Andrea del Verrocchio, but I understood little of it. He seemed enthralled with the new idea of mixing the oil of flax with pigments; this made the colors dry more slowly, and thus allowed the artist to make alterations.

"Would a painter not become sloppy or careless by the forgiveness of these oils?" Mother inquired.

"Perhaps, but there is a gift in regaining a line or shape without the trace of error, especially when it is made by one's garzone. Still, the quickness of tempera on plaster is a skill that separates a maestro from his pupil."

And, in spite of their advantage, Sandro would resist the use of oils for many years.

After the meal, Mona Nera set out fruits and cheeses for us to enjoy. She had opened two of the oranges as a centerpiece, and I was pleased by our contribution. So was Sandro, who gingerly fed me the treasured sections. Mother seemed not to mind how he indulged me.

The next day Sandro took Mother with him to Verrocchio's bottega while I remained behind with Fiametta and Amide. I recall my apprehension at being separated from Mother, but Mona Nera made sure that I kept distracted. They returned at midday to eat, and Sandro spoke excitedly of a possible commission of his very own for the hall of the Merchants' Tribunal at Palazzo della Signoria. Apparently the artist who had been chosen to decorate the hall had been delinquent in its completion, and Sandro had been looked upon favorably as a replacement.

"It means I shall be able to set up my own bottega and advance to the rank of 'Maestro'!" he boasted.

At first his brother, Antonio, did not think their ground floor large enough to accommodate another workshop, but Mariano insisted that goldbeating and painting could be compatible, as long as Sandro did not take on too many assistants. A flurry of more adult discourse followed this conversation until Mother interrupted with a grand idea.

"Shall we take Sandra into town to see the palazzo and the duomo up close?" Sandro happened to have his first sketches to show the tribunal, so he agreed to escort us there with his portfolio.

We traversed the street along the river at first, then turned in towards the great piazza of Florence where stood the Palazzo della Signoria. The tower seemed to pierce the heavens, and I recall how I inquired if that was where our Lord Jesus sat upon his throne. Sandro was highly amused by my young concept of the universe.

"No, carissima. But the great bell that is pulled when the Signoria wishes to call the men of Florence to arms resides aloft and thereby serves as our savior."

Mother chuckled, but I had not yet an appreciation for Sandro's wit and his gift for analogy and allegory. It was a gift he would later apply to his most celebrated paintings.

Children were rarely seen in the great halls of the Palazzo della Signoria, so Mother and I remained on the piazza, watching the finely dressed men and women pass while we waited for Sandro to complete his business. We wandered back near the river where there were shops of fine cloth, and I recall Mother admiring a bolt of beautiful pale blue silk called *alessandrini*.

"This would make a lovely gown for you, Sandra. The perfect accompaniment to your name."

She searched inside the little purse attached to her belt and shook her head, for she had not enough money to make the purchase. When Sandro reappeared back on the piazza, we waved towards him eagerly and I ran up to tell him of "the beautiful blue silk named after me!"

"Then you should have enough for a little gown, my 'Alessandrini.'"

"The cost is very dear."

"But wouldn't her father love to see her in such a dress?"

"Filippo does not wish to spoil his children with finery." Mother had an almost pained expression.

"Filippo is known to take frugality to its extreme." Then he turned and took my hand. "Here now, let your other 'Babbo' spoil you for your journey."

We returned to the shop, where Mother selected enough of the beautiful blue cloth to sew me a gown of simple fit. I was not aware that this would be a rare moment of generosity on Sandro's part.

I was so dazzled by the purchase of the silk that I barely noticed the blocks we traveled to reach the Cathedral of Santa Maria del Fiore.

34

Sandro described the wedding procession of Lorenzo Medici a few months earlier and how a great, striped awning had been built over the street leading to its entrance. Mother was intrigued by his description of the event: the fashions of the bride's Roman guests, the scores of fifes and lutes that played in the procession, and the three days of feasting and dancing that followed.

"To be sure, every sumptuary law was broken then!" Sandro laughed, and so did Mother.

"But why did the Medici break the law?" I did not understand how common it was to "bend" the sumptuary laws, especially when one could afford to do so.

At this, Sandro laughed even louder, finding amusement in my innocent trust of the most powerful family in Florence.

"There are some laws we all must break in order to make merry!" He then held up my bound package of blue silk.

Mother frowned disapprovingly until he reached over and lifted her chin gently with his hand.

"Methinks you spent too long at Santa Margherita, Madonna Lucrezia."

She blushed, and I wondered, for a moment, if he found her as lovely as my father had.

Brunelleschi's magnificent dome hovered over the unfinished façade of the cathedral. Standing beside it and looking up, we could not even see the top. Next to it on the piazza stood the much older Baptistry of San Giovanni. It was an odd, octagonal structure such as I had never seen before, and each massive door sported elaborate bronze relief panels of biblical events.

"Here is the head of the artist, Lorenzo Ghiberti." Sandro pointed to the small bronze sculpture of a balding head with pleasant countenance emerging from a lunette beside one of the panels. "Quite a clever signature for one's work, wouldn't you say?"

"Why, it resembles Filippo a little," Mother marveled while Sandro held me up closer to inspect the small face.

"Babbo?"

"We shall be seeing him, soon, Sandra. Come, let us return to Sandro's house and rest, for we leave in the morning."

35

Sandro carried me part of the way to Via Nuova, until Mother insisted I walk. I remember loving him then more than any grown-up I knew; more than Mother or Vincenza or the father I barely remembered, because these were unconscious affections. For Sandro, I felt the first deliberate stirrings of my heart, and I had no way of knowing what they would make of me one day.

4

Spoleto

I REMEMBER MY FATHER GREETING US AT THE little house that the canons had provided in Spoleto. It was odd to watch my parents embrace, and when my father started to bend down to lift me, my mother stopped him because it might aggravate his injury. Then he crouched low so that I could study his well-sculpted features until finally I could remember him.

"Ah, my little Sandra. You are no longer a bambina. And what a long journey you have made to see Babbo!"

His eyes were filled with tears that had not yet spilled over his face, and I could not yet understand the kind of joy that moves adults to weep. I thought his tears were from the pain of his rupture. He embraced me quickly, and I recall the silent quaking of his heavy body through his cloak.

Mother and I then met Father and Filippino's housemaid, Maria, who assured us of a good supper after our three days of uncertain meals.

"But Filippo's doctor, Maestro Gregorio, has prescribed a lighter fare for him. He says it puts less pressure on his rupture." Maria gave a matronly frown to Father.

Father looked annoyed, and Mother smiled sadly. Later I asked what the "rupture" was, and Mother replied that it was "a very bad hurt" that Father had suffered a long time ago.

"Will it go away?"

"Would that it could," Father murmured.

"Would that you could retire from those scaffolds and give healing a chance!" Maria scolded him.

Mother looked alarmed. "Filippo! Filippino wrote that Diamante was finishing the apse."

"I *am*," Diamante interjected as suddenly as he had appeared.

Filippino was with him and had grown, it seemed to me, a whole head taller since I had last seen him.

"Sandra mia!" He rushed towards me. This interrupted the discord over who was actually painting the apse. Filippino took my hand to show me the rest of the house and the little bed that had been installed for me in Mother and Father's room.

Mother bathed me after supper, and we said Vespers together to prepare me for bed. I missed Vincenza's cooking and said so, but Mother just smiled. "We miss Babbo more."

Later, as I snuggled into my new bed linens, I could hear the voices of my mother and father, my brother, and Diamante as they spoke of Prato and Florence and the future of my godfather, Sandro. Through the walls, their muted words rose and fell like a gentle tide whose rhythms soon put me to sleep.

That September in Spoleto was punctuated by a few, rare intervals of rain, several trips to market with Mother and Maria, and strolls along the Via dei Duchy, where Maria pointed out the eighth-century shops that had been built when Spoleto was the capital of a Lombard duchy. Spoleto did seem older than Prato with its steep, narrow streets. The Duomo sat at one of the highest points of the hilltop city, where it was broad enough for a piazza.

Filippino spent most of the month helping Diamante and Father with the frescoes. But occasionally he would take me out to the Ponte delle Torri to watch the Tessino river rushing under its old Roman aqueduct. Often he sat and sketched, speaking of how he needed to improve his perspectives of architecture and landscape. And sometimes he would end up sketching me instead of the rich scenery that stretched before us.

One time Father had agreed to join us on an excursion, but on the morning of our departure, he announced that he had too much work to do and could not go. In reality his rupture was worse, but he was very convincing and Mother set off with us, thinking him much improved.

In late September, Father received more than his weekly visits from his physician, Maestro Gregorio, along with a stern reprimand not to reach or lift. He also brought medicines in a small jar, not unlike the jars in which Father kept his pigments. I used to wonder how he told them apart and feared he might consume the wrong tonic. For a while, Father seemed to improve and returned to painting the walls in the Duomo. The plasterers scurried back and forth in an effort to accommodate his sporadic ability to work. He had assigned more responsibilities to Filippino, who could now transfer some cartoons as well as mix pigments. Diamante still did much of the brushwork where my father could not reach and worked closely with Filippino. I did not realize the friction that was developing between them then, as my brother continued to speak of Sandro and his admiration for his style.

The canons of Spoleto were not aware of the original injury that had afflicted my father, although they did know of his "worldly reputation." Later, when I was able to study my father's many works, I began to understand why he would not paint the crucifixion. Perhaps he felt more joy in the glad news of the Nativity and the Infant Christ than he did in the suffering of Our Lord. But I believe there was also the agony of his own flesh that prevented him from portraying the crucifixion for what it truly was: the torture of an innocent man.

One afternoon, in the last days of September, two visitors from Florence arrived at our house. They were the Pollaiuolo brothers, Antonio and Piero. They were on their way to Rome and had stopped in Spoleto to see Father and his work in the Duomo.

Although both men were close to Father's age, they appeared to be older, even though Father was the one who was ailing. Their beak-like noses constantly brought to mind the family's poultry business, from which their surnames were derived.

Antonio mentioned Sandro's name often, as Sandro had studied under him after leaving Prato. His younger brother, Piero, was about

to abandon a commission for the Merchants' Tribunal. It was the one Sandro was vying to replace the day he had taken Mother and me to the Palazzo della Signoria in Florence. The three men spoke at length about the new styles coming out of the workshops of their native city, such as the manner of depicting faces with open mouths and teeth. Father had dared to do this with his mourners in his fresco of *The Funeral of St. Stephen.*

Father had seemed invigorated by his visitors, but after their departure he ceased his work in the Duomo and returned to bed. Maestro Gregorio was called in, but the medicines he brought did little good. Father ate very little and slept even less so that Mother finally had my bed moved into Filippino's room. The few times she allowed me to see Babbo, there were constant warnings not to bump him as I crawled atop his bed. He then would rub my back and ask what letters or numbers I had learned that day. I was learning to write my name, and I recall how proud he was when I showed him my first attempt, "Alessandra Caterina Lippi," scrawled on a piece of discarded parchment.

Diamante came in the evenings to report on the progress of the frescoes and to check on Father's health. He had been residing with the priors of the abbey since our arrival in Spoleto. Father made a point to sit up in bed whenever Diamante appeared and to give him detailed instructions for completing the frescoes. The canons had been concerned with the completion of the apse, since they had desired the unveiling of the frescoes by Advent. This, according to Mother, had riled Father sufficiently so that a strained sort of vigor returned to him. He was out of bed and back in the Duomo with his brushes. What I did not know of these final efforts was how my brother sat beside him on the scaffolding to support his weight and lessen the strain of each brushstroke on his rupture. He would then arrive home by litter, a luxury that baffled my young brain. These seemingly privileged days were followed by the agonizing nights during which my mother held my father next to her in an attempt to absorb his pain.

In the second week of October, Father went to lay the final pigments for the fresco of *The Funeral of the Virgin.* Mother had planned to take me to market with Maria, but then decided in the morning not to go. I heard her tell Maria, "Filippo does not look good. I will wait here,

in case he returns before midday." Maria went into town alone, memorizing the list of supplies for that day's supper. I recall how I suddenly became aware of the convenience that reading would have been to her. Not much later, Filippino was at the door and out of breath.

"Father fell! He cannot move! They are bringing him home now!"

Mother's face was white as plaster, and I sensed a terrible fear in her that was now my own. She ran to pull back the bed covers and sent Filippino to the nearest well for more water. She began to brew some sort of broth with a medicine that the doctor had left. Soon there were the voices of the men carrying Father on his litter, followed by a commotion from those neighbors who had witnessed the event. I recall the strange embarrassment I felt for my father, as he had ruined the tranquility of the day. I ran to my room in search of my doll, Caterina, and some solace.

Maestro Gregorio was summoned, and Maria returned from market to an anxious household. Hours must have passed with Mother and the doctor in Father's room. Maria worked intensely in the kitchen preparing supper, and Filippino and I ate it quietly in one corner, feeling, as children often do in times of misfortune, that we were somehow to blame.

Mother did not eat. She went in and out of Father's room with cloths and water, poultices and broth. Maria urged Mother to rest and let her take over, but Mother insisted that she alone should tend to Father.

I remember asking, "Can I see Babbo?" But Mother only hushed me as quickly as I spoke, making me feel more awkward and useless than ever.

Filippino was a most perceptive brother and saw the injury of this chastisement on my face. He led me into the small garden next to the house to pull some vegetables. Then he had me sit on the little bench where we did our lessons and began to sketch my face. It seemed we stayed upon that bench until dusk and the cool autumn mist began to move across the lime trees. When we returned to the house, we found Mother on her knees at Father's bed. She looked up and gestured for us to join her.

"Come and say good-bye to your father, for he is dying."

He seemed not to hear her and his eyelids barely fluttered.

I tiptoed closer, to see if there were any life in the once-jovial face. My father now breathed unevenly and tried to contain his pain, as women often do in childbirth. Even as a child, I could see how he was consumed by it, how he shuddered with an occasional grimace. I hated seeing my father's face so distorted and unfamiliar. But Mother told me, when I was much older, how she had always found him beautiful, even in his agony.

No one could sleep that night. Mother sat up with Father in the light of a single candle. Filippino and I could see its peripheral glow from our room. I must have dozed slightly, for when I awoke, I could hear the voice of a priest delivering the final sacraments. I tried to listen for Mother's weeping, for some confirmation of finality. But all I heard was her gently punctuated breathing.

It was not yet daylight, but an eerie radiance illuminated the entire house. I do not believe it was that lone candle but the bright flickering of my father's spirit, filling every room before it left his body forever.

The poet Poliziano wrote a Latin verse that said, "So rare was his grace in painting that scarcely any other painter came near him in our time." No one knew that Sandro Botticelli was about to do just that.

5

Simonetta

MOTHER AND I RETURNED TO PRATO. FILIP-
pino and Diamante stayed to finish the apse. No sooner
had we left than the rumor began of my father's dalliance
with a woman whose jealous husband had poisoned him. There was
also the story that a jealous mistress had obtained the poison upon
Mother's arrival in Spoleto. People are always so hungry for romance
and murder, but I know this pained my mother, even though Father
left us well cared for. I had an adequate dowry, and there were funds to
pay for Filippino's apprenticeship with Sandro, as Father had stipu-
lated to Diamante. That was how I eventually came to sit for him.

My mother pursued my brother's apprenticeship with Sandro once
his bottega was well established, and Sandro's interest in Dante and
Boccaccio influenced my education. I began to take lessons at the
home of Ser Vannozzo's brother. Mother wished me to read Latin for
the sake of the Scriptures, but I soon took an interest, through Filip-
pino, in Tuscan writers. Sandro had worked on illustrating Dante's *La
Commedia* while Filippino was with him. Filippino was most impressed
with his drawings in silverpoint. Eventually the drawings became en-
gravings for a printed text of Dante, which I longed to own as soon as
I could read as well as the Ciardi girls. They were my classmates and

rivals and the eldest, Giovanna, was soon to be the first kindred spirit of my youth.

Yet my deepest affections lay with Sandro, and his lay with Simonetta. But then, all of Florence was smitten with Simonetta Vespucci.

In the spring of 1473 I was in my second year of lessons in Prato with Messer Fiorentino. I took them at the home of Antonio di Vannozzo along with the daughters of a wool merchant named Giovanni di Ciardi. The eldest, Giovanna, was one year older than I, and when I first met her in the flowering courtyard beside the Bisenzio, I was taken enviously with her long, thick hair. My hair had finally begun to grow and had acquired a reddish tint, which Mother encouraged with lemon juice and saffron when she could afford it. I recall being intrigued that these tiny stamens of the purple crocus could produce so elegant a hue, along with curing many ailments.

Aunt Spinetta was duly concerned that Mother was "sowing the seeds of vanity in such a young child." But Mother replied that she "only sought to embellish what God has given Alessandra." It was the first time I came to think of beauty as a gift and not my own, inherent quality. Thus my rivalry with Giovanna Ciardi's beautiful hair soon softened and was replaced by an eager competition in reading.

"The Ciardi girls are reading Tuscan as well as Latin," I announced to Mother and Ser Vannozzo one day. I recall that our tutor, Messer Fiorentino, had brought a copy of Dante's *La Commedia* to class for them.

Ser Vannozzo shook his head. "Before long we shall have women writing verse, settling accounts, or worse yet, elected to the Commune!"

Thereafter Mother inquired if I, too, wished to read the Tuscan authors, and upon seeing my eager desire, she hastened to request the same lessons from Messer Fiorentino.

"A well-read maiden is an asset to her husband."

But Ser Vannozzo looked skeptical. "And what of her *religious* training, for which she only requires Latin?"

"Alessandra's *spiritual* education is more than adequate, Piero. There is enough religious training in this family for several daughters!"

I recall how proud I was of my mother's retort to Ser Vannozzo. Even Aunt Spinetta was quick to laugh.

My brother Filippino was now sixteen and still studying under Sandro in Florence. He wrote as often as he could. "Certainly more than Sandro wrote to his mother when he was a garzone!" Mother once remarked. He had, in his three years with Sandro, learned to prepare various wood panels, mix gesso to perfection, and transfer cartoons, the prelimary drawings for paintings. But Sandro, he said, "is so great a draftsman and so meticulous in his drawings, he himself rarely employs the egg dot over the gesso or plaster. If he does choose to transfer lines from a drawing, he tends to incise the line through the paper, which only he can see with his trained eye."

My mother read Filippino's letters aloud to our entire household, and then gave them to me to study. Once he mentioned that Sandro had painted his own portrait into a crowd scene in a tondo commissioned by a wealthy merchant. It was a bold thing to do, a kind of signature for his work. And when the young Lorenzo de' Medici viewed it at the home of the patron, he was "most impressed" by the style of this new master who had painted his wedding banners for him.

Thus Sandro Botticelli's reputation grew in esteem and my brother flourished as his student, soon to be elevated to first garzone. When Sandro was commissioned to paint a panel of *San Sebastiano* for the hospital of Santa Maria Maggiore, he decided to use Lorenzo's younger brother, Giuliano, as his model for the saint who had survived the arrows of Diocletian's army. Sandro had agreed to go to Palazzo Medici for Giuliano's first sitting, and had arranged for Filippino to accompany him so that he might see one of our father's panels, a tondo that had been painted for the private chapel of Lorenzo's and Giuliano's grandmother.

Although Filippino was very pleased to see the painting as well as the interior of Palazzo Medici—which belied its austere exterior—his letter spoke more about Giuliano's continued praises of a young woman who had recently arrived in Florence. Her name was Simonetta Cattaneo, and she was the young wife of Marco Vespucci. They had recently married, which made her a new neighbor of Sandro, since the Vespucci family presided over the parish of Ognissanti.

Filippino wrote that "Giuliano hastened to inquire if we had met her yet and if Sandro had not considered using her as a model for one of his Madonnas, even though he has used his favorite, Contessa, for the past two years."

Sandro quickly replied, "Ah, yes, Simonetta, 'The Pearl of Genoa.' Methinks her more a goddess than a Madonna."

"Do you think her husband finds her as fair?" (Giuliano was clearly curious about the lady's marriage.)

"Marco is much older and delighted by his young wife, but still there has been no child . . . "

Sandro's response had served to encourage the infatuated Giuliano, but whether or not this influenced Sandro's commission to design the banners for the next event sponsored by the Medici, Filippino did not say. In mentioning the upcoming ball to honor the Princess Eleanor of Naples, who would be passing through the city on her way to marry the Duke of Este in Ferrara, Filippino came to invite Mother and me to Florence.

"Alessandra is old enough to attend both the Feast of St. John and the banquet for Eleanor. How grand it would be for her!"

But Mother was hesitant to go, having heard of the arrest of one of Sandro's pupils. He had been charged with seducing a child, which caused her much alarm for my safety, but Filippino wrote to calm her fears: "The pupil in question prefers boys, younger than myself, I might add."

Of course, all this was kept from my young ears at the time, but I learned of it in my later years, when I asked Mother why she had seemed so unethusiastic about partaking in the merriment of a Florentine festival.

Meanwhile I studied in Prato, learned smaller stitches for my embroidery, and cultivated Giovanna's friendship, which blossomed along with my Latin. She was highly envious when I told her that Mother and I were going to Florence for the Feast of Saint John. Giovanna's father went frequently to Florence to do business and had brought back the news of the Medici's plans to honor the princess.

"The marriage of Eleanor is on the lips of every Florentine!" she told me when I first mentioned that we would be attending.

46

"Mother only wants to go to see Filippino. He is invited because Sandro is designing the banners."

"How I envy you, Alessandra!" I found this ironic, because Giovanna had long been the focus of my envy.

"Mother says I can only attend the banquet and not the ball." I tried to be as modest as possible.

"Are you excited to see your godfather?" Giovanna knew that I was named after Sandro.

But for this I had no answer. My last memories of Sandro had been while passing through Florence after Father's death. He had been quiet and sombre and inattentive to me. I did not understand, at the time, that he was filled with sorrow. Filippino's letters had reacquainted me with Sandro indirectly as well as encouraging my reading of Tuscan. His next letter mentioned the woman, Simonetta, again. He said that Sandro's neighbors, the Vespucci, had planned to formally introduce their new niece, Simonetta, to Florentine society by means of the upcoming fests.

Because of Sandro's friendship with the Vespucci, the notary, Nastagio Vespucci, had offered his house as lodging for Mother and me. Apparently Sandro's mother and Nastagio's wife had quibbled over the privilege of who was to provide our accommodations, but because the Filipepi household had expanded and Casa Vespucci was larger, Mother agreed we should stay with the Vespucci.

Ser Vannozzo escorted us to Florence one sunny morning in June of 1473. We were greeted at Casa Vespucci by a youth not much older than Filippino. He bade us enter, while he sent his attending servant off to do some other errand. The youth's round face was framed by a cap of blond curls. He wore a striking set of hose; one leg in scarlet, the other deep blue. His doublet had corresponding hues. He introduced himself as Amerigo Vespucci.

Amerigo led us into the small but elegant loggia of the house, and introduced us to his father, Nastagio, who preferred to be called "Stagio." His mother, Monna Lisa, seemed a fussy matriarch who was humored by the rest of the family, which included an uncle, Giorgio, an older cousin, Giudo Antonio, and another older cousin, Marco, the husband of Simonetta.

Although Amerigo had introduced Mother as Madonna Lucrezia Buti, his father insisted on calling her "Madonna Lippi," which I expected to cause her some embarrassment. He alternated this formality with the habit of calling me the more familiar "Alessandrina" instead of Alessandra, which annoyed me at first. But soon we were distracted by the arrival of Simonetta Vespucci, "The Pearl of Genoa," and she was surely as lovely as the reputation that preceded her.

She was dressed in a gown of pink silk with beaded pearls and lace, and her hair was braided and wrapped in numerous coils and satin ribbons. She had a fine, high forehead and an unnaturally small nose for an Italian; and her widely set eyes gave her an unearthly, almost ethereal appearance, one often attributed to her Northern heritage. From those eyes there radiated a gentle and consuming grace, and I recall that I was drawn to her even before I heard her speak.

"And here is a child well worth doting on," she said when I was introduced to her. Then she took my hand in hers to greet me. "How old are you, Alessandra?"

I recall how thrilled I was to have the attention of such a beautiful lady, and I was surprised to hear Amerigo's father say, "Indeed, Simonetta, methinks our Alessandrina may rival you some day in beauty!" This made her smile and me blush. Gazing at that lovely creature, I thought this was a cruel suggestion for anyone to make.

"She need only be the delight of her family, nothing more," said Simonetta.

"And truly she is that!" interjected a new voice. It was Filippino, who had just arrived from Sandro's bottega to welcome us to Florence.

Mother embraced him while I stood awkwardly holding Simonetta's slender hand. Her nails reminded me of polished shells, and she smelled sweetly of some gentle fragrance. I felt that I both feared her and adored her.

"Sandro will be supping with us, too," Amerigo announced as he showed us into the banquet hall where all three branches of the Vespucci met to dine. Three tables formed a triangle, opened at the apex, and they were covered with fine damask, which several servants were carefully setting with silverware and Venetian glass.

It was the most elegant supper I had ever attended, and I was sur-

prised that Mother did not have me eat earlier with Amerigo's younger cousins, nieces, and nephews. I believe she wished me to experience our visit to the fullest, so I napped most of the evening in preparation for the Vespucci's table. Mother was seated next to me and Filippino. Across from us sat Amerigo's cousin, Ginevra, whom Filippino secretly favored, along with Sandro, Amerigo, and Simonetta. Her husband sat with the older men, which allowed our table the exclusive wit of Sandro and the charm of Simonetta. He seemed to wish to entertain her as much as me, which he accomplished by forsaking his portion of sweetmeats and jellies. They were almost as good as Vincenza's.

Sandro and Filippino spoke mostly of their work, while Amerigo spoke of his travels with his cousin, Guido Antonio. Simonetta told us about her childhood in Genoa, which Amerigo had visited on his way to France. Everyone seemed so worldly, save Mother and myself. I leaned against her for comfort, and she stroked my little sleeve with a loving rhythm. I recall how Simonetta watched us with a distant longing in her eyes. She had been married to Marco for almost a year and there was no sign of a child. It was a barrenness that would make her seem all the more intangible and sadly divine.

We slept late and arose the next day to prepare for the banquet for Princess Eleanor at Palazzo Lenzi. The Lenzi were a wealthy family with a great house whose courtyard looked out upon the Arno. Before we dressed for the occasion, Filippino insisted that Mother and I visit Via Nuova to see the many works in progress in Sandro's bottega. Filippino proudly showed us his numerous sketches and studies and his work in gold leafing an altarpiece for a small chapel. Sandro was scurrying about, packing the banners he had designed for the next day's ball. At one point he held up his almost-completed panel of the nearly nude *San Sebastiano* and said, "If Simonetta is there today, you shall find our good Sebastiano not far behind."

Filippino told us later that Sandro often referred to his model, Giuliano Medici, as "Sebastiano," but only in jest. Although the Medici were hosting the ball for Eleanor, it was well known that their main reason for attending this preliminary banquet was to meet the lovely new wife of Marco Vespucci. But I was not to meet any of the Medici that afternoon. I only saw a few of their women across the courtyard,

49

and they, although elegantly dressed, were not nearly as elegant in their faces. Lorenzo's wife, Clarice Orsini of Rome, was "adequate," as his mother had described her to curious Florentines before the wedding; and Lorenzo himself, in his favorite colors of black and purple, was too immersed in one group of men to be seen. His supposedly more handsome younger brother, Giuliano, sat far away admiring Simonetta, even as he made seductive conversation with various other maidens of influential means. At one point Mother was led away to the Medici retinue for a brief audience with Lorenzo, who expressed his disappointment at not being able to secure Father's bones from Spoleto for a monument to him in Florence. It was a disappointment that Mother did not share, wishing, quite literally, not to "dig up" the remains of those days. Lorenzo had passed through Spoleto two years earlier on his way to Rome to congratulate the new pope Sixtus and had requested that Father's tomb be moved to Florence. But the Spoletans had refused, claiming that Florence "boasted many great men and Spoleto very few." When Mother returned to her place at our table, she appeared quite flushed.

"I see our Lorenzo Medici has been flirting again!" Sandro was quite perceptive but Mother made no reply.

When, at last, we were all collected in the courtyard of Palazzo Lenzi, my young eyes were dazzled by the decorations, the finely dressed guests, and the array of food and drink. Although I was nearing ten years old, I felt smaller than ever. And then Simonetta appeared, parting the crowd with her grace and beauty. She approached our table with a careful footing on her finely carved pattens, and Sandro rose instantly to greet her. But she proved to want the attention of me alone, a child, whom she addressed formally as "Alessandra," and she told me how lovely I looked in my linen gown and surcoat. I curtsied and stared at her speechlessly until Sandro interrupted the interlude.

"If I had known I would be in your company for any length, Simonetta, I would have brought my vellum and silverpoint to sketch you."

"Better that you should reserve me a dance tomorrow," she said with a musical laugh.

"A clumsy partner I would make. I am more fain to paint your hand than take it, Madonna."

"It would be an honor to be the subject of the most promising painter in Florence."

And then I noticed how her teeth were small and straight and slid discreetly beneath her pale lips as she spoke. They were like pearls, as much as she was this "Pearl of Genoa," and I felt a longing to be as fair when I was grown.

Sandro continued to entreat Simonetta to sit for him in the near future, a proposal that later resulted in a commission from the Vespucci to have him paint her portrait. Sandro eagerly described the efforts of his brother, Antonio, to prepare the gold dust for her hair at the next day's festivities since Filipepi had maintained their goldbeating trade. In the midst of this banter, during which Mother smiled longingly and Filippino flirted with Amerigo's cousin, Ginevra, I suddenly found myself blurting out a very bold inquiry to my godfather.

"And when do you ever wish to paint *me*?"

I was frightened by the sound of my own demanding voice, for I had often heard the old Tuscan saying that "a child who speaks beyond its years deserves not to live in them." But Mother looked more amused than disgruntled by my request, and Sandro chuckled as he reached out to stroke the hair that fell from my little cap.

"I would love to paint you, Sandra mia, and I hope I shall do it soon when I have not the rest of Florence to fend off for an hour of your day!"

Of course he was referring to Simonetta's popularity and not mine, but his declaration satisfied me, as the pink sun cast its colors into dusk over the Arno. Simonetta dismissed the advances of every man that afternoon to join the Princess Eleanor in a gentle dance, and I could only marvel that so much attention was given to a married woman. Mother explained that, as I grew, I would find members of my sex whom no man could claim and that Simonetta was one of them. It was a remark that seemed to bring Sandro much pleasure.

We returned to Casa Vespucci before dark, with Sandro and Amerigo guiding our passage on the Lungarno to the Borgo Ognissanti. Filippino followed behind with Ginevra, but I could only hear Sandro and Amerigo discussing Simonetta in the reverie that hovered over us. When Sandro reached up to lift me off his grey horse, he held me next to him before he placed me on the ground. He caressed my now-

tangled hair and kissed me on the forehead, and his great chest heaved a sigh. I shall recall that night as dearly as I do greet the light of day, for it marked the beginning of my youth and the end of that blurry fog of childhood that had come before. I was alive in a new way, and I fell into a deep sleep in a bed not far from Simonetta, the woman to whom I would one day be inextricably linked.

6

Tuscany

*W*HEN WE RETURNED TO PRATO, MOTHER and I were met at our door by a very shaken Riccardo and Vincenza. We had been burglarized that morning and the house was still in disarray!

"We only went to market for a short while, Madonna Lucrezia," Riccardo began. His voice fairly trembled and it was unsettling to hear him speak. "The doors were well latched. I implore you to forgive us."

"Did no one see the intruders?" Mother scurried around to see what had been disturbed.

"Our neighbors were away as well," Vincenza answered while holding her youngest child, who was crying.

Ser Vannozzo advised us not to touch anything in hopes that some clue might be revealed in the trail of disorder. He hastened off to the Commune to fetch the *bargello* to make an inspection of the crime. By some good fortune, the thieves had not had the time or ingenuity to open the chest where Mother kept her few jewels and a hidden purse of florins. Nor had they been clever enough to steal any paintings, which were now even more valuable with Father's death. They had taken mostly housewares.

When the *bargello* arrived, Mother followed behind him as he

inspected each room, and I could hear her cry out like a wounded animal whenever she came upon a missing item. When I went into my own room, I was pleased to find my bed and dressing table undisturbed, but then I saw the thing that filled me with heartache and panic and a terrible sense of violation. My doll, Caterina, was gone. I had left her behind, and the burglars had probably stolen her for the little pearl that sat on the crown of her head.

"Why did they not just take the pearl and leave her be?" I remember crying. The emptiness seemed more than I could bear.

"Because thieves think nothing of the hearts they shatter when they already have broken through a door." Mother reached out to hold me.

The *bargello* then suggested we procure a feisty dog and a gaggle of geese to ward off future intruders.

Mother frowned, and before she could answer, Ser Vannozzo said, "But Madonna Lucrezia has always valued peace and cleanliness, which are difficult to maintain when such creatures are about."

"Indeed, but I submit to you, Madonna, that it is easier to remove the droppings of dogs and geese than it is to restore your stolen goods!"

The *bargello* was clearly amused by his own words, but I was not. Ser Vannozzo thanked him profusely and showed him to the door. The next day we went to market and purchased two splendid geese. I named them Guido and Mario, which was changed to Maria after she presented us with eggs. Ser Vannozzo brought us the last pup from his neighbor's dog's most recent litter. He had a piercing bark, and I named him Picchio. Through this addition to our household, we were soon blessed with a family of fleas. This resulted in a visit to our seamstress to have the popular little tufts of fur sewn into the bodices of our gowns where the fleas could congregate. But I disdained this accessory and quickly took to wearing a carved locket that could contain both the fur and the fleas with less distraction.

When I returned to my classes with Messer Fiorentino, Giovanna Ciardi wanted to hear nothing but my tales of Florence and the banquet and whether or not I had seen any fireworks at night. I was still consumed with my anguish over the burglars and Caterina, and I was not interested in speaking of the glorious events that had now been overshadowed by disaster. But as the days and weeks wore on, I

grieved less and thought more of my visit with Filippino and Sandro and Simonetta.

Giovanna seemed intrigued with my descriptions of Simonetta. By winter of that year, Giovanna was reading the poetry of Francesco Petrarch and had decided that Simonetta was as much a figure of adoration as Petrarch's Laura. By now, all of Tuscany knew about this "Pearl of Genoa." Filippino mentioned in one of his letters how she had graced the bottega at Via Nuova by sitting for the portrait that her husband had commissioned Sandro to paint:

> All normal tasks ceased with her arrival, and we could only pretend to be working as we watched Sandro's cautious charcoal capture every gentle line of Simonetta's countenance. Sandro has stayed up many nights, since then, sketching by candlelight in an effort to improve upon her perfection. He intends to learn her profile so well that he will be able to draw it directly onto the gesso without any transfers. And he has been to Casa Vespucci many times to assure him of this familiarity.

I recall a certain envy pulsating gently through my young heart as I read Filippino's words. Was it my yearning for Sandro's attentions or simply my desire to be more beautiful than I already was? By the time I was twelve I had begun to "blossom," as my Mother said, and I was distracting the youths of Prato who passed Giovanna and me on the way to our lessons. Her father regularly sent a servant with us as an escort to the Vannozzo house, but on occasion, her eldest brother, Ciardo, accompanied us. He had recently matriculated into the guild of wool merchants and had business to do in town. He liked to make jest of our admiration for Simonetta and referred to us as "The Pearls of Prato."

By the winter of 1475, Messer Fiorentino had assigned both Giovanna and me to read parts of Dante's *La Commedia*. Mother had permitted the content of *Paradiso* as less disconcerting than the other cantos in the text. The images of Dante encountering his beloved Beatrice in her chariot in Heaven were as inspiring as any of the Scriptures I had learned to read in Latin. I was finally learning the breadth and grace of my own tongue, the Tuscan of Dante and Boccaccio. But it would be

several more years before I was allowed to read the latter's ribald tales.

For the Epiphany of 1475, I received a replacement for my Caterina from Filippino and Sandro. But as lovely as the new doll was, I could not afford her the same affection. She became more of an ornament than a companion, a somewhat forgotton icon of the childhood that was slipping away from me. My interests had grown beyond baubles and toys, and I now spent my leisure time reading or stitching unusual embroidery designs. In our free time between lessons with Messer Fiorentino, Giovanna would often teach me dance steps or songs that her older female cousins had learned in Florence. And Vincenza had decided I was old enough to learn some of her culinary secrets: I began to take more of an interest in our hearth and kitchen.

Filippino's first letter after Epiphany announced a new commission that Sandro had received from a former associate of his eldest brother, Giovanni. It was an altarpiece for the funerary chapel of Guaspare del Lama, a money broker in Florence. Guaspare had requested a depiction of the Magi adoring the Infant Christ, with himself included in a retinue of admiring Florentine citizens. For the Magi, he had selected the three generations of Medici patriarchs: Cosimo the Elder, his son Piero, and Piero's son, Lorenzo "Il Magnifico"—the only one living of the three. Sandro had suggested that Lorenzo's brother Giuliano be included along with their young cousins, Lorenzino and Giovanni di Pierfrancesco. Although Guaspare del Lama, apart from his membership in the same guild, was not closely aligned with the Medici, using their likenesses in his funerary panel was a clever way of declaring an association and of elevating his stature in Florentine society.

Filippino often quoted Sandro in his letters. "The man is no fool. And there is always more than one way for an artist to flatter the subject of a painting: place him among those more important."

Filippino went on to write that Sandro had chosen to flatter himself as well. "He has made his first study for the panel, and he has placed his own portrait in the foreground, looking out from the crowd in his favorite ochre cloak."

My brother was later to use this technique of a signature portrait in his frescoes at the Church of the Carmine. "A painter should take some credit for his work if he cannot take his place in posterity" was

how Sandro defended the practice. They were the words of a now-confident artist—and also the words of a childless man.

Mother was pleased to learn of Guaspare's commission, for she felt this was a good means by which Filippino could learn to paint crowd scenes and capture many models in compositions outside the bottega. The previous Epiphany of 1474 had seen a reenactment of the Adoration with a pageant organized by one of the largest confraternities in Florence. Filippino and Sandro had sat up in the hills of the Belvedere to watch the procession and sketch different views of it as its members descended through the city gates and across the Arno towards the Duomo. Sandro bade Filippino to retrieve his drawings from that day, saying, "This is how we begin. Now for a trip to Palazzo Medici to put faces on our Magi."

My first likeness as an infant had been as the Christ Child in one of Sandro's first "Adoration" panels. I had forgotten this until Mother reminded me and brought out one of the studies he had made when he was Father's apprentice in Prato.

"Is it proper to use a female baby as a model for the Christ Child?" I remember asking her. There were so many laws governing so many practices of life and livelihood, I thought for certain there must be one for the creative process of depicting our Lord and Savior.

"Your father made it acceptable for the Holy Mother to be comely. Why not so for her beloved child? Indeed, you certainly were fair, as you prove to be now, Sandra."

I was at an age where many of my inquiries were answered by another. And my mother was not the only person to challenge my curiosity and thinking. My friend Giovanna did it often, partly out of jest and partly as an intellectual or emotional parlay. But her greatest challenge came to me at the end of January, when she invited me to go with her and her family to view the tournament honoring the Florentine alliance with Milan and Venice. It was also the occasion to display the athletic prowess of Giuliano Medici, the favored son of Florence.

My mother was more protective of me than many mothers of girls my age. Giovanna and her younger sister had been to Florence more often than I. They also spoke more frankly about men and women and nature and, occasionally, the unnatural! Their father, as a prominent

member of the wool guild, had been formally invited to be seated to view the joust in front of Santa Croce.

At the same time, Filippino wrote to say that Sandro had been commissioned to design the banners depicting Simonetta as Giuliano's mistress of the joust and object of his courtly love. By this turn, Mother and I were also invited, but she had declined the opportunity to attend, thereby declining on my behalf. When I presented her with Giovanna's extended invitation, she hesitated and then refused.

There followed, on my part, a volley of protests to her concern that I might witness "so much grandiose display." It soon became apparent how my departure with the Ciardi, if only for a few days, paralleled Filippino's earlier departure from her loving care. In my young eagerness to pursue adventure, independence, and glory with my kindred spirit Giovanna, I had been blind to the fears and heartaches of my mother. Still, her hesitation only fueled my longing to go to Florence and see not only the joust but the lady of the joust, Simonetta.

"Would you have me know these events only through the words of Giovanna or Filippino? I must witness life beyond other people's descriptions or I am no more fulfilled than a cloistered nun!"

My protest came too quickly for me to even recognize its cruelty. I had won the volley, but I had lost my mother's careful posture over me.

Giovanna's family called for me on a pale grey January morning and placed me atop one of their finest horses with Giovanna. Their assurances of my safe return appeared not to relieve Mother. She smiled feebly as I waved and tried to thank her. Then she nodded and turned to embrace Vincenza's child to fill her temporary loss.

7

The Medici

"WELL, MY LITTLE 'PEARLS OF PRATO,' ARE you prepared to observe our great knight's unattainable quest?" Giovanna's brother Ciardo teased us as we searched for our seats in front of Santa Croce. He smiled glibly as he motioned us along.

Giovanna quickly reminded him that we were just as interested in seeing Simonetta as we were in cheering on Giuliano Medici.

"Ah, yes, the Lady of Eternal Chastity!"

I recall that I blushed at Ciardo's sexual remark, especially since Simonetta was a married woman.

Sandro and Filippino had arranged to meet us in the grand amphitheater that was built on the piazza. They had been occupied all morning, seeing to the delivery and proper display of their banners for the procession. When they arrived, they sat behind us and joined us in our examination of the crowd. Towards the center of the amphitheater, we found members of the Vespucci family and, finally, Simonetta, flanked by her maidservant and Ginevra Vespucci. Simonetta waved gracefully to the retinue of soldiers, guards, and Medici partisans leading the procession into the piazza.

"Look, Filippino! It is our old escort, Giuseppe!" I cried out when first I recognized him.

"Yes, and he appears well, if not well attired."

"Do you think he would remember me if I wave?"

Sandro leaned over and patted me on the head. "Who could forget so fair a face?"

I blushed again.

Suddenly we turned our attention to the arrival of Giuliano in his splendid silver armor. It had been wrought by Sandro's former teacher, Andrea del Verrocchio, who also excelled in sculpture and metal work. Giuliano sat atop a fully armored horse with a purple velvet housing. It was covered with embroidered olive branches.

"Think of *that* stitching project, Sandra," Giovanna mused, but I was more impressed by the great shield of Medusa at Giuliano's side.

The different costumes, armor, and trumpeters were almost enough to distract us from Sandro's elegant banners. Even Sandro remarked that he had not seen so many pearls and silks since the Princess of Naples' ball. At last, the fringed taffeta standard was carried past us on a great blue pole held by one of Giuliano's horsemen. We could see the complete allegory of Simonetta as Pallas, the goddess warrior, binding Cupid to a tree.

"But why did you make her seem so cruel?" I asked Sandro as the crowd marvelled at the flowery meadow design on the rare Alexandrian cloth.

"The idea came from a young scholar of Antiquity. He is new to the Medici court and will soon be tutoring Lorenzo's son in Latin. He thrives on such allegories of unrequited love because he is a poet."

"Angelo Poliziano," Filippino interjected, but I did not catch the name. I could only be swept up in the grandeur of the display before me, imagining my own hair fluttering from a helmet of burnished metal as I poised my lance and shield towards the bright sun. By contrast, Simonetta sat in the guarded portion of the amphitheater, wrapped in pearls and ribbons and holding a nosegay, not a lance, to ward off whatever bad fumes of the city might invade her senses.

And then the joust began, with all its clashing of muscle and metal, the brisk clip of gilded hooves, and the roaring of the crowd at every pass. When Giuliano emerged victorious in the first bout, Giovanna's father said, "He has his most excellent trainers to thank today!" to

which the more cynical Ciardo replied, "More likely, the not-so-excellent jousters!"

Sandro was clearly amused by this exchange between father and son and began to describe earlier tournaments in which wild animals had been used in the piazza to entertain the more bloodthirsty citizens of Florence. On one notorious occasion a stallion had been let loose among a group of mares, "to the delight of the women and the education of their daughters, and yet the city fathers deemed it twice the offense than if animals had fed on one another!"

Giovanna's father did not have the penchant for witty anecdotes that Sandro did, but Filippino and Ciardo clearly enjoyed the tale. Giovanna and I pretended not to hear, but I could see her trying to restrain a smile.

After the declaration of Giuliano's victory, Sandro's banners were carried back to Palazzo Medici and the crowd dispersed. There was now much merrymaking to be had, as several feasts were planned throughout the city. The Ciardi had relatives hosting our stay, and although Sandro had invited me to return with him and Filippino to Via Nuova, he could see I wished to remain with Giovanna. But he insisted that my visit to Florence should not end without a trip to Palazzo Medici, so that Lorenzo and Giuliano could meet the daughter of Fra Filippo Lippi and Lucrezia Buti. A banquet honoring Giuliano's victory was to be hosted there, so Sandro and Filippino convinced Giovanna's father and brother that we should accompany them. The privilege was not to be disputed, so off we headed for Via Larga.

Filippino's descriptions of Palazzo Medici had been correct. Its austere façade belied the courtyard and loggia within. Giovanna and I fairly floated past the sculptures and up the staircase to the salon in which the Medici were receiving guests. Giuliano, now out of his armor, was seated comfortably next to his brother and sister-in-law, Clarice. Lorenzo seemed not to mind the gathering of attention towards his handsomer younger brother. Although I had once seen Lorenzo from a distance, during the banquet for the princess of Naples, I did not remember his flat nose or nearsighted squint. He had an odd, nasal voice when he spoke, but there was a special charm to his words that gave him a commanding and pleasant air.

Giuliano's dark curls fit his head like a cap; he was indeed the figure of Sandro's *San Sebastiano*. But he was slightly more robust than the punctured martyr had been depicted.

"Robustness is rarely fitting for a Saint," Sandro maintained.

Giuliano was dressed in a bright red and yellow tunic that contrasted nicely with his brother's favorite dark purple hues. He stood when Sandro and Filippino approached him. They, in turn, were guiding a very giddy Giovanna and myself to be introduced.

"And what lovely rosebuds have you plucked from some garden, gentlemen?"

"This is Alessandra Lippi, the daughter of our beloved and departed Filippo."

"My sister!" Filippino broke in. There was an awkward pause, while Giuliano and Lorenzo nodded. "And this is her friend, Giovanna di Ciardi. Her father is a leading wool merchant in Prato."

Giovanna reddened, along with Filippino, for we all knew that Prato often rivaled Florence in its wool production. But Giuliano put everyone at ease by praising our town while asserting Florentine dominion.

"It is always good to hear of prosperous citizens in the principate! Welcome to both of you."

As we curtsied quickly, Lorenzo stepped forward and took my chin in his hand. "Forgive my familiarity, Alessandra, but you bear a stunning resemblance to your beautiful mother, Lucrezia."

I could feel myself blush along with Giovanna, who was about to feel slighted until Sandro broke in. "And her lovely friend bears a stunning resemblance to her own handsome brother, Ciardo di Ciardi."

Filippino smiled feebly, and Giovanna beamed along with the compliment. Both Giuliano and Lorenzo chuckled, delighting at their private jest with Sandro. Ciardo was not present to enjoy the comparison or its other implications.

"Shall we summon Poliziano for a preview, then, if the good man is not among us?" Lorenzo and Sandro apparently shared some secret in this banter at our expense, but by now Filippino had led Giovanna and me towards Lorenzo's sisters and a more innocent discussion.

As soon as we were introduced, the eldest sister inquired, "Have you met our cousins of the Pierfranceschi?"

We had not, so she turned and gestured to two well-dressed boys.

The eldest was about thirteen, which made him Giovanna's age. He had the prominent Medici nose, which appeared, perhaps, even more prominent by virture of its maturation. He was tall for his years and wore the same hair as his cousin, the victorious Giuliano; and he was handsome in that manner of youth when it changes into manhood while still embracing the boy.

"This is Lorenzo di Pierfrancesco. We call him Lorenzino." Lorenzino glanced back and forth as he was being introduced to Giovanna and me. "And this is his younger brother, Giovanni." Giovanni smiled and then scurried away to entertain the elder Lorenzo's young son, Piero, before he was put to bed.

Giovanna and I curtsied, and the woman went on to explain who we were in relation to the other guests. Giovanna was more at ease than I as she praised their cousin's athletic prowess in the joust and the loveliness of Simonetta, who had been declared "The Queen of Beauty." I stood there quietly until Lorenzino looked at me and said, "My grandfather Cosimo truly admired your father's work."

I nodded shyly, I recall, while fixing my gaze on the leather ties decorating the sleeve of his doublet. I thanked him, and then the older Lorenzo appeared at our side. "Ah, I see you have met Sandro's namesake, Sandra."

They went on to discuss how Sandro's portrayal of Giuliano as Saint Sebastian had spared the explicit nature of his wounds. "Such a pensive countenance for a man bound to a tree and filled with arrows!"

"But would you have him paint a gaping mouth with every tooth and the bloodied hole of every puncture?" my brother argued suddenly, having overheard our discussion. "Sandro works by symbolism. He wanted to show Sebastiano's ordeal through restraint."

"Unlike the Holy Scriptures," the elder Lorenzo chuckled.

"Methinks most Tuscans are not attuned to symbols, cousin," Lorenzino added.

"Then they can have the Saints for drama and Dante for poetry," Lorenzo replied in the distinctively nasal voice that erupted deep within his skull.

"I've been reading Dante!" I was proud that I had something to

contribute. All eyes fell upon me. "Well, I've actually only read the 'Paradiso.'"

"My cousin recites *La Commedia* often, when he is not composing his own poetry." Lorenzino smiled.

"Your father would have been pleased," Lorenzo said to me with a chuckle. "So read on, and you shall be a joy to both your husband and your sons!"

I blushed and turned to look for Giovanna, who had been spirited away to tour the Medici apartments. Sandro stood nearby, receiving numerous praises for his banners; and although Filippino was in the same room, I felt utterly alone. Lorenzino di Pierfrancesco seemed to sense my awkwardness and approached me reassuringly. "Shall we presume you are supping with us?"

I nodded eagerly as if to appear useful.

"Then I shall tell Clarice to have you and your friend seated at our table."

"Sandra! Over here!" Giovanna gestured to me from a hallway filled with tapestries. I excused myself and went to her dutifully, expecting to hear a detailed account of every chamber she had just visited in Palazzo Medici.

"So, what is your assessment of Lorenzo?" she inquired.

"Well, he has a commanding presence but hardly the face or voice of one who commissions great works or sends men to war," I began.

"Not *the* Lorenzo . . . his cousin, Lorenzino."

"Oh, the boy, Lorenzino?"

"He's older than *you*."

"Do you fancy him, Giovanna?"

"He's too young and too pretty," she decided with a shrug.

"Too pretty for a Medici?" I sputtered, and we both giggled uncontrollably.

But before we could continue with our mirth, Sandro appeared to retrieve us for the banquet. We calmed ouselves, until Sandro whispered, "I trust he's not too pretty to sit with?"

"Nor dance with!" I should have answered, for dance I did with the young Lorenzino. I was grateful, then, for the haphazard dance instruction I had received from Giovanna in between lessons at Casa

Vannozzo. My stomach was bursting from the endless courses of food, and I felt I would split the seams of my surcoat. The young Lorenzino had strong but gentle hands, as he guided me through the different couples stepping gaily across the Medici courtyard. The musicians lined the loggia to accompany the dancers with their merry tunes. Being in his own territory, Lorenzino was certainly more confident than I, and yet he put me at ease with his gracious smile. I know not how pleased I might have appeared, but I recall laughing only once and then concentrating my thoughts on the pattern of the dance.

Sandro nodded to us when we passed him, but he was engrossed in conversation with the Medici's new tutor, Angelo Poliziano. This was a delicate young man whose effeminate mannerisms puzzled me, and yet he had earned the respect of all of the Medici, save Lorenzo's wife, Clarice, who found his preoccupation with Antiquity blasphemous. On this occasion, however, Poliziano was basking in the acclaim of his poetic writings, which had inspired the allegories on Sandro's banners for the joust. Oddly enough, the triumphant Giuliano was dancing not with his "Queen of Beauty," Simonetta Vespucci, but with his earthly mistress, Fioretta Gorini.

When I commented on this later to Giovanna, she gave her usual bold response. "Indeed, it would be sad to waste such an athletic physique on a Petrarchan mistress!"

Giovanna was more precocious in matters of sex than I, and she requested a detailed account of my dance with Lorenzino. Had he held me too casually or too intensely? Did he smell good? Did he speak well for a youth his age? Did he ask to see me again? My brain was too consumed by all the events of the day to respond in any logical fashion. She, in turn, was infatuated with Giuliano, although she had transferred her unattainable affection that evening to a youth whose father was a member of the Signoria.

As we made our way through the dark streets of Florence that winter night, I rode with Giovanna on her brother's horse and listened to the clamor of the many celebrations spilling from the various houses between Palazzo Medici and the church of Santa Maria Novella. We parted company with Sandro and Filippino on the piazza of the church, beneath the Ciardi's torches. They would continue southward

to Via Nuova, and we would continue west on the Via della Scala to the home of our hosts. Filippino had promised to rise early and see us off as far as the Porta al Prato. Sandro was eager to begin work on the alterpiece for Guaspare del Lama and dared not waste a moment of daylight. But it was almost February, Filippino had reminded him, and the days would soon be longer.

The next morning, when Filippino arrived to escort us to the city gate, we marveled at how quickly Florence had returned to its normal activities. Vendors and citizens both made their way to market. Shops opened their shutters and doors. The fulling mills churned their dyes into the canals along the Arno, and the church bells rang to clear the air of the dreaded *moria*. As we approached the great arch of the Porta al Prato, I remember commenting on how lovely but sad Simonetta had appeared from her seat in the amphitheater, which, by now, was all but disassembled. Giovanna wanted to know if there had been a banquet at Casa Vespucci and if this had explained her absence from Palazzo Medici. Filippino answered because his friendship with Amerigo's cousin Ginevra had made him privy to Vespucci affairs.

"Simonetta was forced to retire soon after the joust."

"Did she fall ill or was she just tired?"

"Yes, so much admiration *can* be taxing," Giovanna quipped while her brother and I nodded merrily.

"But didn't you know?" Filippino interrupted our jesting. "Simonetta is afflicted with consumption."

It was now April of 1476, and while Giovanna and I dreamed of Giuliano's joust and our first dance with two youths of Florence, our inspiration for grace and beauty lay coughing in her chambers at Casa Vespucci. Her physician asserted that she had not the symptoms of *la moria*. And even if she had, Simonetta was so well loved by the entire household that none of the Vespucci would have abandoned her. Still it was said that her best maidservant had been dismissed from her bedside so as not to see the genteel Simonetta spewing into her cuspidor. Filippino wrote that the entire parish of Ognissanti had prayed for

spring to loosen the grip of her consumption. But Simonetta had no resilience, and in the final week of April, just before Easter, death claimed the Pearl of Genoa.

All of Florence mourned its loss, and Mother gave no protest to my request to go with Giovanna to the funeral. Her brother, Ciardo, had agreed to escort us. When they arrived for me on that fragrant morning, Mother confessed that she, too, felt the passion of our young grief, just as she had recognized the model of womanhood that Simonetta had been to us.

Sandro and Filippino received us that afternoon at Via Nuova, and in the morning, the funeral cortege set out from Casa Vespucci to the church of Ognissanti. The fulling mills along the Borgo had shut down along with every other enterprise in Florence. Citizen and servant alike lined the streets to honor Simonetta.

Amerigo and three of his cousins carried her bier, for grief had stripped the strength of her kinsmen from Genoa. Her husband, Marco, followed behind in silent agony. I remember vividly that no death shroud covered her, and as we filed into the cortege, Giovanna gasped, "They have exposed her face!"

Sandro heard her and moved closer, whispering a line of Petrarch's verse. "Even death seem'd fair upon so fair a face."

A young artist, about Filippino's age, walked slowly near the bier with vellum and silverpoint, carefully sketching the profile of the dead Simonetta. "That's Leonardo da Vinci," Sandro nodded in his direction. "An ardent anatomist." And yet there was something tender in the motion of his silverpoint, as though the young artist was trying to draw life back into Simonetta's pale and delicate features.

When we arrived at the small enclosure of the cemetery at Ognissanti, a terrible panic seized me, and I realized I could not bear to watch the now-inanimate Simonetta enclosed forever in a cold tomb. Perhaps I was remembering my father's interment, or perhaps it was the starkness of reality crashing against the failed romance of life. I stole away very quietly from the rest of the mourners and entered a small door near the main altar of the church. Then, walking slowly towards the entrance, I found the Vespucci's modest chapel and Ghirlandaio's fresco of the family, including the portraits of Amerigo

and his uncle Giorgio, the scholar. As I stood looking up into their faces, I heard someone whisper, "Sandra!"

Standing near the wall was the young Lorenzino di Pierfrancesco in a black doublet and grey hosiery, the mourning colors of many that day. He approached me suddenly.

"So dark a church for so bright a face."

"So dark a day." (Later that same year, Lorenzino would lose his father and enter Palazzo Medici permanently as his home.)

Barely a smile passed between us as he moved closer and put his hand on my arm. He told me then that Giuliano was inconsolable and could barely ride across town to Ognissanti. He had just come from the villa of Careggi, where his brother remained, mourning over the loss of Simonetta; and Lorenzino explained that after the Vespucci's courier had reached Careggi with the news, Lorenzo murmured, "The soul of Simonetta is in Paradise." Then he had looked into the heavens and observed a star he had never seen before. He summoned Giuliano to gaze with him upward. "There lies the spirit of Simonetta."

One of the priors of the church, having noticed our whispered discussion, bade us return to the funeral party in the cemetery.

"But the young lady cannot bear to see ..." I was touched by Lorenzino's defense of me.

Then the man softened his tone and smiled sympathetically. "Come, my children. Simonetta is gone. The tomb is closed."

Suddenly I could contain myself no more: I reached for Lorenzino and wept. He held me close for a moment and then led me by the hand towards the funeral party. I recall noticing his sweet scent, as one of Giovanna's earlier inquiries came to mind. How could I be so disrespectful as to feel the stirrings of my maiden's heart at this unlikely time? But Lorenzino put me at ease, and we walked together up the Borgo of Ognissanti to Via Nuova.

Lorenzino informed Giovanna and me that Marco Vespucci had bequeathed many of his wife's belongings to Giuliano Medici, including Sandro's profile of Simonetta.

"I saw the Medici's livery load a chest of her favorite garments, plus Sandro Botticelli's portrait of her on our horses."

"But why? Did he think her lover more deserving?"

"Ah, my cousin was no more her lover than the rest of Florence. Perhaps Marco felt a kinship with Giuliano, because they both loved her."

"Perhaps he could no longer bear the physical memories of his wife," Giovanna added.

At night the entire quarter of Ognissanti extinguished its candles and its torches to honor the darkness of that sad day. Upstairs at Via Nuova, I lay beside my friend and listened to her gentle breathing, but was unable to sleep. I stared up at the tiny slivers of starlight seeping through the Filipepi's shutters. But I could see only the face of the woman I would one day replace when Sandro would paint me as "the reincarnate of the Queen of Beauty." I would be forever humbled by the legacy of Simonetta and Lorenzo de' Medici's often-quoted description of her: "It seemed impossible that she was loved by so many men without jealousy and praised by so many women without envy."

8

The Pazzi Conspiracy

ANGELO POLIZIANO HAD COME TO LORENZO DE'
Medici's attention by presenting him with a Latin translation of
theentire Iliad. Lorenzo immediately took in the sickly youth and
made him tutor to his younger children. The protection of the Medici allowed the
young poet to write verse to his heart's content, and eventually to the inspiration
of Sandro Botticelli. Angelo's most famous verse was titled "Stanza for the Joust"
in honor of Giuliano's tournament and Simonetta; and from it, Sandro had
drawn numerous allegories for his paintings. Yet even more compelling than the
descriptions of the maiden of the forest in her white gown, or the Venus wringing
her golden tresses from the sea, was Poliziano's account of the assassination of the
beloved Giuliano in the Cathedral of Santa Maria del Fiore. This assassination
took place in April of 1478, exactly two years after the death of Simonetta. Other
chronicles of the attack had sifted down over the years into the Medici collections.
One was by an apothecary and "political observer" named Luca Landucci, an-
other by the architect and historian Giorgio Vasari. But Poliziano's account was
the most vivid and stirring, because he had witnessed it personally. He had
accompanied Lorenzo, the chief target in the conspiracy, and was standing so
close to him at the moment of the attack as to become almost a victim himself.
This had not been the first time that rival factions in Florence had attempted to
overthrow the Medici's power.

The attempt on Lorenzo's life and the taking of Giuliano's came to be known as "the Pazzi Conspiracy" because the plan was headed by a rival banker named Francesco Pazzi. The conflict had arisen over the efforts of Pope Sixtus to buy the town of Imola for one of his nephews. Imola was strategically important to Florence, so Lorenzo had refused to loan the money to Sixtus. But Francesco Pazzi thwarted Lorenzo's plans: he provided the funds, and Sixtus now had cause to usurp the Medici's power whenever he could. His first opportunity was appointing an Archbishop in Pisa without Lorenzo's approval. Further irritation ensued, and both the Pope's nephew in Imola and the Archbishop in Pisa went to Francesco Pazzi to arrange an audience with Sixtus in Rome. Sixtus agreed to a plan to overthrow the Medici, but would not sanction any killings.

In Florence, the aging Pazzi patriarch, Jacopo Pazzi, tried to discourage the three in their plotting, but eventually he joined in. The question was how best to overtake Lorenzo and Giuliano, as both were often found in the company of bodyguards. The answer was some place where they were least likely to be armed: church. Pope Sixtus made his great-nephew, Rafaelle Riario, a Cardinal and sent him to Florence to give Easter Mass at the Cathedral of Santa Maria del Fiore. The Medici could not refuse to attend, as the young Cardinal had requested to visit Palazzo Medici following the Mass.

The original plot was to attack Lorenzo and Giuliano as they escorted Riario back to a banquet at Palazzo Medici. But Giuliano's leg had been bothering him, and there was a possibility he would return by litter. A hasty change of plans was made, and when the Host was raised, Francesco Pazzi and an accomplice fell upon Giuliano, stabbing him so violently that they wounded themselves. Lorenzo was attacked by two priests from Volterra. They had joined in the plot as a means of vindicating the earlier destruction of their city, as Lorenzo had provided Florentine mercenaries to claim the valuable alum mines there. Poliziano stood by in horror as the two men drew their daggers at Lorenzo. He was so close that one of them slashed a tie on his sleeve.

In Poliziano's colorful account, "a good friend and servant threw himself over Lorenzo and received the worst of the assassins' blows. This allowed Lorenzo time to escape and dash into the sacristy with two of his friends. Two other friends and myself were able to push the heavy doors shut before the two from Volterra could reach them. Lorenzo was cut on the neck while his servant lay dead in front of the altar. Giuliano lay not far away, mutilated by twenty-nine blows of the dagger, one of which nearly split his skull in two. Lorenzo remained

inside the sacristy crying out, 'Giuliano! Is he safe?' but there was so much commotion, no one answered him. The crowd in the cathedral thought the dome had fallen in!"

The conspirators entered Palazzo della Signoria, expecting to be welcomed as the liberators of Florence. Instead, they were met with swift and unrelenting "justice." The Archbishop Salviati and Francesco Pazzi were hanged from the windows of the palazzo; others were tracked down and executed, some merely for the sin of belonging to the Pazzi family. By the end of the week, seventy corpses had been hacked to pieces by the populace and strewn over the piazza of the Signoria. The name "Pazzi" was struck from the Florentine registers and abolished from public office.

Pope Sixtus was so outraged by this "frenzy of mad dogs who had dared to hang an Archbishop" that he excommunicated not only Lorenzo but the city of Florence itself. A war with Rome followed, depleting both the Florentine treasury and spirit, and Lorenzo was forced to borrow from the accounts of his younger cousins, the Pierfranceschi. The conflict soon became unpopular, and two years after it began, Lorenzo made a diplomatic overture to the Roman ally, King Ferrant of Naples, who mediated a solution.

In the spring of 1478 I turned fourteen. All the world seemed to be changing as much as I had. Our servant Vincenza bore her third child, a son named Carlo. Mother proposed the name in honor of our *Proposto*, Carlo de' Medici. (As the son of Cosimo the Elder, Carlo had arranged for my father to come to Prato to decorate its cathedral. Following the scandal of Filippino's birth, he had appealed to Pope Innocent to grant Mother and Father a dispensation from their vows in order to bring calm to Prato and honor to our house. Cosimo's influence in the dispensation had never gone unrecognized. Mother once told me how Cosimo had verily delighted in the scandal, saying "it should have incited more mirth than scorn.")

At fourteen, I became keenly aware of the matters of men and women. I was allowed to assist at Vincenza's childbirth so that I might witness both the pain and the glory of my own new womanhood. Thus I was able to speak more knowledgeably to Giovanna, who now seemed more possessed by her domestic training than by academics. I, on the other hand, continued to take an interest in my studies.

For Epiphany, Sandro sent me a volume of engravings and commentary on Virgil—the first book in Italy to be created by the Germans' new printing device. Sandro had worked as a youth with the engraver who had invested in the device. Many Tuscans had found the invention corrupt, along with the subject matter of the book. But whenever anyone questioned my interest in the Ancients, I was quick to reply, "There is more to mankind's history than what Scripture tells us."

Then Giovanna would gasp in jest. "Such words from the daughter of a cleric!"

I was captivated by Messer Fiorentino's lectures on our Tuscan ancestors. As forebearers of the old, Etruscan settlements, they had adopted the language of the Greek sailors who had landed on the shores of Pisa and Piombino. The language traveled south to the settlement that became Rome and to the Latin that would be used by Virgil. The vulgar Latin dialect, which was spoken in every home, became our own Tuscan language, now used on most of the streets of Italy. True Latin was left to pen and parchment, and it was not until the Florentine poet Dante Alighieri dignified the dialect that one might write Tuscan as easily as it was uttered. Simply commenting on it here, I can see how well I have learned the lesson!

I recall speaking up in class one day. "I should like to learn some Greek!"

"Ah . . . Greek is for scholars, not future wives and mothers." Messer Fiorentino was laughing.

"But should not an educated Tuscan woman learn that from which her own language has sprung?"

Then Giovanna, in her eloquent yet earthy manner, said, "But Sandra, as a woman, you are designed to touch the future and not the past."

My only defense was to mention that my brother, Filippino, had learned some Greek while apprenticed to the painter Sandro Botticelli. They were now in contact with the Medici scholars who knew Greek. Was it not natural for me to take an interest in my family's undertakings?

"But as you can see, Madonna Sandra, this is Casa Vannozzo, not a Medici villa. And were I more proficient in Greek, I would be employed elsewhere and not in Prato!"

Filippino continued to be a vital link between myself and Sandro. He wrote whenever he could, although the commissions to the bottega of Botticelli seemed to increase daily. Sandro had received much acclaim for the Del Lama altarpiece, and his bold self-portrait among the Medici family and court had made a name for this "little barrel" of the Filipepi family. In fact, Filippino now referred to this *Adoration of the Magi* as "The Adoration of Botticelli."

But life in Florence was not all jesting for Filippino. He had recently come into the funds of his majority, which until now had been handled by Diamante, even though Dido had reliquished to Sandro his role as Filippino's guardian. Filippino and Diamante had seen little of each other while in Florence, but had tried to remain cordial. Now that he was at the age of financial consent, my brother became rudely aware of the resentments Diamante had been withholding for so many years.

It began with Filippino's desire to purchase a house in the parish of San Pier Maggiore. Sandro had accompanied him to inform the seller of Filippino's good standing in his bottega. As guardian, however, Diamante had been asked to sign to close the purchase. Filippino wrote hastily of this news to Mother and me:

> On the day we went to the notary, we learned that Diamante had been there earlier and had closed the sale on his own behalf! Sandro and I went quickly to Diamante's bottega and confronted him, whereby he insisted he had intended to turn all the papers over to me later. Sandro did well to see that the dispute be settled, using the ruse that he was eager to provide his guest chambers for a new garzone! I am fortunate to be a benefactor of a Maestro who has both wit and wisdom!"

Mother took no offense at Diamante's folly. She considered him an ally from the past, "one who has suffered indignity for his devotion." The fact that he was a lesser artist (if not guardian) than Sandro was, in Mother's eyes, insufficient cause for condemnation. But I, who had only a fleeting memory of Dido displaying a sacred relic above a crowded piazza or blessing the New Year, could not help siding with Filippino's ill feelings.

These were all minor contretemps compared to the horror that followed the infamous Easter morning when Giuliano de' Medici was struck down in the Cathedral of Santa Maria del Fiore. Even after a few months had passed, Florence was still reeling, and Prato along with it. One cannot discern which is worse: the Pope's wrath over the "deplorable" means by which Archbishop Salviati was executed, or Lorenzo's revenge against anyone remotely connected with the conspiracy. And as if the loss of Giuliano were not enough, our good friend, Giuseppe di Fiesolano—who had accompanied us to Spoleto nine years earlier—was killed in the line of service to the Medici by throwing himself over Lorenzo and receiving the brunt of the assassins' daggers. What a sorry time it was.

I did not attend Giuliano's funeral—which, according to Filippino, was overshadowed by the other carnage in the streets of Florence— but I was not alone. Most Florentines, fearful of the rampaging citizens around them, were unable to honor their "Prince of Youth" in the way they had the dead Simonetta. Lorenzo was said to have appeared at his brother's interment wearing a red scarf about his neck, thereby causing all in attendance to take note of his own wound. Then, as a reminder of the attack, three wax effigies of Lorenzo were sculpted with the help of Andrea del Verrocchio and set in various places where the populace might praise the survival of their patriarch. But stranger still was the commission ordered by Lorenzo the same day of the attack.

"A partisan of the Medici arrived in haste at Via Nuova as we were returning from Mass at Ognissanti," Filippino wrote. "Sandro was surprised that any business should be conducted Easter morn, until he heard the news of Giuliano and saw the tumult in the streets moving uptown towards the Piazza della Signoria. The man unrolled a small parchment with the directive for Sandro to paint the portraits of the traitors, while they still hung from the palazzo—right on the walls of the Customs House between the façade of the palazzo and the bargello! Forty florins per figure!

"Imagine our spirits as Sandro and I hurried with our charcoals, pigments, and brushes to sketch this carnage, not knowing how soon the bodies might be disemboweled or hacked to pieces like so much butcher's meat! Sandro confessed that the speed with which he was

required to work was the only thing that kept him from recoiling at the blood and stench. For myself, I drew and prayed and only became ill when I returned to Via Nuova. Another garzone was so overwhelmed by the savagery that he was sent back to the bottega. But Sandro, as repulsed as he was, is wont to sympathize with Lorenzo and lends his own macabre humor to these events. While he was finishing the study of Salviati's corpse, I noticed the care with which he sketched the Archbishop's feet as they dangled beneath the purple cassock. 'Like the clapper of a bell!' Sandro quipped, which put me strangely at ease.

"We worked steadily for the entire week, struggling always with the challenge of applying pigment to the rough outer walls assigned to us. Sandro complained once to Lorenzo that frescoing such a surface was not the same as an interior wall with fresh plaster, but Lorenzo replied that he 'trusted' Sandro to overcome the challenge. When the portraits were completed, Lorenzo composed an inscription to be placed under one of them: 'I was another Judas, a traitor in the church.'

"Our efforts were later threatened by the unending rain that flooded the Arno, from which the executed body of old Jacopo Pazzi was retrieved. Some local children were found dragging it from door to door, saying 'Open for me, Jacopo Pazzi,' and those who answered were given quite a start."

After reading Filippino's letter, I was filled with questions about the Medici and Florence. Mother's opinions regarding "the affairs of men" were rather limited, or perhaps she simply chose to keep them to herself. But our frequent visitor, Ser Vannozzo, was outspoken. When I voiced my confusion about why the populace had not rallied around old Jacopo Pazzi when he called for liberty outside the Palazzo, Ser Vannozzo readily responded.

"Why trade a benevolent tyrant for an unknown one? At least Lorenzo provided them with entertainments and supported their guilds."

The Ciardi's support of the Medici was far more ardent. Giovanna's father was incensed over the assassination of Giuliano. Her brother, Ciardo, was so distraught he left for Florence when the first words of a coup reached Prato, so that he might enlist in whatever army he suspected would be formed to keep the Medici in power. He soon had

this opportunity when Pope Sixtus excommunicated Lorenzo in June, followed by an interdict against the entire city in July. This, of course, meant war, and we were incensed that King Ferrante of Naples went so willingly as an ally to Rome. After all, his daughter, Eleanor, had been graciously received by Lorenzo five years earlier. But Naples had long been aligned with the Pope, Ciardo hastened to point out. He himself was not surprised; he was simply eager to lay waste to all of them!

I don't know what distressed Giovanna more: the danger to her brother in war, or the fact that the interdict now prohibited the sacraments of any death or marriage, even in Prato. For the past year, she had been smitten with Ser Vannozzo's nephew, Antonio di Vannozzo. And all talk of Petrarch's Laura or Dante's Beatrice was now replaced by the pure and glorious love she felt for Antonio. And love is always more desperate when the threat of destruction is at hand. Their betrothal had been witnessed in May, but the wedding vows they took would no longer be recognized by the Holy Church.

"What a curse upon all the youths and maidens of Tuscany!"

Giovanna cried often, and most frequently to me. I would comfort her as best I could, giving little thought to how the interdict might thwart my own heart's inclinations. My contact with the youths of Prato was restricted. Giovanna had confessed to me once that her brother had deemed me "the Untouchable Lady Lippi." He had also told her that most members of his sex found me "too beautiful for carnal satisfaction"—a term I did not quite understand at the time.

But I took no offense at my friend's, or rather Ciardo's, confession. It seemed that he had always disdained me, somehow, and was always disapproving of my inquiries and interests. The irony of his remark was that he, too, was extremely handsome: Ciardo had an unearthly beauty for a man. And as I grew to notice it, I came to understand the comments Sandro had made to Lorenzo Medici on the night of Giuliano's joust. The effeminate poet, Poliziano, had been mentioned, and although Ciardo was surely not inclined towards "unnatural love," I could see where he might attract a man who was. Apparently Sandro had been referring to Poliziano, known for his praises of beautiful women but wont to succumb privately to beautiful men. But Poliziano was not to meet Ciardo for several more years. During the tumult that

followed the Pazzi conspiracy, he was spirited away to Pistoia with Clarice and Lorenzo's children.

When Ciardo departed for Pisa to enlist in the Duke of Ferrara's army, he passed through Via delle Tre Gore to request "the blessing of Madonnas Lucrezia and Alessandra." I recall how I wanted to embrace him, if for nothing else but to taunt him. Yet I found myself holding back until he took my hand and said, "Will you not kiss a good soldier farewell?" I then began to weep uncontrollably, much to Ciardo's surprise and Mother's and Vincenza's chagrin.

—Winter of 1478

If Ciardo's absence and Giovanna's sorrow were not enough, Filippino was now tormented by the conflict regarding his friendship with Ginevra Vespucci, the sister of Simonetta's widower, Marco. Their father, Piero, had been imprisoned for unwittingly aiding in the escape of one of the assassins, Napoleone Franzesi. Having just painted Napoleone's portrait and the inscription "Outlaw awaiting a crueller death," my brother was now caught between loyalties to the Medici versus the Vespucci.

"Ginevra swears her father knew nothing of the attack on Giuliano when he provided the boat for Napoleone," Filippino wrote. "But still he was tortured and his screams could be heard for blocks. My poor Ginevra weeps daily for her father, and Marco has been banished. The rest of the Vespucci have fallen over themselves to denounce Piero and assert their allegiance to Lorenzo. Such events make for lamentable affairs in the quarter of Ognissanti. I am anxious to move into my new house in San Pier Maggiore."

Mother was very disturbed by this news, perhaps because Piero's imprisonment called to mind Father's inquisition. But more disturbing was the lack of news, as Filippino became wary of becoming suspect himself. Lorenzo, by now, had employed spies everywhere, even among the couriers of Florence. Filippino dared not write of his sympathy or love for Ginevra, but I had already guessed it and so had Mother. He was heartsick and could not work for days when Ginevra, for want of safety, was betrothed to a wealthy merchant in Pisa.

"And what has a man of my age and standing to offer a Vespucci?"

Filippino said when we arrived in Florence to help install him in his new home. "I have not yet established my own bottega."

Such was his rationale for having lost Ginevra, but Mother believed that his hesitance to marry had been influenced by Sandro's dedication to bachelorhood. Sandro was known for making jest of the institution of marriage, having once been prodded by a member of the Signoria "to lay his roots in fertile soil." He had responded by describing a dream in which he was married. It had caused him "to awake with such a fright, I roamed the streets of Florence for hours without a torch, for fear that if I returned to sleep the dream would resume."

While Mother and I were in Florence, Sandro arrived at Filippino's house to greet us and to speak to Filippino regarding another commission, as he was now the top journeyman of the bottega. I had not seen my godfather for over two years, and he seemed as surprised by my appearance as I was by his. He was heavier, certainly, and seemed more commanding in his favorite ochre-colored cloak. His hair was also cropped shorter, which made him look older, and I noticed the boldness of his smile and the heavy eyelids that spoke so readily of a dreamer. He reached out, as always, to touch my hair and admire its length and beauty, but afterward he moved quickly to touch my face, saying "Madonna Sandra, I believe Florence has found its next Simonetta!"

I went to embrace him, as a dutiful goddaughter might, but now I noticed the strength in his arms, the texture of the muscle that led from his forearms down to his wrists and gifted hands. I could feel each finger against my waist and how they moved up and downmy back, like those of a practiced sculptor. For him the touch was loving but innocent, yet for me it was new and frightening. I felt within me a sudden stirring, much as I had imagined Giovanna felt when she looked upon her Antonio. My blood pounded in my ears and I felt myself redden as I pulled away. Sandro looked at me strangely, then chuckled and turned to Mother.

"Well, Madonna Lucrezia, am I here to approve of some betrothal?"

I hastened to deny such a possibility, but was interrupted by Mother's response on an entirely different matter.

"What brings these words to your mouth, Sandro, when clearly you

have not been wont to encourage any for Filippino!" Her tone took us all by great surprise.

When Sandro implored her to elaborate, she freely accused that it had been his views on marriage that had dissuaded Filippino from proposing to Ginevra Vespucci. Sandro denied this, speaking only of his concern for Filippino's safety.

"Marriage to Ginevra would have thwarted his career, Madonna. No painter excels in Florence without the Medici's approval. I might have wished for less competition by encouraging such a union, but frankly, I had hoped to matriculate Filippino into the Speziali. You know I have never had a student as gifted as he."

"But he has told us that you remind him often that 'all the great maestri have been unmarried.'"

I stood in awe of the argument and Sandro's response to it.

"Let us not forget his own father's status."

Mother's voice was quivering. "Filippo was a man of God. He painted for the Church."

I found Sandro's words cruel yet true, and his boldness impressed me.

"Look at Verrocchio and Donatello. They cared not for women and took brush and chisel for wives!"

"But such a wife brings little comfort at night and bears no children." It was I who countered his analogy. It seemed to me I was speaking in a foreign voice, but one that now took hold of Sandro's attention.

"Perhaps, Sandra. But for me, the paintings are my children, and I fear not their loss or the loss of the brushes or pigments that made them. I watched my father and mother grieve for my sisters, who died in their arms. And now my father grieves for the loss of my mother. When you make a painting, you love it. Then you sell it, but it is always yours. Even if it is destroyed, you do not have the same grief. You can paint another. But you can never make the same wife or child. I have merely chosen to live with less grief."

He spoke with a tenderness I had never heard in him before, and wishing to arouse more of it, I answered:

"Or joy."

On our return that winter to Prato, Mother and I learned that Ciardo di Ciardi had left the ranks of Ferrara, whose strategy had been to avoid all confrontation with the enemy. Giovanna said her brother even admitted to being a better wool merchant than mercenary and was soon as disillusioned with the war as his fellow Medici partisans. Giovanna discontinued her studies and now immersed herself in the domestic affairs of the Ciardi estate, called Villa Tavola. She spoke only of Antonio and hoped that their wedding might be possible in the coming spring. I rarely saw her, unless Ser Vannozzo was inclined to escort me to Villa Tavola for a visit, or Ciardo brought her into town to see me. Either way, our encounters were restrained by this company, save when we stoleaway to privacy.

One Sunday, after hearing Mass at San Stefano, Giovanna and I ran ahead of her family. She hurriedly confided, "Ciardo has been speaking of you often!"

"And what is his complaint now?" I was barely interested. Another man was on my mind, and I could not shake the memories of his face or voice: his presence was both haunting and comforting. It was Sandro.

Lorenzo de' Medici voyaged to Naples in the dark December of 1479 to appeal to King Ferrante's mediating powers with Rome. The library at Palazzo Medici held the letter he had written to the Signoria on his departure to the port at Pisa: "Perhaps God wills that this war, which began in the blood of my brother and myself, should be ended by my means. My desire is that by my life or my death, my misfortune or my prosperity, I may contribute to the welfare of our city."

To make amends for the war, Pope Sixtus had invited three Florentine masters to Rome to decorate his newly remodeled Vatican chapel. Sandro was selected by Lorenzo de' Medici, who basked in the glory of his diplomatic victory.

9

The Palio

*I*T WAS THE SUMMER OF 1480. AS SOON AS THE interdict against Florence was lifted, Giovanna wed her beloved Antonio. As happy as I was for her, I felt I was losing something precious, and a little part of me died. I replaced it with an occasional flirtation with whoever attempted to distract me. At sixteen, I had completed my lessons with Messer Fiorentino, and this limited those excursions across Prato in which I might catch the eye of some errant youth or unfaithful husband. The power that overcame me with the nod of a velvet cap, the tilt of a rugged chin, or even the most subtle of sensuous smiles was more than I could contain. The heat swelled in my stomach and my breasts and I dared to wonder, Could I be that beautiful? Vincenza had commented on it often, and Mother and Aunt Spinetta warned me against the sin of vanity. But Mother had also said that beauty was a gift, and so I used the gift to entertain my own loneliness.

In June, Filippino wrote to us the latest news from Florence and disclosed the details of Lorenzo's treaty with Ferrante.

> Sandro finds it most ironic, as I prepare to leave Via Nuova and set up my own bottega, that the portraits of the assassins were orderedremoved from the walls of the Customs House.

"That we should part company while our most controversial masterpiece is being erased!" he declared as we passed the workers undoing our painstaking efforts. Meseemed it troubled him more than myself, for I had found it a constant reminder of that nightmarish time. But when I queried Sandro directly about his feelings—which I am not wont to do—he merely smiled and said, "Filippino, I desire my acclaim to come from beauty and not murder. I trust you do, as well?"

We have learned from Amerigo that Piero Vespucci was set free by the terms of the treaty, and that he has fled to Milan, as well he should to be free of any calumny. I can only imagine that Ginevra's heart has been lifted with his freedom, but I have heard nothing of how she fares in Pisa. This reminds me that Amerigo has inquired on more than one occasion about you and Alessandra and hopes you plan to come to Florence for the Feast of St. John. There will be a splendid palio in celebration of the treaty. Do come, Mother, or at least send Alessandra with an escort so that she may see it. Perhaps the Ciardi plan to attend and she can go with them. Either way, one of you must make approval of my new houseservant, Francesca, not to mention the two garzoni who have come to work with me. One was referred by Sandro, which I thought most generous until I learned he had told the youth that I, as a new maestro, would be more patient than he! Still, I have a commission to paint *The Virgin Appearing to Saint Bernardo*, and I am hoping, Mother, you shall sit for me as the Virgin, who is known to be more matronly in this story."

Send your answers by way of Ser Vannozzo when he comes to Florence next week.

I am your loving son and brother,
Filippino

"My first palio!" I squealed as soon as I put the letter down. (I had not yet attended the famous horse race across Florence named for the "palio," or bolt of cloth, awarded to the winner.) "Will you sit for Filippino, Mother? Shall we stay for more than a week? I am tired of Prato. Shall Giorgio and I go to Casa Vannozzo and give Piero our news? Then I can find out if the Ciardi are going. Well, never mind

Giovanna. She is with child, but I dare say I could tolerate her brother
Ciardo well enough to get to Florence!"

"Sandra mia! Slow down, please. Give me a while to think on it."

Mother walked over to the wall where she had displayed one of
Filippino's first sketches of me as a child. It was an immature attempt,
and yet there was a purity in the style and a sense of affection in my
likeness. She stared at the drawing for what seemed an hour and then
turned to Vincenza.

"Can you manage for more than a week if we go?"

"Of course, Madonna. The palio shall be splendid for Sandra to see,
and who knows?" Vincenza smiled slyly in my direction. "Perhaps she
may meet someone there worthy of her dowry . . . and beauty."

Mother glanced at me strangely. "I go not for the palio. I go for
Filippino. As for Sandra, she may do whatever pleases her . . . as long
as she does it with grace and dignity."

We left for Florence the third week of June with Ciardo di Ciardi and
Ser Vannozzo as escorts. Mother rode on Bello, and Ciardo insisted
I ride with him on his favorite horse, Sopracciigliotto, named for the
steed's distinctively bushy eyebrows. Our discourses for the long
morning's journey were limited to Ser Vannozzo's analysis of the
Medici treasury and how the expense of the war had increased his
taxes, Ciardo's commentary on his brief and disappointing military
career, and Mother's crooning over the loveliness of Giovanna's April
wedding. I spoke very little, as I much preferred to pass the time
absorbing the sights and sounds of the countryside. I could not tell if
Ciardo took offense at my silence or if he was contented by it. He was
more attentive than usual and took care to see to my comfort as we
rode. He even occasionally caressed my arm, which I found pleasant
but not thrilling. For no affection lingered in my young heart like the
one I held for Sandro Botticelli.

Filippino had instructed us to enter the city by the Porta alla Croce
for the quickest route to his house. I had not been through this gate
before. Its arch was wider than the Porta al Prato to help accommo-
date the steady stream of visitors arriving to celebrate the Feast of St.
John. We followed the main road through the gate into a part of

Florence I had never seen, crowded with shops and houses. Beyond us, to the east, I recognized the top of the church of Santa Croce, whose piazza had been the site of Giuliano's tournament. On our last visit, we had approached Filippino's house from the south. I was surprised, therefore, when we came upon it so suddenly.

Filippino's house servant, Francesca, answered the door. She was a large woman with a maternal air and I liked her immediately. She showed the men where to tie the horses and bade us all come in to take some refreshment, but Ser Vannozzo was eager to continue on with his affairs and took his leave. Ciardo accepted the invitation and followed us up the stairs to the hearth and kitchen. Francesca set out fruit and cheese with bread and then reached for a small decanter of oil.

"You must taste the olive oil Filippino brought back from Lucca," she said as she poured it carefully into a small dish.

We took our bread and eagerly dipped it in the deep, golden circle of oil. Its rich, earthy fragrance filled our nostrils and delighted our palates. While we were eating, Filippino appeared from his bottega below.

"Such appetites in these Pratesi!" He laughed as he came around the table to embrace Mother and me, while Ciardo offered him a handshake and some kind words on the cut of his apron. Filippino patted his front in reference to our well-dressed friend. "Well, I am no Amerigo Vespucci in this."

It was time for me to speak. "And how fares Amerigo these days now that his family is in good standing with Lorenzo?"

Ciardo appeared slightly irritated by my interest in Amerigo, and I must confess that a part of me had wanted to provoke him.

"He has returned from his travels to Paris and Venice. His father has been ailing. I'm sure you might see him if you go to Ognissanti. His uncle Giorgio is financing the church's commission for two frescoes. Sandro is painting Saint Augustine, and Domenico Ghirlandaio is painting Saint Jerome."

The mention of Sandro's name caused my heart to leap into my throat. I tried to hide my eagerness and to make my voice as nonchalant as possible.

"I should like to visit Via Nuova tomorrow, Mother. Is Fiametta still living there?"

Filippino nodded, and Ciardo said, "You mean such a comely girl has not yet married?" It was his turn, now, to provoke me.

"Beauty is no assurance of a dowry," Mother interjected with a knowledgeable sigh.

"No, and the Filipepi men are known for not investing in the public dowry fund," Filippino added. "Sandro has often lamented that because he is now a successful painter, he will be forced to provide for his nieces."

"But he is generous and he would!" I declared with a fierceness that surprised everyone.

Filippino had to attend to some business in the morning, so he was able to escort Mother and me as far as the church of Santa Maria Novella. From there it was an easy walk to Ognissanti. Before we parted company, my brother advised us to go into the church and find the Del Lama chapel.

"It is very small, but always a candle burns to illuminate Sandro's *Adoration of the Magi*."

"The one with his portrait!" I recalled aloud.

"And others. See how many you can recognize, flattery not withstanding!"

The chapel in question was indeed small and plain. The frame around the alterpiece was the most elaborate decoration. But there, not quite a meter square, hung the colorful masterpiece. So vibrant were the figures that size seemed the only modest thing about it. Mother quickly recognized Cosimo the Elder, kneeling next to his son, Piero. Sandro had so improved the profiles of Lorenzo and Giuliano both that their likenesses were apparent largely by their hairstyles and posture. I immediately recognized two figures in the left foreground: a man in a blue cap leaning intimately with his arm around a well-bred youth. When Mother asked who they were, I whispered, "It is the poet, Angelo Poliziano, with his pupil, Lorenzono di Pierfrancesco."

"Sandro's portrait is no mystery, to be sure," she murmured as she nodded towards the figure standing in the right foreground.

Indeed it was as striking as any of the Medici portraits. His face was an extraordinary likeness, from the texture of his wavy hair to the line of his full jaw, and his mouth was curled into a subtle smile, as though he were both participant and observer. And from beneath the distinctively heavy lids, his eyes seemed to flicker with the candlelight. It was the artist looking at the viewer as much as he was looking at his own reflection.

"Don't you feel that he's watching you?"

"Ah, Filippo. See what you have done!"

Mother smiled proudly, but I could see that, with or without my father's influence, Sandro had truly come into his own style and accomplishment. As we walked down the Via della Scala towards Via Nuova, I began to tell Mother my first recollection of Sandro, when he had found me on the crowded piazza in front of San Stefano and had lifted me up to see Diamante blessing the New Year. I recalled every detail, from the nape of his hair to the leather ties on his ochre cloak.

"He had a special fondness for you, Sandra. More than most godfathers do, although I dare say he has not given you much spiritual guidance."

"Ah, Filippo, see what you have done!" I mimicked her earlier remark. It was well known that Sandro had always admired my father's blatant irreverence for certain tenets of the church.

"Your father was spiritual in his own way," Mother retorted under her breath.

"Then Sandro shall give me guidance in his own way, too."

Mona Nera and Mariano greeted us warmly, encouraging us to stay for the midday meal.

"Sandro is sure to come home to sup since he is working so near," Mariano said. His voice was hoarse and frail. The loss of Smerelda had weighed heavily on him.

"May I walk over to Ognissanti and find him? He isn't laying any pigments yet, is he?" I knew this was crucial work that would not allow interruptions.

"I suppose," Mother consented, and before anyone could tell me exactly where I would find him, I was down the stairs and out the door.

Ludovico, the garzone who had replaced Filippino, was standing in the entryway of Sandro's bottega. Before I could leave, he stopped to introduce himself. He was holding a study of a Madonna that had been assigned as a workshop piece. I recognized the face as that of Sandro's favorite model, Contessa. She was holding her own child, who looked lovingly up at her from a book.

"Madonna del Libro," Ludovico announced. "Sandro is painting the actual panel when he is finished with the Saint Augustine."

"Is it the Book of Hours?" I hoped to reveal my knowledge of sacred literature.

"Yes. Did you know Sandro used to do miniatures for such books before he worked with your father?"

I shrugged and then glanced across the room to a drawing board that displayed a set of sketches. Two were in charcoal and one was in silverpoint. The silverpoint had caught my eye because it was of two lovers in an embrace. Sandro must surely think about love while he depicts it! I thought. I was filled with a sudden excitement and stepped closer to the sketches.

"They are illustrations for Dante's *Commedia*. Sandro plans to make engravings of them that can be printed by press along with the verses!"

"Then these are the condemned lovers, Paolo and Francesca, descending into Hell," I ventured to guess. "Sandro must be working on the 'Inferno.'"

"Ah, Madonna Sandra, so you have read it."

"Sandro gave me a copy . . . inscribed, of course."

"Then some day you shall have the printed version, the first Tuscan manuscript to come off a press! Lorenzo de' Medici's cousin has commissioned it!" Ludovico was clearly proud of this privileged information.

"His cousin Lorenzino?" I asked as I started for the door. The image of Lorenzino's young face beside Simonetta's tomb sprang into my mind, and I could not fathom his commanding such a scholarly innovation. But then I was older, and so was he. I excused myself from the bottega and entered the street.

It was the first time I had walked alone in Florence, and I felt both giddy and frightened. Ognissanti was only two blocks away, but I made the most of the glances I received. Several workers were setting

up the barricades for the palio, which would begin at the Porta al Prato and follow along the Borgo past Ognissanti.

I had not been in that cold, dark church since Simonetta's funeral. I forced myself to shake the memory in order to find Sandro.

He was standing close to the door, making measurements of the wall and holding a large sketch up to the light that filtered in through the dull glass. The other painter, Ghirlandaio, was already transferring a cartoon to the opposite wall. Sandro took no note of me until I came up and put my hand on his back. He turned with a start and then smiled.

"Sandra mia! You are here!"

"Mother's here, too. We came for the palio. At least I did. She came to sit for Filippino. She's with your father and Mona Nera now. Will you sup with us?"

"Of course. Of course!" He patted his ample stomach. Then he took one of my braids in his admiring hand. "Such hair on this girl! I swear I shall have to paint you before the year is through. A Venus pudica, perchance, squeezing her golden tresses as she rises from the sea?" He whispered this pagan reference so as not to offend the brothers of the Umiliati, who were about to pass through the entrance. Before I could answer, he took my hand. "Come, you must meet my very temperamental friend and rival, Domenico Ghirlandaio."

The painter on the low scaffolding across from us frowned at Sandro and then shook his head. He was carefully incising the lines of his cartoon into the freshly laid plaster. Some painters used an egg-dot technique in which ground charcoal was pushed through tiny perforations along the lines of the cartoon. It assured an accurate transfer, but Ghirlandaio was as skilled a draftsman as Sandro and preferred the less distinctive transfer of incising.

"I'm not laying any pigments until after the race," Ghirlandaio announced to his garzone. "The thunder of hooves might shake loose some of the plaster."

"Fear not, Domenico. This is a sturdy church," Sandro reassured him.

"Let us hope it is as sturdy as it is damp and that summer's heat is upon us soon or none of our frescoes shall dry properly."

"You've been working too long. Come away and sup with me and meet Filippo Lippi's daughter . . . my namesake I might add." But

Ghirlandaio refused the invitation and we left Ognissanti without him.

Walking back up to Via Nuova, Sandro noticed the attention I received from the workers setting up the racecourse. I could only smile and blush while Sandro placed a protective arm around my shoulder, which caused me to redden further.

"See what a distraction you have become, Sandra! Is there no youth in Prato who has claimed your heart?"

How difficult it was to reply to his inquiry! I could only clear my throat and say "No."

"Ah, well, I imagine you are too much of a jewel to the Pratesi men. And no doubt your mother has better designs for you."

Just then we spotted Amerigo riding a well-draped horse along the Borgo towards the Vespucci houses.

"Practicing for the palio, are you?" Sandro called to him in jest.

Amerigo turned to look while holding his bright red cap against his long, blond curls. He was more handsome than I remembered him. He waved at Sandro and laughed, then rode in our direction at the corner of Via Nuova. He seemed not to recognize me, but looked at me with strange delight and amazement.

"Can this be Filippino's sister?"

"Ah, hold that look, good Amerigo. It is the same stupefaction required of my noble Augustine as he ponders the beautitude of sainthood." Sandro was now making light of the awesome task ahead of him.

I nodded to Amerigo. "Yes, it's Sandra. I'm here for the palio. Will you be racing tomorrow?"

Amerigo dismounted and took my hand.

"No, I returned too late to register my entry. But I have been invited to attend a banquet tonight at Palazzo Medici. My friend Lorenzino di Pierfrancesco is riding, and his mother hosts a banquet for all the riders."

"As a dutiful godfather, might I suggest that Sandra accompany you?"

Amerigo nodded eagerly. "Splendid! Do you find the suggestion as agreeable as I, Sandra?"

"I shall have to ask Mother and Filippino." I began, but in truth I felt my heart racing at the prospect of seeing my first dance partner

while escorted by the robust and worldly Amerigo. It would be awkward, I thought, but challenging.

"Filippino's house is not far from Via Larga," Sandro added.

"I don't know if the gown I brought is suitable for such—" Now I began to stammer.

"Then let us see if you can be fitted for one this afternoon." Sandro gave a generous grin.

There was a flurry of activity for the rest of the day as I was outfitted in a floral surcoat with lace. Fiametta dressed my hair, and Amerigo arrived that evening with a string of pearls that had belonged to Simonetta. His mother had agreed I was the only maiden she had met recently "worthy of their sentiment and beauty."

Just as we were about to depart for Palazzo Medici, Ciardo arrived to dine with Mother and Filippino. He seemed as surprised by my departure with Amerigo as I was by the apparent jealousy that ensued.

"You are taking our Sandra away, good man. Dining shall be dull without her discourses!" Ciardo gestured widely while dismounting from Sopraccigliotto.

I could not avoid the sting of his sarcasm. Ciardo had never asked or valued my opinion on anything.

"Then the table at Palazzo Medici shall be the brighter," Amerigo replied in clear retort.

"Palazzo Medici, indeed! Is this our fair Alessandra's well-earned introduction to Florentine society?"

"I have been there before. Sandro took Giovanna and me there to meet Giuliano after his joust. Don't you remember, Ciardo?" He could see I was disturbed by his interrogation.

"You were children."

"Meseems the past four years have been most kind to your sister's friend." Amerigo's eyes widened emphatically.

Ciardo recanted any protest once his possessive tone had been called into question.

"Forgive me, Sandra. I trust you'll be watching the palio from Via Pietrapiana?" Ciardo pointed to the main street one block away.

"Perhaps," I answered as Amerigo lifted me gently onto his horse. It was the first time I had thought to be coy with Ciardo or any man.

The loggia and courtyard of Palazzo Medici were so crowded that I feared we might never find Lorenzino di Pierfrancesco. It was the first genuine celebration since Lorenzo de' Medici had returned from Naples with the treaty that had ended the war. Several servants circulated, passing out candied pine kernel to whet our appetites. The ever-suspicious Lorenzo had posted guards at every doorway and corridor, for the attack in the cathedral had made him wary even at festive events. Amerigo introduced me to faces and names too numerous for me to recall. The men greeted me with eager eyes, the women with competitive smiles.

"They are all wondering, Who is this dazzling creature with Amerigo Vespucci?" Amerigo whispered into my ear. His breath was now heavy with wine.

"Has Simonetta been reborn on the eve of the palio?"

It was a man's voice, but not Amerigo's. I turned and saw a slender youth in a red and black tunic. It was Lorenzino di Pierfrancesco, taller and older. He was not as handsome as Amerigo but every bit as charming. Amerigo was very perceptive.

"It seems you have met before."

"But our last encounter was much sorrier than now," said I.

"Your good cousin's interment at Ognissanti," Lorenzino explained.

"I am glad to meet you in happier times."

"It is only happier if you grant me a dance, Madonna Sandra."

The musicians had not yet assembled, but when they did I became the focus of a strange volley between Amerigo and Lorenzino—who was much the better dancer. I danced with one and then the other until I was quite dizzy. The Medici's generosity with wine only deepened my confusion, and as I pirouetted and dipped beside each partner, I felt the eyes of all the other guests upon me. For the first time I was intoxicated not just by the music and unrestrained drink but by the power of my own beauty. It was as frightening as it was pleasing.

Before the enchantment of that evening faded, the young Lorenzino had taken me aside to one of the pillars of the loggia.

"If I win the palio tomorrow, Sandra, I shall give it to you." Then he kissed my hand so gently that the moisture of his lips barely evaporated into the night air.

"Lorenzino fancies you, it appears," Amerigo teased while helping me mount his horse. I no longer cared if I was crushing my skirts as we rode. He mounted behind me instead of walking the horse and held me tightly. "But he is a better scholar than equestrian."

"I thought all the Medici were athletes," I replied with a laugh.

"Only in bed. But that is not for a lady such as you to know."

"And what of the Vespucci men?" I was glad there was no mother or aunt to censor me.

"Ah, they are scholars, too, and better navigators than horsemen, which means they never get lost . . . even in bed."

It was my first experience in arousing a man or being aroused beyond mere fantasy. My heart had never beat so frantically. I had forgotten all about Sandro! Amerigo caressed my bodice as we rode but never touched my breasts, yet always there was the constant pressure of his swollen codpiece against the back of my gown. Giovanna had spoken often of the glory of the marriage bed and her "sweet Antonio's manhood," how it "soared like a ferocious hawk" only to "nest softly like a sparrow" once it had "seized its grateful prey." But I had never appreciated her imagery; in fact I had found it silly until now. I could only whimper, like some wounded animal, while Amerigo stroked my hair and called me his beauty.

"Beware the flattery of men," Aunt Spinetta had always warned me. It had been her contribution to preserving my chastity. But now I was thriving on the very flattery that might ruin me. I could only return Amerigo's kisses as he lifted me down by Filippino's doorway. His mouth was firm and his tongue slid against my teeth as though he wished to consume me, and it felt very different from the time Giovanna and I had tried kissing as children. We had hidden behind the Ciardi olive trees to experiment the embrace of the lovers, Paolo and Francesca, whom we had read about in Dante's *Commedia*. Our kisses had been delicate and soft, tempered by our innocence. Now I had to pull myself away from Amerigo's mouth, for fear that he would swallow me.

A candle illuminated one window, so I knew that Mother was awake and waiting up for me. I had to go in.

"Say you'll watch the palio from Borgo Ognissanti," Amerigo insisted.

"No, I must stay here," I whispered. "Can you come here?"

"No. I am expected to watch with my family. My father is ill. It may very well be his last palio."

Amerigo left, a dutiful son who had promised to call on me later. But my dreams that night were not of Amerigo or Lorenzino. My dreams were of Ciardo and myself, clinging in the same embrace as Dante's condemned lovers. Sandro was sketching us and he instructed Ciardo to "reach for my sweet fruit and find its nectar." I resisted, but Ciardo was strong and Sandro compelled me to yield to his touch. It was for art. It was for the drawing, I was told. Then a strange tension rose up between my legs and entered my womb. The tension pressed on me like a slow, dark friction, and suddenly I was transported in the dream to Ciardo's horse. I rode him with a gentle rhythm, and we increased in speed and cadence until a slow, pulsating sensation left my womb and traveled through my body. It brought with it a surge of heat and joy. "A joy that God brings to every woman when she truly knows a man," my mother had once said. It was the only time she had spoken frankly of the sexual union. But this had been without a union, only the movement of the horse. And then Ciardo was riding with me. I felt the moisture beneath my skirts, but there was no man's seed. It was my own woman's blood. Ciardo reached between my legs for the crimson cloth. I watched in horror as he raised it to the crowd at Porta alla Croce. "Here is your palio!" We had won the race.

I awoke with a start to a breeze blowing across my skin. I felt the predictable heaviness within my body. My monthly purgation had begun. I realized, then, the significance of the dream and tried to dismiss it. But later, when Ciardo arrived to watch the palio with us, I regarded him differently, as he did me. We cheered the riders who passed. I thought of the thundering hooves shaking the plaster at Ognissanti and Amerigo hailing them as they did so. I scanned each rider, looking for Lorenzino di Pierfrancesco, who said he would be wearing his cousin's favorite purple. But all the while I watched Ciardo from the corner of my eye and he watched me. We barely smiled, suspicious of each other's motives.

I never did see when Lorenzino passed our checkpoint on the Via Pietrapiana. But when a unified cry rose from the crowd near the end

of the course and a young man in purple was lifted up from his horse, I realized that it was Lorenzino and that he had won. By tradition, he took the bolt of red cloth and began the course in reverse to display the prize. But this time he was handed two bolts at the finish line at Porta alla Croce. When he approached the corner nearest Filippino's house where we were standing, he slowed down and came my way. The line of spectators parted as he held out one of the bolts of cloth. He was breathing heavily, and all eyes turned towards me.

"I give the other palio to Alessandra Lippi, for she is the new 'Queen of Beauty' this day in Florence!"

A cheer rose from the crowd as Lorenzino pressed on with his prize, while I remained behind, holding the luxurious cloth.

"Such an overture is not to be taken lightly," Ciardo murmured to Filippino.

"And neither is Sandra." My brother was curt in his reply.

Thus began a new era of confidence for me—a confidence that would be my undoing.

Dante's Commedia, *with drawings by Sandro Botticelli, was the first illustrated manuscript to come off an Italian printing press; and with "The Inferno," in the desperate embrace of the condemned lovers Paolo and Francesca, the painter seems verily to have harnessed the "swirling in the winds of Hell." In fact, through the delicate and bold lines of the two lovers, Sandro had captured the same beautiful sorrow that he himself had instilled in the secret sighs of his goddaughter.*

10

The Magnificat

*I*T QUICKLY BECAME APPARENT THAT AMERIGO
had not revealed his intentions towards me to his friend, Loren-
zino di Pierfranceso, and this bit of secrecy had been duly recip-
rocated by Lorenzino. I, in turn, had not revealed Amerigo's overtures
to Mother, for fear she would have me return the palio. But then I
decided that perhaps I should consider the palio as an expression of
chaste affection in which Lorenzino was merely mimicking his dead
cousin Giuliano's declaration of courtly love to Simonetta. This notion
was soon dispelled after I was invited to visit the Medici villa of Cas-
tello two weeks later on our return to Prato.

Although Filippino had made sufficient studies of Mother for his
painting *The Virgin Appearing to Saint Bernard*, he had hoped we would
stay in Florence until August. But Mother was eager to return to Via
delle Tre Gore and said that if I wished to remain, I could. By now the
conflict between Amerigo and Lorenzino's affections had overwhelmed
me, as had Ciardo's cynical analysis of the two. I decided I should
accompany Mother home.

Ciardo—after giving me a very vague farewell kiss on the forehead—
had returned to Prato a week earlier to help his father. Not long after,
Lorenzino sent one of the Medici couriers to inform us that escorts

would be arriving the next day for Mother and myself. They would see to our safe return to Prato, but we would take a slight detour north to Castello, which was about an hour's ride from the gates of Florence.

Before we departed, Amerigo called for us to sup with him at Casa Vespucci. Mother interpreted the invitation as merely social, but I saw it as a gesture of serious intention. Sandro had been invited also, however it was difficult for me to respond to Amerigo with any sort or candor. He sensed this, I know, and my excuse was that I was obligated to practice a measure of reserve until I had received my godfather's approval on a suitor. Of course this was merely a pretense to avert the real restraint, which was Sandro's overriding presence.

My heart beat towards his strong face and grand persona at the Vespucci table as much as it did at Amerigo's frivolous flirtations underneath it. His left leg was a constant companion to mine, and his young hands occasionally smoothed the hip of my skirt. And as much as I enjoyed his touch, I was continually distracted by Sandro's mouth as he bit into the larded capon, tenderly running his teeth and tongue along the soft meat as though he were making love to it. I do not know whose kisses I wanted more: Amerigo's, which I had already tasted and enjoyed, or Sandro's, as unlikely as they were forbidden.

When Amerigo learned of my invitation to Castello, he seemed only slightly concerned. He told me it was a pleasant villa and farm that Lorenzino and his younger brother had acquired on their cousin Lorenzo's recommendation. (In fact, Lorenzo had handled the transaction, as he was in charge of the Pierfrancesco funds.) Amerigo assumed that the Medici merely wished to show it off to Mother and me as a gesture of hospitality, and he did not—or so he said—mistrust the purely "courtly" intentions of someone as refined as the young Lorenzino.

"I would escort you there myself were it not for Father's illness. But I am needed here."

I suppose I was partly relieved by his absence, which left me to assess Lorenzino's intentions for myself. But I found that whenever I was in his company, I was immediately attracted to Amerigo. He was virile and yet boyish, well educated and traveled, and immaculate in his taste for clothes. He had turned the eye of many a maiden in Florence, according to Sandro, who had recently done a portrait of Amerigo for

his father, Stagio. I sensed that as soon as I passed through the Porta alla Croce, Amerigo would be wooing some other comely maiden, and I hated to admit that this made him all the more desirable.

Mother found him gracious and entertaining when he escorted us back to Filippino's house, but Filippino had taken on so many commissions that he had not had time to be entertained by even the most compelling host. We proceeded with Sandro towards Via Nuova, where Mother and I would say our farewells. I found that I was grateful to be distracted while saying good-bye to Sandro. He took Mother's hands in his and clasped them warmly while bading us return before winter. When it was my turn, I embraced him like a dutiful child and recalled the familiar scent of pigments and oils that I loved so well.

"I hope that our 'Queen of Beauty' is ready to spend some time in my bottega."

"You may call for her whenever you will." Mother's smile was tired.

It was difficult to pull away.

Amerigo's kisses still lingered on my mouth and breast the next morning when I mounted the Medici escort's horse. Mother rode Bello with our parcels of clothing, unaware of the voracious good-bye that Amerigo had rendered the night before in the darkness of Filippino's door. I was as intoxicated with this new desire as I was with the sweetness of the country air and the glorious flowers in bloom. I felt a grandeur, as though all the world had been created for me. "I know not if it were more honor to escort the Madonna of Fra Filippo Lippi or the new Queen of Beauty!" our good servant said.

Mother smiled graciously, looking, indeed, very much like a weary Mary on her donkey following the road to Bethlehem. It struck me then that I had taken her place as "the radiant lady of Via delle Tre Gore"—that she was the fading blossom and I the bright new bud.

When we reached the place called Il Vivaio, we turned off the main road to a tree-lined path that widened as we approached the princely villa. Behind it rose a veritable Eden of gardens, lemon groves, and fruit trees. Two servants met us and led Bello and the horses to the livery. We then proceeded through the house to the loggia and terrace to meet our hosts.

Lorenzo Medici's younger sister, Bianca, greeted and introduced us to Clarice and Lorenzo's children. They were returning to Florence from the Medici villa of Cafaggiola, where they had spent much of their self-imposed exile during the war with Rome. Clarice had gone on ahead to prepare Palazzo Medici for their arrival and also to avoid the impending visit from Poliziano, who was her children's tutor. Poliziano had also tutored the Pierfrancesco brothers and had been urged to visit Castello when he was not in Fiesole.

"Clarice and Poliziano are like oil and water," Bianca explained as discreetly as possible. "That long year together at Cafaggiola was too much for both of them. I told Lorenzo that putting a woman as devout as Clarice in close quarters with a pagan poet was just asking too much!" Bianca had a twittering laugh that I found a little annoying. Perhaps it was the collapsed nasal cavity of the Medici nose.

"But Poliziano is a Humanist," I ventured to remark.

"And he exalts in pagan allegory. All those Platonists and scholars of the Ancients do."

"I thought it was just part of the poetry. Why, even Virgil rides with Dante in the chariot of Heaven."

Bianca eyed me curiously, and Mother tried to alter the subject as graciously as possible.

"Well! See what a paradise your nephews have here," she enthused while stepping onto the terrace.

Just then the young nephew, Giovanni, appeared from the garden with his older brother, Lorenzino, behind him. At thirteen, Giovanni was the right age for an angel but too bold of features. He was stockier than his slender brother, who took my hand and bade me follow him up into the lemon groves and fruit trees to tour the garden.

Many fallen lemons punctuated the matted grass beneath the grove, while in the distance, trees of tiny green fruit showed the promise of golden apples just beginning to form. Lorenzino made note of the few apricot trees which the original owners had prized, claiming that they had been planted from cuttings brought back from China and the Middle East. He reached up to finger the delicate apricots, which were not yet ripe, and said, "Some believe this was the forbidden fruit of Eden that tempted Eve."

"And Adam," I added with a provocative eyebrow.

"Yes, and Adam. One wonders how much poetic imagery God intended in the writing of Genesis and which fruit Eve was offering to Adam. Was it 'the apple of sweetness,' which my tutor Poliziano praises when he describes the Venus stepping from her shell?"

I dared not ask which part of the female anatomy this might be but I could readily guess, and a blush rose upon my cheeks and neck.

"'She presses her golden tresses to her apple of sweetness while wringing the froth of her father from her hair.'" These were Lorenzino's favored lines from Poliziano's "Stanze." He then turned with much directness. "Your pale skin is very lovely when you blush, Sandra."

It would have been insolence from any other tongue, but I said nothing, having never seen or touched the "froth" of any man. Lorenzino continued, in a most scholarly fashion, to comment on the genius of his tutor and how he had urged his cousin to commission "a worthy painter" to illustrate his poetry.

"Does my godfather, Sandro Botticelli, not come to mind?"

"Botticelli always comes to mind when one speaks of illustration."

"And Clarice when one speaks of Lorenzo. Would not these pagan images of Venus disturb her? I have heard she is most offended by such themes."

"Not if our goddess upon the sea portrays a holy baptism as much as a mythological birth." He took pleasure in his own cleverness and subtlety.

"But I thought the poem says that the sea is the froth from her father's ..."

"Her father was the god Uranus." Now he was the one who appeared to blush.

"So it may follow that the sea is the water of life, the froth of our Christian God the Father."

"Are you as devout as your mother, Sandra?"

The question took me by surprise, and I laughed nervously.

"As devout as any child raised by clerics!"

Lorenzino laughed also, but then he became more serious. He took my hand and led me back down the steep path between the fruit trees

and towards the lower terrace. His sensitivity in what he said next greatly impressed me.

"Methinks it would please Clarice if Lorenzo would commission a devotional piece in her honor. Perhaps a tondo for a favored convent or the church of her confraternity. A Madonna, as radiant as a goddess but holy and sublime, surrounded by angels who are portraits of her children . . ."

"How divine!"

"Indeed, thereby proving the Platonists correct—that beauty is as sacred as truth. Plato merely paved the way for Christ's arrival by recognizing and teaching the divinity of goodness."

"And how shall Lorenzo come by this idea?"

"By his trusted servant, Poliziano, who thereby shall win some favor with Clarice, thus making for a happy family at Via Larga."

"I thought your cousin preferred to stay at Careggi."

"What he prefers and what pleases Clarice usually differ, but I am glad of your familiarity with my family."

"I would not presume to be familiar."

"Not even with me?" Lorenzino drew my hand up to his lips. His charm, by now, had surpassed Amerigo's.

Bianca called us into the house to take some refreshment, so I was unable to answer that poignant question. But it was evident that the Pierfranceschi were less direct in their demands and preferences than the bolder branch of their Medici cousins. I suppose that was the result of continued political posturing.

We supped well that evening, and I slept even better in the guest chamber of Castello than I had at Filippino's. Perhaps it was the quietness of the country and the fact that there were only stars and no torches to light my dreams. Or perhaps I was merely satisfied to have conquered so many hearts on my brief "campaign" through Florence. Such moments of power are rare for a woman in an overpowering world, and this was my moment.

Lorenzino did no more than kiss my hand and caress my face during those two days at Castello, but I felt more altered by these gestures of affection than I did by Amerigo's blatantly sexual overtures. Amerigo had aroused my flesh, but Lorenzino di Pierfrancesco had aroused my

intellect and soul. As we rode to Prato, I had almost forgotten that Sandro had aroused all three.

—Autumn of 1480

Ciardo was an attentive but uncommitted suitor for the remainder of that summer. He had neither the literary background of Lorenzino nor the worldliness of Amerigo, but still there was a certain charm I could manipulate merely because it flattered him to be associated with "The Queen of Beauty." I encouraged his company because it gave me access to Giovanna. He called for me often on his way to Casa Vannozzo, where she was heavy with child. Seeing her in such discomfort and anticipation alarmed me for a while, but soon I grew accustomed to, if not envious of, her figure. The swollen belly and posture are considered attractive by Tuscan standards.

Giovanna no longer quoted Boccaccio or alluded to the earthly pleasures she had once enjoyed. She had vowed to entertain "only the purest thoughts" for the sake of the baby's health and spirit. Meanwhile, the burgeoning womanhood within me could think of nothing but such things: the size of a man's codpiece, the willing pain of the punctured maidenhead likened to the "ecstasy" of Saint Theresa as her heart is pierced. There was no one else to whom I could speak such thoughts. And so I read the ribald tales of *The Decameron* without comment, kept my curiosity to myself, and harbored numerous fantasies in my brain.

In September, Filippino wrote to say he had begun laying the pigments for *The Virgin Appearing to Saint Bernard*. One of the Camoldese monks had agreed to sit as the model for Bernard. His letter also mentioned Sandro's finishing the Saint Augustine at Ognissanti and that it had impressed Lorenzo de' Medici so much that he wanted Sandro to paint a tondo—a Madonna of the Magnificat in the fashion of Fra Filippo Lippi—for the church of Clarice's confraternity.

"It is to be a Madonna surrounded by angels," he wrote "and Lorenzo has suggested that their children pose as the angels, with Giuliano's baby son as the Christ Child." The child was a product of Giuliano's dalliance with one of the daughters of the Gorini family. This "earthly mistress" had produced an heir to Giuliano a few months after his

death, and the little Giulio was raised alongside the other Medici children as soon as he was weaned.

I could not help divulging to Mother the plan that Lorenzino di Pierfrancesco had devised at Castello.

"He knows well the best means by which to reach his cousin," she remarked.

"Were you aware that Poliziano's ideas were valued so highly by his patron?"

"Ah, the elder Lorenzo is as much the poet's friend as he is a patron, and the younger Lorenzino instructs his tutor as much as he does his cousin. Thus, he is twice as clever as both of them to bring some peace to their houses . . . and his own. For as long as Clarice is pleased, no trouble shall come to Castello."

Apparently Mother was more aware of the affairs of the Medici than I thought. And it was through this knowledge that she pressed me to choose a suitor with some diligence, for she knew that a match with Lorenzino di Pierfrancesco would be for some advantage and not love, and that Amerigo, who was more content on foreign soil, was not inclined towards marriage. Lorenzino, since our meeting at Castello, had written twice but without confession of love. But he had sent a transcription of Poliziano's "Stanze" so that I might read for myself the beautiful description of Venus stepping from her shell.

You could see the goddess with eyes resplendent, and the sky and the elements laughing about her. . . . You would swear the goddess was really issuing from the waves, squeezing the tresses from her right hand and with the other, covering the apple of sweetness, and that when her sacred and divine foot was imprinted on it, the sand clothed itself in grasses and flowers.

I felt I dared not reveal either the courtly flattery of Lorenzino or the more earthly affections of Amerigo. I knew that Mother preferred a more common husband to be glad of my dowry—the dowry she had been denied in her youth. And such a well-respected merchant as Ciardo di Ciardi was just the common husband she might choose. But not I.

In September, Sandro dispatched one of his rare missives to Via delle Tre Gore, explaining that he had begun the preliminary studies of the Medici children as angels for his tondo. Now all that was needed was a Madonna "as radiant and sublime" as any that Father would have painted.

"I am traveling with Ludovico to the Medici villa at Poggio a Caiano to inspect some walls to fresco. May I request, Madonna Lucrezia, that Sandra meet me there, where I might make of her as memorable a Holy Mother as you first were at the hands of Filippo?"

And who might best escort me to the nearby estate but the ever-attentive Ciardo, who was no more interested in art or devotion than his bellicose father? Nevertheless, the ride on Sopraccigliotto was not unpleasant. We spoke of Giovanna and his younger sister, Angelina, whom his father had decided not to educate, because "one literate woman in the family was enough."

The house at Poggio a Caiano was an old villa undergoing restoration by the architect Giuliano Sangallo. Its gardens were more elegant than the house, but the quarters were still comfortable enough for Lorenzo and Clarice and their children. When we arrived, everyone was there along with Sandro, who had not seen Ciardo since Giuliano's joust, and Poliziano, who appeared eager to meet him.

"What a handsome Zephyr he would make!" Poliziano exclaimed to Sandro when he set his eyes upon Ciardo.

"But not nearly as lascivious, I pray, as your god of wind," Sandro replied in reference to one of Poliziano's poems.

"And not nearly as long-winded." Ciardo's jesting made up for his literary failings.

Poliziano stepped forward and fingered the fabric of Ciardo's doublet. "Your escort dresses elegantly, as would be appropriate to our new Queen of Beauty."

"Ah, but methinks he is no Amerigo Vespucci!" Sandro laughed.

And, in remembering the latter's voracious overtures, I could only offer a brief, "Indeed."

Lorenzo, having recent cause to mistrust the Vespucci, neither smiled nor frowned but quickly bade us take some refreshment before I began my sitting for Sandro.

"Will you be returning to Prato or shall we prepare a chamber for you?" Clarice inquired of Ciardo.

I did not welcome the thought of having him hovering nearby for the three days that I would have Sandro to myself, so I was very relieved when he answered that he would be departing.

"I shall call for Sandra three days hence."

He smiled at me strangely and with a new familiarity, then joined me in the meal that Clarice had laid before us. Sandro partook of it hungrily, but Ciardo barely ate. Before mounting Sopraccigliotto, he lifted Giulio Medici, the babe I was to hold as the Christ Child, and smoothed his golden hair.

"He is so fair of face that he could well be yours, Sandra." It was the first time Ciardo had directly praised me.

This was my first genuine sitting for Sandro, and I quickly learned how meticulously he positioned his subjects. My two mantles had to be readjusted several times while the child fussed impatiently on my lap. To my right, Lorenzo's two sons, Piero and Giovanni, kneeled as wingless angels. One held the inkwell for the Virgin's quill and the book in which she would write the words from the song of Zachiary and the hymn of Vespers, "The Lord doth magnify my soul."

"There isn't really ink in it, is there?" I worried aloud as the baby Giulio reached for the well.

Sandro distracted the child by handing him a partially peeled pomegranate and turned to me. "It was your father's favorite symbol, the pomegranate. Do you know its significance?"

"The multiplicity of the spirit?"

"And the eternity of the soul. Each seed grows another fruit, which in turn bears more seeds. A tribute to maternity, as well, is it not? I have been brooding over the theme for days and I have decided I would show the Virgin's hair—to humanize her."

He pulled out a large, braided shock of my hair from beneath the first, diaphanous, layered mantle. The child looked up at me, away from both the inkwell and the pomegranate.

"Perfect! The adoration of the child is returned to you!"

Sandro grabbed his silverpoint and began to capture it with an

intensity in his eyes and hands. The child continued to gaze up at me and I tried not to smile, in order to maintain the melancholy of the Holy Mother. At this crucial moment, all I could think of was my mother's words, "There is no truer love than this." And it seemed to fit all three: the love of a child, the artist's passion, and my own maiden's aching heart.

Sandro wished to begin early the next day while Giulio was less tired or active. The nursemaid brought him into the room in the villa where Sandro had constructed our scene. He was showing me his sketch and how three more angels would fill the outer edges of the round panel. The countryside, in the distance, would be seen between the one grouping of angels and the Madonna.

"I am thinking of using Giovanni di Pierfrancesco for the angel behind you, Sandra. He is but thirteen and a loving nephew to Clarice."

When Sandro spoke of Lorenzino's younger brother, I could hear my heart in my ears! Would this mean the Pierfranceschi would be coming to Poggio a Caiano? But before I could speculate further, there was a great commotion and shouting of men outside the walls of the house. Sandro was too disturbed to continue, so he hurried out to investigate the disruption.

"He is a spy, I wager!" I heard one servant cry.

"A spy or a pilgrim?" Sandro inquired.

Lorenzo's voice was unmistakable. "One could claim both, serving either Sixtus or the Pazzi."

"But there are no Pazzi left, to speak of."

By now I had returned little Giulio to his nurse and excused myself from the wide-eyed and curious Medici children. From my chamber window, I could see a plainly dressed man held down by two servants. Lorenzo, Poliziano, and Sandro stood before him.

"Pray, I beg you, Signor Medici, I am calling on behalf of the Pope's envoy in Pisa. The port has been closed to make a stronghold against the Turks' flotilla!"

"The Turks dare not sail this far north!" Lorenzo bellowed, sounding even more suspicious. "It would mean war with all of Christendom! Neither the Signoria nor I have called for any strongholds there."

"Sixtus has ordered all ports guarded and closed. All trading must be inspected. Even Venice has complied!" The man's voice broke in terror as he spoke, but for Lorenzo it had the sound of a desperate alibi.

"Have you papers to prove this? Why are you not dressed in the habit of a courier?"

"I am under cover, Signore."

"From what? There is no longer a war and there are no Turks in Tuscany save a few female slaves. Come. Show me your papers."

The man searched beneath his girdle. "I have no papers."

"Only a dagger, I see!" Poliziano reached to the side of the man's belt and pulled it out.

"But all travelers must carry some protection!"

By now, Lorenzo's fear and the memory of assault had overwhelmed his more reasonable suspicions. Sandro said he had let down his guard since the treaty with Ferrante, and the Turks' brief invasion of Naples a few weeks earlier had supposedly ensured a new unity with Rome. There was no longer a place for internal strife with the threat of the Ottoman Empire looming over Italy. But for Lorenzo, there was no security. The treachery of the Pazzi had shaken his senses and judgment forever.

"Take him to your quarters, men! We shall see what truth he is willing to confess!"

Poliziano followed the men, but Sandro returned to the house with Lorenzo. I could hear them speaking in low, eager voices, but I could not understand what they said. Then suddenly, Sandro was in the doorway of my chamber with a grave countenance. He was about to speak when I heard the horrible screaming. It was the man crying out in pain. Terror gripped my heart, and I covered my ears. Sandro hurried to the windows and closed the shutters to dull the sound. Clarice was in another room with the children, trying to distract them with a shrill and worried voice. The baby started to cry.

"What are they doing?"

Sandro tried to quiet me. He held me tightly, and I could feel the moisture of his breath as he spoke.

"It is Lorenzo's right to question anyone who calls uninvited, especially at his retreat."

"An inquisition such as my father bore?"

"Ah, but that was the Church. There was a valid complaint."

"But what did the man do?"

"What *might* he have done? Would you prefer the screams of a dying Medici?"

After that, all I could distinguish was the man crying, "Not my feet! Not my feet," and then his muffled anguish as he continued to be pressed for some confession.

I could not eat that evening. Clarice's kitchen servant tried to bring me broth and bread, but I could stomach neither. I was too haunted by the events of the day and the stories I had heard about my father's inquisition. Sandro would not admit until later that he had found Lorenzo's suspicions excessive.

"The man has lost a brother, Sandra. The blood of vengeance still moves in his veins."

But the morning was no better for this explanation. Piero and Giovanni were still shaken, having felt the potential threat upon their father. They kneeled closer to me with the book and the inkwell. As I looked down at the quill in my hand, I felt the solemn expression that Sandro had requested for his Madonna settle into my ashen countenance. The child seemed comforted by my embrace. I fingered the peeled side of the pomegranate beneath his plump, tiny fingers as though they were the fragility of life itself.

The man died the morning that Ciardo was to call for me. Sandro explained that Lorenzo had instructed his servants to scrape his feet over a fire "until the fat ran." But they learned nothing from the man, except "the tediousness of torture." His body had been removed before the children and I were awake.

Poliziano congratulated Lorenzo on the prudence of his actions and reminded all of us of the horrors of that Easter morning at Santa Maria delle Fiore.

"I can see the slain Giuliano just as clearly now as two years ago. Such a beautiful boy cut down like that! *There's* cruelty for you!"

I said nothing, and Lorenzo prepared to depart for Careggi with no words of farewell to anyone. Sandro planned to ride with him and continue on into Florence, where he would perfect "his most splendid

Madonna" and transfer it to a seamless round panel of poplar. But I cared little, now, for the outcome—only that I arrive safely back at Via delle Tre Gore. Sandro had taken Ciardo aside and explained the events that had precipitated everyone's black mood. When Ciardo mounted Sopraccigliotto behind me, he held me close as we rode up the wide entry from Il Vivaio to the intersecting road to Prato. I wept all the way.

11

The Virgin Annunciate

—Winter of 1480 to spring of 1481

THE FOLLOWING AUTUMN WE RECEIVED LIT-
tle correspondence from Filippino. Sandro wrote once, to
thank Mother for my participation in the tondo and to as-
suage any fear I might have that future sittings would be "as trau-
matic." When Lorenzino di Pierfrancesco learned of the events at Pog-
gio a Caiano, he promptly dispatched his courier to Prato to apologize
on behalf of his cousin's "necessary adherence to duty" and to assure
me that the rest of the family "truly regretted the incident." He went
on to say that I had been "understandably disturbed" by it.

He ended his letter with the statement, "I trust that our good San-
dro Botticelli's rendering of the Holy Mother was graced by your
beauty and you felt it was a worthy undertaking."

So dispassionate a greeting and conclusion! Was this all the seem-
ingly devoted Lorenzino could muster? Did he fear some intrusion in-
to the missive by his courier or did he always make his personal corre-
spondences this formal? Indeed, if his intention was to display his
command of the language and his extensive tutoring at the hands of
the eloquent Poliziano, he had accomplished it beautifully, but he did
little to express any genuine affection towards me, and I was somewhat

offended. I decided to withhold my reply in the same fashion as he had withheld his feelings.

This left me open to some of Ciardo's haphazard advances, which had come to seem more charming than before. Now that I had been declared "The Queen of Beauty," I was apparently worthy of his attention. But at times it felt more like badgering than courting. This conflict was soon overridden by his sister's travail, which began soon after Christmas and distracted us all from the preparations for Epiphany.

Giovanna's struggle to bear her child was long and arduous. Ciardo called for me one dark winter evening with his sister Angelina by his side.

"Giovanna calls for you," cried Angelina. "You are her dearest friend!" I rushed to gather my cloak and mantle, but I could see that Mother was concerned with my attending what might be a difficult birth. Vincenza's had all been relatively easy.

"There *is* a midwife with her now, is there not?"

"Of course, Madonna Lucrezia," Angelina replied with the wide eyes of a worried sibling. "Will you send up your good prayers to Santa Margherita?"

"Yes," said Mother, a little hesitantly; but I added, in my own anxious and thoughtless departure, "My mother's service to that saint is long ended!"

I had no time to notice her reaction to the remark, as I was soon atop Sopraccigliotto with Angelina. Ciardo led us in a quick sprint, holding his torch as best he could. When we reached Casa Vannozzo, I could hear Giovanna's rhythmic panting and moaning even from the livery. I rushed through the small loggia and up the stairs to her chambers, where she was attended to by her mother and the midwife chosen by the Ciardi. Apparently Antonio's mother had preferred a different woman, but had acquiesced to Madonna Ciardi's choice. It certainly was no time to bicker.

I wiped Giovanna's brow with cool cloths while the midwife massaged her belly in circular strokes. This was partly to relieve her and partly to help turn the child in the womb.

"It is not quite breech, but the head is not dropping easily," the

woman muttered with a grimace as she reached up through the bed-
clothes to check the progress of the child.

Giovanna gasped and cried out again, this time more loudly.

"Will Santa Margherita not rescue her soon?" Angelina's eyes were
desperate. I could see that she felt each pain along with her dear sister,
while I felt only a detached sort of sympathy. I recall being struck
by the sight of my friend in such a state—her wet hair clinging to her
face and neck, her contorted features no longer delicate and smooth. In
truth she was grotesque, and I tried to imagine my own earthly self
succumbing to such unsightliness. I wondered, Was I vain for thinking
this?

The midwife tried to help Giovanna breath more steadily. It was
soon well past midnight and we all wished to sleep, Giovanna no
doubt more than any of us. Each woman traded positions for a while
as we took turns coaxing our friend. At one point she shrieked and
then uttered an almost comical inquiry.

"Is this to be my penance for enjoying the marriage bed by such
great measure?"

I restrained my mirth and looked to Angelina, whose eyes were
wider still. The midwife barely smiled, as though accustomed to worse
remarks, and she continued her tireless efforts on behalf of Giovanna's
comfort. It seemed we struggled there on that bed for the remainder of
the night; the bedclothes were soaking with blood and sweat and wa-
ter. When we finally pulled Giovanna's wet gown from her trembling
limbs and belly, she seemed an awkward creature, consumed by her
own massive womb and the child that endeavored to emerge from it.

Finally we felt the piercing rays of morning through the shutters. A
few servants murmured below in the yard. I sat behind Giovanna's
back to support her, as she no longer had the strength to sit up by
herself. Angelina stroked her arm and chanted the same soothing
words, "Give us the child . . . Give us the child." Then, with one final,
desperate push, the head suddenly appeared in the midwife's hands.
She turned it ever so gently, as though examining a rare fruit, and then
pulled the little purple shoulders and arms along with it until the
entire body was out.

"Madonna! Madonna!" Giovanna's relief was glorious.

The child cried slowly, as though savoring the damp morning air. The midwife cleaned him with brisk strokes before she even cut the cord, "to encourage his color." When he had made several good, lusty announcements of his arrival, she chuckled as though sharing in the success and placed him in Giovanna's arms. It was a boy, and he turned his round face to suckle immediately at her breast.

"Antonio mio, Antonio nino," Giovanna crooned. Her face all at once was more radiant than ever. I wondered if I would ever be as happy.

The joy and exuberance over little Antonio filled the otherwise dreary winter months in Prato. I went often to Casa Vannozzo to assist Giovanna and found Ciardo a frequent visitor, too. He was very attentive to his new nephew and even carried him about, which most men are not wont to do. I must admit I was quite taken by his affection for the infant. I even imagined him as an equally doting father, but never remarked on the fantasy. My heart was still heavy, if not confused, over the formalities of Lorenzino di Pierfrancesco and the apparent aloofness of the seemingly fickle Amerigo Vespucci.

Then, in early February, I was surprised with a visit from the wandering Amerigo, who had decided to pass through Prato on his return from the Vespucci farms near Peretola. He was as comely as ever, although more modestly dressed, "as befitted the countryside." He greeted us all heartily when Vincenza answered the door, and then brushed my cheek with his when I came downstairs to meet him. It was as though he had assumed that no time or distance had passed between us and that my family had approved of his affection. His confidence impressed me and made me forgiving.

Amerigo quickly announced the news of Mariano Filipepi's failing health. "Sandro and his brothers do not expect him to last the month."

Mother put her hand to her mouth and then crossed herself.

"And how fares Sandro?" I was quick to ask.

"Working too much to grieve. He's very practical. But he wanted me to tell you of his recent commission for a nearby hospital, the one on Via della Scala. He wants you as the model for the Virgin Annunciate. He bades me bring you back to Florence with me."

"Another Virgin?" My answer seemed to amuse Amerigo.

"And is our Queen of Beauty tired of her status? As it could easily be altered!" He laughed.

Riccardo and Vincenza laughed with him, but Mother only smiled cautiously. It was not the wisest remark to make before asking if he could escort me to Florence. But Amerigo had a certain command of affairs and Mother agreed, especially after I expressed my desire to assist Sandro and his family at this troubling time.

I had but a few hours to gather some semblance of a wardrobe before we mounted Amerigo's horse. As he helped me up into the saddle, he turned to Mother. "We are traveling by way of Castello, Madonna. I have some brief business with the Pierfranceschi."

She nodded amicably while I tried not to gasp.

"Do you mind, Sandra?" Amerigo looked at me rather plainly. "Lorenzino says you have visited before and enjoyed it. Would another evening there not please you? Especially before meeting the possible sorrows at Via Nuova?"

As we rode across the piazza of San Stefano and out to the main road, I had to cover my mouth suddenly to restrain my laughter. Just who, I wondered, did he think it was who had named me the new "Queen of Beauty"?

On the way, Amerigo elaborated on his relations with the Pierfranceschi; and mentioned that his uncle Giorgio had tutored both Lorenzino and Giovanni. His father had always been on good terms with their father and had encouraged the friendship between Amerigo and Lorenzino; and in the aftermath of the Pazzi conspiracy, the brothers Pierfrancesco had been hesitant to share the rest of the Medici's suspicions about the Vespucci's allegiances. Amerigo said that Lorenzino had confided to him his belief that Piero Vespucci had been innocent of any crime connected with the conspiracy. He now regretted the war with Rome more than most Florentines, after learning that his good cousin Lorenzo had "dipped" into the Pierfrancesco accounts for funding. This was a matter that the younger Lorenzino intended to have rectified as soon as he reached the age of his majority, which was in three more years.

Amerigo's words brought me some measure of understanding about Lorenzino di Pierfrancesco's unpredictable affection and formality. He

suddenly had had reason to doubt his guardian, at least his financial guardian. He had shared in all the schooling and material advantages of the other Medici offspring, but would always be second to his cousin Lorenzo. Castello was as much a retreat from these shortcomings as it was a reaffirmation of the Pierfrancesco autonomy.

When we stopped to rest in a small grove of trees off the road, I pressed Amerigo for more personal information about his friend Lorenzino. Had he much experience wooing women? Surely he was surrounded by comely maidens in the Medici court. Had he a mistress? Amerigo sat down and covered a place for me to sit while chuckling to himself.

"Ah, Lorenzino is a disciplined youth who has not the earthly appetites of his cousins . . . or comrades!" This he declared while pulling my face into his and kissing me vigorously. It was a spirited embrace that did not end there. He moved the whole of his torso over me while my mouth melted into his. I shivered from the wind that blew over us from the hillside, and he took this opportunity to cover us both with his long cloak.

"I will have no chance with you at Castello, or Florence, for that matter."

He pressed on me relentlessly, and I shivered more from the delight of his weight than from the weather. But it seemed an awkward time and place to consummate any kind of desire. I murmured his name as I kissed his brow and he gently explored my body. I was as frightened as I was eager for him to have me. He brought my hand to the front of his codpiece so I could feel his fullness and firmness—but then I suddenly recalled Giovanna's pleading words about doing penance for enjoying Antonio in the midst of her travail. I had no intention of doing such penance at this juncture of my life, especially with an ill-suited husband like Amerigo. I felt myself both gasp and laugh at the same time as I pushed his eager mouth away from my breast, and pulled my hand away from his body. His own hands retreated from the depths of my skirts as he sat up, panting.

"I know I may not have you here . . . or anywhere, Alessandra Lippi!" Suddenly he was imbued with an air of sexual agony.

"You have not declared any love towards me, Amerigo Vespucci!"

"Nor you towards me, my Queen of Beauty!"

"But I am not *your* Queen of Beauty."

"Yes, yes, I know. You belong to *all* of Florence now!" Amerigo stood up and straightened his doublet over his hosiery while adjusting the manhood that filled it so precariously.

I rose and straightened my gown as well, then looked at him coyly, glad that I had denied him his impulsive will.

"Do you not know who declared me so?"

"Why, I thought it was Lorenzo de' Medici who wished to honor you with the same title as the dead Simonetta. Sandro said he had suggested as much." Amerigo tied the cloak about his neck.

"Sandro suggested it?" I was astounded and my heart pounded harder than ever.

"To Lorenzo," he repeated.

"But to the other Lorenzo, to Lorenzino, your friend of the Pierfranceschi. That Medici you say was 'no equestrian' who nevertheless won the palio!"

Amerigo threw his head back and began to laugh, his golden curls shaking. He continued to chuckle strangely as he pulled me up in front of him upon his horse.

"Then you know, Sandra, you are destined to be his Petrarchan mistress, his Beatrice in Paradise. No wonder he has commissioned Sandro to illustrate *La Commedia*. He must have *you* in mind to soothe his intellectual soul." Amerigo held me tightly and caressed my breasts as he directed his horse back onto the road towards Castello. "Lorenzino may have wooed you more cleverly than I, but he has not the *earthly* will to satisfy himself or any woman. At least not yet."

The tension at Castello was unbearable that evening, not because I felt torn between these two Florentine upstarts but because Amerigo conducted himself so aloofly and with not the slightest hint of jealousy; and Lorenzino, indulging in the aftermath of Lent and impressing us with elegant foods and wines, was as merry (and apparently impersonal) as ever. He displayed no concern about his friend's temporary custodianship of me, and his generosity was almost disconcerting. He kissed my hand politely when I arrived, retired for bed, and departed,

116

but otherwise he made no overtures—although he did seem to stare at me longingly as we supped. Amerigo, on the other hand, ate vigorously, consuming the fare with a carnal delight that intrigued and enticed me even more.

Lorenzino read from *La Commedia* the cantos of "The Inferno," in which Paolo and Francesca discover the story of Guenivere and Lancelot and are moved to inevitable lust and damnation. "That day we read no more." I saw Sandro's drawing before me, the lovers swirling in the winds of hell. Was I that same forbidden lover to Lorenzino? Because I could bring the Pierfranceschi and the Medici no more riches than the richness of beauty itself, was I doomed to be reached only through allegorical verses and symbolic palios? Did Amerigo prove to be my only earthly promise: a man who gave no promises to women?

The next day we rode quietly into a sombre, grey Florence. Filippino was leaving his bottega to return to the church where he was preparing to install the panel of *The Virgin Appearing to Saint Bernard*. He had many other workshop pieces to attend to and had come home to check on the progress of his two garzoni. Amerigo was pleasant in depositing me with my brother's household, but Filippino looked worn and tired. There was a special sadness in his face that day, and as soon as I had settled in, he told me why.

"Sandro's father is dead. The funeral is this Sunday. I will walk you to Via Nuova tomorrow."

Mariano was interred in a small burial ground adjoining the nave of Ognissanti. It was gratifying to Sandro and his brothers to see the members of so many different guilds at the funeral. There were tanners and goldsmiths, many of Sandro's fellow painters, and some of his brother Giovanni's former associate money brokers in attendance. From listening to them all speak, it was evident that Mariano had been an honorable man who had loved his family and had respected his neighbors.

Filippino and I brought Mother's condolences and regrets that she could not be there. She had always spoken well of Mariano Filipepi. She had often recounted how he had traveled to Prato with Sandro, at the beginning of his apprenticeship, to see him installed in Father's bottega. Mariano had hoped that his son would benefit not only by

"the great talents of the great Fra Filippo Lippi but by the good air of Prato," for Sandro had been a sickly youth. It had been difficult for me to imagine our Sandro as ever having been sickly until now, as I looked upon his pale, grieving face. His brother, Giovanni, and sister-in-law, Mona Nera, stood on either side of him, and for the first time I thought how lonely he appeared without a wife. I wanted to stand by him myself and declare, if nothing else, my filial affection. I was, after all, his goddaughter and namesake. But I was content to stand behind his nieces and nephews with Filippino.

Amerigo and a few of his family stood at the edge of the cortege. My heart was numbed by the sadness of the day, and I felt little stirring within my woman's breast save the sudden need to be closer to Sandro. The Vespucci left after the priest's final words, before any of us had knelt to kiss the grave. Amerigo only caught my eye once and nodded. I knew he expected to see me again.

I did not think that Sandro would be up to working for at least a week after his father's death, so I was surprised when, only three days later, his nephew, Amide, called for me to come sit for Sandro at Via Nuova. This suited me well as I had little to occupy me at Filippino's other than stitchery, reading, and assisting Francesca in the kitchen. When I mentioned this to Amide, he laughed and shook his long, dark locks. "Such common tasks for the Queen of Beauty!" Clearly, he had inherited his uncle's quick wit and love of irony.

Amide was fifteen, one year less than I, and had as pleasing a manner as ever. He was a comely youth, but I had never noticed his attractiveness until now. Perhaps this new awareness of the flesh came with age, or perhaps it had come with Amerigo's feverish kisses and adoring sighs; or perhaps my sovereignty over beauty allowed me to witness it better around me. Amide was, perhaps, simply an easy subject. But he kept his distance after helping me mount the Filipepi's horse, and he led rather than riding with me.

"It is not too far from Via Nuova to walk, you know, " I said coyly as we started across the city.

"Sandro is eager to start early and he said he wishes you no fatigue before you arrive, for you will be in strenuous poses."

"Strenuous?" I almost laughed suggestively, but feared I might offend

118

Amide if I were to reveal any knowledge of the act I had just conjured up in my mind's eye. "Pray tell me, just what has our Sandro in mind? I am not one of these athletic maidens who have learned to play at tennis."

Amide did laugh at this remark. "The Virgin Annunciate has to bend just so when she receives Gabriel." He impressed me with his awareness of his uncle's craft.

"Have you never sat for Sandro yourself? Methinks you would have made a lovely angel."

"He has done some studies, in the evenings, when I was younger. I believe he finds me too old now to be your Gabriel. I have passed that fragile threshhold from boy to man." Then he turned and smiled curiously at me.

"Not entirely." I was surprised at my own flirtation.

"Do you find me too young to escort the Queen of Beauty?"

"Neither too young for her nor too old for the Holy Virgin."

And with that, the handsome Amide mounted the horse behind me and took the reigns into his hands with aplomb. "To speed the journey I had hoped to savor," he said, and his breath was as sweet as he.

When we arrived at Via Nuova, Sandro greeted me warmly and then sent me upstairs to change into the mantle and gown he had chosen for the sitting. He told me to ask Mona Nera for some refreshment, if it pleased me, so that the sitting would not have to be interrupted for the sake of eating. This was unlike Sandro, who always enjoyed even the simplest meal.

"Let us see the new Queen of Beauty transformed into the future Queen of Heaven—the young Mary at the moment of incarnation when she receives the glad news from the angel Gabriel." Sandro arranged the folds in my skirt where he wanted me to stand, then turned to his top garzone, Ludovico. "Alessandra has both the humility and the poise, does she not?"

He nodded, and I suddenly felt concerned that I was to portray the Holy Virgin so soon after experiencing the desire for a man.

"Our Holy Mother was, no doubt, younger than I when first she learned of the fruit of her womb," I began as he positioned me in front of the model for Gabriel. He was a younger friend of Ludovico, and

just lovely enough to portray that unearthly luminescence of youth before it changes into manhood.

Sandro's bottega was becoming known among other artists for harboring "the prettiest boys in Florence"—a temptation for those unnaturally inclined toward pederasty. Thus far, he had escaped the scandal of rumor, even though one assistant had been arrested for the crime, because it was common to use attractive boys to portray angels in devotional paintings.

"Why not use handsome girls instead?" I had inquired in jest when Filippino divulged this practice. I had seen "manly" women and boyish girls on the streets of Florence. I even admired them in a strange sort of way.

"Because Sandro's eye is too keenly bent towards the feminine, and the most radiant of maidens, at least for his art," my brother reminded me. This was part of the honor he had done in choosing me to be his model.

The *Annunciation* panel for which I sat had been commissioned for the Hospital of San Martino on the Via della Scala. It would be painted as a fresco in the hospital's small chapel in honor of the victims of the plague who had died there. Sandro explained, as he drew me, how important it was for him to capture both the innocence and the joy of the Virgin as she receives Gabriel into her chamber.

"It is not just a posture of humility, Sandra, but also joy in Gabriel's news. She is surrendering to the will of God."

Ludovico's friend, Jacopo, stood on a small table across from me with his arms crossed over his breast, in blissful surrender to his role as Gabriel. All I could think of, as I crouched and curtsied before him, was how much he resembled Lorenzino di Pierfrancesco, that chaste admirer who had himself barely become a man. I, in turn, surrendered to my role as the young Mary, about to leave the easiness of maidenhood with Gabriel's news.

"The Virgin must display a supernatural quality at this moment, as though it were the immaculate conception itself!" Sandro had a certain fire in his eyes as he began to draw. "And Gabriel" (he addressed Jacopo as though he were really the angel), "your sublime entrance into her chamber must suggest that same supernatural quality, of a boy

passing from the feminine terrain of childhood into the rocky land-scape of manhood."

"You speak as though children are merely wild creatures of the same sex," I interjected as I stretched my arms.

"But in a sense they *are*! See how alike all infants are in gender and how they play as children. But as they grow and their bodies define their differences, they change in mentality and nature, too. Perhaps the Ancients were correct in seeing the sexual union as the effort of men and women to rejoin their lost half!"

It was the most Sandro had ever spoken while he drew, and I was both amazed and intrigued. No wonder he could not help making his angels as beautiful as his female figures. Even the men he painted had a certain delicacy. Was it flattery or an infatuation with both sexes, I wondered? Was there any truth to the rumors that had circulated about Sandro's bottega becoming "a shop of idlers" or worse? When I inquired about these curiosities to Filippino that evening, he could only laugh and shake his head.

"Does it not seem odd that Via Nuova would change so drastically once I left? Those rumors only began when that apprentice Betto was arrested for pederasty. And the child he seduced was nowhere near the bottega. Sandro does not 'love' boys any more than he loves women, Sandra. Sandro loves the beauty of the human form. He is a true Platonist in that regard. Let him be accused of *that* instead!"

I was relieved to hear my brother's assurance on the matter of my godfather's natural desires. But I felt odder still that I, as his god-daughter, should be so concerned about them in the first place. I could not confess my affections for Sandro to anyone, even myself.

I remained in Florence only another week to sit as the Virgin Annun-ciate. During that time, Amerigo called on me three times, twice in an effort to alter the virginal status I now held more dearly than ever. He said I had been "too transformed" by my occupation as the young Mary, and on his last visit to Filippino's he jested:

"Methinks I shall suggest that next time, our Sandro depict you as the goddess of Poliziano's 'Stanze,' and then, perhaps, you shall be wont to yield to that occupation over which the Venus rules!"

"You would deflower me in my brother's house?"

"Nay, some garden would be more to my liking."

"With soft grasses, I trust."

"But I am practical and lean more towards the comfort of bed-clothes and pillows."

"But not the *marriage* bed?"

"Come, come, Madonna Sandra! Would I deprive the men and youths of Florence their Queen of Beauty this soon? I am too good a sport for such treachery."

"Methinks that *love*, to you, is a sport."

Amerigo did not protest. After my days immersed in the wit and wisdom of Sandro's bottega, Amerigo Vespucci had begun to seem more like a trifling cad, albeit a handsome one.

The night before I was to return to Prato, Filippino and I were invited the Pierfrancesco apartments at Palazzo Medici. Lorenzino and his brother were back in Florence, which they claimed to be "more conducive to the winter rains than our lovely villa of Castello." They were celebrating the first of March, the month of the Florentine New Year. I had expected to see Amerigo there, but it was a small banquet, attended only by the Medici family and a few outside guests. Sandro accompanied us because Lorenzino had wished to speak to him further about his drawings for *La Commedia*. Sandro's earlier work with goldsmithing had prepared him to do all the plate engravings himself.

This enterprise seemed to dominate the dinner conversation, save for some polite inquiry into Filippino's growing commissions. The pre-viewed praises of his Saint Bernard panel had attracted the attention of the Signoria, and Lorenzo de' Medici had suggested that Filppino be awarded a commission to decorate one of the halls of the Palazzo della Signoria. Soon after that, he inquired when Sandro would see fit to paint the Venus of Poliziano's "Stanze." He much preferred to see her in the garden of the Hesperides, "surrounded by her Graces and her counterpart, Flora." His cousin then added:

"Surely you can make a goddess as comely as your Madonnas!" Lorenzino looked at me, knowing I would guess his reference to the Magnificat, which he had suggested through Poliziano.

Poliziano rose from his seat and reached out for my hand in an

invitation to dance. The fifes and lutes had begun a lively refrain in front of the tables.

"And here she is! That same goddess 'who hath no mortal face' stepping from the shell that has carried her to the shores of Cyprus!"

I could not very well refuse to dance, and Poliziano's grace upon his feet proved to be as eloquent as his quill upon parchment. But although the poet was a competent performer, his student, Lorenzino, was a more alluring partner. His breath smelled sweetly of the after-dinner fennel, and his hair held the faint scent of the frankincense that had been burned at Mass. Perhaps he was more devout than I had guessed (or had chosen not to guess). Perhaps his lack of overture was merely an applause for my chastity. I was able to read more into the innocent touch of our fingers entwined than I had felt in all of Amerigo's lustful kisses and caresses. To Amerigo, I was simply a conquest. To Lorenzino, I was truly a Queen. And to Sandro, I was just an innocent maiden about to be captured in the first spring fresco of his thriving career.

12

In the Realm of Venus

—Spring and summer of 1481

THE SPRING AFTER MY RETURN FROM FLOR-
ence was mild and fragrant in Prato. Giovanna's son, Anton-
io, had thrived, and Giovanna had regained all of her strength.
She had not hired a wet nurse because she preferred to nurse the child
herself. Her mother said this would change after enough sleepless
nights had passed, but the child slept well, in the end, and both were
the better for it.

Ciardo called often, mostly to escort me to see Giovanna. Little had
changed in his manner towards me, although now I seemed to take
better notice of his countenance and its many emotions. He was a
comely young man, to be certain, and I felt drawn to him in a new way.
I found, on our many trips to Casa Vannozzo, that I felt more con-
fident in speaking to him. Often I confided more than I did to Giovan-
na, who was now more interested in her child than in me.

Ciardo seemed to enjoy our discourses, although he maintained a
certain distance from me in spirit. He usually let me ride Sopraccigli-
otto alone, but one evening in May, as we returned to Via delle Tre
Gore, he rode behind me and hummed to himself pleasantly—or
nervously—until I chose to speak.

"Meseems you are a doting uncle, Ciardo."

"And you a doting friend, Sandra."

"Giovanna is like a sister to me."

"Indeed. And I a brother, I suppose?"

"I *have* a brother of my own, Ciardo."

"And a fine one he is at that!"

"I don't know what you should be to me, then." I was surprised by the seductiveness in my own voice, which I had not intended. Ciardo, in reply, was almost plaintive.

"Certainly a man of my station could not compete with suitors such as Lorenzino di Pierfrancesco and Amerigo Vespucci."

"Who says these men, or dare I say youths, be suitors of mine?"

"Giovanna . . . and I dare say, your own mother!"

"She assumes much more than she sees."

Ciardo nodded slowly and with a certain relief. "But they are *admirers*, are they not?"

"Any Florentine might admire his Queen of Beauty."

"I meant, admirers of *romantic intent*."

"Perhaps those are their intentions. Meseems the delights of the flesh are the intentions of most members of your sex."

"But they have, at least, *some* intention."

"They have not asked for my hand," I assured him. "And what, pray, Ciardo, is *your* intention by inquiring thus?"

We were approaching Via delle Tre Gore and he had slowed Sopraccigliotto down to an easy trot. He held the reigns tightly and his hands brushed against the bodice of my dress.

"Forgive me, Sandra," he began, but did not correct the touch.

"There is nothing to forgive, Ciardo. Your familiarity flatters me." I felt seduced by the sound of my own voice.

"I have been familiar with you for a long time, but it never *flattered* you, did it?"

"I was a girl." I sighed and we came to a stop.

"And I a churlish youth." He dismounted and reached up to help me off the horse.

"Ah, but a comely one!" I murmured as I slid into the brief hold of his warm hands.

"Comely?" Ciardo looked amazed. He paused with his hands still on

125

my waist, and his breath, though not sweet, was exciting. It had the deeper scent of a man. I longed for him to hold me there and beg for my kisses, but he restrained himself and breathed deeply, taking in the perfume of my hair.

"What a beauty this little girl has become."

After that evening, I began to think differently of Ciardo. His simple graciousness clouded my former image of him as the contentious and overbearing older brother of Giovanna. At the same time, I continued to think often of Sandro, who, according to the letters from Filippino, had begun to lay the pigments to plaster at San Martino. One evening, when Mother and I were alone in my chamber and she was undressing my hair, I asked her about Sandro and his life in Prato, before I was born.

"Has Sandro ever courted a woman?"

She looked surprised, at first, and then reflective.

"Why do you ask that, Sandra?" She loosened the braids across the top of my head and began to take them out with the very comb Sandro had once sent me for Epiphany. It was inlaid with mother-of-pearl, and I cherished it every time I did my hair.

"I don't know. It seems he paints women so wonderfully but has none in his life."

"He did once, when he first came to Prato. She was older even, the daughter of an apothecary who sold pigments and varnishes and gold dust to your father. I believe the girl shared in his affections, but Sandro still showed signs of poor health at the time. The shadow of his ailing childhood was still on him, and I think the girl feared for their future together. Her father's trade had inflamed these fears, for he often sold treatments to men whose wives were barren. The men had proved to be sickly youths—some with the fever or other malady. Then, when their wives chanced to take a lover and conceived, it proved their lack of seed. I suppose the girl feared this same fate for herself and Sandro, and soon discouraged his overtures."

"What became of her?"

Mother sighed and shook her head sadly. "She married a well-born, robust man and died in childbirth."

"The very irony Sandro would find amusing."

126

"Not in this case." Mother frowned.

"But now that he is well and respected at his craft, why does he not at least take a mistress?"

"Perhaps he does."

"It was not evident while I was at Via Nuova with him."

"But that was during the day while he worked."

"But he takes no one with him to social affairs, banquets and such in the evening."

"Methinks Sandro prefers to take his mistresses in private."

I lowered my voice cautiously. "Do you think he might have the same desires as the poet Poliziano?"

"*Unnatural* desires?"

"Lorenzino says they are natural for Poliziano . . . as it is his nature to see beauty in men."

"Lorenzino said that?"

"The younger . . . although I'm sure his cousin would agree."

"Ahhh . . . they are Platonists and have ancient explanations for everything!" Mother laughed.

"But the Ancients were wise in many ways. Amerigo says Lorenzino learned from Poliziano that the Platonists believed a man's love for another man was the purest love of all, because it went beyond the animal instinct to breed."

"Amerigo speaks to you of such things?" She stepped back from me and put the comb on my little dressing table.

"Only because I had asked him about Lorenzino and their friend-ship."

"Did he say Lorenzino had the same nature as Poliziano?" The maternal disappointment of a potentially lost suitor for me seemed to hover in the inflection of her voice.

"No . . . he merely was relaying some Platonic instruction. But it is up to interpretation . . . much like the Scriptures."

"Sandra!" It was as though I had uttered a blasphemy even to compare the two.

"But the Scriptures are another kind of ancient writing, are they not? The first Platonists cannot be blamed for existing before the time of Christ. And Sandro says we must credit them for being first to witness

God's blessings on man through beauty and the ability to perceive it."

"Well, I see such thoughts satisfy you more than saying Vespers!" Mother halfway jested as I stepped into my sleeping gown.

I crossed myself, for her sake, and she embraced me with a smile. "Beautiful Sandra! You must always give thanks to God for the gifts He has given you in face and form."

"Did you when you were my age? For you were every bit as comely as I, Mother."

"I accepted His gifts always with humility, I believe."

"Perhaps I am too vain." I lifted the small, silvered looking glass on my dressing table and glanced at myself.

"A maiden can be confident without vanity."

"Is it wrong, then, to be glad of it?"

"God wants us to be glad and humble both, methinks."

"I wish I could be glad for love as well as beauty," I said as I slid beneath my bedclothes.

"But many people love you, Sandra!"

"Well, if they do, they have declared my beauty more than their love."

"Do you mean Amerigo or Lorenzino? . . . Or perhaps Ciardo?"

I could not answer, even if she had included Sandro in the inquiry.

I had wished to go to Florence in June for the Feast of Saint John, and bade Mother come with me. She declined, but encouraged me to go and reclaim my title amidst all the festivities. Ser Vannozzo planned to accompany the Ciardi, and thus Ciardo was quick to invite me too. His sister Angelina and younger brother Gio went also, but this time I rode with Ciardo on Sopraccigliotto instead of with Angelina. Ser Vannozzo smiled knowingly at us from time to time as if there were something to "know," so we obliged him by returning the smile and sitting even more closely together.

Ser Vannozzo and I stayed with Filippino while the Ciardi remained with their cousins in another quarter of town. Before they left, Ciardo said that he wished to escort me to see the fireworks over the Arno the next evening. I had not declared my presence to anyone else in Florence yet, so I agreed. I believe the vanity in my heart wished to pique the jealousy of certain Amerigos and Lorenzinos.

That evening, when the word had circulated that "the new Queen of Beauty" was again in Florence, I was invited to be fitted for a gown by the official seamstress of the Medici. Filippino said the courier had been sent by Clarice on behalf of Palazzo Medici, but he believed that the suggestion had come from the young Lorenzino, who had found favor with his cousin's wife. Since the Palazzo was not far, I said I needed no escort, but Filippino insisted and went with me. This was, at least, less awkward than my going with Ciardo. When we arrived, however, and I was shown up to the *guardaroba* of the Medici chambers, Lorenzino was no where in sight. In fact I saw neither him nor his brother Giovanni the entire evening of the fitting and was told they were attending a banquet at Casa Vespucci.

Clarice was most attentive as she oversaw the work of her seamstress. The gown was red taffeta with yellow inset sleeves. There would be real gold roping around the neck, and she hoped I had brought "suitable" earrings or necklace to compliment the attire. I said I had a gold brooch but no necklace, so we agreed to that. She brought out two kinds of red satin ribbons for my hair and bade me take them back to Filippino's to practice with. After all the measurements and pinning had been completed, I was told the finished dress would be delivered the next afternoon for my ultimate inspection and trial.

"And then my sister shall fly across the Arno like a shining pyroglyph!" Filippino teased as we departed Palazzo Medici. I found more humor in this than the seamstress did, and when we were safely out the door, I laughed heartily and informed my brother of the banquet we were missing at Casa Vespucci.

"Well, I can't announce your arrival to *everyone* in Florence." My brother was rarely curt with me.

"I don't despair at having missed my two greatest suitors at the same table! Perhaps I will go to Via Nuova on the morrow and bid Sandro show me the fresco at San Martino." But Filippino was cautious.

"Sandro may decide to work throughout the festival."

"Then I'll go with Ludovico . . . or Jacopo if he is still in Sandro's employ."

"I am certain the bottega could use the diversion. They have been in an uproar ever since the commission came from Sixtus."

"Pope Sixtus?"

"None other. Florence has been honored to send three of its greatest painters to Rome to decorate the walls of the newly rebuilt capella magna at the Vatican, and Sandro is among them!"

"Rome?" I was stunned by his announcement.

"I'm sure he wished to tell you himself. You can congratulate him alongside the fireworks."

"Who else was elected to go?"

"Ghirlandaio and Rosselli. They will join Perugino, who was the first selected. You can be sure our own Giovannino Dolci had a good hand in the selection, as it was he who did the new design for the chapel. Of course, Lorenzo Medici had his say as well. Part of making amends with Sixtus, no doubt." Filippino yawned. The thought of such an awesome commission had tired him.

"Is Sandro pleased?"

"Why don't you ask him?" Filippino smiled and repaired for bed.

But I could not go down to slumber that night. I had expected to start seeing much of Sandro, to sit for him again and more often. I had even thought to remain in Florence and make it my home in an effort to, perhaps, make him my suitor. How insane could I have been? The *confidence* of being Queen of Beauty had been too intoxicating for me to have conjured such possibilities.

The next evening, the dress and I were as stunning as the fireworks. That, at least, is what Ciardo said. It was the first time he had openly complimented me. We watched the festivities from the Belvedere, the hill above Florence on the other side of the Arno. Sandro and Amerigo both joined us there; and Amerigo, assuming Ciardo to be merely a family friend, was unruffled by his presence. He spoke mostly of the palio, which would be held the next morning, and invited us all to watch the first leg of the race from the balconies of Casa Vespucci.

He did take me aside at one point to inform me that Lorenzino had elected not to enter the race this year. Amerigo also had the privilege of letting me know that the winner would be instructed to name me "Queen of Beauty" for a second year.

"And that is the reason for the dress?"

"Is the embellishment of beauty not reason enough?" he answered rhetorically.

"The Medici are generous."

"And clever. Now that they have won your favor, your mother and Filippino dare not protest Lorenzo Medici's plans for a new tomb to honor Fra Filippo Lippi."

"In Florence?" I knew that Lorenzo had once tried to take possession of Father's bones.

"Or Spoleto. He's sending Sandro to visit the cathedral there on his way to Rome and make his own recommendations for a design."

"How do you come privy to all this? Your friend Lorenzino, I suppose?"

Amerigo nodded and smiled. I was not sure if he meant to annoy or goad me with his news, but I said nothing as I wished not to waste my breath during the sudden proclamations of the crowd overlooking the spectacle below. Ciardo appeared annoyed at my preoccupation and came to reclaim his place beside me.

"I see Amerigo continues to distract you," he said later as we headed down the hill together.

"It was merely his effort to confide some news regarding Father's tomb." This was a lie, for I knew that Amerigo had found me dazzling in my red and gold taffeta gown.

"And which of the many banquets do you attend tonight?"

Several would be hosted in the city. Thus far, Filippino and I had been invited to three. I chose the one with the earliest dancing, and Ciardo promised himself as a dutiful partner.

I was surprised by his agility and grace until I realized that, as with me, Giovanna had been his first instructor. Ciardo seemed pleased to be in the company of such noteworthy bankers and merchants. Certain members of the wool guild in attendance smiled approvingly as we sailed by.

"Perhaps my dancing will bring new accounts for Father!" he quipped.

I had never seen Ciardo quite so merry, and in his merriment he displayed a new affection for me. For that moment, amidst the laughter and wine and summer flowers, I basked in a certain joy I had not

felt before. The fear of Sandro's long forthcoming absence in Rome had settled into the recesses of my spirit, yet before I had departed the festivities of the evening, four different young men had brought me crowns of roses: one red, one yellow, one white, and one pink. And each time, Ciardo graciously crowned me "Queen of Beauty" and stepped aside to let me dance with my very temporary suitor.

Late that night, as we rode back to Filippino's on Sopraccigliotto, Ciardo stacked all four crowns upon my brow and we made great jest of their appearance. I decided I would give them to Francesca to give to her four young nieces, for they were like daughters to her.

"You are as kind as you are lovely, Alessandra Lippi," Ciardo told me beneath the bright night sky.

"And you are as generous in spirit as you are handsome, Ciardo di Ciardi." I was expecting him to kiss me, but he did not. Instead he helped me gently from Sopraccigliotto and saw me to Filippino's door.

"It is much too late for you to cross town again," I said. I was glancing at the moon. "Stay here, in Filippino's guest chamber so you will be rested for the palio."

"How rested might I be, sleeping under the same roof as The Queen of Beauty?" But he walked Sopraccigliotto to the back stable and stroked his mane lovingly, a gesture I might have enjoyed for myself.

We entered the house together, taking care not to disturb the quiet of those who slept. Two garzoni were in the bottega, and Francesca was upstairs. Ciardo followed me up to the extra chamber next to Filippino's. I went into the kitchen and brought him a pitcher of water for his dressing table. I wanted badly for him to embrace me but knew that he would not, there so close to the walls of my sleeping brother. Had he been Amerigo, the breech of respect would have been of little concern, and this small act—or lack of it—made Ciardo seem all the more desirable. He took my hand and caressed it only once and we smiled at each other as I took my candle and departed the room.

We all wanted to stay at Filippino's the next morning to watch the palio, but we agreed that it would be an affront to ignore Amerigo's invitation to watch the beginning of the race from the Vespucci balconies. No one seemed surprised by Ciardo's presence at the breakfast table. Francesca set out the bread she had just purchased with soft

cheese and fruit and then admired the crowns of roses I had set by the window.

Ciardo, proud of my generosity, explained: "Sandra saved them for you, one for each niece."

"You would not wear one to watch the palio?" she asked me.

"Methinks our Sandra has been decorated enough thus far!" Filippino interjected.

"Let us seek out one of the Medici and see what other gifts they have to adorn me!"

Perhaps because I was feeling defensive, I then divulged the matter of Lorenzo's desire to create a new tomb for Father. Filippino furrowed his brow in curiosity, and Ciardo nodded while I spoke. When I had finished, Filippino calmly set his bread upon his plate.

"Let us assume, then, that when Lorenzo comes to me for my approval, he shall also ask for the design!" We laughed along with his top garzone. "Such is the cleverness your brother learned at the hand of Sandro Botticelli!"

When we headed toward the quarter of Ognissanti, Ciardo left us to join his family at his cousin's house. I was relieved to be escorted only by Filippino to Casa Vespucci. Sandro arrived soon after we did and looked harried, either from work or too much merriment the night before. I wanted to approach and congratulate him on his commission in Rome, but there was too much commotion: people were now taking their places on the three Vespucci balconies. I sat between Amerigo and one of his nieces and in front of Filippino and Sandro.

The crowd that lined the Borgo blocked any preliminary view of the horsemen at the Porta al Prato, but soon we heard the firing of the harquebus, which signaled the start, and then the quick thundering of hooves along the Borgo. The hats and hair of the horsemen bobbed colorfully in the distance as they made their approach to our vantage point. The Vespucci cheered madly as they passed, but I noticed that both Filippino and Sandro were quiet, taking in the display with an artist's quiet observation.

My brother squinted, for his sight had begun to weaken and I worried that he was working too hard. The Saint Bernard panel had brought Filippino the same acclaim as the Del Lama *Adoration* had

brought to Sandro at the beginning of his career. He refused not even the smallest commission, and according to Francesca he was becoming known as so "affable" that he would send no potential patron away. I could not help wondering if he was so eager to make up for Father's reputation as "a difficult painter."

After all the horsemen had passed, we went inside to avoid the glare of the sun, and the Vespucci hosted the serving of cheeses, cakes, sweetmeats, and wine. Amerigo, thus far, had regarded me with a gentle detachment, but he began to express his ardor as soon as he had quaffed a few goblets of wine. I might have responded accordingly were it not for Sandro's observing us quietly from across the room. What was he thinking? I wondered to myself. Was he picturing his next painting or engraving for *La Commedia*? Was he quietly approving or disapproving of Amerigo as a suitor for his goddaughter? Or could it be that he gazed at me only, had reserved some affection for me he dared not express, just as I had for him? I was uncomfortable receiving Amerigo's flirtations while I thought solely of Sandro and how any potential love between us, forbidden to begin with, would now be interrupted by Rome. Perhaps, I thought, I should express my affections before he left, but how might I do so? The Ciardi were escorting me back to Prato the next day.

It was evening before the festivities of the palio came to an end, and, true to Lorenzino di Pierfrancesco's promise, the winner did ride back through the course to Porta al Prato and stop beneath the Vespucci houses to hold up the red bolt of cloth and declare me "Queen of Beauty" for another year. The crowd along Ognissanti cheered as I waved dutifully to send the horseman on his way. How I wished that my joy could have been as great as my pride.

Before Filippino and I left Casa Vespucci, Amerigo announced his plans to call on me in Prato on his way to Peretola the following week. I agreed to receive him but knew he sensed the lack of enthusiasm on my part. When I saw that Sandro had made his farewells to several of the guests, I suggested to Filippino that we hasten to depart at the same time, so that we might walk with him to Via Nuova. Filippino looked confused until I reminded him that this would be my last chance to speak to Sandro before his departure for Rome.

The three of us walked on to the Borgo together, recalling the race that had been run only hours earlier. There was a new breeze in the night air, and Sandro, like a dutiful godfather, took off his favorite ochre cloak and placed it about my shoulders. I felt myself quiver like a rabbit, not from the breeze but from the overwhelming scent of his flesh and sweat mingled with the smells of the bottega: the oil and varnish and glue, the lime, gesso, charcoal, and ink, all trapped in the fabric of that cloak. Meseemed I could feel him lifting me up again in front of San Stefano, and suddenly I wanted to weep.

"What is it, Sandra?" He put his palm to my face. Would that I could have kissed it then and told him of my despair at his departure and of the silent love brewing in my blood. Instead, I restrained my tears.

"Filippino may no longer send his reports of you when he writes to Mother and me with you away in Rome."

"Ah, your brother is not enough of a gossip, then," he laughed.

"Might I write to you, in care of Pope Sixtus?"

"If it pleases you, although I cannot promise a dutiful answer. I am a poor correspondent, as well you know."

"Sandro will be in the service of the Vatican, Sandra! Don't place such demands on him." This was a reprimand.

Perhaps because I was glaring, my brother suddenly seemed to understand that my farewell to Sandro begged for privacy. He stood at the corner of Via Nuova and waited as I strolled with Sandro up the narrow street to his door. As we walked, Sandro spoke of Lorenzo de' Medici's request that he travel overland to Rome, by way of Spoleto, and inspect my Father's tomb.

"He wishes to commission a new design that will remain there with the Spoletans."

"I have no vivid memory of the tomb."

"You were a small child . . . as lovely as the cherubim I had hoped to paint from you."

"And have you any other hope for me, dear Sandro?" I felt a sudden burst of emotion.

"Ah, Sandra, you have the art of eloquent interrogation. You would do well to be a servant of the Church!" Now he was jesting to disperse the tension that arose between us.

"I would do well, then, to be a man."

"Then whom might I imagine for my Venus?" He reached down to touch my hair.

"I will be here for you always."

"Sandra . . . " His voice was solemn and his breath was warm. "I have not been the spiritual guide that a godfather is supposed to be. Nor have I been much of a protector or guardian. But I promise, I shall fulfill the honor of your namesake when I return by doing tribute to your beauty and to the Ancients. Therefore, my hope for you is that God preserves your health and loveliness so that I may capture it . . . and that with some fine husband, you may bear beautiful children whom I might paint as cherubs!"

He kissed me, then, upon the brow, and I could do nothing but return his cloak—which I needed more than ever in the chill of this sadness.

The routines of Via delle Tre Gore were strangely comforting when I returned, as was Ciardo's restrained affection towards me. He gave Mother and Vincenza an animated report on the fireworks and palio and the banquets of St. John's Feast, and Mother seemed pleased to hear that Giovanna's dance instructions had made "pretty partners" of us both. I brought her the glad news of Filippino's health and spoke not of his overworked bottega. She was thrilled with the report of Sandro's commission from Rome and merely shrugged when I mentioned his detour through Spoleto.

"Lorenzo may do what he likes with marble or paint so long as he does not disturb Filippo's bones."

Angelina retold all the same events to Giovanna the next time I visited Casa Vannozzo. Ciardo entertained me with little Antonio, who was evincing a desire to crawl. The week passed so quickly that I almost forgot Amerigo's visit on his way to Peretola. He arrived at noon of the designated day; and as it was slightly off his path for him to stop in Prato, Mother felt compelled to bid him stay the night and start anew for his family's farms in the morning. He accepted gladly with a new enthusiasm in his eyes.

After supping midday with us, Amerigo suggested that he and I go

walking along the Bisenzio. The sun was bright, so off we went down Via delle Tre Gore until we reached the embankment of the river. I recognized two of the men with their fishing carts and greeted them as they passed us. One of them slapped Amerigo on the back, as though to encourage whatever tryst he had in mind. He tipped his cap to the man, smiling, and then followed suit by putting his hand to my waist and guiding my steps to a private grove of trees near the water. Amerigo was far more serious than usual.

"You may have sensed my need to be alone with you, Sandra."

"You sound so grave. Is all well with you?"

"With me, indeed, except that my father is ailing. I must confess, it was not my original plan to stop in Prato, although I am pleased to have done so." He seemed to be carefully choosing his words. "I am calling on you at someone's behest."

"Is it Sandro?" My heart rose in my throat.

Amerigo looked at me curiously and shook his head.

"No, no, he troubles himself to leave for Rome. It is my friend and your admirer, Lorenzino di Pierfrancesco."

"But I sent him my thanks for the gown Clarice had ordered."

"And he has acknowledged that and more." Amerigo took a small, rolled parchment from beneath his doublet, impressed with the arms of the Pierfranceschi and Medici. "He has asked me to deliver this letter and remain with you while you read it."

"Has our friendship angered him?"

"He knows not of our few intimacies. He is too occupied with imagining the same with you." Amerigo's smile was sad.

I unrolled the letter and began to read:

My Dearest Alessandra,

I am sending this missive by my good friend, Amerigo, and trust he may be of good comfort to you upon completing its message. May I first say how lovely you were in your gown at the viewing of the fireworks for St. John's Feast. You made as magnificent a sight as the pyrotechny itself! You must be quite moved that Florence continues to applaud you as her Queen of Beauty.

I have admired you much since the day we first met and I

learned you were the daughter of the great Fra Filippo Lippi, whom my grandfather, Cosimo, admired as Florence's greatest painter. I know your good brother, Filippino, now seeks that same status but not without competition from other good artists, including your godfather, Sandro Botticelli. In following the achievements of your family, meseems you have earned whatever privilege you might attain by your grace and intelli-gence as much as by your beauty. It is no empty praise for me to say I should be honored to take a wife such as you. However, it has always been in both the interest of Florence and the family for a Medici to marry by political and monetary advantage. As you might know, my good cousin, Lorenzo, had chosen Semiramide d'Appiano, the niece of the late Simonetta Vespucci, as a bride for Giuliano, until he met his terrible fate at Santa Maria del Fiore. Lorenzo has now extended that choice to me, since a union between a Medici and the house of Jacopo d'Appiano will secure for Florence access to the iron mines of Piombino and Elba. I agreed to a betrothal but only after some painful hesitation in examining my affections for you. Clarice has assured me that Semiramide is as fair as she is kind and that she will be happy to come live in the adopted city of her beloved aunt.

Therefore, I must humbly apologize for any unseemly overtures that may have been perceived from me as I withdraw these feeble efforts of your most chaste suitor.

> I remain your friend and servant
>
> by my hand, July 3, 1481,
>
> Lorenzo di Pierfrancesco de' Medici.

The letter was as eloquent as any he had ever written me, and every bit as lacking in passion. I almost laughed aloud at the irony of the scene: my earthly lover, Amerigo, watching me read the gentle missive of my "most chaste suitor." And yet, as much as I knew that whatever serviceable dowry Father had secured for me would never be sufficient to marry a Medici, a definite melancholy of loss began to settle over me. I realized then that the gift of beauty is never enough.

"I see you are saddened by the contents." Amerigo touched my hand.

I rolled the letter up and placed it on the winding root of one of the trees.

"It is a confusing sadness. I never knew him well enough to love him, but he had the power to make me loved by everyone else."

"Think upon it as no great loss, Sandra. Methinks our Lorenzino is often more in love with poetry than people. He might not have accepted any of your tiny flaws. Besides, the Medici always have some turmoil to attend to. Turmoil does not suit so serene a face."

Amerigo stroked my face with his hand, and I was touched by his words and tenderness. He helped me up and placed Lorenzino's letter in an inner pocket of his doublet, as I wore no girdle or pocket myself. Then he proposed we walk further, outside the walls of the city and into the freshness of the countryside.

Beyond one of the roads we saw the small house of the servant of a notary who knew Amerigo's father. The man recognized Amerigo as we approached the door and bade us enter and take some refreshment at his table. He offered us bread, cheese, and wine, and we made idle but merry conversation until the man realized he had a chore he had not attended to in Prato. As he scurried to mount his horse, he urged us to enjoy the garden behind his house before departing. Amerigo agreed and waved the man away more eagerly than I thought fitting. Then he took me by the hand and led me through the back of the house to find the said garden and partake of its joy.

There were rose bushes and hanging pots of flowers, which pleased me in their fragrance. Amerigo continued to drink wine from the demijohn the man had left for us and offered me to drink from his cup, as though we were taking some vow of intimacy. My heart raced with the thought of abandoning myself to his arms. In the heat of the day and the carefreeness brought on by the wine, meseemed there was no other man for me to love. Sandro was taking his forbidden self to Rome and Lorenzino was betrothed. Ciardo had only offered vague and sporatic affection. I realized that Amerigo was, perhaps, the earthly lover intended for me.

Thus I yielded to his arms and curious hands in the intoxication of the garden and the moment. He removed his doublet and undid the bodice of my gown so that the flesh of our breasts might mingle as

closely as our lips and tongues. He whispered my name and I his, and then, in securing the privacy of all the doors, he reclined with me on a cushioned chaise within the garden. Feverishly and with no question to his intent, he untied the straps of his codpiece and with gentle encouragement bade me take his manhood in my hand and caress it "like a bird." I became the spirited maiden of a Boccaccio tale, and by his invitation I fulfilled my maiden's curiosity and his. I would even have pressed the sweet bird to my maidenhead had he not the concern for my virginity and the experience of restraint. I watched him move against my legs with an expression of anguish on his face, and then his torso convulsed as he spilled his seed. I reached down to touch its glistening froth, and suddenly I could imagine the significance of Poliziano's poem and his description of the Venus "born upon the sea, which was the froth of her dead father, Uranus."

Later, as we were returning to town and Via delle Tre Gore, chance dictated that we should encounter Ciardo on the road from Villa Tavola. He stopped Sopraccigliotto and greeted us with a certain suspicion.

"A pleasant day for a promenade," he began, while glancing at me curiously. I smoothed my skirt for fear it had betrayed some sign of indiscretion. "And what brings Amerigo to Prato?"

"I am on my way to Peretola. Prato is a fair detour if the girl is comely enough!"

Ciardo smiled but did not appear to enjoy the remark.

"Amerigo was acting as a courier. You know, Sandro departs for Rome in but a week! And he is stopping to inspect Father's tomb along the way." My excuse was passable.

Ciardo nodded and, dismounting, began to walk with us. I felt odd between the two of them, with the moisture of Amerigo's seed still upon my flesh. And yet it was somehow a delicious secret, one I would replay in my mind later that night as I stared up from my bed at the stars and Amerigo slept soundly in a nearby room.

The next day, after Amerigo had gone, Ciardo called at Via delle Tre Gore while I was at market with Vincenza. Mother and Riccardo entertained him until we returned, and out of a sudden eagerness both to please him and to waylay his suspicions, I invited him to sup with

us. Ciardo agreed quickly but was put off by my obligation to assist Vincenza in the kitchen. Mother, who was most perceptive, insisted on replacing me and dismissed Ciardo and me to more social discourses. We retired to the small garden that Riccardo was tending but he, too, excused himself to provide us privacy.

"Well, I see everyone is *most* accommodating," Ciardo began awkwardly.

"And how fares Giovanna and Antonio?" I thought this an innocent and agreeable topic.

"They are well and thriving, as I see you are in accommodating any suitor."

"Ciardo! Why do you speak so cruelly to me?" I could feel my face redden from anger and surprise.

"So it is *I* who am cruel when you have mocked me and made a houseguest of your lofty suitor?"

"And just *what* have I mocked, Ciardo? What vow of love have we exchanged?"

It was after this outburst that Ciardo confessed his true affection for me. I confessed that Amerigo was "as unlikely as lofty a potential husband" and that I had only succumbed to his worldly overtures when I had learned that Lorenzino di Pierfrancesco was betrothed. Was it so wrong for me to be human, to want a human caress when, thus far, I had only been offered cheers for being some chaste and symbolic Queen of Beauty?

"And are you, Sandra, thus far at least, *chaste?*"

"Would my caress be any different were I not?"

Ciardo took my hand and pressed it to his cheek and mouth. "No," he whispered.

"I have done nothing to dishonor my dowry."

"I care not for the gifts of your dowry. Sandra, I have known you longer than any other so-called suitor. I care only for the gift of you. Let me make you a true sister to the friend you have loved so long."

"Ciardo, there is much to consider before making such a proposal to me."

"And what is that?"

I paused while my mind raced. The bottega at Via Nuova flashed

before me. Would I ever see Sandro again? Would he remain in Rome, as some painters had, in total service to the Pope, or would he return to Florence to paint Poliziano's Venus?

"I have promised myself as a model to Sandro, should he return from Rome."

"But he *shall*, he is a true Florentine. Besides, how fair a woman can he find to paint in Rome?" Ciardo answered with Tuscan pride.

"One who 'hath no mortal face.'" I waited to see if he recognized the lines of Poliziano's verse, but he did not.

"Sandra, I am a merchant, not a man of letters."

"But you know Latin well enough, I trust, to read Poliziano. I have a copy of his 'Stanzas for the Joust.' Will you read it and then, knowing Sandro as its perfect illustrator and my promise to him, make again the same proposal?"

I led him to my chamber where I retrieved the manuscript. He pressed it in his hands, and I could almost hear the fateful words of Dante's Paolo and Francesca. "That day we read no more."

13

La Primavera

*M*YSTERY AND SPECULATION FOR CENTURIES HAVE *surrounded Botticelli's long horizontal wood panel,* Venus in the Forest of the Hesperides—*which, because of its allegorical figures and lush representations of flowers and trees, has long been known as* La Primavera, *or* Spring. *Was that the profile of Alessandra Lippi, "The Queen of Beauty," as the central of the Three Graces dancing next to Venus in the magical forest of the Hesperides? And was she pregnant, as the other two Graces appeared to be? It was difficult to tell, as only her back showed through her gossamer gown. Was Lorenzino di Pierfrancesco's bride, Semiramide, depicted as Flora or Venus? Why did Alessandra's figure look so longingly towards Lorenzino as the figure of Mercury, driving the grey clouds away with his caduceus? And why was she depicted as the target of the small cupid who fluttered, blindfolded, overhead? Such questions would only anticipate those to surround the even more famous* Venus Arriving on the Shore.

—Autumn of 1481 to spring of 1482

Although Mother was eager for Ciardo to declare himself formally my suitor, I had to remind her that I had made a promise to Sandro and that a man of Ciardo's upbringing would not tolerate my services as an artist's model.

143

"Why don't you ask him? We could write some agreement into the *impalmatura*," she suggested in reference to the betrothal papers that were usually signed by a parent or representative of the bride and groom.

"That would be crass. My services to Sandro are not for monetary purposes," I protested.

"But they *are* services you would perform outside your marital duties."

"Mother, you make it sound as if modeling interferes with making love!"

"It was my way of loving your father . . . before we . . . " She paused poignantly. "But Sandro is your godfather. The affection would not be the same."

How wrong she was, and how I wanted to tell her! But I had to hold my tongue and believe in the more suitable affections of a Ciardo or Amerigo, who did not write or visit for the remainder of the summer. I wrote to Sandro in care of the secretary to Pope Sixtus in Rome but received, as he had predicted, no response. Then a letter from Filippino in early September revealed the news that Sandro, Ghirlandaio, and Roselli had been working frantically to produce the portraits of the preceding popes, from which Sixtus would chose a head painter. That artist would oversee the stories from the Old Testament to be frescoed on the chapel walls.

"According to Sandro's letters to Via Nuova, Roselli impresses Sixtus with his excessive use of gold and blue and thereby distracts any genuine study of form and detail," Filippino reported. "He says he misses the Tuscan cuisine in spite of the abundant meals offered out of the Vatican kitchens. Methinks our Sandro may return as an even more abundant man!"

Sandro's girth had never seemed unattractive to me. He was a tall man and carried himself well, with an upright posture unusual for one who labored over drawing boards and gessoed panels. I thought of the comfort of the weight of him, juxtaposed with Amerigo's lean, taught body or what I imagined to be Ciardo's muscular frame. I am not a petite woman, as Mother was, and preferred a man with some bulk; frail and wiry figures did not appeal to me greatly. Earthly thoughts of Sandro occupied my mind throughout that autumn, even while I received Ciardo with gracious recognition.

His little sister, Angelina, married that September, much to my surprise and concern. She was fifteen, two years younger than I, and Mother remarked on the fact often. The money that had been invested for me in the local dowry fund had matured two years earlier, as they do for any maiden when she reaches fifteen. The expectation of a betrothal had hovered over me since then, only to increase with Angelina's wedding. For a while, I used the argument that I was to be held up as a symbolic and unattainable mistress for all the men of Florence, just as the married Simonetta had been years earlier. But that excuse paled as I grew older and the maidens around me married and bore children.

"If you deny too many, you shall find yourself with no suitors at all," Mother warned one day. Apparently Ciardo had approached her at Angelina's wedding banquet with the hope of drawing up our *impalmatura*. The Ciardi daughters were gone now from Villa Tavola, and his mother would need assistance with domestic affairs, "the things that women are wont to do."

"Did you tell him that 'Sandra is wont to study Dante and sit for paintings'?" She did not much care for my mocking tone.

"No. I told him that if his intentions were serious, he should see your brother when next he rides to Florence."

"I have not spoken at any length to Filippino about Ciardo," I reminded her.

"Filippino has eyes. He has seen you together and he pictures things well."

Clearly we were at odds with each other, and worse yet, I was at odds with my entire sex. What young woman my age would balk at marriage as I had, especially to a man as handsome and well-stationed as Ciardo? True, he was not a man of letters, as he had said, but neither was Sandro. Still, Sandro had the sensibility of a well-educated man; Ciardo had the sensibility of a merchant. When I mentioned this half-hesitantly to Mother, she quickly replied that it would behoove me to remember that the Medici had begun their dynasty "with the sensibilities of merchants." In fact, the city of Florence had "risen on the backs of merchants."

"Do you believe that Ciardo is truly the best husband for me?"

She paused, thinking perhaps of her own shortcomings in life. "You have had your choice of suitors, Sandra. I did not. And when I met your father and sat for him, I believed that it was he, and not Christ, who was the best husband for me. But it was too late. Even after the dispensation it was too late in many ways. He would not take me legally as his wife because he felt still married to the Church *and* to the painting it had allowed him to do."

"But did you not feel dishonored?" Suddenly I felt her remorse and pain.

"How could I? I felt honored just to have his love . . . and his children."

"It is an honor, then, just to have the man you love," I said as I repaired for bed. I went to my chambers and wrote again to Sandro, telling him the simple news of Prato, Angelina's wedding, and Mother's hope for me to marry. I wanted to tell him I would wait for him if he felt any earthly affection for me as a wife, but I feared too much this candid overture in ink. Instead, I promised myself to him as the model for his Venus, whenever he wished, under any circumstances, even in the event of my marriage. "My duty to you is filial as well as artistic," I wrote. And, knowing I could never have him as I wished, I added, "I shall make sure that my future husband will agree to it."

Sandro never responded to the letter, nor to the next two I wrote that autumn. I was little entertained by a short missive from Amerigo, saying he was setting off by boat for Naples with his older cousin, Guido Antonio, and hoped to pass a warm winter. There was no mention of the intimacy we had shared, save his flowery ending: "I remain in the warm glow of your beauty." I was certain, then, that a winter would not pass without his finding some lovely Napolese maiden to warm him.

Filippino received numerous commissions that winter. Many were workshop pieces referred to him by Sandro's brother. Mother worried for his health and was gladdened by his agreeing to come to Prato for Epiphany. On that visit he brought news of Sandro's progress in Rome and his assignment of a trial fresco on the right-hand wall of the chapel depicting *The Temptation of Christ*. It was ordered to be completed by the end of March under penalty of fifty ducats. Filippino said that

Sandro's last communication with Via Nuova complained of his and his fellow painters' obligation to adhere to "a most boring uniformity in style" and that their patron cared not for "depth of form or drapery unless captured in precious pigments or gold." Clearly he devoted his days wholly to the completion of his artistic commission and did not have time for the "extravagances" and "debauchery" often conjured up when one speaks of Rome.

The three of us passed a most jovial Epiphany that year by attending the festivites at Casa Vannozzo. Giovanna announced that she was again with child, only one month ahead of Angelina. I had noticed that neither of them partook very enthusiastically of the delicacies served at the Vannozzo's well-laid table. Before the evening was over, Ciardo had presented me with a gift I was not prepared to receive, a bolt of cream-colored silk intended for "whatever gown you desire." Mother, of course, saw this as a thinly veiled proposal of marriage and encouraged Filippino to invite Ciardo to Via delle Tre Gore to discuss my betrothal before he returned to Florence, but I discouraged the notion as Ciardo had made himself scarce of late. I did not reciprocate with a gift, which embarrassed me further, but Filippino saw my discomfort and put me at ease by offering to paint a small panel of Ciardo's choosing for Villa Tavola. Ciardo chose a portrait of himself as his subject and readily agreed to sit for Filippino over the next three days before his departure.

He arrived the next morning while I was at market with Vincenza, but he remained until we returned. Ciardo agreed to sup with us at midday and returned to his affairs only after he had sat with me in the privacy of Riccardo's garden. This gave me an opportunity to thank him more graciously for the silk and to explore the preferable design of a gown. It was then that he bolstered his courage and expressed his intentions towards me.

"Whatever design pleases you, Sandra, shall please me. But I would be lying to say there was no thought of how the silk would fare in the form of a wedding gown."

"Just as Mother wished!"

"But not yourself?" He seemed unable to cope with the possibility of my rejection.

147

"I have already told you my reservations. Have you not read all of Poliziano's 'Stanzas'?"

"Yes. Some of the Latin eluded me, but I was able to fill in the gaps. I shall return the manuscript when I come tomorrow."

He kissed me lightly on the hand and took his leave.

He returned the manuscript but did not remain after his sitting to sup or discuss anything with me. I busied myself with errands and stitchery in the course of the sitting so I knew nothing of the exchanges between my brother and Ciardo. But Filippino told me later that he found Ciardo "most likely to agree to any special terms of an *impalmatura*," meaning that my promise to model for Sandro would not be threatened if I chose to marry.

"If he is as agreeable as he appears to be to me, Sandra, I would hasten to accept his proposal. Your eighteenth birthday is approaching, and I believe there are few men who dare to realize their dream of matrimony with the Queen of Beauty!"

I was taken both by Filippino's candor and by his endorsement of Ciardo. He knew something of the other overtures that had been made to me: the politically impossible fawning of Lorenzino di Pierfrancesco, the carnal explorations of Amerigo Vespucci, and the numerous showy pretenses of the Florentine everyman, "for whom I was no more than an unattainable courtesan."

"Indeed!" I replied in great offense, although I knew he was correct. My brother had always been keen in his perceptions. But even if the possibility had crossed his mind, he said nothing of the forbidden affections of a godfather and the encouragement I might make of them.

"Your brother is merely telling you what he believes to be in your best interest," Mother interjected at this point. "Ciardo is the only suitor who truly knows you and sees you as a woman and a wife."

"Whom he would keep at Villa Tavola for his convenience."

"*And* yours. Would it not be an honor to rule over such a household?"

"Madonna Ciardi rules over Villa Tavola and appears to be in good health, with no need of a substitute."

"But her daughters are gone now."

"As you seem to desire me to be."

"But I can manage this house with Vincenza and Riccardo."

148

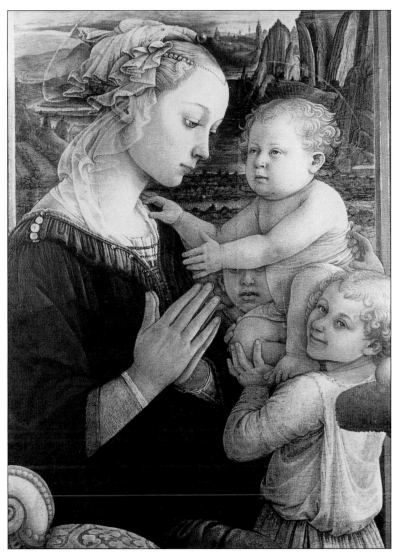

FIGURE 1. Often called "The Uffizi Madonna,"
this portrait (*ca.* 1458) by Fra Filippo Lippi
represents the Madonna (Lucrezia Buti)
with the Child (Filippino Lippi).
Courtesy of the Galleria degli Uffizi, Florence.

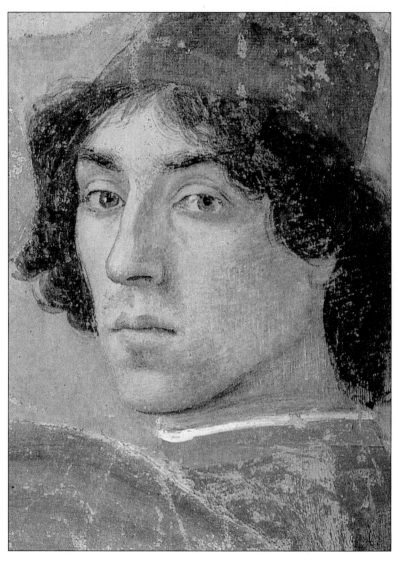

FIGURE 2. Detail of a self-portrait of Filippino Lippi
(*ca.* 1485) from *The Dispute With Simon*
in the Brancacci Chapel, Church of the Carmine,
Florence.

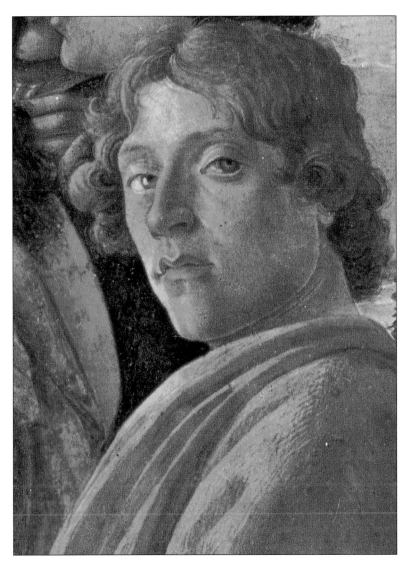

FIGURE 3. Detail of a self-portrait of Sandro Botticelli
from *The Adoration of the Magi* (ca. 1476).
Courtesy of the Galleria degli Uffizi, Florence.

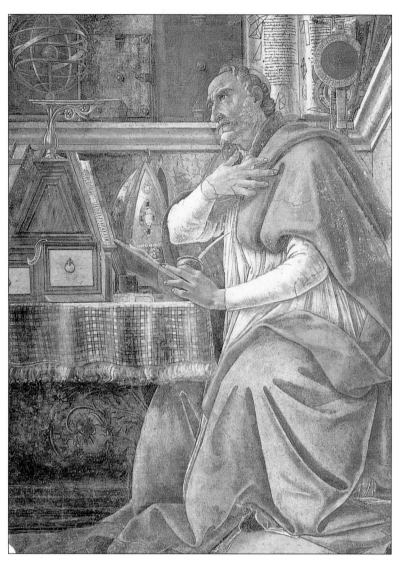

FIGURE 4. Botticelli, *St. Augustine in His Study*, ca. 1480.
Courtesy of the Galleria degli Uffizi, Florence.

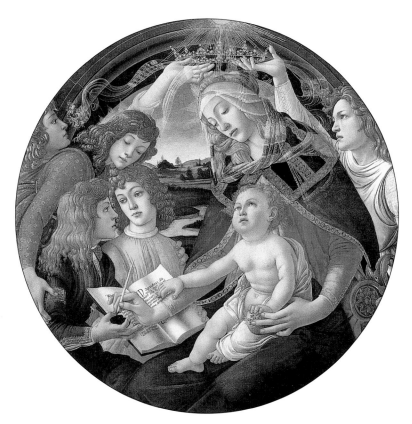

FIGURE 5. Botticelli's *La Madonna del Magnificat, ca.* 1481.
This is Alessandra's first sitting as the Madonna.
Courtesy of the Galleria degli Uffizi, Florence.

FIGURE 6. Detail from Botticelli's *La Primavera*
("Allegory of Spring"), *ca.* 1482,
of Lorenzo di Pierfrancesco dei Medici,
who was the cousin of Lorenzo the Magnificent.
Courtesy of the Galleria degli Uffizi, Florence.

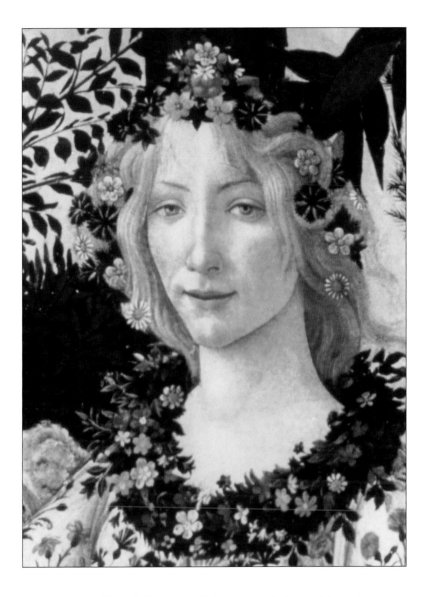

FIGURE 7. Detail from *La Primavera* of the goddess Flora, thought to be a portrait of Simonetta Vespucci. Courtesy of the Galleria degli Uffizi, Florence.

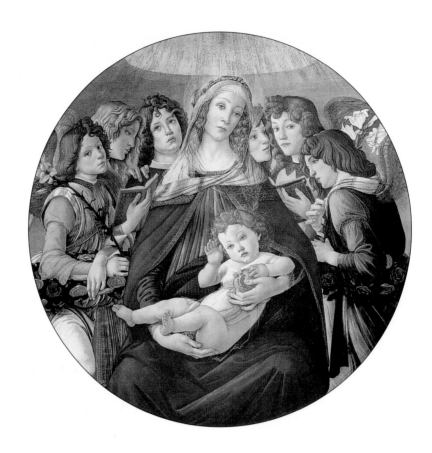

FIGURE 8. Botticelli's *La Madonna della Melograna*
("Madonna of the Pomegranate"), *ca.* 1487.
Alessandra sits with the infant Filomena.
Courtesy of the Galleria degli Uffizi, Florence.

"Sandra, Mother is only trying to reassure you, and so am I. Ciardo appears willing to agree to your modeling for Sandro. He is well aware of your sensibilities and that you are a painter's daughter . . . and sister."

Would that I could have said "And wife!" But I held my tongue and tried to look upon Ciardo's proposal favorably.

On the final day of the sitting, Ciardo asked to speak with me as he departed towards the stable. He had brought a second horse with him, which I had assumed to be some favor for Filippino or Mother, even though she had always found Bello an adequate animal. He stood next to Sopraccigliotto and stroked his neck and mane quite lovingly, a mannerism I had always enjoyed in Ciardo.

"It seems I have had difficulty giving you gifts, Sandra. But this I give to you with no hesitation, for I know the affection you bear for Sopraccigliotto. He has carried you and Giovan na since your childhood, and I pray he may carry you until his or your untimely death. I give Sopraccigliotto to you now, to show my good intentions in allowing the sittings you have promised to Sandro. He is yours to ride to Florence or wherever you need go, so long as you return to me, your husband."

"And if this is not agreeable to me?"

"Then return Sopraccigliotto to Villa Tavola and I shall appeal for your hand no longer."

"You barter like a true merchant, Ciardo. Your horse for my heart?"

"Think on it the next few days. I shall not call here until I have heard your answer." And with that, he rode away on his other horse, leaving me to calm the somewhat confused whinnies of his faithful steed.

Filippino left the next morning. I said little to him or Mother, and in the afternoon I rode Sopraccigliotto to Casa Vannozzo to call on Giovanna. Antonio was napping, and my friend was pale with the nausea of her new pregnancy. Angelina had joined her for the day to commiserate. It was up to me to introduce the subject of Ciardo's proposal. I knew that they would be thrilled with the idea, but what I wanted to learn was their possible reaction if I declined. Would I lose Giovanna's friendship? Would Ser Vannozzo be so disapproving that

my own house would suffer his recriminations? Could I remain in Prato if I refused, or would the awkwardness of my rejecting a Ciardi force me to go to Florence?

Giovanna, though obviously surprised at my questions, was patient with me. She watched as I paced back and forth next to Sopraccigli-otto, patting him and presenting my dilemma. Finally, she stood up from the chaise, on which she was reclining to settle her stomach.

"Sandra, if you do not embrace the thought of marrying my brother, do not do it just to please your mother or me or the town of Prato. You need not choose your mate as a Medici does. You can marry for love as I have married my Antonio. And I assure you, there can be no truer bliss than that, to sleep with your beloved every night!"

Angelina blushed slightly and stroked her still-flat belly. I thought, then, of Sandro, far away in Rome, and the unpredictable Amerigo, somewhere in Naples. Lorenzino di Pierfrancesco was probably in Florence, where preparations for his spring wedding were underway. There was no other suitor for me now. But still I had reservations. What would my relationship with the Ciardi be if I turned Ciardo down? Giovanna assured me that she and I were "kindred spirits" and that our friendship would endure.

I slept little for the next three days. Finally, I decided to go to Villa Tavola with Riccardo as my escort. He rode Bello and I rode Prac-cigliotto, with the intention of returning him and declining Ciardo's proposal, at least for that year. But when we arrived at the gates of the Ciardi estate, a strange feeling possessed me. A liveried servant received us and went to call for Ciardo. Madonna Ciardi came out into the loggia and informed us that Ciardo was away and she was unsure when he would return. I thought it easiest simply to leave Sopraccigli-otto and dispatch a letter later in the day. But then I heard horses and saw Ciardo and his father approaching on the road in the distance. I had forgotten how fine a figure Ciardo made upon a horse. My heart was suddenly pounding in my throat.

"And what brings the lady Alessandra here unannounced?" Ciardo's father asked in a loud voice that became a belch.

His wife quickly ushered him inside and bade Riccardo join them for some refreshment. Ciardo guided me over to the livery so that I

might remount Sopraccigliotto and ride with him onto the farther grounds of the estate.

"I see Sopraccigliotto is doing well with you." There was something of a shy boy in his manner.

"And I with him," I replied every bit as coyly.

"Then you are wont to accept him as I have offered?" Ciardo tied both horses to a tree and took my hand in his.

"I have always loved Sopraccigliotto . . . but I have not always loved you." My voice was very halting.

"I know." Ciardo's face changed suddenly: he did not wish to appear crestfallen.

"Nor have you always loved me." It was less a statement than a question I had not known how to ask.

"No, Sandra. No, I have not, but I will not let you turn away from me now." Suddenly he took me in his arms, with no care for who might be watching, and kissed me fully on the mouth with a hunger I had never felt before. As he kissed me all about my face and neck and bosom, I felt the moisture of his tears against my skin. Somehow it was more intimate than the moisture I had felt from Amerigo's seed, and I realized the sincerity of Ciardo's passion.

"Sandra, tell me I might be as dear to you as you are to me," Ciardo sobbed. "Say you have not come here to return Sopraccigliotto and rebuke me!"

I held his head against my breast and rocked him. "Ciardo, Ciardo. How can I refuse when you have shown me the dearest side of you?"

We huddled together until the winter clouds moved in and announced the coming of dusk.

Our *impalmatura* was signed the week after Lent. Filippino attested to the funds of my dowry and sent the completed portrait of Ciardo in a lovely frame. With our betrothal now secured, Ciardo became more comfortable with showing his affections to me. He wished me to ride out frequently to Villa Tavola and "acquaint myself with my future household," who were most accommodating in providing us with privacy. He was careful not to arouse me so much that we would forget ourselves and do dishonor to the marriage bed, but he took pleasure in assuring me of his manhood.

On one occasion, he even confessed that his father had encouraged him to "enjoy" me thoroughly, so that he might claim me even before the sacraments of marriage. In fact, he said, it would worry neither his father nor mother if he "got me with child before he got me to church," and I almost succumbed to that possibility one evening when Ciardo escorted me back to Via delle Tre Gore. But Mother and Riccardo and Vincenza were not as pliable as Ciardo's household, and we were forced to restrain ourselves.

We had planned for the wedding to take place in May, but when I learned that Lorenzino's marriage to Semiramide d'Appiano had been scheduled for that month, I decided to wait until June. Then, by great misfortune, Lorenzo de' Medici's mother, Lucrezia Tornabuoni, died in March, on the very day of the Florentine New Year, and the Medici wedding was postponed until July. I decided not to tamper with my wedding date after all. Then Filippino wrote to us the news of Stagio Vespucci's "turn for the worst" and Amerigo's return home. Stagio died the first week of April, and I felt obligated to attend the funeral after all the hospitality his house had shown to me.

Ciardo was willing to accompany me, but I felt awkward and said I was obliged to go with Ser Vannozzo, who wished to bid farewell to a fellow notary. This seemed reason enough to Ciardo, so presently I found myself in the company of the lover who had first wooed me out of my earthly innocence. Amerigo, in spite of his sorrow, looked well rested from his days in Naples, and he made no delay in taking me aside after the interment at Ognissanti. The knowledge of my betrothal did not prevent him from embracing me and stealing a kiss.

Perhaps I was as weakened by the passion of our reunion as Amerigo was by the passion of his grief. I agreed to accompany him back to Casa Vespucci, where his part of the household had vacated to attend the funeral banquet. He praised my beauty as the only good thing to punctuate this sorry day and inquired if Ciardo had "seen fit to prepare me for the joys of marriage." I would have taken offense had the question not come from his sensuous mouth while his most earnest countenance awaited an answer. Perhaps if he had not appeared so elegant in his black dress of mourning, or perhaps if I had not recalled again the delight of his eager body, I would not have succumbed to his

next overture. But soon I was delirious with his kisses and would have yielded to him had I not remembered that his father was barely interred only a few blocks away.

"How shameful we have been to engage in this! Are we mad?" I rose from his bed.

"Only I, Madonna Sandra. And it is the madness of grief that has caused me to struggle for some small share of your love!" Amerigo buried his face in his hands, and suddenly his entire body heaved with sobs. I had not hard enough a heart to watch without taking him in my arms.

In due course, Filippino and Ser Vannozzo came looking for me at Casa Vespucci and escorted me back to Filippino's house. As we passed Via Nuova, I looked up to see Sandro's brother, Giovanni, walking slowly to the door of their house. I imagined Sandro's empty bottega, void of activity and mirth. The street, even, did not seem the same now that he was gone. And I knew that the world could not be the same for me, either, if Sandro never returned.

After that, I begged Ser Vannozzo to return to Prato the next day where, overcome by grief and guilt, I flew into Ciardo's arms with such emotion that he mistook it purely as a flare of ardor fueled by our brief separation. Most of the servants at Villa Tavola were outside the house, and his father and mother were in town for the day. The privacy of Ciardo's chambers was at our disposal, and I offered myself to him entirely as penance for the unknown sin I had committed in Florence. Ciardo was all too willing to give me his manhood, but wishing not to "taint" our future marriage bed with the blood of my maidenhead, he took me into his brother's room, where he murmured, "Shall we be one before the Church declares us so?" He entered me, gently first and then with a vigorous sigh. "Carissima, now you are truly my prize."

I could say nothing to him afterwards. The pain was minor, certainly not a suitable punishment for my indiscretions with Amerigo. Afterward there followed a strange sort of pleasure, a warmth in my womb I had not expected. Suddenly, I rose and dressed.

"We must marry sooner, Ciardo. In case this results in a child. We must marry before the first of May."

On April 30, 1482, I rode to San Stefano on Sopraccigliotto, followed by Giovanna and Angelina and two of Sandro's nieces, who had traveled from Florence. We approached the piazza of the Cathedral, where I dismounted and met Ciardo with his four attendants standing behind a floral garland. I received their ceremonial gift and praises of my beauty —which, I admit, one attendant uttered with more enthusiasm than was necessary. Then, as the custom dictated, Ciardo broke the garland and escorted me into the church, where we kneeled and made our vows.

My marriage to Ciardo di Ciardi pleased many citizens of Prato besides Mother, Ser Vannozzo, and Giovanna. By taking Ciardo as my husband, I had agreed to live in this time and world and to forfeit my imagined life with Sandro Botticelli. I thought little of Sandro on my wedding day, except when I passed by Father's fresco of the dancing Salome in San Stefano. I knew Sandro had painted most of it as a garzone, and it showed his budding talent for grace and movement and lovely hands and feet. Only then did I think of the other world I might inhabit as a goddess in a magical forest or on a giant shell blown to the faraway shores of Cyprus. I shook these images from my senses and looked into the comely face of my new husband.

The Ciardi hosted the wedding banquet. Filippino had brought gifts from numerous friends in Florence, but there was nothing from Sandro, and my heart sank for a moment. Then, however, before the final course was laid upon the table, he took out a carefully wrapped present sealed with the arms of the Medici. Ciardo began to unwrap it, but seeing that it was a book, he passed it across to me. It was one of the first printed editions of Dante's *La Commedia*, complete with Cristoforo Landino's commentary and Sandro's elegant drawings, freshly struck from the printer Baldini's plates. Inside the leather cover was this inscription:

> To one who honors every Beatrice with her virtue,
> Every Francesca with her passion,
> And every Simonetta with her beauty.
> > From Lorenzo di Pierfrancesco.

I pressed the manuscript to my breast with only a comforting melancholy. It was an ambiguous declaration to come from Lorenzino, but a touching one. To avoid arousing comment, I turned my attention to

the next gift, a Book of Hours from my mother. It resembled her own illuminated text with extra pages in the back for recording the births and deaths of family members. Her copy listed Filippino's and my birth followed by the death of our father in Spoleto. She would give it to Filippino when he married. But mine was to begin anew for this line of the Ciardi, who had passed their own Book of Hours to Giovanna.

My arrival at Villa Tavola brought about a transformation in me so gradual that even I was unaware of it. Ciardo's parents treated me with courtesy but not warmth; and because I had been accustomed to my mother's illuminating presence as well as the memory of my father's enthusiasm and vivacity, this adjustment to more subtle expressions of affection was difficult for me.

Ciardo's young brother, Gio, was only thirteen and wont to follow me about as though he had some secret he could not divulge. This was highly amusing as it was I, or rather Ciardo and I, who had the secret: the new joys of the marriage bed. But apparently Ciardo had revealed the details of his "joy" to Gio out of some sense of bravado. Giovanna told me so one day in the Vannozzo's garden while little Antonio toddled in and out of the rows of herbs and flowers.

I confessed that I had yet to experience that "joyful swooning" that women come to know in the sexual union.

Giovanna nearly admonished me. "Sandra, you must think of your womb as the heart of Saint Teresa and your husband's manhood as the arrows of Divine Love."

I dared not lift her from so solemn and sacred an analogy. "Giovanna, there are other things to rejoice in."

"Are you with child?" she gasped and held her hand against her breast. "No, forgive me, it would be too early." She stroked her pregnant belly and smiled. "But you do wish for a child, do you not?"

"I am willing to receive a child. But first I wish to sit for Sandro when he returns from Rome," I said cautiously.

"And Ciardo does not protest?"

"He has agreed to it in the *impalmatura*. After all, your brother has married a painter's daughter."

"You would do service to your godfather before your husband?"

My feeling for Sandro was the one thing I had never confessed to Giovanna.

"Perhaps I am not as prepared as you to 'forsake all others' in my life." My answer felt feeble, but I knew she heard a certain bitterness in my voice.

"I have not forsaken you, Sandra," she reassured me. "And let me tell you now, if I have a daughter I shall teach her to cherish her dearest friend as I have cherished you."

That night, as I lay with Ciardo, I received him with all the affection that Sandro had denied me and thought of the possibility that a child might grow from that final pulse of joy within my womb.

Sandro returned to Florence in the third week of May along with his fellow painters, all of whom were dissatisfied with the pressure under which they had worked. He had called on Filippino one afternoon to partake of Francesca's generous table and to recount his journey home with the disgruntled Perugino and Rosselli. Ghirlandaio had left the month before. Filippino reported that Sandro had brought with him one of Roselli's assistants, who had taken the Christian name of his master as a surname. Sandro had brought the young Piero di Cosimo to Filippino's bottega to show him the possible success of "a serious garzone."

"He was an odd sort of fellow," Filippino wrote, "but most impassioned towards his art. When he saw one of my studies of Sandra's face, he put his hand to his heart and cried, 'It is Simonetta restored to us once more!'"

This event, as he later claimed, inspired Sandro to begin his much awaited *Venus in the Forest of the Hesperides*. And in a most timely fashion, it was a theme suitable for the wedding gift that Lorenzo de' Medici had commissioned Sandro to paint for the impending marriage of his cousin Lorenzino to Simonetta's niece, Semiramide. The elder Lorenzo had requested a large panel with mythological figures to grace the walls of the couple's bedchamber on Via Larga. When Sandro learned that I had married Ciardo and resided at Villa Tavola, he hastened to arrange a visit to Prato to make his studies for the panel.

Sandro dispatched a courier to both Mother and me with the

message that he would travel by way of Castello to sketch its gardens, particularly the orange groves. Then, if it suited both Giovanna and Angelina to "return to the fold," he very much wanted them with me at Villa Tavola to sit as the Three Graces, the attendants of Venus. I was filled with much anxiety and pleasure at the thought of seeing Sandro again, but this I hid from the entire Ciardi household.

Ciardo's father was eager to have the newly acclaimed "servant of Pope Sixtus" be his guest at Villa Tavola, but Sandro preferred to stay with Mother at Via delle Tre Gore to reclaim the memories of his youth. He arrived with his garzone, Jacopo, the day before the Sabbath with the intention of remaining a full week. He would spend each day sketching in the gardens at Villa Tavola, and each evening reminiscing with Mother and Vincenza and Riccardo. I might have wished to join this warm reunion, but I was married and dared not show any disloyalty to my new family. And yet I had much anticipation in seeing Sandro again. How would I appear to him, no longer innocent and pure, and how would he appear to me?

He and Jacopo escorted Giovanna and Angelina out to Villa Tavola on the first day. I could hear their voices from the courtyard and ran to the front gates to give them entry. He embraced me gingerly but long enough for me to take note that his stature had indeed grown during his service to the Pope.

"The heavy Roman cooking is to account for this!" He slapped his expanding waist. The long days upon the scaffolding in Sixtus' new chapel barely showed in his face. He was weary, he said, and yet "rejuvenated" by Prato.

"And you, Sandra, are as lovely as ever. I see marriage sits well with you!"

It was more a question than a statement, but I could only smile. Then, after the brief refreshment that Madonna Ciardi offered us (with her expectant daughters primarily in mind), we repaired to the gardens where Sandro showed us his studies of the orange trees at Castello. There were also sketches of Lorenzino's face, one three-quarters and two profiles. As he was the groom, his likeness would appear in the figure of Mercury, one of the lovers of Venus.

"When Semiramide arrives in early July, I will do her study for my

157

Venus. But fear not, Sandra. You shall be my central Grace, flanked by your two sisters here in the flower of their womanhood." He gestured to Giovanna and Angelina and their pregnant bellies. "A most comely posture for the attendants of Venus, not to mention Flora, the goddess of fertility!"

Sandro had selected the gossamer gowns for us to don as the Three Graces, and he bade us form a circle with fingers intertwined above our heads. But Angelina was wont to cast her eyes over her shoulder toward Sandro and his sketch book instead of upward. Sandro worked so intensely when he drew that he could not speak, but he did clear his throat abruptly with an admonishing glance in her direction. Jacopo sat by him diligently doing the same.

When we rested, Sandro reminded us of the significance of the Graces, who were "young and uncorrupted" and whose dance passed from hand to hand, always returning upon itself.

"Their dance is the allegory of the benefits we confer when unrestrained by any expectation."

Ciardo's father, who was disgruntled by the sheer camisoles we wore, had passed through the garden in time to say, "Meseems the Graces were unrestrained by any modesty as well."

Sandro chuckled and then dismissed the remark. "It is the sincerity of generosity that returns to us in full."

"Ah, yes," The elder Ciardi pretended to understand, then turned his attentions to Ciardo, who had just returned from town with a new account.

Sandro greeted him eagerly while recalling his earlier assessment of Ciardo as a suitable Zephyr who was both god of the wind and messenger of spring.

"So, is it Zephyr come to claim the nymph of spring?"

Ciardo nodded and smiled but did not respond until later. "I can only claim these three as the paragon of Tuscan beauty!"

"Who guard the golden fruits of the Medici while they dedicate the same symbols to Venus."

By that week's end, the Ciardi were all well versed in the tales of Antiquity and knew how each figure and symbol corresponded with Scripture. Sandro explained how Plato's essays had precluded the

teachings of the Church by embracing the goodness of knowledge and beauty and rejecting the sin of ignorance. Still, for all the insight he brought to Villa Tavola, I now felt a new distance from him. Perhaps he no longer knew how to receive me as a married woman, no longer the child or maiden he had known. Perhaps his former affection had been aroused only by my innocence, which I had given over to Ciardo. And yet, before he left, he said he would await the delight of my countenance "in the flower of maternity" when I might sit as his next Madonna or goddess of love.

The garden that provided the backdrop for La Primavera *was considered wild, tangled, and unkempt in comparison with the manicured gardens of England and France, but this was simply another underestimation of Italian, and especially Tuscan, culture. Tuscany had the most superb cuisine in the world and had devised sophisticated implements for eating, like the fork. Italians had invented glass lenses to improve vision, and an Italian monk had created the system for writing down music so that it could be read and re-created for every instrument. The Venetians blew the finest glass and the Romans had built the most magnificent aqueducts centuries ago. The Tuscan wool trade that had helped the Medici banks to flourish had also refined the spinning and dyeing of fabrics of many textures. No architects from the North had designed or built a dome as grand as Filippo Brunelleschi had at Santa Maria del Fiore, nor had any Northern sculptor ever crafted as grand or lifelike a figure as Michelangelo's David or Donatello's sleeker version before that. Finally there was painting.*

The rebirth of classical forms in painting was claimed first and foremost by the Italians, and more specifically by Sandro Botticelli, the master of allegory. And what well-traveled man, who had seen the decorations of all the courts and churches of Europe, had ever beheld as elegant and striking a depiction of feminine beauty as he who looked upon a Botticelli maiden? Even the other great Italian artists—Leonardo, Michelangelo, Rafaello—could not claim such rapturous mastery of the female face.

14

Madonna Ciardi

—Summer of 1482 to winter of 1483

I PASSED MY FIRST SUMMER AT VILLA TAVOLA acquainting myself with the routine of the Ciardi household and with the likes and dislikes of my new in-laws. Ciardo's mother displayed what little passion she had in the affairs of her kitchen, her larder, and her servants. There were three housmaids who served her, but one had left to live with Giovanna. She had been my favorite, but Lucia, a dark girl of Moorish blood and temperament, had remained; I felt most at ease with her. She had more fire and spirit than anyone else there except myself, and I believe she sensed my good affection for her. Still, Lucia was not like Vincenza, nor was she loved as dearly within the family. I soon came to value the spontaneity and good humor at Via delle Tre Gore, which I now so sorely missed.

All such longings aside, I chose to distance myself from my mother and her house in order to appear the dutiful wife she had wished me to be. I encouraged her visits but knew she felt uncomfortable with Ciardo's parents. In addition, Villa Tavola was well beyond the double walls of Prato, which made an inconvenient journey for her. Thus I was wont to find cause to go to market with Lucia so that I might stop at Santa Margherita, where Mother often went to visit Spinetta.

Mother told me, in later years, that these visits within the cool and gentle walls of the convent had been a blessing for her that first summer without me.

Ciardo's parents had given us the first printed copy of the great Vulgate, the Latin Bible as translated by St. Jerome. It was the first "modern" text to appear in their house after *La Commedia*, and they seemed to take more pride in it than either Ciardo or I. At first his parents, like many Italians, had believed a printed Bible to be the work of the devil, but eventually they changed their view as more of them circulated throughout Italy.

"It is a fine work for the devil then!" Sandro had said of the controversy, and I liked to quote him whenever I could.

The Book of Hours from Mother was hand-scripted because of the elaborate miniatures that decorated the beginning of each prayer. I read each office almost daily, not out of devotion but out of a need to fill the void of my mother's absence. Normally one would receive the Book of Hours as a wedding gift from one's godparents, but Mother had said she did not expect Sandro to indulge in such a commonplace custom. Nevertheless I thought of him whenever I turned those gilded pages and tried not to feel slighted. I did not yet know that the same summer he had painted *La Primavera* he had also produced a lovely panel for my wedding chest.

It arrived at midday, when Ciardo was away with his father. His mother was occupied with Lucia and another servant, and I was too eager to see the contents to await an audience for the unveiling. I paid the courier his gratuity and hastened to my chamber to unwrap the parcel, where I cut the twine with my sewing tools and hurriedly unrolled the coarse wrapping. I felt a special intimacy with Sandro as I pulled out his creation, like a midwife assisting at a birth.

It was the truest likeness of me he had painted yet, except that my eyes had a rather pious stare. The figure stood in contrapposto in a sheer gown, a barely clothed Venus but modest in its tribute to love. At first I feared that Ciardo might find such a portrait of me intrusive, but he was more displeased with the gift's premature unwrapping than with its contents.

"You have the impatience of a child," he said with a laugh when he

saw the hastily rewrapped parcel. "But I can understand your eager-
ness to see a gift from your godfather."

When he held the panel up for all the family to see, his father
bellowed, "It is truly Sandra in all her glory!"

Ciardo's mother subdued him with a frown. "A lovely keepsake to
attach to your wedding chest and as valuable for its sentiment as for
being painted by the hand of Botticelli."

"I might prefer to frame it and display it on a wall," Ciardo ven-
tured.

"But the gilder in Prato is a devout man. He might object to framing
a pagan image."

"But it is Venus who blesses marriage and the new life that springs
from it!" Ciardo's attempt at poetry was somehow amusing, but I was
pleased that he stood up to his mother.

"Why did you not say I had the face of the Madonna?" I asked him
later that night, partly in jest at his mother's more pious concerns.

"Because you have the face of a goddess." He stroked my cheek and
let his hand trail down my shoulder and arm and up again playfully.

"Indeed, my sweet Zephyr!" I pulled him to me to kiss. "But I
shall just as surely have the face of a Madonna 'in the flower of her
maternity.'"

"Are you with child, Sandra?" Ciardo put his hand over my womb.
His eyes were wide with amazement.

"I am."

We embraced for most of the night, but he would not enter me for
fear of harming the child. It seemed that as soon as I had come to
enjoy the fruits of the marriage bed I was forced to assume the chastity
expected with its harvest.

The autumn brought a new fulfillment to me in spite of the nausea
that plagued the beginning of my pregnancy. Giovanna comforted me
as best she could, advising me on the most satisfying foods, but soon
she delivered her second son and was too occupied to be much of a
companion. Mother made the journey to Villa Tavola with Riccardo
every other day, which I believe irritated Madonna Ciardi to some
extent, as though she and Lucia were not comfort enough for me. But
I tried to ease their tension by showing exuberance over the few letters

Mother brought from Filippino. I pretended they were the focus of her mission.

According to Filippino, Lorenzino di Pierfrancesco's wedding to Semiramide was elegant and grand but not quite the splendor he had expected from the Medici. Apparently the Medici treasury was still depleted from the war, and Lorenzo had sought to economize even though he was economizing with the Pierfranceso funds. The new bride and groom were residing for the time at Castello, and Amerigo had already been named Lorenzino's new agent to oversee the accounts of the Pierfrancesco farmlands in the Mugello Valley.

Sandro was laying pigments to *The Garden of the Hesperides*, which had required three panels of poplar. Filippino explained that Sandro was experimenting with an extra layer of gesso to provide more light beneath the pigments and that Lorenzo de' Medici had agreed to the cost of extra azurite for the blue needed in the forest and the figure of Zephyr.

Filippino himself was happy to announce that he had been nominated to finish the frescoes in the state anteroom of Palazzo della Signoria. The project had been abandoned by Sandro's former colleague, Perugino, and Sandro had recommended my brother for its completion. Mother hoped this would give Filippino cause to limit his other commissions and invest some time "in the pursuit of a good wife."

I wrote to thank Sandro for the portrait panel and told him how greatly it pleased me. Then I mentioned my pregnancy and reminded him that he had always spoken of Venus as "a fine figure of womanhood and full in belly—a Madonna transformed by divine sensuality." But he did not reply, and I tried not to be saddened by his aloofness, which I knew had been imposed on him by the the acclaim of Rome and Florence.

"Keeping track of correspondence will soon be the last concern to occupy you!" Mother reminded me when I complained of his unresponsiveness.

I was soon to marvel at the devotion I would give to motherhood. Giovanna told me that I would be "consumed by love for my child, asmuch as a maiden loves her first youth." The analogy had less significance for me, as my first love had not been some awkward, gangly

boy. I would yield fully, however, to the demands of my new vocation.

The winter passed quickly, it seemed, in spite of the rains. Then I was blessed in the season of Epiphany with the strength to meet that singular travail of my sex. I admit I went into it with the undeniable fear that grips all women in childbirth, a fear washed in the relief of either new life or death. Mother came to me, as did Giovanna, to stroke my face with cool cloths and create that circle of hope that delivers all women from their trial. Madonna Ciardi called in the midwife who had attended to Giovanna. She worked well with me, true to her reputation, but even her assurances could not relieve the surprising pain and exhaustion.

An entire night and day passed in my travail, and I became so delirious that I could no longer distinguish the voices that spoke to me. I barely heard myself call out to Santa Margherita, who hears the prayers of women in childbirth and renders to them God's mercy. Suddenly my suffering swelled to a crescendo that seemed to be almost the gladness of death. I felt as though my womb would burst within me, but there followed a hot and violent pressure and I looked down to see the midwife holding up my child. She was still wet with my life's blood and covered with a silky fluid that glistened in the morning light; and then the child cried, breaking the holy silence of the moment as she received her first true breath. The good air of Prato was now hers.

I named her Lucrezia Giovanna Ciardi after my mother and my beloved friend.

Filippino and Sandro received Mother's happy news at the same time while working together on the decoration of the Medici's villa at Spedaletto. The weather was not yet suitable for frescoes, so they were pleased to have an occasion to be dispatched to Prato in time for Lucrezia's baptism.

I named Filippino her godfather, and as we stood beside the baptismal font at San Stefano, Sandro leaned in towards my brother and whispererd, "Can the years have passed so quickly since I stood in your place and beheld your sister?"

Their laughter blended with the general banter in the church until our party quieted itself for the first sacred gesture of the priest. His words lingered in my ears like an unshakable song.

"What do you ask of the church of God?"

"Faith," Filippino answered on the part of the child.

"And what does faith give you?"

"Life everlasting."

"If you would enter upon life everlasting, keep the Commandments. You shall love the Lord God with all your heart, with all your soul, with all your will. And your neighbor as yourself."

The priest then blew his breath upon the child, and she gurgled with delight. We all endeavored to restrain our mirth while the priest made the sign of the cross three times and ordered the Devil "to emerge from the body of Lucrezia Giovanna." He laid his hands upon her tiny head and prayed.

"God powerful and enternal, Father of Our Lord Jesus Christ, turn Thy glance on this Thy slave, whom Thou has deigned to initiate into the rudiments of the faith. Per Christum Dominum nostrum."

The priest then brought one finger to Lucrezia's tiny mouth to give the "salt of wisdom" for her to savor. She whimpered, turned her head, and made a smacking sound to show her satisfaction at the new flavor. The priest placed his thumb in holy oil and anointed Lucrezia on the breast and back.

"Lucrezia, do you desire baptism?"

"I do," Filippino responded for her.

It seemed as though my brother's voice had somehow taken her from me for even that brief moment, and I held her closer in my arms as we all answered in one final "Amen."

How powerful were these words, to transform my child from a creature of man to a creature of God. And yet I wondered then, as I still do, about the souls of non-Christian children: the children of the Jewish money-brokers who kept the markets of Florence thriving, the children of the Moors with the blood of my fiery Lucia, the Infidels whom Amerigo would later meet in Spain. Were they not just as precious to their families and just as hungry when they suckled at their mothers' breasts?

After the baptism I continued to think about those who did not know Christ or could not have received the holy blessings of the Church because they had lived before Him. What of the Ancients who had no

Book of Hours by which to pray? And what of those mortals who defied the natural laws and mingled with the deities? Were they not as Saint Teresa in the rapture of God? Was Christ not a man who had joined with God? And why had God waited so long before revealing himself in His Son?

And what of Sandro, who honored Christ and the Church while praising Plato? He had spoken of the sights of Rome, the sculptures and mosaics of the Ancients, and he had marvelled at their genius. He had agreed with Lorenzo de' Medici that the first Platonists had proved the existence of God long before Christ by embracing beauty as part of a divine wisdom. I wanted to speak to Ciardo of my thoughts, but he was not inclined towards such lofty subjects. Yet they were questions I never asked of anyone, for women were not to discuss theology as men of letters might. I did not even broach the subject at the baptismal dinner, although I knew that Sandro, having been among philosphers like Marsilio Ficino and Amerigo's uncle, Giorgio Vespucci, would have enjoyed bandying it about.

Instead, the women spoke of the joys of children and the intimate little habits of infants, while the men spoke of their trades and their varying vexations. Filippino and Sandro talked about the political intricacies of painting for the Medici, although Sandro had felt much more freedom in his commissions from the Pierfrancesci. *The Forest of the Hesperides* was soon to be hung in Lorenzo's and Semiramide's chamber at Via Larga, and Sandro was very pleased with the quality of the underlying gesso, which he had boiled to an ivory finish.

"Do you remember the lime and clay we collected that day near Spedaletto?" he asked Filippino. "It made the perfect gesso for well-seasoned wood and created a sort of luminescence beneath the pigments."

Filippino had been exasperated by his efforts in decorating the villa at Spedaletto and could only nod. Sandro confessed to having a new enthusiasm for using linseed oils when mixing pigments: he found that they not only preserved the texture of each color but also prevented any deterioration in the underlying gesso.

"Lorenzino has ordered another painting to be the counterpart to this panel, with the theme of Chastity Conquering Lust—a tribute to

Semiramide, who is due to deliver their first child." Sandro then glanced my way. "But my studies have come up with the figures of the goddess Pallas subduing the Centaur—more a tribute to Wisdom Triumphing over Violence, methinks. I thought to paint the harbor of Pisa in the background."

"Whatever for?" I inquired.

"Why, to evoke the memory of Lorenzo de' Medici's heroic trip to Naples that ended the war."

"Ah, Sandro, you are shrewd to flatter your patron's good cousin next door!" Filippino was chuckling.

"And does Semiramide sit well for you as the Pallas?" I assumed that he would use her likeness for the painting.

"I must confess, Sandra, that thus far I can only see your face when I draw."

"Then who, pray tell, is the face of your Centaur?" Ciardo interjected.

"Fear not that it is *you*, good Ciardo. Although I still have a mind to use you as my next Zephyr."

"I believe I am a better merchant than Keeper of the Wind. An empty trade, is it not?" This was clearly an effort to impress Sandro with his humor.

"Then thanks be to my patient youth, who thinks nothing of his strenuous posture or that inflated grimace for his pay!"

Sandro continued to describe the four panels he had designed for the impending wedding of Antonio Pucci's son. Pucci had decided on the theme of courtly love, and Sandro had suggested illustrating four scenes from Boccaccio's tale of the Knight Nastagio degli Onesti.

"Do you mean to say the new bride has been frightened into marriage?" I began as Lucia brought Lucrezia to me to hold.

"So bold an interpretation, Sandra!"

"But it *was* fear," Giovanna noted in my defense, "when his mistress saw the fate of the other girl who suffered everlasting torment for refusing her suitor," Giovanna continued by explaining to her husband and mother the events of the tale, in which a young maiden is condemned to the eternal chase and assault of mastiffs after refusing her suitor's affections.

167

"A telling tale for ungrateful women!" Ciardo's father bellowed from his end of the table.

Everyone laughed, but Giovanna and I were not amused.

I did not see Sandro for a long time after his visit to Prato. The affection I had for him burned within me, but in a more distant and impossible place. My heart, as nature would have it, beat towards my child and towards Ciardo, the father of that child, who as a husband had satisfied my earthly needs. I had the comfort of Villa Tavola, my mother's pride, and Giovanna's friendship. Following the proper days of chastity, Ciardo and I returned to our marriage bed with vigor and delight. Although he satisfied my flesh as best he could, he did not, somehow, satisfy my soul.

Aunt Spinetta had once said that only Christ could do this, but even Mother did not agree. (She, however, was exceptional, having loved a man who was both holy and earthly.) Lucrezia's birth had brought me closer to my mother, who now came occasionally to Villa Tavola whenever Riccardo had cause to go beyond the walls of Prato. They often purchased wine from the vintner who had once employed Riccardo, and he had invited them to come pick out their demijohns rather than select them at market. Mother would stay the entire morning and return to town when Riccardo had finished his business.

During these hours, I could imagine my mother when I was an infant and how she must have cherished her children. She cooed and sang to Lucrezia, who would fix her dark eyes on Mother's face and reach up to touch it with her tiny, curious fingers. Sometimes Lucrezia would turn her face to Mother's breast as if searching for a nipple, and Mother would laugh, almost sadly, at the errant gesture. Then she would transfer the child to my arms and help me open my gown so that the child could suckle. As Lucrezia took my nipple into her mouth, she would caress my breast or the folds of the fabric around it. Mother would see this and sigh. "There is no sweeter love than this."

We passed the New Year of 1483 with much merriment, but by May I had taken ill with fever. It began as a strange malaise, which followed the news that Lorenzino di Pierfrancesco's wife, Semiramide, had delivered a son. Giovanna, who was now with child yet again, saw

this as the manifestation of a strange jealousy and suggested I find myself pregnant once more to stave off any further bad humor.

"It is too early for such an event," I argued as my fatigue continued. I desired neither food nor drink, and when I retired to bed I was soon consumed with fever and pains.

The Ciardi called in a physician, who confirmed that I had no signs of *la moria*. "But she is losing her milk, and a wet nurse must be hired to nourish the child."

A woman whose child had just died was employed to take over Lucrezia while I slept, shivering beneath my covers. When Mother heard the news of my malady, she came quickly to my bedside and brought the remedies of my childhood: savory broths and refreshing juices and even an infusion of willow bark. Madonna Ciardi welcomed Mother and seemed to take no offense at my preference for her.

"That is her way," Ciardo once said when I had despaired of his mother's aloofness towards me.

"Madonna Ciardi shows her concern through Giovanna and Ciardo," Mother explained. "Their kindness is her kindness."

Following the crisis of my fever, I was able to see the wisdom of my mother's words. Madonna Ciardi made certain that every servant saw to my comfort; and after my recovery, she began to speak to me with a new candor. She invited me to assist with the harvesting and pressing of the olives at the end of summer. I was, once again, invigorated by life and by my child, who had now returned to me. Teresa, the wet nurse, stayed at Villa Tavola throughout the summer and autumn. I no longer saw her as a threat to Lucrezia's love, even though it was now her breast that the child craved.

But with my renewed vigor also came thoughts of Sandro and Florence. Filippino wrote to Mother regarding a competition to find a painter suitable to finish Masaccio's frescoes at the church of Santa Maria del Carmine. This was the church of Father's Order, and it was Masaccio who had inspired my father to become a painter while he was still a novice monk. Filippino had decided to enter his drawings for the completion of Masaccio's *Life of St. Peter* in the Brancacci chapel. He also reported that Sandro had chosen to paint his *Pallas and the Centaur* on canvas instead of wood, and that Giorgio Vespucci had

commissioned a panel to honor his former pupil, Lorenzino, and his young wife, Semiramide.

"It is a long, horizontal panel of Venus and Mercury, but I dare say the Mercury looks more like Giuliano and the Venus like Sandra! I wonder what Semiramide thinks of this face that is always in Sandro's vision!"

My desire to go to Florence and sit for Sandro was greatly aroused by Filippino's letter. Finally I wrote to Via Nuova to express that same desire to Sandro, hoping he would have cause to do another Madonna soon. I explained that I had a wet nurse and could bring Lucrezia so that he would see I was instilled with all the virtues of motherhood. I knew Sandro admired the bonds of maternity. But he did not respond to my letter.

There was no news from Florence until Filippino wrote at Advent. The commission to complete the Brancacci chapel at the Carmine was his! The acclaim for his *Saint Bernard* and the frescoes for the Signoria, in addition to his more current work on Lorenzo de' Medici's villa at Spedaletto, had enhanced my brother's standing among the master painters of Florence. Both the canons of the Carmine and the members of the Brancacci family had agreed that Filippino Lippi was the master "who could best accommodate Masaccio's style while honoring those themes that had been laid out for the chapel."

I found it odd that the Church that had both nurtured and persecuted my father had now chosen to honor his son. Such honor glowed brightly in those final autumn evenings in Prato. The pink and yellow sunsets beyond the surrounding hills showed barely a hint of winter. I spent those days in serenity with Lucrezia and gave her happily to Teresa, although she now had begun to eat soft porridge and dumplings. But because there was a certain aching in my breast, I began to indulge the child more than a mother should.

"Methinks it time for a brother or sister for Lucrezia," Teresa observed. Even Lucia, the housemaid, agreed, having brought back from Giovanna the same sentiments, which she heard during her visits to Casa Vannozzo.

"Giovanna wishes you to bear a child close in age to hers who will then know the joys of friendship that yours has been!"

But I thought not of another child. I thought only of my Lucrezia and, with a sporadic passion, of Sandro, who now busied himself by honoring the niece of Simonetta. At night, when I stroked Lucrezia's brow and sang her favorite songs, I would look to the stars and think of the loved ones who had left the earth. I knew that Simonetta's star still burned brightly in the heart of Sandro. He was reliving his early days by painting Semiramide. And yet, I felt certain, it was I who should be the figure for his next Venus.

15

Venus Rising

—Winter of 1484 to spring of 1485

*O*UR CHRISTMAS WAS QUIET AT VILLA TAVOLA, although Filippino did break from his work on the Brancacci chapel studies to visit Prato for Epiphany. He seemed well, but looked pale from his long hours both in the bottega and in the damp chapel at the Carmine. He mentioned that, although most of his cartoons were completed, he would not call in the plasterers until the cool weather had passed.

He spoke also of Sandro's welfare and his displeasure at the Pope's lingering debt. He finally had to employ Amerigo's brother, Antonio, as a notary to empower his nephew in Rome to collect on the payment Sixtus still owed him for decorating the walls of the Vatican chapel. I recalled the studious Benincasa, who now worked at the counter of the Salutati bank, and agreed that if anyone could confront the Papal treasurers it would be he!

But Filippino had little else to report about Sandro, except to note his fulfillment in painting the pagan figures that appealed to his newest and most ardent patron, Lorenzino di Pierfrancesco. I have to admit that a strange jealousy possessed me when I heard this news. It followed me into the marriage bed, where I yielded to Ciardo more enthusiastically than before.

172

Before the chastity required of Lenten Season overtook us, I had conceived another child. This brought great joy to Villa Tavola, my mother, and Giovanna. Meseems my own contentment was a pragmatic sort of bliss. Lucrezia was well and beginning to babble and explore her world. The Ciardi's profits brought good meats and cheeses to our table and a fine damask to cover it. The best wools and linens made my gowns and surcoats, and satin ribbons adorned my hair.

Mother, Vincenza, and Riccardo continued to thrive at Via delle Tre Gore, and Vincenza's first son, Giorgio, was now a fine youth who could assist his father. He often escorted Mother to visit me at Villa Tavola. Still there was a distant joy I beheld but could not touch: the forbidden joy of Sandro's love. Perhaps it was forbidden to any woman he might know. Perhaps that is what made it so desirable.

Giovanna was delivered of a second son in that spring after the New Year of 1484, and I emerged from the early malaise of my pregnancy. Lucrezia's footing became steadier as she toddled about the grounds of Villa Tavola, often falling in the loggia or the courtyard. This distracted me from Ciardo's preoccupation with a male heir. Lucrezia, unaware of men's desire for a son, sought to please her father by saying "Babbo" and pulling at his doublet or hose. Then he would lift her gently into his arms as though cradling that delicate guilt of preference for a male child. At such moments, I could not but think of the sensations a female remembers from a loving father. They are memories she carries with her into womanhood. For myself, I could recall my own father's quick affection for me as I crawled on him at supper or followed him from room to room. Even during his last days in Spoleto there had been the delight of his caress, of pressing against his great chest and hearing the resonance of his voice as it penetrated my ears.

Mother had once told me that "a man owes his son a good name and honorable trade, but a father owes his daughter the gentleness of his heart and hand. It is worth as much as a good dowry, for it comes to fruition when she cares for her husband and children. Thus the circle of kindness is completed for all men and their sons."

"Just as any benefit we may confer," I heard myself murmur. I was thinking of the continuous dance of the Three Graces. I was thinking of *The Forest of the Hesperides* and Venus, and I was thinking of Sandro.

I sat myself down with quill and parchment and wrote to Sandro under the guise of announcing my pregnancy.

When I expressed to Giovanna my dismay at receiving no immediate reply from Florence, she smiled and sighed. "Well, do not think of it now. You are much too big to pose as any Venus."

"But this is the very figure Sandro would embrace for his goddess of love!"

Then Giovanna grew more serious. "You would not dishonor Ciardo in your condition, would you? I mean, if Sandro were to come this way as he did before and ask you to sit for him."

"Perhaps," I murmured, and this caused her both confusion and surprise. "Did Plato not wish for a new republic where a woman's virtue might equal a man's?"

Such ruminations were not appreciated by any of the Ciardi, not even Giovanna, who seemed to be taking on more of the piety of her mother with every child she bore. Platonic ideals passed over such people like a shapeless cloud that meant no more than a hundred other clouds that might bring rain or block the sun. The mention of any truth apart from Scripture or a Tuscan proverb was as foreign to them as Ficino's Greek. The language of the Ciardi was the language of survival, not loftier ideas that might improve one's lot—yet Giovanna, before being brought to earth by marriage, had aspired to Petrarchan love. And in her affection for me, she decided not to question my fascination with the Ancients.

Throughout that summer, as my body blossomed and Lucrezia acquired a command of speech, Mother took care to pass on to me my brother's reports from the Carmine. His letters had never been so prolific during other great commissions. By habit, he would work from dawn to dusk, but he knew that his news of this work would be dear to Mother, as it centered upon tales of our father's early days at the monastery of the Carmine.

An elderly Carmelite monk, upon hearing that the painter finishing the Brancacci chapel was none other than the good Filippo Lippi's son, started bringing Filippino bread and cheese and wine at midday while speaking his remembrances of Father.

"The old man says he was a sprightly youth, not inclined towards

the ways of the Church, but eager to partake of the instruction in the arts which it did provide. The Brother recalled the many hours Father sat aside the great maestro Tommaso Masaccio and watched him paint these very walls. Father was in such a trance, he was often late for prayers. Later, when Father came into the service of the great Cosimo de' Medici, he would hazard to leave Palazzo Medici by night in search of some merriment, usually in the form of a woman! This so delayed the completion of his commissions that the good Cosimo locked him within, in hopes he could stay to the task. But Father, then more athletic, was compelled to 'freedom' by wooing a maidservant to bring him shears so that he might cut his sheets into strips and make a rope for lowering himself out of the palazzo's topmost windows!"

I was surprised that Filippino wrote such reports to Mother, but I soon learned she was as amused as we by the antics of our father, especially since she knew many of them already. Filippino also told of meeting an old woman who remembered our grandmother before she died. She could recall our grandfather's butcher shop and the aunt who had taken Father in when he was orphaned.

In this way I came to learn of the cousins that I had never met who resided in Florence. Some made themselves known to Filippino when he worked at the Carmine. Many had been claimed six years earlier when *la moria* swept through Florence, some say as God's wrath against the vengeance of the Medici. But there were also the sons and daughters of our mother's older sister, Margherita, who had not taken in Mother or Spinetta when their brother decided to abandon them in Prato's abbey.

I asked Mother why we had never announced ourselves to these relatives on our visits to Florence, but she could only reply, "It would be false affection, would it not? Besides, I am filled with you and Filippino and my own household. And now there are the Ciardi. It is enough kinship for one lifetime."

Filippino wrote of other matters in addition to life near the Carmine. He had occasional news of Sandro and the Medici and even Amerigo. The remodeling of the villa at Poggio a Caiano had been postponed, partly because of the financial difficulties that had come to light when Lorenzino di Pierfrancesco tried to claim the funds of his

majority. To settle the affair, Lorenzo de' Medici had been forced to give over to the Pierfrancesco branch his farms of the Mugello and the villas of Trebbio and Cafaggiolo. As Amerigo was the agent of the Pierfranceschi, this widened the domain of his accounts.

Filippino made no mention of any family strife that these events might have caused, but I was well aware that much of the Pierfranceschi's pleasantry toward their cousins was superficial and "for the good of Florence"—so long as Florence was in the hands of the Medici.

"But Amerigo is caught between his allegiance to both branches, especially now that Lorenzo's Academy is embracing the teachings of the late Toscanelli. Amerigo even has a copy of one of Toscanelli's maps, showing a world beyond the Antipodes and a possible route to Asia going west by sea! Imagine Amerigo's former navigations being put to such a test!"

When I read these words to Ciardo and his parents, Madonna Ciardi frowned. "I must claim ignorance or disbelief."

Giovanni Ciardi grimaced and tried unsuccessfully to withhold a belch. "If there be a world beyond the Antipodes, then let it be cursed!"

"But not if it is filled with spices and minerals and the makings of dyes. These would be a blessing to us and to *you*! Look to the boon of Marco Polo's travels and tell me they were cursed."

Ciardo smiled in agreement and pride at my clever musings—but I cannot say if he gave any more thought than his father to their possible wisdom. Although life was pleasant at Villa Tavola, one had need of intellectual dialogue to illuminate it. Still, I decided to say little on behalf of any philosophy or my brother's creative letters. Instead I settled into the final days of carrying Ciardo's hope for a son and tried to keep my soul close to the earth and not in the clouds of Antiquity.

It was in the cool abundance of autumn that the child was due to come into the world. I felt strangely weak and took to bed, where my travail quickly began. The midwife arrived to assist me at the same time as my mother and Giovanna.

"No sweeter love than this!" I heard myself breathe with each paralyzing wave of pain. Again I could not distinguish exultation from agony.

The hot expulsion of the child burned within me, and soon I saw the tiny infant gasping, as I did, for air.

"Give me my son!" I reached for him, for I saw that it was a male child and my heart was gladdened for Ciardo's sake, but the midwife's hands shook nervously to unwrap the cord which I could see pulsating about the tiny neck and head. The child's own life blood was strangling him. He did not cry, and it was as though he had not been filled with enough of this new world to want to greet it. The midwife struggled desperately, but there was only one final gurgling sound. I sat up and looked hard at the child, thinking of Lucrezia's rosy color and how unlike it his greyish-purple flesh was. He had a well-formed face, like Ciardo's, but he barely quivered. Then, like the grey of well-veined marble, he grew colder and colder, until he was lifeless in my arms. A little statue he seemed as he lay there. Even the cherubs of Donatello's pergamo were filled with more life than he.

The child had lived too little to show even the struggle for life on his sweet countenance. The midwife cut the cord and cleaned and wrapped him before returning him to my arms. I wept and rocked him like a floppy doll, and I had an odd remembrance of my first doll, Caterina. She had been stolen from me by a thief. That was not unlike this mindless hand of death.

We named him Filippo and buried him the next day in the Cemetery of the Innocents at San Domenico. Ciardo led the small funeral cortege while I remained at Villa Tavola. I was too weak from my travail and too overcome with grief to watch the tiny, swaddled body be laid into its grave. Mother and Giovanna did their best to comfort me. I tried to fill my empty arms with Lucrezia, who did not understand what had become of the "nino" growing inside of me.

Still, there was a young hope in me that half-expected I might recuperate from this empty birth. The flesh heals easily in comparison with the spirit. And in her efforts to console me, Mother recalled a severe cut she had suffered as a child.

"The wound closed fairly quickly, but the horror of the blow still comes to mind."

"Would that I had a piece of flesh to give in place of a child." I felt like accusing her of trivializing my sorrow.

There arose between us an awkward silence which lingered throughout the dark winter that followed this most painful season of my life.

I spoke very little to anyone save my servant, Lucia, and Lucrezia, whom I spoiled to assuage my guilt and anguish. Had I not nurtured this male child properly when I was carrying him? Had my thoughts centered too much on literature and Antiquity? Tuscan folklore taught that as soon as life was felt within the womb, a woman's thoughts could encourage or discourage the vigor of her child. But I had argued with Ciardo that a woman disposed towards more scholarly interests might then produce a child with good intellect. Was this not desirable in a son?

Such arguments only served to drive me further away from the husband I had been so reluctant to love. I directed all my affection towards Lucrezia and even began to nurse her again with the new milk that had been lost to little Filippo. She took this milk eagerly, with the surprise of a child who has been denied an occasional sweet and then is suddenly offered a new confection even sweeter. I could see that Madonna Ciardi frowned on this, as did Lucia, who said nothing. Ciardo eventually became most disdainful. But after a few weeks, the joys of other tastes and textures and the friendliness of the faces that offered them were soon of more interest to Lucrezia than my constant breast. Thus, my only child began to refuse me just as I refused her father.

Indeed, Ciardo made few overtures to me after the loss of Filippo. Even once the proper length of chastity had ended, he lay beside me in what had become our solemn tension of neglect. By day we spoke politely about the house and delighted in the antics of Lucrezia, but we were separate in our delight. The greatest sign of Ciardo's displeasure was at table, where he began to eat off his own plate and instructed Lucia to bring me my own. I had always found the custom of sharing one conjugal dish to be a pleasant reminder of being one in flesh, but since we were no longer, I accepted my separate plate with no question or protest.

Ciardo's mother sensed our sad discord, and the result was a new enthusiasm, but she tried to draw us out in a manner so unlike herself that it caused discomfort to Ciardo. I merely resented the fact that she should demand our cheerfulness, but later I could see that she was not demanding, only hoping in her own misdirected way.

Ciardo's father reacted to all this with a new soft-spokenness: he became more cordial and passive than he had ever been before. This,

too, I resented for its falseness and helplessness. It was difficult to see a man of his demeanor become so emotionally powerless. Alas, when I had had enough of my own heartache and theirs, I decided the best thing to do was to take my leave of Villa Tavola.

I had thought to go to Florence and stay with Filippino, but with the warmer weather approaching, I knew he would be working heavily to lay the pigments for the frescoes of the Brancacci chapel. His sunrise to sunset schedule would only leave me wanting for companionship. But Sandro was in Florence, and the thought occurred to me that I might sit for him again. At this same time, news of my disposition had traveled from Mother to Filippino and then to Via Nuova.

It was only a week after the New Year of 1485 when Sandro wrote to me in his unpredictable way. He reported that his good patron, Lorenzino di Pierfrancesco, had decided to move the panel of the *Venus and Mars* from his townhouse on Via Larga to Castello, where he and Semiramide spent most of their days. He had requested that Sandro make another painting of the Venus, "in which she was the singular focus," and which could serve as a counterpart to the *Venus and Mars*. Sandro had suggested an illustration of Poliziano's "Stanzas" describing her birth from the sea. This had appealed greatly to Lorenzino, who still admired his former tutor and who wished to honor his talent for verse. He also found it a fitting tribute to the ancient Greek painter, Apelles, whose *Venus Anadyomene* had been lost for centuries.

Sandro wrote, "At last I have found a patron for a Venus arising from the Aegean sea! And I can think of no less mortal face than yours, Sandra mia. Come to Florence and sit for me, if you can part with your little one for the season. Your brother and I welcome you!"

I made haste to reply, and wrote my intention of bringing Lucrezia with me, as she was still a great comfort. I planned to bring Lucia to act as her nursemaid when I was indisposed, although I had not yet inquired whether this would please or displease Madonna Ciardi. As soon as I had sent the letter, I disclosed my plans to Ciardo and his family, and everything was agreed to on both sides. But I could tell that Ciardo consented reluctantly, for he had always disapproved of my sitting as the Venus "rising from the sea."

"I fear Lucrezia may be alarmed by the sight of her mother in some state of undress."

"I am neither ashamed of the subject nor of the honor of serving Maestro Botticelli in his finest hour!"

"Meseems that every time you sit for him it is his 'finest hour.'" Ciardo scoffed. It was the first sign of jealousy towards Sandro that I had ever sensed in him.

Sandro wrote that he had agreed to accompany his *Venus and Mars* to Castello to oversee its hanging and would be pleased to meet Lucrezia and me there, if it suited our escort. He assured me that the child was welcome and that Semiramide had two nurses to accommodate her children and "any others."

The thought of seeing Lorenzino di Pierfrancesco again under these circumstances stirred me to both apprehension and excitement. Would it be uncomfortable for me to see him with Semiramide? Would it be difficult for him? We had not met since before his betrothal, and certainly not since either of us had married.

When I suggested these plans to Ciardo he was more bitter than ever, having recalled the younger Lorenzino's once "courtly" claim to me. And when I mentioned the presence of Semiramide's nurses, he surprised me with the remark, "Yes, I have heard that Lorenzo's bride has more than compensated for the barrenness of her Aunt Simonetta. A child every year . . . and sons! Meseems she serves her husband well."

"Perhaps he *treats* her well!" I flew out of the room in distress.

On the morning of my departure, Ciardo decided he could not escort Lucrezia and me and instructed one of his grooms to ride with us to Castello. I knew it was out of heartache that he refused, but I could not deny him that. When Lucrezia danced into his arms to bid him farewell, he kissed and caressed her profusely, and I had to turn my eyes away, not out of spite but to conceal the tears that filled them.

The meadows and trees of Il Vivaio stretched before us with such splendor that morning, and the air moved so fragrantly with the April breeze, that soon my sorrows were almost overcome. I saw God's beauty engrained in every plant and stone, and for the first time I felt able to forgive what He had taken from me. I held Lucrezia's small body next to mine on Sopraccigliotto, and Lucia rode on my horse's

daughter, a spirited mare. She was a good match for her mistress! We dismounted at the gates of Castello, where two grooms greeted us and led the horses towards their stables. Our escort refused the offer of refreshment and returned to Prato.

A house servant directed us around the villa to the courtyard behind which Sandro and our hosts awaited us. As Semiramide rose from her chair, her fine linen gown fell gently about her tiny body. She was indeed petite and had the flat, round countenance that Sandro had captured so well in his *Forest of the Hesperides*. The constant blush about her face was most becoming to her, but she was not as timid as she initially appeared.

"Welcome to Castello, Madonna Alessandra. May I say, you are truly my Aunt Simonetta's equal!"

She spoke with such genuine warmth and enthusiasm that I was immediately drawn to her in spite of my distant jealousies. Her small child and infant were with her, along with their nurses, and I noticed how intrigued by them Lucrezia became. She seemed to prefer the infant over the child closer to her age, while the nurses doted over Lucrezia and called her "little rose petal from Prato."

At that moment, Sandro emerged from inside the house, where he had been speaking with Lorenzino. Lorenzino was still in fine form, although his hair was cropped shorter than in his youth. He wore a brown tunic and saffron doublet with saffron and brown hose. Sandro, though without his favorite ochre cloak, offset Lorenzino's colors with his almost purplish blue. I embraced him and thought of the corn-flowers in Castello's lower garden, which Lucrezia now explored with Lucia close behind. Sandro was as fleshy as ever but still a commanding form.

"Can you see how well I eat at my good patron's table?" he began as he clapped me between his arms. "Castello is just the place for a pale mother to be transformed into a robust goddess!"

I took his jesting with a slight blush, and then marvelled at how a brief embarrassment had done more to return the pulse of life to me than blatant praise had.

"Our chef has been instructed to prepare whatever pleases you, Alessandra." Semiramide smiled, and Lorenzino nodded almost shyly.

As I excused myself to retrieve Lucrezia from the cornflowers, I heard Lorenzino murmuring to Sandro so that his wife might not hear. "Your goddaughter is lovely even in her sadness." I turned in time to see Sandro nodding with a proud but sympathetic smile, and once again I felt jarred by my forbidden desire for him even as I struggled with my lesser feelings for Lorenzino. Yet these feelings were a sign of my returning vitality, so I em-braced them quietly. In one afternoon, I would experience a range of emotions I thought buried forever, along with my dead child.

I feasted for the next two days at Lorenzino's and Semiramide's table and found myself liking her more and more. Sandro entertained us with tales from his bottega and the most recent exploit of his gar-zone, Biagio. It seemed that Biagio had undertaken a tondo of a Ma-donna and angels much like Sandro's *Magnificat*, and the patron was a member of the Signoria who had been brought into the joke.

"The good citizen had offered six florins for the tondo—a hand-some sum for any garzone. And accordingly, on its completion, Biagio hastened to the man's house to bring him back to Via Nuova so that he might see the tondo in a good light. While Biagio was away, my other garzone Jacopo and I made eight red paper hats, like those worn by the Signoria, and we affixed them to the heads of the angels with some wax. Of course, I had forewarned the good citizen of some tem-porary alteration and advised him to act as if he saw nothing wrong. You can imagine Biagio's face when he returned with the patron and looked upon his Madonna and Child seated among our makeshift Signoria!" Sandro gestured widely with his wine glass and was red with mirth.

"And what said Biagio?" we all asked.

"He was about to cry out in alarm when his patron began to praise the tondo and Biagio's efficiency. Thus Biagio was forced to quiet himself and they left to finish the transaction, while Jacopo and I removed the caps and prepared the tondo for transport. We were in as great a fit of giddiness as Biago, who thought he had seen some divine message!"

Although the laughter of the tale restored my spirits, I continued to wonder at the lengths Sandro would go to for a moment of mirth.

182

The next evening, we spoke of Sandro's plans for his *Venus Anadyo-mene* and his hope of depicting a pagan goddess as a devotional theme. Lorenzino glanced my way and spoke of his tutor, Marsilio Ficino. "He once wrote to me that 'By her beauty, Venus shows to man her true divinity. . . . She is humanity born of Heaven. . . . Her eyes are Dignity and Magnanimity!'"

"Then she is not a Florentine!" Sandro roared, recalling Dante's assessment that his countrymen were "miserly, jealous, and proud."

"Then we are blessed that Sandra is a Pratese."

Lorenzino turned to Semiramide and said, "Take our jesting not to heart, dear wife, for Ficino also wrote to me that 'humanity itself is a nymph of excellent comeliness who would make all your years sweet.'" When he took her hand, the tenderness between them caused my heart to swell in both admiration and remorse.

Perhaps Sandro recognized my melancholy, for he quickly inter-jected his praises of my father, "who first depicted a comely Madonna with that virtue which is beloved by God. What a blessing for man-kind!"

"Beauty can be a curse as much as a blessing." I was no longer able to contain my bitterness.

"Certainly it has not been a curse for you, Sandra!" Semiramide looked astonished.

"I imagine it is a curse for a husband who must share his prize with others," Sandro added thoughtfully.

"But a husband would exult in such a prize." Lorenzino gestured towards me specifically and then pulled his hand back with chagrin.

"Exult in the 'prize' but not in the wife," I replied, yet I could see they did not understand the extent of my remark.

At this juncture, Lucia walked Lucrezia towards me so that I might kiss her good night. I took her into a fond embrace and caressed the golden curls above her brow.

"Shall you live to paint this Venus, too?" Lorenzino asked Sandro, as he reached out to touch the child's hair.

Sandro took Lucrezia's supple hand in his and shook it until she said, "Babbo Sandro," much to his delight. Then he murmured:

"If I am not blind by then."

"Come, let us kiss the children all good night and then take a walk through the groves beyond." Semiramide was anxious to keep our words upon a pleasant course.

In the setting colors of the day, we toured the grounds of Castello and reveled in Flora's blessing upon the earth.

"Careggi is nothing like this," Sandro whispered to me in the sweet night air. "But as a Medici villa, it has its own charm." He was careful not to speak aloud of those things dear to Lorenzino's powerful cousin.

But I no longer thought of rivalry.

"Sandro," I said, "the splendor of any place lies in the affections of those who reside there."

16

Venus Arriving

—Summer of 1485

AFTER THAT SHORT STAY AT CASTELLO, I FELT
I could reclaim my memories of my first visit there. I was
eager now to see my brother. Sandro was eager to return
to Florence and begin work on the Venus, as Lorenzino had just pro-
vided him with enough florins to purchase the canvas he would paint
it on and most of his pigments. Lorenzino bade us farewell by remark-
ing on Sandro's good fortune to have Simonetta "reborn" in his own
goddaughter. Semiramide showed no annoyance or jealousy at her hus-
band's comment and merely said, "Nothing is too difficult for God."

It seemed we had barely made our way on the road from Il Vivaio
when we came upon the cobblestones that would lead to Porta'a
Faenza. When Lucrezia saw the city gates and the view of Florence
beyond, she became as animated as I had been on my first arrival there.

"This is the city of Nonna Lucrezia," I told her, as she squealed with
delight and snuggled closer to me in the saddle.

After we had settled in at Filippino's, Sandro took his leave for Via
Nuova, saying he would send one of his garzoni to call for me the next
day. I suggested that perhaps Filippino could escort me on his way to
the Carmine, but Francesca quickly interrupted us by bemoaning my
brother's unrelenting schedule.

"You'll be awakened too early even for the dead if that is your pleasure, Madonna. It's sun up 'til sundown for Maestro Filippino!"

"But perhaps he would leave a little later, since he knows Lucrezia and I are here."

"Pffff! Your brother is too busy trying to impress his patrons and the Canons of the Carmine to attend to family concerns." Francesca became dramatic. "If you ask me, if he doesn't slow down and eat something he will be spending this splendid fresco season in bed while I am relegated to nursemaid!"

"Can you not have him tend better to his health?"

"Pray, Madonna Sandra, I am not his *wife*!" I nearly laughed, for she was surely not the picture of anyone my brother might be attracted to.

"But my own Lucia, here, often has more sway over Ciardo's conduct than I." Only then did I realize that I had not uttered my husband's name for three days.

Lucia smiled gratefully at this tribute and then took Lucrezia upstairs for a nap. Sandro looked eager to take his leave of this family squabbling and remounted his horse. I soon decided to join my daughter and took her from her little bed to lie with her in the larger guest chamber. I suddenly felt as tired in my heart as I was in body, and was glad to doze lightly here in the house I considered more my home than Villa Tavola.

When Filippino arrived that evening, he looked tired but happy to greet us. His spirits, he said, had been invigorated by the acclaim he had received after unveiling his completed fresco of *The Raising of the King of Antioch's Son*.

"Both the Canons and Signor Brancacci were very pleased with my blending from Masaccio's style. And now I am free to do the other stories from the life of Saint Peter, and they will be entirely by my own hand!"

Filippino was clearly consumed by this recent commission: he felt he was somehow atoning for our father's sins by surpassing the work of Masaccio at the Carmine. But what of the sins of those Carmelite canons who had ordered Father's inquisition? I wanted to raise that subject but knew I would need to wait until we were alone. Yet even after Lucrezia was put down for the night, and the others (Lucia and

Francesca and Filippino's two residing garzoni) excused themselves for bed, I chose not to discuss the matter. I knew that Ciardo had passed this way when he was in Florence the week before, and Filippino seemed as eager as I was to speak of him.

"Ciardo is most remorseful, Sandra," he began with a weary sigh.

"What man isn't after the loss of his first son?"

"But his remorse is not for the child alone. He regrets his recent treatment of you."

"Has he confided this to you?" I must confess I was astonished.

"It's always easier for a man to tell another man his woes and follies."

"Ciardo withholds his heart from me."

"He knows you need more from him than the comforts of Villa Tavola."

"But some things he cannot give me."

"Sandra, Sandra. Do you not see the anguish of a man who understands so little of your passions and cannot partake of them? Ciardo is a merchant who reads ledgers, not Dante or Petrarch. He knows not the mysteries of the Ancients or the stories that Sandro wishes to illustrate . . . especially those in which his own wife's figure is to be glorified."

"But he agreed to that on our betrothal."

"An agreement on paper is never reality."

These words, spilling from my brother's most sensitive tongue , did indeed make sense of Ciardo's hurtful disregard for me. For the first time, I thought of Ciardo's pain as well as my own.

At sunrise, I was awakened to see if I wished to ride to Via Nuova with Filippino and his newest garzone, Niccolo. I gave Lucrezia to Lucia and kissed her good-bye for the day, then dressed quickly and mounted Sopraccigliotto. Niccolo was happy to lead, as he did not have a horse of his own; and he, who was two years younger than myself, seemed to watch me with a ferocious fascination. Niccolo spoke very little as Filippino and I rode through the awakening streets of Florence.

At the junction of Borgo Ognissanti and Ponte Nuovo, Filippino decided to let Niccolo escort me to Sandro's bottega while he and his first garzone continued across the Arno in order to arrive at the Carmine in good time. He instructed Niccolo to catch up with them quickly,

and his assisstant agreed to the assignment with great enthusiasm.

"If I am detained this evening, I shall send someone to escort you home!" Filippino called as he began to cross the bridge.

When we reached Sandro's door, Jacopo bade me enter while Niccolo hastened away to rejoin Filippino. He only looked back once as I waved to him, and I might have thought nothing of it had he not had such a look of longing upon his countenance.

I entered the bottega in front of Jacopo, and Sandro approached me from the side of the room where he had set up his vellum and charcoal for the sitting. My senses were filled with the smell of simmering glues and gesso and varnishes, and the sight of Sandro's serious pupils grinding pigments or mixing them with linseed oil and egg yolk. At that moment, I marveled at how much a painter and physician had in common, as one depended on the elements of the earth to render life and likeness to a surface while the other used the same elements to restore life to the flesh. And as I thought these things with great admiration for the skills required, my love for Sandro seemed to quicken from a dim flicker to a lively flame.

When I told Sandro my analogy and asked him, "Do you ever think of yourself that way, as a sort of physician?," he smiled and gave me the covering I was to wear.

"I will if I can bring some life back into that lovely face of yours!"

I went behind his dressing partition to change into the sheer gown. "Oh, you mean the one that is not 'mortal'?"

I could hear his garzoni, Jacopo and Biagio, chuckling in one corner, and I was proud that I had brought some simple mirth to this so called "workshop of idlers." When I emerged in my thin covering, I was tempted to inquire if Sandro intended to paint a nude or a covered Venus, but I restrained my question for the time as he reached up to unwrap my hair. He wanted it to cover me as much as possible, hanging so that I might press the "golden tresses" to that part which Poliziano had called "the apple of sweetness."

I was instructed to stand atop a wide, round stone that Sandro had brought in for this sitting. It was to take the place of the giant scallop shell on which the newly risen goddess would ride "on the froth of the sea."

188

Sandro stepped up to the stone and bade me hold myself in contrapposto, with my head slightly turned in the direction of my right foot while the rest of my body turned and rested on the weight of my left foot. He sketched me this way for nearly an hour and then was content to rest, while he brought in his models for Zephyr and Chloris. They were to stand beside me on a small platform in order to appear to be hovering above the water. They were the same models Sandro had used for *The Forest of the Hesperides* and since that time, the two had become lovers. Their names were Enrico and Gianna, and they made no effort to conceal the truth of their intimacy.

"It was inevitable after clinging naked to Chloris for so many hours!" the young Zephyr declared. Both had taken on the names of their mythological characters all too willingly.

When Sandro was ready to work again, Chloris stood poised under the left arm of Zephyr in order to appear carried by him. Her weight was partially suppported by another hidden platform with a cushion. Sandro sketched them at a slight tilt for his cartoon so they would appear to be moving in the same direction as the wind, which was "blowing" me to shore. It was difficult not to laugh every time Zephyr formed his most earnest countenance with inflated cheeks. Finally, and by Sandro's own good humor, we were allowed to laugh at intervals while he worked.

We adjourned promptly at midday with the bells of Ognissanti to sup at Mona Nera's table upstairs, as Sandro always took both his health and his nourishment very seriously. I worried only once that Lucrezia was being fed properly (as I was), but I knew that Lucia and Francesca had undoubtedly spoiled her by now with cakes and other sweetmeats.

Later that afternoon, after only another hour of posing, there came a knock at the bottega door. Biagio opened it to a youth not more than thirteen, accompanied by a young boy of ten or eleven years.

"Maestro Filippino Lippi has sent us to escort his sister home."

Sandro motioned to Biagio who bade them enter, then asked, "And who might these young idlers be?" as if he already knew them.

Biagio covered me with a nearby mantle, while Zephyr and Chloris pulled their flowing cloaks about their naked limbs. I stepped off the

stone to meet my brother's messengers. The eldest boy introduced himself as Francesco Granacci, a pupil interested in painting who had been watching Filippino at the Carmine. His younger friend was named Michelangelo Buonarroti, but was called "Angelo" by his companions.

"You might recognize him as the figure of the kneeling boy whom Filippino painted to finish Masaccio's fresco of *The Resurrection of the Youth*." Sandro explained.

"Ah, the Brancacci frescoes." I nodded, although I was embarrassed to admit I had not yet seen them.

The young Angelo dropped to his knees. And *you*, Madonna Alessandra, are the *Madonna of the Magnificat!*"

"Have you seen it?"

"My father took me to Palazzo Medici when we first came to Florence. He had some business there and I saw it in the chapel of Madonna Clarice. It is truly a fine tondo full of angels!"

"Meseems you and your companion would both make perfect angels, would they not, Sandro?" The young Angelo laughed aloud, and Sandro chuckled.

"Ah, Francesco wishes to paint more than pose."

Then I turned my attention back to Angelo. "And what of you? Do you wish to take up my brother's and godfather's trade?"

Angelo shrugged at first and then replied, "I have been sketching some at home but do my best at chiseling stone. My father says this is because I was nursed so near the quarries at Settignano. For now, I am busy with my studies, to learn some Latin and possibly Greek." He was both animated and serious as he spoke.

"Getting groomed for the Medici Academy some day!" Sandro interjected as he wiped the charcoal from his hands.

The two boys examined his sketches while I went to dress and have Mona Nera help me wrap my hair. In due course, I emerged as well groomed as I had arrived, and stepped out with my escorts onto Via Nuova.

"Another sitting here and then we go above Forte di Belvedere!" Sandro called to me as I mounted Sopraccigliotto.

"For what purpose?" I was busy arranging my skirt about my legs.

190

"The winds! Your hair and Zephyr's cloak! I must draw them truly as they are blown, as if to shore!"

I had forgotten the importance of the wind, which blew more fiercely at that point above the city, so I rode back to my brother's house filled with anticipation while speaking to my two young escorts on the subject of my father's work and how it had influenced both Sandro and Filippino. I spoke also of Prato and its green marble quarries, and the young Angelo enthusiastically offered his impressions of Maestro Antonio Pollaiuolo, who preferred to work with the dark marble.

"Your brother is using Maestro Pollaiuolo's portrait in his next fresco. Did you know? He figures in the group of men depicted for *St. Peter Before the Proconsul*."

"Meseems you are more in tune with my brother's work than I! I had best hasten to the Carmine and inspect these frescoes. But I know why Filippino used Antonio's likeness. He was a friend of our father's, and he befriended Filippino when he first worked with Sandro. He was also Sandro's teacher for a while. Did you know that?"

Angelo nodded, and Francesco agreed with him that Pollaiuolo was a more gifted sculptor than painter. Then I asked the young Angelo how he became privy to seeing the tondo of the *Magnificat*, and he quickly gave me a moving memoir of the event.

"I was only seven, and it was shortly after Lucrezia Tornabuoni's death. My father had been the *podesta* of Caprese and had some cause to speak with Lorenzo de' Medici. He brought me with him so that I might see Donatello's incredible bronze *David* and *Judith Slaying Holofernes*. Have you seen them there?"

"Oh, yes, I do recall." I nodded, but then I lowered my voice. "It is the *David* that caused a bit of a scandal."

"Only because he is so beautiful!" The young Angelo beamed. "In any event, Botticelli's tondo was being moved. You see, I was not actually in Clarice's chapel, but it was being moved for some reason and I recall how everyone in the loggia stopped and kneeled as your figure of our Holy Mother passed by. I could never forget your face!"

That evening, when Filippino returned with Niccolo and his other garzone, Luigi, I told him of my pleasant escorts who made, perhaps, better entertainers than protectors. Filippino spoke well of them, even

though their constant observation at the Brancacci Chapel had annoyed him at first.

"I remedied this by making good use of them. Thus, Francesco was sent to run errands or messages and the young Angelo, who preferred to study my every move, agreed to pose as the son of King Antioch. I dare say, had we not been working in a House of God, he would have stripped to nothing just to do his part!"

"To 'honor the divinity of beauty in humanity'?" I was quoting the scholar Ficino.

"I thought that was *your* good stead in life, Sandra."

"Sandro is taking us up to the Belvedere for the wind. You know, the wind is blowing me ashore—"

"Will you be naked then, too?" His inquiry drew the attention of the ever-curious Niccolo.

"No more than I was today, in a sheer gown—not far from the stove where they boil the gesso. All that heat and still he kept me dressed!"

"I am surprised—Sandro has always been such an anatomist. But then, he has your modesty to consider. You are not a common woman. You are his goddaughter still." Filippino seemed relieved.

"But I would gladly sit for Sandro any way he wishes me to. It was my promise to him."

"Come, Sandra. Let us go greet Lucrezia and hear about her day." My brother was none too eager to discuss the virtues of nudity in art, not even in front of Luigi and the eager Niccolo.

The morning Sandro took us above Forte Belvedere, the winds were not fierce enough to blow my hair or Zephyr's cloak with sufficient force. Nevertheless he did some sketching and bade us not be distracted by the passersby on their way to the city gate. At midday, we stopped to watch a group of youths engaged in a casual Tuscan boxing match and partook of the meal Mona Nera had packed for us. The wind came up for a short while, but then subsided. Sandro decided to take us and his disappointment back to Via Nuova.

We returned by way of Palazzo Pitti, the most recent construction of note in Florence. The Pitti were a family whose wealth nearly rivaled

the Medici's and were rumored to have the grandest design of any residence in Tuscany. The hill into which the builders dug had become, most conveniently, the quarry for the Palazzo's stone.

Sandro laughed as we passed by the mammoth site full of workers and then murmured, "The stonecutters' frugality is only to be offset by the patron's extravagance."

From here, we passed by the Church of the Carmine to call on Filippino. He was high atop a scaffold when we first entered, and upon seeing us approach the chapel he climbed down. He instructed both Luigi and Niccolo to continue with the same pigments where he had been working. Niccolo acknowledged me with some nervousness and thereafter appeared quite distracted. I would have regarded this with some amusement had I not seen my brother take a weary breath of damp church air.

"Will you not rest one full day between now and the Sabbath?" I asked him, but he shrugged and began to wipe his hands. ThenSandro chided him.

"Lack of nourishment is your woe!"

"I trust you have taken your midday meal up into the hills with you?" To Filippino's mind, a serious painter would not think of food until he had finished for the day.

"Indeed! I do not wish to paint some pale Venus or a feeble Zephyr!" Sandro put an arm around me.

Although I welcomed the gesture, it seemed to cause Niccolo considerable consternation, and it interrupted his already slow work from the scaffolding. When I looked up at him, he smiled and then returned to his pigments. Soon I realized the disruption we had made in Filippino's progress, which would only delay his supper, so I suggested we take our leave and implored Filippino to arrive home at a reasonable hour.

That evening at table, Niccolo became more talkative and began to inquire about Sandro's illustration of Poliziano's verse.

"Did the winds not chill you terribly up on the Belvedere?"

"No, for they were few, and I have thus far bared neither belly nor breast!"

"Of course," he answered in embarrassment. "It was a foolish

question, but then, Maestro Botticelli has been known to defy convention."

"Indeed." Filippino gave a wry smile.

But this very question would prove to consume almost every man, woman, or child who viewed the finished canvas. The nudity of Sandro's Venus would appear both gentle and bold, a tribute to both the perfection and the vulnerabilty of the human form. Even Semiramide's children, when they saw the painting in their parents' bedchamber at Castello, would later ask me if I had stood "naked like that on the Belvedere for any passing traveler to see." Sandro, not wishing to reveal the secrets of his bottega, would reply that the goddess had been "an apparition in the likeness of Alessandra Lippi." And yet this "likeness" was to become the first great conflict in my service and my devotion to Sandro Botticelli.

It was during our next descent from the Belvedere, where the wind had cooperated sufficiently and made for a contented Sandro, that I confessed to Chloris my willingness to sit for Sandro without the encumbrance of a gown or camisole. She listened intently and displayed none of the usual maidenly alarm. Having taken a lover before marriage had relieved her of such a disposition—which was the reason I had approached her with so much candor. I was astonished, therefore, by her disapproving response, as though she were privy to something I did not know. She spoke of Sandro's desire to avoid "the rampant gossip of Florence" regarding any "unnatural affection" he might have for his own goddaughter. In response to this remark I could barely whisper.

"Methinks there be more *unnatural affection* in all of the Medici Academy than between Sandro and myself!"

But Chloris, well aware of that "higher love" touted by the Platonists, revealed that Sandro would fear an accusation of incest more than a suspicion of any other sort, even the idea that he was "intimately involved" with the beautiful young boys he hired to sit as angels.

When I returned that day to Filippino's house under Zephyr's escort, I began to speak of my discourses with Chloris and the reasons she had revealed for Sandro's desire to preserve my modesty. Zephyr

laughed suddenly and threw his head back while exhaling with the force of his "windy" persona.

"And did my lady love not mention that Maestro Botticelli has employed a courtesan to honor that portion of the anatomy he dares not let you show? Be assured, Madonna Sandra, this woman has not your face nor hands nor graceful feet, but her torso is sufficient for the form of womanhood that Sandro seeks to paint."

I felt a desperate burning in my bosom, as though my breasts had been defiled by their replacement with another's. My brain raced furiously in reaction to the unexpected news, and I was unable to speak.

17

The Finest Madonna

—Summer of 1485

T HAT EVENING I TOLD MY SORRY NEWS IN private to Filippino, who was quick to sympathize with Sandro. "But, Sandra, you must recognize the delicate position Sandro is in. He wants to paint a classic nude, the first female nude of his time, and yet he has his goddaughter, a well-bred, *married* woman, for his model. He wishes not to offend your kinship nor your modesty. Besides, it is not uncommon for an artist to use more than one model for the same figure. It is your face and hands and feet he wishes to capture the most."

"And so you find it more honorable for Maestro Botticelli to grace the walls of Castello with a goddess born of *my* face and neck and hair and hands, a goddess who would step from her shell on Alessandra Lippi's pretty feet while bearing the weight and torso of a common whore?"

So shocked was I at having uttered these words that I was unaware of the amazement on my brother's countenance. We both said nothing for what seemed an endless time until he lifted up his voice to my beleaguered soul with that protective love that he had always shown me.

"I doubt that Sandro would betray you or his idea of Venus with the body of a 'common whore.' Besides, such women, as you would call

196

them, have long been the only models available to some painters, so let us not speak ill of either trade. If you wish to confront Sandro on the matter, then do so with my blessing. But bear in mind what he has at stake with this painting."

"Meseems you deride the exaltation of the female form, yet no one questions the beauty of Donatello's or Verrocchio's *David*."

"Sandra, you know I find no scandal in the figure of the Venus. The scandal, good sister, is with your wishing to stand in a profane state for your godfather while your husband labors unwittingly in Prato!"

"The classical form cannot be profane when it comes from Scripture. Sandro is painting the Venus as the first Holy Mother to reign over land and sea. In her he shall make his finest Madonna . . . and that Madonna should be *me*."

At that moment, I pretended to find the matter settled and went to check on Lucrezia and Lucia. Filippino sighed and returned to his studies in his bottega. As we supped that evening, I could only think that I should do what my brother had suggested I do: confront Sandro! And I would not just confront him with my knowledge of the other model. I would confront him with my love! All those times before I had been thwarted by my own, young hesitation. Perhaps he only needed to know and to hear it from me. No more was I a hesitant maiden, but a woman of conviction and purpose!

Once Lucrezia had been bedded down for the evening and Lucia and Francesca were busily taking inventory of the larder for the next day's market, I summoned Filippino's garzone, Niccolo, to escort me to the nearby church of San Pier Maggiore for Vespers.

"It is only proper that a sister give good thanks for her child's health and her brother's hospitality," I told him while securing my summer mantle about my hair.

"But the church is not too far for you to bring your maidservant, Madonna." He was trying to be cordial. I could see he was inclined to retire for the day but also eager to win my favor.

"But it is near dusk and this is Florence, not Prato. Lucia shall be watching over Lucrezia's slumber and Francesca is occupied in the kitchen, and I would not disturb my brother now while he is finishing his studies. Besides, I shall be returning to Prato soon and will be

without your good company, Niccolo." I said this with as much charm as I could muster.

The youth's countenance briskly changed: he was flush with renewed spirit and energy as he donned his short cloak and went to inform Filippino of our "brief departure." But when I headed for the livery to fetch Sopraccigliotto, Niccolo looked confused by my need of a horse for a walk of two or three blocks. After I had mounted Sopraccigliotto, I explained that our true destination was Via Nuova. He shrugged.

"Indeed, Madonna Sandra, you appeared much too eager to be on your way to Vespers."

Niccolo led me out to the street and mounted Sopraccigliotto behind me. I turned my face to his. "Then if you knew I had some deception in mind, why did you not inquire?"

"Why, to question my patron's sister would be discourteous, and to refuse her company would be all the more foolish!" Niccolo now had a smile that was most inviting.

We said little as we made our way through the streets of Florence towards the quarter of Ognissanti. Those who passed regarded us with some curiosity, and when I remarked on this, Niccolo shook his golden curls and said that my beauty was the cause of their distraction.

"The bronze doors of the Baptistry are the only other spendid sight for those who travel this evening!"

I was suddenly taken by his new openness with me. I explained to him that I was seeking an audience with Maestro Botticelli just long enough to discuss some "urgent matter" regarding my sitting for the Venus. I instructed Niccolo to remain outside the house until I had finished my business. He nodded obediently as he grasped Sopraccigliotto's reins more tightly; then he dismounted at Via Nuova and led me down the street. Though there were few people about, it was not yet dark enough to require a torch. I dismounted two doorways before Sandro's house, barely noticing how tenderly Niccolo helped to steady my feet on the cobblestones.

Suddenly I saw a party of attendants appear with a fine litter at Borgo Ognissanti, the other end of Via Nuova. Because they were carrying it in our direction, I motioned to Niccolo to lead Sopraccigliotto back a few doorways, while I hid myself partway in another. A woman in a

magnificent purple cloak emerged from the litter directly in front of Sandro's door. I could not see her face, but the finery with which she traveled suggested elegance and importance. I could not be certain it was Sandro who greeted her as she went in, but upon seeing this new development, I quickly lost my passion to speak with him.

"It appears not the best time for me to see Maestro Botticelli."

"Perhaps the woman is dining late with the family?" my escort ventured somewhat feebly.

"Pray, she appears to be much more than a dinner guest!" I moved to remount Sopraccigliotto.

Niccolo joined me. "You wish to leave then, Madonna?"

I nodded and we turned about face, back toward the Via della Scala. I was filled with grave apprehension. "I must try again at dawn. Will you accompany me on your way to the Carmine?"

"If it pleases you."

As we rode home, I began to commend Niccolo on his loyalty to Filippino and his future as a painter—although according to Filippino, it was not that promising. I could sense his pleasure in my flattery, and when he lifted me down from Sopraccigliotto I could feel a certain heat radiate from his body, only to be lost in the coolness of the night.

At dawn I rose and dressed without washing and left instructions for Lucia to bathe Lucrezia. She had slept easily through the night, while my own slumber had been most uneven. I took no breakfast and went straight to the bottega in search of Niccolo, who slept in an adjourning chamber. I tried to rouse him without waking Luigi. Filippino, who was packing his supplies for the day but was not yet ready to depart, looked with some displeasure at my interference with Niccolo, but agreed that he could escort me to Via Nuova, after I spoke falsely of Sandro's early need for me.

It seemed as if Niccolo and I had spent the entire night together as we rode quietly through the newly stirring quarters of the city. With my lack of sleep and the low haze of the morning sky, I felt myself in a dream, or possibly in one of Boccaccio's lofty tales. Perhaps I was some difficult maiden and Niccolo a youthful suitor whom I might please or discard with little consequence in my quest for even more unreasonable passion!

Such bold imaginings filled me with the strength I needed to confront Sandro, but as we approached his house once again we saw the same woman, like the apparition she had been before, leaving the bottega in her purple cloak. Her attendants waited outside the door and helped her into the litter. Then she disappeared into the morning traffic on Borgo Ognissanti.

"It appears that Maestro Botticelli has a mistress," Niccolo exclaimed beneath his breath. "Think of that! The rumor I heard was that he has no interest in women other than to paint them!"

"What mistress accommodates a man at his own residence, where his family abides?" I scoffed at Niccolo's insinuations about Sandro, and in my misdirected rage I went on boldly to describe how Sandro had once shown me the scholar Ficino's translated texts of Plato, who had considered the carnal consummation of love between men to be "a waste of seed." This embarrassed Niccolo sufficiently so that he spoke no more of natural or unnatural "inclinations"—and yet I almost wished that his first observation could be the truth and that this woman were not the "other half" of Venus but Sandro's very accommodating mistress.

"Are you going in?"

"I must."

And Niccolo, who sensed my distress, added, "Be of good cheer, Madonna. At least you know that Maestro Botticelli is awake."

Sandro responded immediately to my knocking and unbolted the door. He looked at me as though he were expecting someone else.

"Sandra mia!"

"Forgive me, Sandro. I know it is still early."

"But I have no need of you until much later." He seemed very curious while showing me in.

I waved at Niccolo and entered the bottega. The easel boards and panels were still undergoing preparation. Near Sandro's desk was a long, slender chaise with cushions, and beside it flickered a candle in a mass of molten wax.

"Does one candle burn sufficiently for an entire night of lovemaking?"

"What is it you inquire, Sandra?" Sandro smoothed his unkempt hair and yawned.

"I am speaking of your work and your marriage to it. Once you said a wife of flesh and blood would give you nightmares, and yet you would spend all night with some agreeble courtesan—indeed, even paint her so that your most devoted model might never know!"

"Sandra! Tell me the cause of such an outburst!"

He put his hands upon my shoulders as though to steady me, but I wanted him to either hold me like a lover or lift me like a child.

"I saw her!" My heart seemed to explode. "I saw the woman in the purple cloak. She must be the woman Zephyr told me about, the harlot who does honor to that part of me you dare not paint. Your Perfect Venus. Your Mistress. Your Finest Madonna!"

Sandro said nothing. Alarm had overtaken him. He sought to calm me by having me sit upon the very chaise where she had in all probability lain with him.

"So you know?"

I nodded as I dried my eyes with one edge of my mantle.

"And you saw Cortesia leave just now? For I thought you were she at the door, having forgotten something."

"*She* 'who hath no mortal face' and *she* 'who presses her golden tresses to that apple of sweetness'?"

"Poliziano's verses have impressed you."

"And it is *she* whom you have chosen to spare my precious modesty?"

"Sandra mia. I might have used Chloris in such a fashion and you would not protest it so."

"Chloris is not a whore."

"And neither is Cortesia. She may be a courtesan, but she is no common whore. She is better schooled than you or I, and her Latin and Greek rival any man's at the Academy."

"Is she your mistress then?" The inquiry felt sharp in my throat.

"She is more my tutor now than mistress, but she sits for me as well. Now, are you to examine my private affairs along with my paintings?"

"You would not speak to Chloris or Contessa or your other models this way!"

"And they would not arrive at my house at dawn and inquire about how I passed the night, my dear *goddaughter*. But if you are so concerned about my exchanges with my models, let me remind you that I

intend to reimburse you for your many hours. Lorenzino has given me an ample account for such purposes. Moreover, I am not about to take advantage of our kinship, Sandra."

"And how might you determine the value of those parts you study and those you dare not gaze upon?"

"I have preserved your modesty out of respect for your husband and your brother."

"And they gave me to you as a model for any purpose in my *impalmatura*."

"Sandra, Sandra. I fear your jealousy of Cortesia has blinded you to the honor you so deserve."

I buried my face in his chest and cried, "What honor can there be if my face is attached to the breasts and belly of another woman?"

"But my tribute is neither to you nor to Cortesia, Sandra. My tribute is to the goddess who blesses love and to the beauty whose perfection is truth, which redeems us all."

He stroked my hair and then helped me to dry my eyes, and even as I recall this moment, I also recall the tenderness with which Sandro spoke of his *Venus Arriving on the Shore*. It was the love of an idea and not a woman that possessed him; and I was merely the instrument by which he strove to reach it. Later, when the painting was installed at Castello and viewed by any lucky guest who might call upon Lorenzino or Semiramide, many would say that Botticelli had reconciled the Holy Church with all Antiquity. He had painted a Venus that was "the finest Madonna in all her grace."

18

Niccolo

FTER THIS ENCOUNTER WITH SANDRO, WE both agreed that I was free to return to Prato, as his studies of my face "in all its gentle melancholy," as well as my abundant hair, were sufficient for him to transfer from cartoon to canvas. The various hues he knew by heart, and he had planned, as a final touch, to guild my almost auburn tresses with gold. As for the goddess of the seasons who waited on the shore to cover me with a floral cloak, Sandro had the studies from his portrait of Simonetta to copy. It was a profile that would accommodate the composition well.

I spent the rest of the day with Chloris and Zephyr in the bottega and then said my farewells. Niccolo called that afternoon to escort me home. When I explained that I would be returning to Prato, his earlier, boyish bravado relaxed into remorseful silence.

When we arrived at Filippino's, Lucrezia squealed with delight and I embraced her with a new attentiveness. I announced to Lucia that we would be leaving in a day or two, depending on the availability of an escort.

"At last! I am ready to return to the good air of Prato."

That evening, I spoke briefly to Filippino of my visit to Via Nuova but said nothing about my outburst. I was weary from the straining of

my passions and decided to retire early after first writing a letter to Ciardo to announce our imminent return. Filippino decided he was at a suitable point in the Brancacci Chapel to take respite and decided he would depart with me. He had good cause to inspect the remodeling of Lorenzo de' Medici's villa at Poggio a Caiano, which he had been commissioned to decorate.

"We can stop at Careggi on the way, for Lorenzo to settle his account with me, and then Niccolo or Luigi can escort you on to Prato while I tend to my affairs."

This seemed a happy solution for everyone involved, particularly Niccolo, who hoped to serve as the escort. We all supped together, and his appetite seemed not the least bit suppressed by his earlier dismay. Indeed he tore his bread and took his broth with a hunger almost fierce. It reminded me of the way Sandro ate, which caused a strange stirring within my womb. I realized that I longed for the joys of the marriage bed—or of any lover's bed!

But I was soon distracted by Lucrezia's antics, which everyone tolerated at the table. I decided that if she were too pampered during my estrangement from Ciardo, it was to bestow on her those affections that had been denied to me. Niccolo appeared very much amused by her, and in the middle of the meal he extended his hand and made a playful dance about her arms and face, with each finger assuming its own persona.

"If I had a quill and ink, I might draw a face on 'Maestro Dito,'" he said.

I excused myself and ran to Filippino's study to procure these very items, and Niccolo immediately proceeded to decorate his first finger with the features of a veiled woman. His second finger became a cloaked citizen in a cap, and his thumb took on the role of a swaddled child. Then the happy family performed their simple drama before us. Lucrezia clapped and giggled with delight, and Lucia and Francesca were duly charmed. Even Filippino was impressed by his otherwise "unimpressive" garzone. He smiled and nodded his approval, while Lucrezia pressed Niccolo's little family to her own fingers and said, "Dito! Dito! Niccolo!"

Later, after Niccolo had retired his hand of characters and Lucrezia

was put to bed, I used the same quill and ink to write to Ciardo. I knew not what tidings I should make to him except to announce that Lucrezia, Lucia, and I would be home in three days, and that we would be spending at least one night at Careggi while Filippino finished his business with Lorenzo. For want of something else to write, I finished with, "I expect this can be accomplished without the interruption of any trial or inquisition of unannounced couriers!" I only briefly mentioned that Sandro had made sufficient studies for the Venus and that he had planned to paint it on canvas instead of wood.

The morning we were to depart, Filippino decided that Luigi should oversee the bottega in his absence and Niccolo would be best to accompany us. I had already expressed my preference of Niccolo for the journey, as he had served me so well throughout the streets of Florence. In private, Filippino often compared Niccolo to Diamante by remarking on how "his loyalty exceeds his talent." But for this excursion, he confessed he was more in need of the former than the latter!

We arrived in less than an hour's time to much activity at the villa of Careggi. Poliziano had just returned with Lorenzo de' Medici's young son from a diplomatic mission to meet the new Pope in Rome. A very young and handsome scholar named Pico della Mirandola was also there as a guest of the Academy. He was curious about Poliziano's impressions of the "intellectual climate" at the Vatican, as he planned to introduce his nine hundred theses on religion to the Pope's council. Lorenzo's athletic son Piero, however, preferred to discuss his success at various sports and expound upon the many executions of the game *gioco del calcio*.

As for our host, Lorenzo, I could not discern if his current demeanor stemmed from some disappointment in his son's shortcomings or from his constant gastric disorder. At one point, as I heard him speak of needing another visit to the hot springs at Spedaletto, I thought of Sandro's unfinished frescoes there. Other guests were quick to praise Filippino for his work at the Carmine. Then Lorenzo—who I later learned was a little envious of his cousin's commission with Sandro —inquired about "Maestro Botticelli's progress with the Venus Anadyomene."

At first I knew not if I should comment on the painting, although

Lorenzo seemed to know I had been chosen to sit as Sandro's "exqui-
site goddess." Many eyes turned to me, so I chose to preserve my
humility by saying very little about myself and nothing at all about
Cortesia. Yet I could not help exclaiming in the end that "Maestro
Botticelli's rendering of the Venus rising from the sea may very well
rival the nudes of Donatello or Verrocchio."

"Does that mean she hasn't any breasts?" Poliziano jested with a
knowing wink to Pico.

Everyone laughed openly because my breasts were still very full
from my recent pregnancy. But I found little mirth in the remark, as I
knew the breasts that Sandro would be painting were not mine, and
Filippino was aware of my discomfort.

"Pray, gentlemen, my sister's honesty exceeds her beauty. And,
indeed, if one speaks of Florence as the 'New Athens,' then Botticelli
might well be called the next Apelles."

There was nodding and agreement to this, along with mumblings
about when they might be invited to Castello to view the magnificent
picture. Poliziano could do nothing but fawn over me and extol San-
dro Botticelli for his "secular boldness and genius in illustration."

"He has brought poetry to those who cannot read, thus making all
men and women literate by his works!"

I later whispered to Filippino, "I wonder what Lorenzo's Academy
might say of their beloved Sandro if they knew what favors he received
from the courtesan, Cortesia."

"No doubt it was through them that they were introduced! How
else might Sandro know a woman who reads Greek and Latin and
provides services of both earthly and intellectual delight?"

Niccolo, who had overheard everything, surprised us further. "I find
the *earthly* delights to be the more pleasing of the two!"

"Indeed? And with such inclinations, you shall have only the title of
Journeyman within your reach for having never learned to write a
proper inscription!"

My brother must have felt a need to illuminate his pupil's shortcom-
ings, but I, for one, found Niccolo's "inclination" to be as charming as he.

That evening, after having favorably dined, I dismissed Lucia from
her nursemaid duties and put Lucrezia to bed myself. The child had

an exhausting intensity before she faded for the day, and she pleaded with me to tell her a story with my fingers.

"Dito! Dito! Niccolo!" she implored me.

"But Niccolo is downstairs with the men."

"No, *you*, Mamma. You do 'dito' like Niccolo." She motioned with her tiny fingers.

"But they have no faces, carissima," I held up my blank hand.

Lucrezia reached out to instruct me in the proper designation for my family of fingers.

"Dito Babbo, Dito Mamma, and Dito Bambino!"

She needed no ink to define her characters, but for want of a device to assist in the show, I slipped off my wedding ring and began a tale I had read from Boccaccio's *Decameron*, told by the maiden, Filomena, on the first day of the lovers' retreat from *la moria*. It was a tale to challenge both the heart and the mind, about the Sultan Saldin, the Jew Melchisedech, and three rings. I held my ring before Lucrezia's dark, eager eyes and moved it from one finger to the next as I spoke:

"Once there was a wealthy man who owned a beautiful ring, and he ordered that whichever of his sons should own this ring would be head of the family upon the man's death. The man had three handsome sons and they all were obedient and loved their father equally."

Lucrezia held up her fingers and counted, "One, two, three."

"Very good! And so the father grew older and did not want to have to choose only one of his sons to have the ring and be declared owner of his fortunes, so he went to a jeweler in secret and said, 'Make for me two more rings exactly like this one.' But the jeweler said, 'That will be very difficult, for this is a magnificent ring!' But the father insisted the rings must look alike, and the jeweler accomplished this for a very large fee.

"Later, as the father lay dying, he called each son to his bedside, one by one, and gave each of them a ring. After he died, each son brought forth his ring to prove his inheritance, but as none could recognize the *true* ring, they all put aside the question of who was the chosen son and divided their father's wealth equally and in harmony."

Lucrezia held the band of gold as I finished the story, and soon she slumbered so deeply that I feared waking her if I removed it. I left it in

her soft fleshy grasp and rose to find Niccolo in the doorway of the room. He had been listening to my tale with boyish curiosity. I moved quietly from the bed as he whispered, "A clever riddle for the Christian, the Jew, and the Saracen, is it not, Madonna Sandra?"

"Ah yes. Each believes himself the true heir of the Father. Did you know that Boccaccio wrote his *Decameron* about a villa much like Careggi? It was in Fiesole, I believe."

"Do you think such a tale would be well received in Rome?" We walked together to the stairs and descended towards the garden.

"Pico della Mirandola might think of using it when he presents his theses to the Vatican." I knew that the scholar's works had sought to defend the existence of other faiths. I was also pleased to find Niccolo so perceptive.

From the terrace we could see that everyone had gone inside. Filippino was engaged in a game of backgammon with Poliziano, and Lorenzo was playing chess with Pico under the uninterested eye of Piero. No one saw us pass by as we entered the night air.

"Does night's blackness please you, Sandra?" Niccolo seemed to have discovered a new ease of discourse.

"Not as much as the stars."

"Their light does more to honor one so lovely."

His candor surprised me more than his flattery, and we walked further, past the grove of lemon trees. He offered his arm, which I took until we reached a carved bench to rest on. Below us, Verrocchio's fountain of the *Boy Upon a Dolphin* trickled playfully. The plump stone figure of the boy seemed to come alive with laughter as the water spouted from the dolphin's mouth. The fragrance of the lemons filled all my senses.

I looked up at the stars and murmured, "Think of all those souls winking at us here on earth."

"Do you believe they see us?" His voice thrilled me with its gentleness.

"Does anyone ever see us . . . as our true selves, I mean?"

"It is easy to see *your* true self, Sandra. For you are as near perfection as I have ever seen."

"I am not the perfection you think you see, good Niccolo."

"But you are as close as any woman comes to it! You are comely and well read. You speak well, even to someone as great as Lorenzo Medici. You are a dutiful sister and mother and . . . "

"Wife? *That* I am not, Niccolo." I sighed.

"Perhaps that is your husband's folly and not yours."

He took my hand and felt the absent ring, and when he found it gone, my heart raced. Suddenly he drew me to him, and I felt myself too weak in body and spirit to resist his overture. He pressed our hearts together with a ferocity that I feared would make them burst; his mouth was tender and desperate, and his kisses covered my face and neck and breasts with *joy*! I recalled, in that flash of hunger, how Giovanna had once said that "desire might accomplish what experience cannot." Yet it appeared that Niccolo had both as he continued to caress me.

From that point, I recall no words I might have uttered in our passion. The delight of his body seemed to fill every part of me so that I could barely breathe. But then, like some wounded animal, I cried out suddenly "Not here! Not here, my love!"

"Then come with me!"

He led me down the walkway towards the livery, and revealed that he had befriended one of Lorenzo's grooms, who had his own lodging near the stables. Niccolo went to the man with some tale of urgency, and the servant agreed to vacate his chambers. I found the clandestine arrangement compelling, as though I were one of Boccaccio's maidens with no investment in my days save the pleasures of the moment.

As soon as we were alone he hastened to remove his tunic and doublet and hosiery. Niccolo was muscular and lean, with "a well-turned calf and thigh," as Poliziano would have said. This thought slightly amused me as he reached to help me unfasten the buttons of my gown. I had no inclination to resist his desire; indeed I wanted to give myself to him fully with no regret. But instead of entering me in haste, as Ciardo often did, Niccolo stroked me in my most vulnerable places and whispered to me the joys my body gave to him.

Then with the deliberate motion of his tongue, he tasted the metaphor of Poliziano's verse, "that apple of sweetness" no longer hidden by my "golden tresses." So shocked were all my senses by this pleasure

that I could not withhold the favors I returned to him. I reached forthat bud of manhood that is so quick to blossom to the touch, while he directed me to cherish the moment as he did his calling for fulfillment.

And when he finally entered me, I received him with a desperate ecstacy that had been denied my womb my entire life. It was a new joy, and I could not but wonder at that moment if the scripture of Genesis had intended to include that joy by declaring, "A man must leave his father and mother and cleave unto his wife."

We clung together afterwards for nearly an hour, and it seemed we slumbered there without truly passing into our own dreams. Finally, however, we were shaken by the coolness of the air and the servant's scratchings at his own door. We rose and dressed hastily and departed, I to Lucrezia in the guest chamber and Niccolo to his.

We spoke little the next day on our way to Prato. So radiant was I that I felt no need to clutter the air with words, and Niccolo maintained a courteous aloofness for the sake of appearances. He devoted most of his attention to Lucrezia, who sat with me on Sopraccigliotto. Filippino filled any silence by relaying his exchanges with Lorenzo the night before. Lorenzo had rendered payment for supplies needed for the decoration of Poggio a Caiano, but was also eager for Filippino to produce a design for his monument to Father. Lorenzo had wanted to build one in Santa Maria del Fiore, but he felt that monuments without the bones of the deceased were "empty tribute," like Dante's at Santa Croce. Filippino had suggested, then, that Lorenzo improve upon the tomb in Spoleto, even though our mother had always felt it an adequate one.

I was now so full of life again that it was difficult to speak of tombs and death, but I agreed with my brother that his idea was the best.

We reached Prato and Via delle Tre Gore at midday, and Mother bade me rest a little before proceeding on to Villa Tavola. Vincenza laid a most inviting table for us, including her jelly molds for Lucrezia. Mother was glad to be rejoined with Filippino, who spoke at length of his commissions.

At some juncture she turned to me and said with uninvited poignancy, "Ciardo eagerly awaits your return, Sandra."

"Is he coming to escort us home?" I anxiously twisted my wedding band, which had returned to my finger.

Although Niccolo displayed no emotion at the mention of my husband, I sensed his discomfort. I had no wish to see the two of them beneath the same roof—not out of shame for Ciardo's cuckoldry, but because I desired to keep our joy as a separate mark upon my memory.

Mother continued the discourse with a report, by way of Giovanna, that Ciardo had gone to Pisa to secure new shipments of raw wool from France and England.

"The suppliers can ship them from Marseilles, which makes a quicker trip than overland, but Ciardo and his father must agree to purchase half the ships. Ciardo found this a risky transaction without seeing them, and by some good fortune they were made available to inspect at the harbor in Pisa. They will be in need of a ship's chandler or some knowledgeable agent to advise them, so I suggested Amerigo."

I found the mention of a former lover at this time a rather ironic digression.

"So you see, Sandra, your influence with Lorenzino di Pierfrancesco has become most timely!"

"And what influence is that?

"Why, your likeness to the Venus he commissioned Sandro to paint."

"A partial likeness," I murmured. A knowing smile escaped Filippino's lips, and then Vincenza placed her hand upon my shoulder.

"Our Sandra has always accepted God's gift of beauty with humility and grace."

I could only wonder, now, if that were true, and think of the many stolen moments of gazing into my looking glass, searching for whatever imperfections women see in themselves, yet all the while admiring what I saw. What hypocrisy this made of Vincenza's praise! I rose and walked alone about the small garden that Riccardo had tended so lovingly all the years of my youth. I tried to imagine how it had been for Mother in this house when she first broke closure from Santa Margherita. I thought of Father and his young pupil Sandro, walking this very ground, entertaining me as a child in the same way Niccolo now entertained my small daughter. I thought of the unchangeable

cycle of events that gave a sense of order to a world that had none, and I wept.

My last moments with Niccolo were with Lucia and Lucrezia on the road to Villa Tavola. Filippino, who remained with Mother to visit, sent Niccolo as our escort. I had hoped to say good-bye to him away from the watchful eyes of my family, but knew this could not happen.

When we approached the entrance to the estate, he stopped his horse and looked at me. "Are you sure he is away?" It was as though he could not bear to speak Ciardo's name.

"Mother says he is still in Pisa. Yet if he were here, he would be no less distant from me."

We had all dismounted and made our way on foot to the wrought iron gates. Lucia moved in haste towards the house, calling for Madonna Ciardi as she carried Lucrezia on her hip. When they were far enough away, Niccolo turned to me and asked when I might return to Florence.

"I cannot say. I am certain of so little, except that I must make a life for Lucrezia . . . and an heir for Ciardo." I twisted my wedding ring about my finger, hoping he might find some kindness in the honesty that so cruelly stung him.

"But what if your next child . . . is not his?" His voice halted at every word, as though he were about to cry.

I pressed my hand to my belly and sighed. "That is God's will."

"And ours. Shall you be fearful now?"

I tried to show a countenance of assurance even as this new fear curdled in my stomach. I had given no thought to this possibility in the rapture of our union.

"I am always fearful, good Niccolo." I touched his hand.

The moment was broken by Madonna Ciardi, who called for us to enter with her usual aplomb. Here Niccolo made his apologies and refused the invitation. He said he needed to settle early at Via delle Tre Gore so that he and Filippino could make the journey to Poggio a Caiano first thing in the morning.

My entire body seemed to ache already with his absence as he dismissed himself and returned to his mount. I scarcely noticed as one of the Ciardi's servants led Lucia's horse and Sopraccigliotto to their

stables. Instead I watched as Niccolo's figure grew smaller on the road leading away from the grounds, for which I still felt no affiliation. I waved only once, trying to contain my sorrow. But he did not look back, for fear of showing his.

19

Filomena

THE NECK IS LONG AND GRACEFUL, AS ARE THE *arms; and although suspicious viewers* might *decide that those arms belonged to a different torso, that was the Botticelli style. The hands and feet are exceedingly graceful—but* was *that the bosom of this model, or did it belong to a very different creature?*

The Zephyr and Chloris, though playful, are also solemn and dramatic; and the Season on the shore receives the direction of the winds with dignity and aplomb, waiting to give the goddess Venus her most worthy cloak and comfort. Her gown is almost identical to one in The Garden of the Hesperides . . .

—Autumn of 1485 to summer of 1486

My reunion with Ciardo was not as strained as I had expected it to be. He doted on Lucrezia and gave her a tiny carved ship that he had bought as a trinket in Pisa. We spoke of his venture in purchasing half the value of the import ships and how best to persuade Amerigo to take leave of his post with the Pierfranceschi to make an inspection. I offered to write to both Lorenzino and Amerigo on the Ciardi's behalf. It was the first time my husband had ever consulted me or valued my assistance with his trade.

Ciardo made no inquiries about my sittings with Sandro and I offered even less, although Lucia often teased me in his presence as "the goddess of perfection" and "the grace of Tuscany." I said nothing about Cortesia or the fact that he was using another torso for the nude Venus, even though the fact might have brought him some solace.

Although Ciardo evinced no interest in approaching me in bed, I discovered, much to my surprise, that my carnal awakening with Niccolo had aroused new desires in me. He seemed as surprised by my overtures as I was, but he did not refuse my caresses. I found myself stimulated by my own appetite for his manhood and for the "piercing arrows" of St. Teresa's ecstasy, which Giovanna had so applauded. Thus I received him easily into my womb while remembering the smooth cheek of Niccolo, the tender mouth and sighs.

Perhaps Ciardo perceived my affection as the new fruit of our estrangement. I know he did not imagine it to be the "harvest" of another man's seed. Lucrezia now demanded, at her bedding down, that Ciardo amuse her with a story, saying, "Dito story, Babbo, Dito!" And I could only marvel at the irony of her wishing in him Niccolo's talent for storytelling, just as I wished for his talent in lovemaking.

Strangely enough, I thought little of returning to Florence in those last weeks of summer and settled back into life at Villa Tavola. I turned my energies, instead, to assisting Ciardo's mother with the house and preparing for the pressing of the olives. My curiosity about Sandro's progress on the Venus would have been most acute if I had let it, but inquiring held no purpose in calming my heart. Filippino's time was consumed by the laying of pigments in the Brancacci chapel in order to take advantage of the warm, dry weather "and the good humor of the plasterers." He wrote to Mother once that season but made no comments about Sandro or his loyal garzone, Niccolo.

When the first pressing of the olives came due, I noticed the malaise that fell over me. Mother assumed it was the exceptional sun of September, or the fact that Lucrezia was at the exhausting stage of learning to use her chamber pot, but I recognized the inexplicable feeling of being with child. Every scent and odor had become exaggerated, and my fatigue was overwhelming. I took some comfort in the repetition of symptoms, for I had heard tell that this was a sign to wayward wives

that a child was of the same seed as its siblings. But still the fear grew in me daily that the child was Niccolo's and not Ciardo's.

I waited two more weeks before announcing my condition. Ciardo said he had already guessed the reason for my waning energies and was only waiting for me to speak the knowledge of my own body. Giovanna was thrilled by my news and applauded it as "the blessing of Venus" in order to convince her brother that my time in Florence had served him well. Mother wrote to Filippino on my behalf, and he finally answered that he was pleased to hear of such "fruitful reconciliation."

My brother also mentioned his efforts in designing a relief for Father's new tomb. When he asked Mother if she could find the preliminary studies Father had made for his self-portrait in *The Funeral of St. Stephen* at San Stefano, she showed me the partially damaged ink-on-vellum sketch she had kept from Father's bottega near the Mercatale. She sent it in haste by courier to Florence. I had thought to include a small note to Niccolo, in care of Filippino, but knew this would be too obvious.

When next we heard from Filippino, he reported that he had settled on a marble bust of Father's likeness emerging from a scalloped shell, "much like the one that carries Sandro's Venus to shore." Apparently he had been to Via Nuova and had seen the canvas in progress, so he enjoined Mother to "tell Sandra she will be more pleased than she imagined when she sees it."

He also mentioned that one of his garzoni had left his bottega to work with Domenico Ghirlandaio. "Sandra will remember him as the fawning youth who escorted her to Via Nuova." This brought me even more chagrin; and as autumn lingered and the child grew heavier within me, I began to fear what countenance it would bear and that it might prove the anguish of my private sin. I wanted to write to Niccolo, but no manner of communication was sufficiently discreet.

Finally, as the weeks of Advent were upon me, I received a gift from Filippino to Lucrezia. Attached to the parcel was a sealed envelope to me. Inside was a letter by the hand of Niccolo attached to a small carved ivory dove for Lucrezia. My heart raced anxiously to see the careful swirls of his penmanship against this symbol of fidelity. I awaited the moment when I might be alone to read his words.

Carissima,

Too long I have waited to explain my sudden change of apprenticeship from Filippino's bottega to that of Maestro Domenico Ghirlandaio. Certainly your brother was a more agreeable master, but I could no longer abide within those walls that still hold the very breath of you. Nor could I bear to receive what passing news I might receive regarding you and your rightful life at Villa Tavola. Thus, I find myself more content when removed from such agony, while still I cherish the memory of our night at Careggi. It is ever on my mind, and no maiden in Florence can distract me from it.

I ask only that you hold the same kind regards for me as you did in the beginning and that our souls may shine some day from those heavens that witnessed our fateful night.

I am with much affection,
Niccolo

Meseemed I carried that sweet missive against my breast for days until I relinquished it to the bottom of my wedding chest.

I passed a very introspective Christmas that winter. My only joy was to watch Lucrezia as she became aware of the Nativity and to see her new delight in the candles and gifts. For the banquet of Epiphany, Ser Vannozzo and his family, Giovanna and hers, and Mother all gathered at Villa Tavola. Vincenza brought her special jelly molds and sweetmeats, including candied pumpkin. Though I was at a stage of my pregnancy where I could enjoy our well-laid table, I was too troubled inside to eat much.

I attempted to dismiss my fearful thoughts as the winter passed into the Carnival season before Lent. Many Pratesi traveled to Florence then to enjoy the rousing masquerades and processions. This year they brought back reports of "a magnificent float" designed as a tribute to Botticelli's recent painting for Lorenzino di Pierfrancesco. Filippino wrote that the woman chosen to play the Venus was "not nearly as blessed in form or countenance" as I and required several hairpieces to adequately cover her! The float was both applauded and condemned. Some saw it as "the excellence of beauty and a tribute to the Ancients,"

but the more pious citizens found it "a lurid and pagan offense to God and man."

Sandro dismissed such criticisms as coming from "the dim eyes of the dimwitted," but little of this news concerned me as the birth of my child grew near. I had accepted that my pain and travail would be fitting penance for my transgression, even if the child were Ciardo's; and although I prayed that God and Saint Margaret might spare the child any injury, I asked no comfort for myself. As my labors began one cloudy afternoon in February, I prepared myself for this trial of the flesh and spirit.

By some good fortune, the child came with little difficulty and in so short a time that Ciardo barely had the chance to bring Mother from Via delle Tre Gore to assist the midwife. And even at that pinnacle of pain, I felt a burning ecstasy in pushing the child into the world. It was not unlike that bright firethat Niccolo had set within me three seasons ago.

The midwife and Mother cried out in unison, "It is a sister for Lucrezia!" and I eagerly laid my hands upon her to see what features I might behold in her tiny purple face. Her complexion was dark, like Ciardo's, but her hair was fair. Although her features had not yet softened in the candlelight, her serenity reminded me of Niccolo's gentle temperament. I held her closely to my breast to suckle and she took the nipple tenderly, not eagerly as Lucrezia had. I nursed the child in a partial slumber, marveling how the suckling creature was like a lover, clinging to the woman's flesh in its own expressive way.

In this twilight of reflection, I found myself again like a character from *The Decameron*, bringing forth another episode in my own life. Thus I chose for my new daughter the name Filomena after the maiden who had told the tale of the ring.

"A fine name!" Ciardo agreed when I proposed it. He made every effort to hide his disappointment that she was not a boy.

"It is a graceful name for a graceful child," Madonna Ciardi added.

I explained that *filo* came from the Greek *Philo*, which meant love; and although I felt a need to weep over the uncertainty of this new being, I held her up cheerfully in the morning light and said, "She is beautiful and has a healthy cry!"

218

In the days before the New Year of 1486, Filomena suckled and grew and her face became more plump. Those who saw her remarked upon her resemblance to Lucrezia or me, yet all I saw in her was Niccolo. Madonna Ciardo saw Giovanna as an infant, which reinforced the possibility that she was Ciardo's issue. Perhaps my judgment had been distorted by my guilt, for if I could have torn my silent turmoil from my heart, I might have seen only an infant soft and endearing in the sheer veil of slumber. And whenever Filomena slept, that veil protected me as much as her.

Giovanna and Antonio were named godparents, and Filomena's baptism went quietly. Some citizens of Prato jested the notion that she was "the daughter of Venus" and thereby bore the face of Mars or Mercury! Those who remembered Sandro as a young garzone and knew of my recent visit to Florence gossiped that perhaps the child "resembled Botticelli more than a Ciardi." I ignored such comments as best I could, but they had a way of entering the most innocent of discourses. I feared mostly their effect on Ciardo, who now prepared to take his second trip to Pisa with Amerigo's assistance.

Amerigo had responded favorably to my letter, via Lorenzino and Semiramide, and both parties sent congratulations on Filomena's birth. I had not spoken to Amerigo since his father's funeral, and I confess that I had mixed feelings regarding his arrival. I wondered how I might appear to him, now that I had borne two children and lost another. I wondered what his feelings might be towards me and whether or not I would feel that same powerful attraction to him.

He was as well dressed as ever when he arrived that April morning, having recently come through the Mugello to inspect the planting of the Pierfranceschi's crops. Although Amerigo had recently sold off the lands of his father's estate in Peretola, he still had good cause to travel there to see certain members of his family. He greeted me warmly and brought many compliments for Lucrezia and Filomena.

"Have you seen the finished Venus at Castello?" he asked immediately, apparently unaware of the turmoil it had caused me.

"I have been indisposed." I handed Filomena to Lucia.

"Your godfather has certainly made a great tribute to both you and Poliziano's poem."

"And the Ancients, I trust?" I attempted a poignant smile.

"Indeed, but I think you'll find your likeness as melancholy and serene as any Madonna, which is Maestro Botticelli's wont. Some say the Venus Rising from the Sea embraces the theme of baptism more than it shows the birth of a pagan goddess. The church fathers shall be pleased with that!"

"But it was not intended as a devotional panel. It is meant to decorate Lorenzino and Semiramide's chambers."

"And well it does. Did you know that my good patron asked specifically for *you* to grace his walls?"

I reddened, slightly, although Ciardo was not close enough to hear.

"Methinks you are ever on his mind," Amerigo whispered in confidence.

"But what of Semiramide?"

"She is a gracious and generous wife in every way." He had a very coy grin.

"And what of *you*, Amerigo? You are just as generous to assist Ciardo with the inspection of these ships, for your knowledge certainly does us a good turn."

"It is my pleasure to serve Ciardo and his father . . . and you, of course, Madonna Sandra. After all, there was a time when you did serve me well."

"For myself, it was a service of the heart, but apparently a mere convenience for *you*." I hoped he would see more insult than discomfort upon my countenance.

Amerigo reached out to touch my hand. "It was a service I would not deny, were it to be offered again. And believe me when I say it was a joy more pleasurable than convenient."

Thereafter, he produced a package he had brought from Lorenzino and Semiramide. I called Madonna Ciardi to help me open it and found a lovely christening gift for Filomena. It was a silk and lace gown accompanied by a letter from Semiramide. She sent her blessings on our new child and spoke of Sandro's painting as "the envy of every dignitary who has come to visit Castello."

Before Ciardo and Amerigo set off for Pisa, Amerigo handed me another even more startling item. It was a letter from Sandro, describ-

ing the triumph of the Venus as "his finest hour" with brush and pig-
ment. He then explained his next commission, to decorate a villa for
the marriage of Lorenzo de' Medici's cousin. The patron, Giovanni
Tornabuoni, was giving one of his villas near Fiesole as a gift to his son
and wished for Sandro to fresco the walls with some allegory that
might include portraits of the bride and groom. Sandro had decided
on the theme of *The Three Graces Presenting Giovanna Albizzi to Venus*
and *Lorenzo Tornabuoni Seated Among the Liberal Arts*. Would I agree to
sit for him in triplicate as the Graces? he asked. He already had made
a study of the bride and agreed to come to Prato.

At first I was disinclined towards this proposal, as the betrayal of
the Venus still stung my heart. But then I realized that the Torna-
buoni were also the patrons of the chapel that Ghirlandaio had begun
to decorate; and as Niccolo was now in the employ of Ghirlandaio's
bottega, my favor with the Tornabuoni might enable me to bypass
Filippino and Sandro in an effort to communicate with him. I quickly
sent a courier to Florence with my reply that Sandro was welcome at
Villa Tavola whenever he chose to come.

My invitation evoked a multitude of feelings in me. Was my brief
encounter with Niccolo merely a retaliation for the jealousies that
Cortesia had aroused in me? Had Sandro realized some new affection
for me? Had I sufficiently supressed my old affection for him, or would
his presence rekindle every fire in my heart? Could either of us deny
our importance to each other?

Sandro stopped at Via delle Tre Gore before arriving at Villa
Tavola. He reported his announcement to his patrons, the Tornabu-
oni, that Alessandra Lippi, "the second queen of beauty," had agreed to
sit for the frescoes. The Tornabuoni followed suit by sending a wed-
ding invitation to myself and Ciardo. I feared I would not be able to
attend because I did not wish to leave Filomena with a wet nurse, but
Sandro reassured me that the "blessing of my immortal face" in the
frescoes was presence enough.

Sandro, who made no delay in setting up his vellum and charcoals
on the rear terrace, worked during Filomena's napping and encouraged
her interruptions to nurse, saying that "a satisfied infant is a quiet one!"
He made his studies off a previous design in which each figure had

already been positioned, and drew as close as possible to the actual car-
toon size so that he would not have to enlarge the entire composition
when he transferred it to the plaster. He planned to start laying the
pigments even before the wedding in June.

While he was in Prato, Sandro took only enough respite from his
studies to visit San Stefano and relive the painting of the frescoes
there. After his first visit, he came to Villa Tavola, remarking on
Father's skill and how he had "elevated the art of painting for all of
Italy." Along with this nostalgia, he also began to recall pieces of my
own childhood: how I followed him around the bottega, what a pretty
child I was, how eager Filippino was to assist Father with his trade and
me with my toys. It was the most he had ever spoken while he drew,
and I found a new energy in him and in his work.

The final cartoon of the Graces displayed a more cheerful figure
than the Castello Venus. The mouth and eyes appeared more ani-
mated, and the Graces stepped lightly aside the profile of Giovanna
Albizzi like nimble escorts. Sandro seemed pleased with the results.

Ciardo and Amerigo returned from Pisa before Sandro left so that
he could plan to travel back to Florence with Amerigo. Sandro com-
mented that a woman "could not welcome two more virile and hand-
some gentlemen," which left me wanting for a suitable remark. I busied
myself with Filomena and Lucrezia while the men spoke of the wool
market and what a boon to it the shipping industry might be.

"Lorenzo de' Medici would do well to invest in the enterprise of
ship building at Pisa and thereby make a better claim to that city,"
Amerigo observed. It was well known that Pisa had long been strug-
gling for independence.

"But Lorenzo," said Ciardo, now demonstrating surprising astute-
ness, "prefers to keep the university there, separate from the dominion
of Florence."

"Separate from his Academy, most likely," Sandro replied.

"But the Academy is for his own pleasure as much as for the plea-
sure of scholarship," Amerigo added.

"Ah, Lorenzo does not want the study of the Ancients to be subject
to the scrutiny of the Church," Sandro whispered, as though it were a
dangerous remark.

The banter continued this way until it came time to break for supper. Trying my best not to observe Sandro's voracious appetite, I left the table early to attend to the children. After Sandro announced his departure in the morning, I realized I must send a response to the Tornabuoni's wedding invitation. I secluded myself in the Ciardi's study to write not only my regrets to the parents of the betrothed, but also a note to Niccolo in care of Ghirlandaio. Sandro agreed to deliver both missives and seemed too preoccupied with packing his supplies to notice the address of the latter.

It was a short letter, for I found it difficult to write to someone who now seemed only a personage from a dream. I spoke of my lingering affection for him and the beautiful baby girl born to me in February. I made no suggestion that she could be his, except to say that she had a disposition "unlike her sister's."

In the following weeks I waited anxiously for a reply that did not come. In July Mother heard from Filippino, who had just received the important commission to decorate the chapel of Filippo Strozzi at Santa Maria Novella. Recommendations from the Medici now brought my brother more work than he could easily complete, and he was still occupied with the design for Father's tomb.

Filippino mentioned his encounter with the young "Angelo" Buonarroti, who had recently been apprenticed to Ghirlandaio. He had seen him in Santa Maria Novella when he went to take his measurements for the Strozzi chapel.

"Domenico is keeping the boy well amused with the Tornabuoni frescoes," Filippino wrote. "It is good that he has the talent for them." But to me the mention of Domenico Ghirlandaio brought only thoughts of Niccolo to mind.

"Does Filippino say anything about his former garzone?" I asked Mother, who was reading me the letter aloud. She scanned the rest of the letter and then stopped.

"There is some news here of another youth." She had a curious frown. "Filippino bids me inform you of the fate of Niccolo dei Vincetti."

I had never given much thought to Niccolo's surname, and it made him seem older to hear it.

"He says you met him during your stay last year in Florence. Apparently he suffered 'a most grievous fall from one of the high scaffolds in the Tornabuoni chapel where he was working. There was a great injury to his head and he did not recover.'"

The shock of this news so swept over me that I could not respond to Mother's inquiries.

"Did you know him, Sandra? Filippino remarks that he had always found the youth a little clumsy . . . "

I covered my mouth with my hand to conceal my grief, as if grief were only expressed in the teeth and lips. But my eyes and every muscle of my face must have betrayed me.

"Actually . . . " I could only begin with difficulty. "I found him to be rather graceful." I could not help thinking of his embraces at Careggi. "He was a pleasant escort and most attentive to Lucrezia. He told her stories by drawing little faces on his fingers."

I could speak no more, as my voice sounded foreign even to myself.

"What misfortune! May the Lord receive his soul." Mother crossed herself.

That night, I held Filomena closely and absorbed the private consolation that she brought to me. I thought there could be no joy for me again, but then I realized a certain grace in Niccolo's death, for I would never have been able to look upon him without longing and pain. My love for him had been my love for Sandro, disguised. Eventually I gathered my cheer, for I also realized that there was no longer a question of Filomena's inheritance. Ciardo was her rightful father on earth. And that night, as the heavens laid their blanket of darkness over us and every candle was extinguished at Villa Tavola, I was content to hold Filomena, and to know that Niccolo would see her as his soul shone from some bright star above.

20

"Ave Gratia Plena"

—Autumn of 1487 to spring of 1488

SANDRO COMPLETED THE TORNABUONI FRES-
coes by August. I was invited to the villa for their unveiling but
declined, for I was now more tied to Villa Tavola and life in Pra-
to. Lucrezia and Filomena were growing as much as my joy in them
grew. The efforts of raising infants had subsided, and I was barely able
to grasp what beautiful children they had become.

By winter of that year, Giovanna was carrying her fourth child, and
it became evident that Ciardo wished to have me carry a son. I pro-
tested only because Filomena was not yet weaned and I had wished to
nurse her for another year while she caught up with her sister. Lucre-
zia, at three and half years, was capable of endless chatter and amuse-
ments, but she still requested her favorite finger stories, which I could
not indulge without thinking of Niccolo. Finally I turned to the tales
of the Testaments, as she was old enough for such learning.

Mother had made a little game out of teaching the Beatitudes by
beginning with "Blessed are the poor. . . ." Lucrezia would then have
to complete the line. Of course she much preferred to say the first part
and have mother finish the rest, which was something Madonna
Ciardi refused to do.

"The Beatitudes are not riddles for children's entertainment."

But Mother believed that a child's religious training should be a pleasant experience, "so that one can come to God with love and not resentment."

In the next year, Amerigo's influence with the Pierfranceschi brought an investment in two of Ciardo's designated ships. The Ciardi now controlled all imports of raw wool from Marseilles to Pisa. An agreement with the wool guild allowed for half the shipments to go to Prato and the other half to Florence for processing. The dyeing and fulling mills of Florence were more productive by their yield, but the carding, spinning, and weaving were thought to be better in Prato, where the clean air made more efficient workers.

I, in turn, took a greater part in overseeing the harvest of the olives. The endeavor gave me something more in common with Ciardo's mother, who oversaw the pressings and distribution of the oils. These stocked the larders of our extended families, while the excess oil was sent to market with a vendor who had contracted to sell it.

Filippino had completed his design for Father's tomb and wrote that he wished to have both Mother's and my approval of the finished relief. We agreed to come to Florence after the New Year of 1487, when Filomena would be weaned. At the same time, Sandro wrote that he had a commission from his own guild of the Speziali in conjunction with the Augustinian Canons. He had designed a Madonna enthroned with Saints, featuring Saint Barnabas and Saint Catherine. He wished for Filomena and me to sit as the Madonna and Child and for Mother to sit as Saint Catherine, "thereby bringing three generations of women into the picture." Mother was not inclined to go, except to see Father's stone; but because Filomena was welcome in the bargain, we brought both her and Lucrezia, so that they might see the bust of their grandfather before it was transported to Spoleto.

Thus we traveled by entourage of the entire family to Florence on the first of May, 1487. Ciardo and his father had their business with the wool guild; Mother and Filomena and I sat at Via Nuova for *The Madonna Enthroned*; Lucia entertained Lucrezia; and Filippino was engaged with finishing a painting for the church of Santo Spirito. He also was beginning his contract to fresco the chapel of Filippo Strozzi.

As soon as we arrived at Filippino's house he led us to his bottega,

where the bust and tablet for Father's monument awaited wrapping. The sculpting of the bust had been done by a journeyman under Antonio Pollaiuolo, who had overseen the entire relief free of charge, out of fondness for the memory of Fra Filippo Lippi. The face was indeed a good likeness, as I remembered him, and both Filippino and the sculptor had captured Father's capricious smile. Even Mother was pleased. The inscription on the tablet had been composed in Latin by Poliziano at Lorenzo de' Medici's request. Mother and I read it quietly and without remark, but because Ciardo's use of Latin was directed towards commerce and not literature, I read aloud a Tuscan translation, which was also to the benefit of Lucia and Lucrezia:

> Here rests the great painter Filippo Lippi
> Well known to all who marveled at his skill
> In giving life to color and soul to every
> Figure executed by his courageous hand.
> In remembrance by Lorenzo de' Medici
> This marble tomb is given to replace
> The humble burial of so great a man.

After some length of silence, Filippino cleared his throat. "I would not have called Father's burial humble . . . but I cannot protest Poliziano's sentiment."

"I believe Lorenzo wished it to be known that more tears were shed in Florence after your father's death than in Spoleto," Mother interjected.

"*Our* tears were shed in Spoleto," I added defiantly.

"I know, Sandra." Mother's fingers lightly traced the lines of Father's brow and nose. Then she stepped away from the table where the stone sat.

A week later, while Sandro was finishing his composition for the cartoon of *The Madonna Enthroned*, one of the canons who had commissioned the altarpiece came to Via Nuova to inspect the drawing. I had gone upstairs to feed Lucrezia and Filomena, but Mother relayed to me the curious conversation between Sandro and the man.

"This Madonna appears quite woeful," the canon had observed with his hand to his chin, "as opposed to the exuberant child."

227

Sandro then explained that his model had to contend with calming "a most lively child," which accounted for her weary countenance. He reassured the canon by saying it was his intention to portray the Holy Mother as "the solemn Queen of Heaven."

The man then expressed his misgivings that the same woman from the supposedly scandalous Castello Venus should appear in his convent's altarpiece, even though the Augustinians were more tolerant in the matters of literature and art.

"And so Sandro told him that the illustrious Alessandra Lippi was indeed the same model for the Venus as well as the Tornabuoni frescoes and that you were also the wife of the wool merchant, Ciardo dei Ciardi, who had done much for the Tuscan industry by which we all thrived. To finish, he reminded the canon that you were the daughter of that excellent painter, Fra Filippo Lippi, and the gracious Augustinian, Lucrezia Buti, who now sat as his Saint Catherine but had once modeled as the most elegant Madonna of all! Then Sandro turned to me and nodded!"

"What did you do?"

"I nodded back and then excused myself. Imagine!"

"But only Sandro could say all that and keep a serious countenance," Mona Nera added with a healthy laugh.

Thus the canon left, pleased with Sandro's work on the panel and honored to make Mother's acquaintance.

Before we left Florence that spring, I had hoped to accomplish three other goals: to view Filippino's work at the Carmine, to meet Mother's oldest sister, Margherita, and her children, and to find Niccolo's grave. Mother, of course, was enthusiastic about visiting the Carmine, but was less curious about seeing her sister or helping me find my "lost" cousins. She had not seen Margherita since she had married the prominent citizen Antonio Doffi, taking most of the family's dowry funds with her. I'm sure there was still a great deal of animosity left towards Margherita for not offering to take Mother and Aunt Spinetta in when their brother decided to bring them to the convent of Santa Margherita.

"She said she was gladdened by the fact that another 'Margherita' was caring for us." Mother was rarely sarcastic.

"But Filippino knows where she lives, and I'm sure she has heard of him by now."

Mother argued that as Margherita had not seen fit to introduce herself to him by now, there was no point in reentering her life. Filippino agreed with her openly, but later took me aside to say, "We shall find our cousins in our own good time."

My sittings with Sandro on this visit were orchestrated in such a way that I had no time alone with him. I wondered if he had arranged this by inviting Mother to be Saint Catherine, or if it were mere happenstance. I knew he had not forgotten my earlier disturbance over the Venus, and yet he conducted himself the same as always. I wondered if he had guessed my affection for him, or if such a conclusion were only exaggerated in my view of things. On my last day in the bottega, after Mother had gone upstairs, he took me aside and said he wished to speak with me about a private matter. My heart raced in my chest, for I feared some kind of confrontation.

Instead, he offered to escort me back to Filippino's house via Santa Maria Novella, where we might stop to bid good afternoon to Ghirlandaio and his new apprentice, Angelo, as well as see the chapel Filippino would be decorating for the Strozzi. Mother agreed to wait at Via Nuova with Lucia and Lucrezia and come later with Filippino, when he had finished his business across the river at Santo Spirito. I left Sopraccigliotto with her so that I could walk and converse more easily with my godfather.

As soon as we were alone, Sandro announced that he wished to pay me my due for my previous sittings and that in order to avoid any monetary offense that I might construe from the offer, he had decided to pay it in the form of a dowry fund for Filomena. He said he had intended to invest earlier in the public dowry fund, but was waiting to make sure the child had passed her first year in good health, as it was customary to do. I thanked him for his generosity, but pointed out that some of his own nieces did not have adequate dowries and I did not wish them the same fate as my mother.

"Those are the affairs of my brother Giovanni." He seemed unmoved by my awareness of these facts.

I had thought to protest his contribution to Filomena's worthiness

by inquiring what sort of payment the good Cortesia had received for her "services," but I had the good sense to hold my tongue in the matter and not ignite any more scenes. I did not, at the time, stop to ask why Sandro had taken such an interest in little Filomena.

By the time we reached Santa Maria Novella, we had come to an agreement that payment for any previous sittings would be deposited in the Monti delle Doti in Filomena's name, and any subsequent payment would be given to her directly in my care. As we entered the church, I wondered if my status with Sandro had changed from goddaughter to employee and how it would affect his regard for me.

When we reached the Tornabuoni chapel we found Ghirlandaio and his pupils working in the wake of an earlier incident that had both upset and amused them. One of the abbots had brought the crew what Domenico described as "an inadequate midday meal." Domenico's brother David, who was even more ill-tempered, had assaulted the abbot with the same stale loaf of bread that had been included in the meager offering. Sandro, who always made sure that he and his pupils fed well during the day, remarked that the abbot's "pale generosity" had only served to illuminate Ghirlandaio's folly in not providing a well-stocked larder for his bottega. The young Michelangelo Buonarroti agreed with this, so Domenico asked him, "Then would you prefer the bottega of Maestro Botticelli?" It was well known that, as a result of this luxury, Sandro payed his apprentices less.

"Oh, I fear to have a pupil who may outpaint me!" Sandro said before Michelangelo could reply.

"Why, he has already outpainted me!" Domenico laughed, and everyone took part in this amusement.

But I had difficulty sharing their mirth, because I knew I stood near that very place where Niccolo must have fallen to his death. I dared not ask about the incident, and yet it haunted me as I looked up into the high ceilings of the church. As soon as Sandro and I were outside and crossing the street, I raised the subject by asking him if he remembered Filippino's former garzone who had died.

"Indeed I do. He was with you the morning you discovered Cortesia." Sandro displayed no discomfort at all. "He was a handsome youth, was he not?"

"To my eye or yours?" I took his arm.

"Ah, we both notice beauty when we see it!" Sandro gave a poignant sigh. "And, I trust, we both mourn its loss. Would you like to visit his grave? It is not far."

It was as though he had read my thoughts all along.

I passed a pleasant summer in Prato, having felt some closure to my affair with Niccolo. Filomena thrived well, but I was late in weaning her, as I had planned. Ciardo spoke often of having a son; Giovanna was expecting her fifth child. Mother received few letters from Filippino, who was engrossed in preparing the cartoons for the Strozzi chapel. But the market crier in Prato brought reports of another kind to entertain us. A strange gift had arrived in Florence, sent to Lorenzo de' Medici by the son of the Sultan Mohammed the Second. It was an odd, towering animal called a *giraffe*, which sported an incredibly long neck and mottled coat. It was kept in a stable near Via Larga, where it was continuously fed by curious visitors. Later, during Carnival, the poor beast was paraded though the streets of Florence, where it frightened the horses and was terrorized itself by the furor it had created. It soon died.

That autumn, after overseeing the harvest of the olives at Villa Tavola, I noticed the familiar malaise that signaled another pregnancy. I welcomed it perhaps as much as my husband did and enjoyed the favor it brought to me. If Ciardo had thought my state of maternity would at last end my career as Sandro's "most glorious model," he was mistaken, for not long after our discovery, I received a letter from Florence.

Sandro had received a commission from one of the city magistrates for a tondo, which he had not painted since *The Madonna of the Magnificat*. Several workshop pieces had been similar to the *Magnificat*'s composition and style, but they had been painted by various garzoni and not by Sandro's hand. Sandro described the theme of the tondo as the Holy Mother and Child surrounded, again, by angels. And again, the Christ Child would be holding a pomegranate, one of my father's favorite sacred symbols, as "the apple of divinity."

"I have already designed the cartoon and need only to personalize it

with your and Filomena's figures. The Christ Child holds the opened fruit with all its seeds, representing the multiplicity of the eternal spirit. You are surrounded by six angels, this time with wings! Let me come to Villa Tavola and finish my studies if you are amenable to sitting for them."

His letter ended with the news that Zephyr and Chloris had married and were soon to be parents.

Ciardo did not protest against the proposal, but jested that Sandro should consider using Chloris as his Madonna. Of course, a noticeably pregnant Virgin Mary would have been an offense by any standard, but Giovanni Ciardo found the idea highly amusing.

Mother received Sandro three weeks later in October, when I was feeling better, and he worked steadily for two to three hours on my part of the cartoon. Another hour he devoted to Filomena's figure, continually holding up his hand in a gesture of benediction for her to imitate. Her other hand, with the pomegranate, soon became a scarlet marinade of juices, which she licked intermittently with delight.

Ciardo's younger brother, Gio, agreed to pose as one of the six angels, and dutifully stood close behind me for the sake of the composition. Sandro would finish the studies of the other angels from his bottega models. One would be holding roses and wearing a sash that read *Ave Gratia Plena*, meaning "Hail, Full of Grace."

Filomena became more animated with Gio's presence and continually reached up to offer him a taste of her pomegranate. He stroked her hair gently and repositioned her hand for Sandro, who made every effort to be patient with us.

When I later saw the finished *Madonna della Melograna*, I saw how Sandro had continued to capture the gentle melancholy of my countenance. Had it been my fatigue, I wondered, or did I always show such a face when I sat for him? Perhaps this was the face of unrequited love. Had I known this was the last time I would sit for Sandro, I might have put forth a less mournful Mary. But such was the expression Sandro liked to depict with his Madonnas: the Virgin's contemplation of the crucifixion even as she holds the hope of the world.

That winter, both Lucrezia and Filomena took delight in the story of the Nativity and offset the candles of Chistmas with their "flashing

Buti eyes," as Giovanna called them. She was due to deliver soon after the Florentine New Year in April, whereas I was due in May. Filippino did not come to visit for the Feast of Epiphany because he was in the process of purchasing a new house. He had decided that he needed larger accommodations for his bottega, and had succeeded in finding a suitable location on the Via degli Agnoli, not far from the Via Servi and the hospital of Santa Maria Nuova.

"I trust you will find it a fine house," he wrote in his letter of Christmas tidings.

Mother thought it odd to be making such a transaction in the midst of the Holy Season, but Ciardo's father found it a wise undertaking.

"Everyone is more honest this time of year."

Ciardo agreed with the observation that the usurers lowered their interest during Lent.

"Of course, this time Filippino does not have to contend with the 'approval' of Diamante," I pointed out. Mother found it ironic that I should mention Dido, because Filippino himself had remarked that Diamante was no longer in Florence, having been appointed as a Prior somewhere near Volterra.

Early that spring, as the child grew and turned within me and Filomena explored the new world of a walking, talking two-year-old, the news came to Prato that Lorenzo de' Medici's wife, Clarice, had died of the same malady that had taken Simonetta Vespucci. Some say she followed in grief after her daughter's death a few months earlier. Even the tempestuous Poliziano, who had been a certain Nemesis for Clarice, grieved at her passing and wrote an eloquent eulogy. She would be remembered as the most Christian of the Medici women.

Although it was known that her husband had taken mistresses throughout their marriage, no one could deny that Lorenzo de' Medici had always loved and respected Clarice. After her death, he was seen less at Careggi, where he had so often stayed without her, and sought the comfort and relief of the hot springs at Spedaletto. Lorenzino di Pierfrancesco remembered her as the caring cousin who had acted more like an aunt, and I remembered her as a high-born woman who valued beauty as much as God.

But the saddest death to touch my life that year of 1488 turned a

once-hopeful season to darkness. Giovanna was taken in her travail, and I was robbed of her final words and breath by not attending this cruel birth. The child, a son, was delivered safely by the mercy of God, but by His great design, he had not wished to spare Giovanna in her struggle to bring forth another life.

The midwife argued that such deaths were the result of too many birthings "that came too close together for the womb to heal." The sudden expulsion of the child could cause the weakened womb to tear, and then there would be no means to stop the hemorrhaging. Giovanna had died without me, "in an act of greatest love," as her eulogy proclaimed.

But this earthly and moral logic gave me no comfort as I watched her still-young face disappear beneath the burial shroud. It seemed only a year ago that we had played and loved, studied and whispered our darkest fears and brightest hopes to each other. I could only imagine that perhaps there was a need, somewhere in heaven, for another star—one to accompany those of Simonetta, Niccolo, and even my little Filippo.

Ciardo's parents mourned their daughter quietly, but I could not; and although Ciardo wept openly for the first time since the loss of Filippo, he soon cautioned me against too much grieving, "for the sake of the new child within." Thus, for its sake and his, I kept my tears to myself. The best I could do now was to offer my affection and attention to Giovanna's other four children. Ciardo's mother had asked them to reside with us, but Antonio declined the invitation and remained with them at Casa Vannozzo. He employed a wet nurse for the new babe, who had been given the name Paolo. I had thought to suckle him myself after my milk came in, but this was more of an emotional than a practical proposal.

I feared that my sadness over Giovanna might threaten my travail when it began, but one month later I was delivered easily of a healthy son. This contradicted the Tuscan proverb, "Struggle longer and bear a son." We named him Giovanni, after his grandfather and in honor of his gentle aunt who was no longer with us. I felt determined then to live well for her memory and for the children she always wanted me to have.

21

Cortesia

LUCREZIA AND FILOMENA WERE FASCINATED BY their new brother and wanted to entertain him almost more often than he could bear. He did not sleep as well as his sisters had, and thus the demands of motherhood gave me less time to see either Mother or Aunt Spinetta. Aunt Spinetta rarely broke closure now and was content to stay cloistered at Santa Margherita.

That summer, Filippino received the honor of being recommended by Lorenzo de' Medici to decorate the chapel of Santa Maria Sopra Minerva for Cardinal Caraffa in Rome. Lorenzo saw the advantage of sending my brother south so that he might also oversee the installation of Father's monument in Spoleto. This he did in August, when he traveled overland to Rome to inspect the chapel and begin his designs.

After realizing the magnitude of the Caraffa commission, he returned in haste to Florence to make arrangements for such a lengthy absence. The painting of the Strozzi chapel would certainly be interrupted, and he would also have to install himself in his new house. Because Filippino returned with a papal convoy that landed in Pisa, he was able to pass by way of Prato and visit Mother and me and meet his new nephew.

Mother encouraged him to see a notary in Florence—possibly Amerigo's brother, Antonio—and draw up a will for his protection.

Filippino had already decided to bequeath Father's two houses in Prato to Mother and myself respectively. Ser Vannozzo oversaw the rental of the house near the Mercatale and agreed that Filippino was long overdue in securing his estates "for posterity." Perhaps Mother thought such an endeavor would encourage my brother to think more seriously of marriage, but it was obvious that the number of commissions he undertook precluded any commitment to a woman.

When Filippino departed again for Rome in October, he sent us copies of his new will. Mother was pleased but also baffled by his directive to keep her supplied monthly with wood, oil, and salt meat.

"He is like your father," she told me one morning when she came to visit Villa Tavola with Riccardo. "He scrutinizes his daily expenditures to the point of miserliness, but lavishes unexpected gifts with uncommon generosity."

"Then he is also like Sandro." I was thinking of Filomena's private dowry fund. "From which of the two did he learn it more?"

"They learned it by being Tuscan!" Ciardo interrupted when he overheard our discussions. After all, it was a part of his trade to scrutinize daily expenditures.

My brother wrote once before All Saints Day to announce that Father's bust and the tablet had arrived safely in Spoleto and were installed in the south transept of the cathedral there, not far from Father's frescoes behind the main altar. Filippino had continued on to Rome with a Medici envoy and escort. The envoy was sent to pursue the betrothal of Lorenzo's son, Piero, to another daughter of the Orsini. When I remarked that Piero was more interested in athletics than marriage, Mother could only sigh, "Much as Filippino pursues commissions over a wife."

Filippino's work in Rome left him no time for further correspondences, while news from or about Sandro was equally scarce. The *Madonna della Melograna* was reported to be "as radiant as the *Venus Arriving on the Shore*," according to Semiramide. She had sent four Venetian goblets as a christening gift for Giovanni, and her letter expressed the hope that he and his sisters might drink from them some day. She also remarked on the many visitors to Castello who came, she had supposed, specifically to view Sandro's magnificent painting.

"We are wont to withhold an invitation to anyone who might possess an attitude of condemnation or offense and only bid entrance to those who have assured us of respect for both the art and the artist."

Semiramide proved to be a prolific correspondent, and I felt that I might find a friend in her. She would certainly never replace Giovanna, but her missives were kind and personal and she shared with me any matter of interest in her household. Amerigo's uncle, Giorgio, who had once tutored Lorenzino, had been named *Proposto* of Santa Maria del Fiore and was preparing to forsake his worldly goods. As for Amerigo—and I assumed she knew nothing of his exploits with me— Lorenzino was planning to send him to Spain to inspect the Pierfranceschi's investment in Seville. Lorenzo and his brother had employed a silk dealer there, and a recent acquisition of mulberry bushes to raise silkworms in the Mugello had prompted a need for negotiations. Amerigo was the perfect agent for the job: he picked up languages easily, as any well-traveled man might hope to do.

Lorenzo de' Medici had installed his New Academy in the gardens of San Marco that had previously belonged to his wife, Clarice. Semiramide had found this "a curious memorial to Madonna Clarice, considering the fact that she had never embraced his love of the Ancients." Lorenzo defended the moving of his Academy from Careggi and Fiesole, which had restricted "all studies and pursuits to the rightful escape of solitude," by providing a place where "citizens who are equally devoted may gather and be enriched."

I was inclined to ponder the conflicting worlds of Clarice and Lorenzo de' Medici as I began the religious instruction of my own children. Lucrezia had learned her alphabet and had begun to read simple words. To her and Filomena I read passages from the Testaments, prayers from the Book of Hours, and the progression of the Sorrows of Mary and Joseph. If Ciardo were pleased with my new occupation, he spoke no words of praise. For him, religion was a ritual comfort but not a spiritual one. The ethics of good business or trade were the true gratification of his daily creed, as opposed to any prayer he might utter. Still, little Giovanni's baptism had brought him a special joy in being able to present "so worthy a child, this son, to the sight of God."

Sandro's next major commission had been an Annunciation panel for the chapel of a notary at a small church near Santa Croce. This was the Church of Cestello, and although Sandro had thought of me first as his Virgin Annunciate, he knew he would need to procure another model—one capable of the strenuous posture required in the continual bending of submission to Gabriel's announcement. For his archangel, he had thought to "borrow" Ghirlandaio's young garzone, Michelangelo, but the latter's talents had recently come to the attention of Lorenzo de' Medici, who hoped to take him into both his Academy and his care. Of course, I could not help pondering who might sit now for Sandro. I was no longer the truly Virginal maiden I had been when I had posed for the *Annunciation* at San Martino many years earlier, but the woman he chose was even older and a good deal more experienced than I. It was Cortesia, whom I was not to meet for another year.

Giovanni was weaned by the spring of 1490, which allowed Ciardo and me to travel to Florence for the festivities of the Florentine New Year. We were able to stay in Filippino's house on the Via degli Agnoli, although Francesca served another household in his absence. Two of his garzoni had remained in his bottega to finish several minor commissions but spent part of the day with another master painter.

On the Sabbath after our arrival in Florence, I decided that Ciardo and I should hear the Mass of the Annunciation as part of the observation of the New Year. We had heard there was a new monk from Ferrara who gave rousing sermons at San Marco, which was the nearest church to Filippino's house. He was said to refer to Florence as "The New Jerusalem" and admonished the Medici and their "ilk" who had attempted to make it "The New Athens." His words compelled the learned and the illiterate alike, the citizen and the servant. Although he had preached in Florence before with little acclaim, the name of Fra Giralamo Savanarola was now on the lips of every Florentine, even those he had condemned as "pleasure-seeking heathens."

When we came to San Marco that Sabbath morning, Ciardo and I discovered a crowd so large that most of the congregation spilled out of the nave and entrance and into the street.

"Perhaps the people have, at long last, found some entertainment in

the church." Ciardo was almost amused, and one woman responded by saying that there had not been such a tumult over a cleric "since a priest some years ago burned sulphur in the censer to protest the false coins left in his offertory." Savanarola's rage was far greater than this, however, and he appeared as a new force in Florence at the turn of the decade. Ciardo and I were unable to hear the friar that day, but I was more curious than ever after seeing the crowd he drew.

Because of our proximity to the gardens of San Marco, we stopped to visit Lorenzo's New Academy, and there we found not only Lorenzo but Sandro, Poliziano, Antonio Pollaiuolo, and the young Michelangelo. They were engaged in a lively discourse over the spiritual warnings they had just received.

"The good friar appears to fairly swoop down over his congregation as a hawk surveys his prey!" There was both genuine and mocking respect in Poliziano's voice.

"The man has more a beak of a nose than our friend Antonio," Sandro said with affection for his former teacher, Pollaiuolo.

I had not seen Sandro for a year and a half, and although I was not surprised to see him here, I did not expect to feel the same feelings for him. He greeted Ciardo and me warmly, asking if our "wayward souls" had been pecked sufficiently by Fra Giralamo. We said that we had not been able to hear the controversial friar.

Ciardo was put at ease by this opening, and we turned our attention to Michelangelo, who had been chiseling a small marble cupid in the courtyard. Antonio Pollaiuolo was offering his theories on anatomy to the youth, and Sandro informed us that Antonio would soon be seeing Filippino in Rome, as he had been commissioned to work on the tomb of Pope Sixtus.

"Of course, the chances of payment are just as good with Sixtus *in* the tomb." (Sandro could never forget his own financial dealings with the Pope.) At this Lorenzo laughed most heartily, for he prided himself on paying his artists promptly.

Although I had accustomed myself long ago to the admiring glances of men, I felt awkward receiving them in the company of these esteemed Florentines. Perhaps it was feeling the admiration while being with my husband; perhaps it was merely Sandro's presence alone and

not knowing whether or not he saw and felt what was in the eyes of other men. That is to say, other men than Poliziano and the young "Angelo," who looked more longingly at Ciardo than at me! But Ciardo took no note of this and carried himself well in most situations where he knew I was the focus of attention.

"Whatsoever a man possesses by his good name and good physique can replace the clever words of any lettered man." Sandro had once said this and it was true of Ciardo. Perhaps I loved Ciardo because he was "handsome enough" for me, although he did not stir my soul or intellect as Sandro did. A woman of my beauty required a comely mate, as one exquisitely crafted salt cellar required a pepper mill of equally superlative design.

As I sat that morning in the gardens of the Academy, enjoying the recognition I had always received and conversing with these men of good cheer, I saw that I was not to be the only female there for long. From behind the courtyard a graceful and elegant-looking woman appeared, escorted by some servant who left her as soon as she was greeted by Lorenzo. Her gown was the color of red eggplant, and its skirt seemed to dance behind her as she walked. She was older than I but radiant in her maturity. The woman glanced once at Sandro and eyed Ciardo with a fiery curiosity, but when she turned her regard towards me her eyes flashed against her dark complexion.

"This must be your godddaughter, Sandro." She had a voice as musical as my mother's but with more assertion.

Sandro reached out, took her arm, and drew her to his side, which set my heart to pounding uncontrollably. "Please meet Cortesia Cattalani, Sandra. And this is Alessandra Lippi, now Ciardi, and her husband, Ciardo dei Ciardi, of Prato."

The woman curtsied gently, which seemed almost capricious for one her age, while I returned the gesture with a simple nod. Ciardo took her hand and nodded also, and I wondered if he would have preferred to kiss it.

"Cortesia has sat for me on occasion, and is, moreover, a fine tutor in Latin and Greek." Cortesia smiled with the confidence of a woman who is aware of her attributes but does not flaunt them.

It was the first time I had felt intimidated by my own sex, and

although I was perhaps lovelier in my countenance than she, Cortesia spoke and moved with an aplomb I could not rival. It was odd to feel the envy other women must have felt towards me. I had never considered it, at least not for very long, when I was being admired in public or at some social event. Perhaps I was too busy receiving the singular adulation for my beauty to be concerned with the complex idea of worthiness. But as Cortesia expressed her pleasure in meeting me, "the immortal face of Sandro's Venus," I was swept away to that early morning nearly five years ago when she had emerged from Sandro's bottega, barely visible beneath her purple cloak and hood, and had shattered all my confidence.

Can it have been so long, I wondered, since I had felt betrayed by her and Sandro *and* by that unseen torso I had yet to view upon the walls of Castello? Sandro had blended our bodies for the sake of art and my "modesty," but we were, now more than ever, completely separate women.

"Sandro speaks of you, Madonna Sandra, as often as he has painted you!" Cortesia's words forced me to turn my attention back to the moment at hand.

"And, perhaps, as often as he has turned to you for instruction of one kind or another."

She laughed her musical laugh and hastened to speak. "Then you know how your godfather is wont to contemplate whatever might benefit his art . . . be it literature or women or the changing aura of some handsome youth!"

Lorenzo, Poliziano, and Sandro smiled in amusement (particularly Poliziano!), but Michelangelo looked up from his cupid with a curious glance.

"Indeed," Sandro rejoined, "but to hear Fra Giralamo speak, I had best now contemplate the climate of Hell!"

Poliziano responded, "Did the friar not say 'the faith of my Florentines is like wax; a little heat is enough to melt it'?"

"Do you believe we are all hopelessly condemned by worldly indulgences?" I was fingering the strand of pearls about by neck.

"Ahhh . . . ask that of Saint Francis or any Franciscan," Poliziano replied.

"Or Dominican!" Lorenzo added. That was Fra Giralamo's order.

Cortesia put her hand to the silver and gold brooch that glimmered on her scarlet bodice. "God gave us a world full of cruelty and pleasure, ugliness and beauty. Should we not partake of both?"

Sandro agreed. "One needs good wine as much as vinegar." I felt a wave of jealousy sweeping over me again as he put his hand around her waist. This was the jealousy that had driven me into Niccolo's arms.

"And wisdom as much as righteousness." Lorenzo gestured towards the walls of Saint Marco. I was struck by his allowance for the friar's recent attack on him, for he was able to contain his analysis of Fra Giralamo's popularity to logic. In this respect, Lorenzo was a true Platonist.

"Then you have no fear that the friar's vision of the city may come to pass?"

Lorenzo chuckled lightly and turned to me. "Believe little in other people's visions, for even the holy have limitations." With this he stroked my "worldly" satin sleeve, as if to be seeking the flesh of Venus herself. Ciardo was now engaged with Antonio and Michelangelo and did not witness the subtle overture.

Cortesia, being a woman of refinement, sensed my discomfort and intervened in her gracious way.

"Have you seen Sandro's altar piece at the Cestello?" She took my other arm and led me away from Lorenzo.

"*The Annunciation?*" My reply captured Sandro's attention.

"He wanted you, of course, but I was content to be the substitute."

"I trust this was not the first time you have rescued Sandro from an artistic dilemma," I said loud enough for him to hear. He refused to acknowledge my remark, but Ciardo did.

"A maestro such as Sandro knows when one model might complement another. Is it not like blending two grades of wool to get an even more superlative fabric?"

"Ah! The merchant speaks when no one else can," Lorenzo applauded Ciardo. Then he honored us with an invitation to sup with them that evening at Palazzo Medici.

When the day was done, I found myself less threatened by Cortesia Cattalani. She had the genuineness of my dear Giovanna and the

graciousness of Semiramide. And I sensed, by her repartee with Sandro, that her affection for him was not at all the same as mine. At dinner we spoke of many subjects: Fra Giralamo's rise in popularity, the sins that troubled man and woman alike, the future of Florence.

That night, as I gazed up into the stars from one of Filippino's windows (at long last, a Lippi house blessed with glass!), I pondered the words of the friar I had not yet heard. I was combing my hair with the inlaid comb Sandro had given me in my youth: Was vanity so great a sin, and could I cleanse it from my soul as easily as I might put water to my face? Was pride in beauty wrong, or did the pleasure that beauty brought to those who looked upon it not redeem whatever worship we gave to it?

Before we returned to Florence, Ciardo and I agreed to go to the Church of the Cestello to view Sandro's *Annunciation* panel. I went out of curiosity for his depiction of Cortesia as the Virgin Mary; Ciardo went out of simple Florentine camaraderie. Sandro met us, and I was surprised that he came alone, without Cortesia. When I asked where she was, he answered that I should recall my own lack of interest in the finished Venus. It was as though he had not realized the turmoil its completion had caused me.

"And what of you, Sandro?" Ciardo inquired. "Do you never tire of seeing your work?"

"Do you never tire of the same wool account when it is to your profit? Do you ever tire of the sight of your own child?"

Ciardo smiled and nodded. When we reached the threshold of the small but wealthy church, I could not help turning to Sandro. "So, my dear Maestro Botticelli. Let us see your newest daughter!"

The Guardi had been one of the first families to build off the sides of the new cappella maggiore, and the theme of The Annunciation was fitting for the not-yet-completed church. The chapel was a simple recess with a stained glass window and a small altar. Sandro reminded us that The Annunciation of Gabriel to the Virgin Mary was meant to portray a sacred and exquisite moment of feminine rapture. It required an acquiescing posture coupled with the grace of the crouching Gabriel offering his stalk of lilies.

Sandro had painted the Virgin's scarlet robe and azure cloak more

brilliantly than he had in the *Annunciation* for San Martino, and the cloth swept restlessly against Cortesia's gesture of humility and awe. Her face was both pious and sensuous, as it was in life, and yet he had made her look much younger to accommodate the reality of Mary. He had painted her as a woman I could both admire and envy. Beneath the panel was the inscription:

> The Holy Ghost Shall Come Upon Thee
> And The Power Of The Most High Shall Over-Shadow Thee.

The next morning, as we left the city, I no longer wanted to deny Sandro his love of any woman or any thing. And by this good motive, I was fain to suggest we travel by way of Castello to call on Lorenzino and Semiramide and view the *Venus Arriving on the Shore.*

We were received most graciously despite the fact that we were unannounced and had arrived at the same time as Amerigo, who had just returned from Spain. Thus there was a tumult of news and discussion. Amerigo had passed through Semiramide's native Piombino and had met her brother, Jacopo, with whom King Ferdinand and Queen Isabella had hoped to make an alliance. To that end, Spain had just levied new penalties against any ship that might disturb the iron-rich port. This brought equal relief to Ciardo, who now considered his wool ships more secure: they would be without the threat of Spanish pirates invading the harbor of Pisa.

Amerigo announced that he had adapted well to the language and culture of Spain, but had missed the Tuscan cuisine. He spoke of an Italian colony in Seville, where he had met a Genoese who remembered Semiramide's aunt, the young Simonetta Cattaneo. The Spaniards called him "Cristobal Colon," and Amerigo found that he and the man had a common interest in astronomy and geography and the maps of the learned Toscanelli. The discussion of cartography and trade and a fourth continent interested the men more than Semiramide and me, so we excused ourselves to speak of children and our own households.

Semiramide was pregnant again, and I could not help recall Ciardo's bitter words regarding her superior fecundity. I envied her wealth and even her importance as the wife of a Medici, not realizing that at the

same time she envied me for my "immortal face." Had I understood the threat that my very presence brought to her, I would not have imposed upon her hospitality. Nevertheless she felt the closeness towards me that I felt towards her, especially here in Castello, where we both had experienced the affection of Lorenzino di Pierfrancesco. But she was his wife, whereas I was only an idealized image of color on canvas on the wall of his favorite villa.

"Come, you must see Sandro's *Venus*. I understand you have not seen it yet." Semiramide gently touched my arm.

She escorted me to the grand salon in which the painting hung in harmony with the earlier *Mars and Venus*. In its completion, the canvas had more movement than I had recalled in Sandro's cartoon. Zephyr and Chloris seemed truly to ride on the air. One could almost feel the wind in my luxuriant hair. But no, it was not my hair: it was the hair of the goddess, resplendent with real gold. She stood in contrapposto upon the carefully formed shell and gazed out from the canvas with more sorrow than self-consciousness. Even the greeting of the Season Hora on the shore did not distract her gaze. Her lips were gently pressed into a barely discernible smile. It was a smile that spoke of hope in a world of woe.

And if the torso, breasts, and belly were not my own, this was not obvious in the composition. This Venus had the blossoming of youth within the ripeness of a maternal body. In the light azure sky behind, one could see where Sandro had altered the position of the arm that was bent and held up to her breast: the pentimento, or "memory," of the original position was barely visible. The oil that Sandro had once questioned in his early years had allowed for this change, and perhaps only the most diligent viewer would notice it. As I stood there with Semiramide, who had lived agreeably with this image and her husband's adoration of it, I could finally see that the Venus rising was not painted in rivalry of my beauty against Cortesia's. It was, indeed, Sandro's composite tribute to all the women he had ever studied. It was his "daughter" as much as I was my father's daughter and Lucrezia and Filomena were mine.

22

The Convertite

CIARDO AND I WERE HAPPY TO REUNITE WITH Lucrezia, Filomena, and Giovanni, whom we had begun to call "Vanni." Sandro was correct; one never tires of the sight of one's child (unless he is disobedient or unindustrious). Even in our short absence they had begun to change. Lucrezia now seemed more studious and ready for tutoring. Filomena's speech had become more coherent and less of a babble, and Lucia hastened to take credit for the improvement.

"Filomena speaks well without a doting mother who is willing to guess at every sound she utters!"

Lucrezia had visited Mother, who was excited over the impending marriage of Vincenza's son, Giorgio. The summer was to bring many new developments, including Vanni's first occasion to wear a tunic and matching set of hosiery. They had been purchased by "Nonna" Ciardi from a well-known hosier who knitted the leggings to size.

After the worst of August's heat had passed, I arranged for a tutor to instruct Lucrezia: at seven years of age she was eager to read and do math. Ciardo neither protested nor discouraged these arrangements, but remarked that the daughters of other merchants "were not especially grieved by their purely domestic education." When I told Mother

246

this, I ventured to assume that Ciardo thought literacy might cause Lucrezia to be "wayward." I was thinking of the tales of *The Decameron* and how they had influenced me that night at Careggi.

Mother interrupted my daydreaming by asking, "And do you believe *your* literacy has made *you* wayward?"

"Some would say so, by my sitting for the Venus."

"Because she is a pagan goddess?"

"And without covering or shame." But I was thinking of Cortesia's body and not mine. "There is a secret about that painting which I did not confide in you, Mother."

And Mother, being no stranger to the scandals that art can bring, sat up in attention to hear more. It was then that I informed her of Sandro's concern about my modesty and his decision to use another model for the naked torso of the Venus. I told her of my sense of betrayal, which Sandro had since dismissed, as his painting was a tribute to love and beauty and the female form and not to any particular woman. I came very close to confessing my nonplatonic love for my godfather, but at this point it was immaterial. Nevertheless I could not withhold the fact that the other model was a courtesan, as it seemed too significant to the newly brewing controversy over "the profane paintings of the Medici."

"Her name is Cortesia, Mother. Isn't that ironic, given her vocation?"

"But I believe Sandro has used cortesans before as models. Many painters use even less cultured women."

"She is indeed cultured. She knows Latin and Greek and most of the members of Lorenzo Medici's Academy."

"No doubt that is how she and Sandro met."

"That is the same thing Filippino said!" I couldn't help laughing.

"How old does she appear to be?"

"Possibly ten years older than myself or more."

"That is interesting, because my eldest sister, Margherita, bore a daughter not long after Spinetta and I were sent to Prato. She named her Cortesia, and I know her husband had wealth enough to educate all his children very well."

"And you have never seen her?"

"I never saw any of Margherita's children, and I have not seen my sister since I entered the novitiate. She was possibly too chagrined about not taking Spinetta and me in after her marriage to Messer Doffi. And after the scandal of Filippino's birth, I'm sure she was too ashamed, for the rumor had been that both Spinetta and I had borne a child."

A birth that had resulted in someone as talented and respected as my brother hardly seemed scandalous now. But time changes the shape of all things, just as it had changed my view of the Venus.

By Advent of that year, Lucrezia had made many advances in her study of Latin and math and helped Filomena to learn her alphabet. The two of them expected their little brother, who was only two, to recite along with them. Ciardo found little time to notice any of their talents, because he now traveled every other week to Pisa to oversee the arrival of his wool shipments. His father never made the trip, as old age had begun to visit its infirmities upon him. And although Ciardo had expressed a desire for another son, Lucia was wont to jest that he "would have difficulties giving me a child from his bed in Pisa."

I did yield to Ciardo's desires, but Christmas passed and I had not conceived. At Epiphany, Filippino sent us his tidings from Rome, where he was approaching the completion of Cardinal Caraffa's chapel, but because he would still be detained until at least the following autumn or winter, he realized that he needed to find tenants for his house in Florence. He hoped to have this accomplished before Lent, when people make fewer transactions, and asked if Ciardo and I could assist him if Ser Vannozzo tended to the actual lease.

Ciardo agreed that Carnival season would be a good time to go to Florence so we could secure tenants before the actual festivities began. Lucrezia overheard our discourses and begged to accompany us, but Ciardo told her she was too young "for such corruption."

"You speak as a man who has stayed too long at San Marco," I teased him, but Ciardo was little amused by my reference to Fra Giralamo. He said he was "merely taking the caution of a good father."

Procuring tenants for Filippino turned out to be much easier than observing Carnival. A notary and his wife agreed to care for the house at Via degli Agnoli with the utmost regard for Filippino's furnishings.

They understood that Filippino was scheduled to return the following year to comply with his contract for the Strozzi chapel. But more than this, the couple seemed very curious about the matter of my brother's bachelorhood, as they knew him to have been "a student of that scurrilous Sandro Botticelli, aligned with the Medici's Academy, which was known to attract men of questionable inclinations."

Of course, I dared not mention that I had been the model for the "scurrilous" Venus or any other Botticelli paintings, let alone the former "Queen of Beauty," proclaimed by one of the Medici! I knew not how to respond to their inquiries until Ciardo, with his merchant's diplomacy, assured the couple that they would not be bothered with visitations from any "Neoplatonic idlers." He also metioned that "the only passions that Filippino Lippi had acquired at the hands of Maestro Botticelli were those for painting and nothing more!"

Sandro was highly amused by this tale when he stopped by Via degli Agnoli the next day. I had hoped not to offend him with the anecdote, but by now he was accustomed to the disparaging rumors regarding his bottega and Lorenzo's Academy. Ciardo invited Sandro to sup with us, and he returned the invitation with the request that we accompany him the next evening to a banquet at the home of Cortesia Cattalani. A strange emotion seemed pressed into his countenance as he spoke, and he finished by revealing to us Cortesia's intentions to renounce all "worldly things" and enter the convent of the Magdalenas.

"Are they not the Order of repentant prostitutes?"

Mother had spoken of them before. Their small convent stood across the Arno, not far from the Church of the Carmine.

"Yes. Cortesia has been converted by the inspiration of the pulpit at San Marco and by the virtue of her spirit."

"You mean she has heeded the words of Fra Giralamo and cast off her harlot's gown?"

"She was never a *harlot*, Sandra. You know that as well as I do. Cortesia enlisted herself in the only trade she could rely on, as few men are willing to employ a woman tutor. But her Latin is as good as Poliziano's and her Greek is as good as Ficino's."

"Had she no husband to care for her?" Ciardo marveled.

"She did, but she feared for her life and the life of her children when he began to beat them. He had killed another wife before her."

"Why was he not imprisoned then—or hanged?"

"Sandra," Ciardo interjected with mercantile exactitude, "you have forgotten that the punishment for killing a woman is merely a fine of sixty-five florins."

Sandro nodded sadly. "Not much more than a modest dowry."

He continued by explaining how she had taken her children and fled from Siena while her husband was away; and rather than return to her parents' house, where she would be found, she chose to use her gift for languages to acquire a suitable cordon of patrons to sustain her. Now her two daughters had recently married and her son was established in a good trade and she desired to relinquish both the heartache and the pleasures of the world. As a gift on her behalf, Sandro was painting an altarpiece for the Church of the Magdalenas.

"It is one of my first Crucifix panels. I am like your father, Sandra. I care not to paint the death of our Lord. But perhaps I am changing too."

Cortesia's banquet was held on the last night of Carnival, an event to stir the thick blood of Florence as it emerged from the chill of winter. Ciardo and I rode from Via degli Agnoli to Via Larga and past Palazzo Medici, which always looked solemn and austere from without. But by all repute it hosted a great deal of frivolity within. The Campanile of Santa Maria del Fiore towered over the raucous citizens on the piazza below, bringing to mind the figure of an indulgent parent watching its children at play.

We cut across the city towards Ognissanti to meet Sandro at Via Nuova and then accompany him across the river to Cortesia's house on the Via de Serragli. Just as we were about to knock on Sandro's door, we were jostled by two youths in pursuit of two older women. Because of this commotion, Sandro appeared in time to see the curious nature of the youths' masks. The noses had been fashioned in the shape of phalluses, which caused us all to laugh and Ciardo to say, "Art appears in many forms this time of year!"

"As does courting," Sandro added.

I had hoped to go upstairs and greet Sandro's brother, Giovanni,

and Mona Nera, but they were both feeling poorly. (It was hard to imagine the robust "Botticello" taken to bed at Carnival.) Instead we mounted our horses and continued down Via Nuova and the Borgo to the bridge and across the river.

The entrance to Cortesia's house was unassuming and concealed an elegant and spacious interior. A servant greeted us and took our cloaks and then led us into the dining hall on the next floor. Cortesia, in a dark blue gown with no lace or embroidery, only the simple embellishment of pleated sleeves, rose from her chair as soon as she saw us.

"Welcome!" she said as she held out her hands, but then spoke little more as she directed us towards the three long banquet tables and showed us where to sit. Amerigo was one of her many guests, and I could only assume that he had once patronized her services. He greeted us casually, flashing his bright eyes my way as though nothing had changed. In my flush of discomfort, I held my goblet up rather eagerly to the servant girl who poured the wine.

"That girl bears a striking resemblance to Fra Giralamo!" Amerigo whispered to Sandro.

"Indeed, she is dark and has the same nose."

"She is a Moor but has been converted... as have I," noted Cortesia as she lowered herself onto her chair and called for the blessing of the meal.

After grace, one of the guests observed that the Moors had always been "a handsome race but a scourge to Christiandom." Amerigo replied that we should not condemn the Saracens while we profited from their knowledge, reminding us that we used their numerals and math. Sandro then added to the argument.

"If beauty is indeed a part of truth, then God has willed some recognition for His 'handsome race.'"

I could think only of the tale of the ring and the events that had followed my telling it.

The banquet continued in this vein with little reference to the conversion of its hostess, but in her own gracious way, Cortesia managed to convey the message that this night was not intended for piousness. It was meant to be observed by rejoicing in the things she had renounced: abundant foods, exquisite wines, and scandalous conversation.

The meal lasted well into the evening as each guest recalled the

most memorable antics of Carnival. Ciardo described the provocative masks we had seen on Via Nuova, while Amerigo relished the sight of two youths who had ventured onto the Piazza della Signoria in women's pattens.

"They were barely able to walk on the high shoes and were escorted by two maidens who had donned the garments of men. Each wore a set of male hosiery, with stuffing in the codpiece!"

"Ah, much as you do, then," one woman jested boldly.

This brought great laughter to the table, and it was the first time I had ever seen Amerigo blush . . . though perhaps it was the wine. He soon overcame the moment by impressing our table with his tales of Spain and his knowledge of a Portuguese pilot who had sailed around the bottom tip of Africa.

Such ideas were too distant for my own imagining, so I turned my attention to the musicians who now entertained us. Cortesia's son had mastered the lute and was among the quartet of strings and flute that so cheerfully serenaded the closing of the meal. His mother, in a gesture of her new humility and servitude, passed out the fennel to clear our tongues. To each guest she gave her own blessing. "Rejoice in our temporal delights as you pray for more everlasting joy!" Then she ended her offering by declaring, "As of now, I abandon the name that I took in marriage just as I abandon all the delights and trouble of the world. I return to the purer self I was in childhood, so I am no longer Cortesia Cattalani but Cortesia Doffi. I keep this name until the Order of the Magdalenas deems me worthy of a new one."

Cortesia Doffi! The sounds resounded in my brain as my thoughts raced to retrieve the name my mother had spoken in regards to her sister Margherita's husband. She had married a Messer Doffi and borne a daughter named Cortesia. Could this Cortesia be, in fact, my cousin? Could it be she knew nothing of the two aunts who had been sent to Prato and the children that one of them had borne with Fra Filippo Lippi? I had assumed that every Florentine knew who the "Queen of Beauty" really was: not just a painter's daughter but the daughter of a lonely nun and wayward monk.

The guests embraced Cortesia as they rose to prepare their torches for their exit into the night. To each one she gave some belonging of

her house or person, whether useful or sentimental. Her son and daughter had planned to stay the night in order to escort her in the morning to her new quarters at Santa Maria Magdalena. It had been her wish to be installed before the first day of Lent.

When Ciardo and Sandro moved to retrieve our horses from the livery, Cortesia approached me with a bulky package bound in ribbon.

"Please accept this, Sandra." Her words fell rhythmically, much like the repentant vow she was about to make. "I have given my house and furnishings to my son. To my daughters I have bequeathed all my worldy adornments. To my servants I have given lesser belongings but with no less affection. But to you, the true half of Sandro's Venus—the true daughter of his life's work—I wish to offer a garment that befits both your warmth and your charm."

"Am I to look upon it now?" I couldn't help fingering the satin ribbons around it. They looked like the same ribbons that had wrapped a section of my hair when I had posed for the Venus.

"If you wish."

A sudden self-consciousness engulfed me. She watched as I untied the ribbon and pulled back the wrapping. Therein lay a folded garment of deepest purple velvet, a royal color I had seen only on the Medici or Tornabuoni women. When I held it up, I saw that it was a magnificent cloak with satin lining. At the edge of one collar, a fine gold brooch served as a clasp to secure each side at the throat. It was the same cloak she had worn the morning I had seen her leaving Sandro's bottega—part of the image that had haunted me for so long before I had met her, and even after.

"Why do you not give this to your daughter?" I asked in disbelief, since it was as worldly an adornment as any.

"Because it is part of our history with Sandro. And there is no other woman more beautiful than it."

All my former jealousy of Cortesia seemed dispelled at this moment of her generosity, and indeed I felt bound to her somehow. Sandro and Ciardo were watching us from the doorway, and I knew that Sandro must have been gratified to see the two figures of his Venus come together in harmony at last. At that moment I was compelled to ask her if her mother's name was Margherita and if she had been the

daughter of the silk merchant Francesco Buti. Cortesia replied that she was, but all she knew of my mother and Spinetta was that she had two aunts in Prato whom she had never met. She had not realized until now that the painter Filippino Lippi and his sister were her cousins! Cortesia smiled solemnly.

"It is God's will that this knowledge comes to me at this hour of my repentance, for I did not deserve the friendship I could have had before with you."

As she stepped forward and embraced me, I felt the delicate texture of her skin against my face and the scent of her perfume that was soon to be replaced by the sacred fragrances of incense and myrhh. Then Sandro came and kissed her gently on the cheek, a rare display of emotion for him.

I wore Cortesia's cloak for our night's journey across the Arno. It was made in relative calm and contemplation, although everyone around us still reveled in the last hours of Carnival. Amerigo rode with us, but only he and Ciardo actually conversed. As I watched the two men speak with little bravado, neither knowing what sexual innocence the other had taken from me, I marveled at the folly of women and men.

Ciardo and I said good-bye to Sandro and Amerigo on the other side of the bridge and made our own way across town, down Via del Cocomero to Via degli Agnoli. When we had settled into our chamber in Filippino's house, I remarked that I would have little occasion to wear such an elegant garment in Prato.

"Nor here in Florence under the eyes of these new Dominicans," Ciardo added. "Isn't it strange the way we fear beauty?"

I hung the cloak in the wardrobe along with my gown. A looking glass lay nearby on the table and I took it to view my own reflection.

"We fear it because we fear its loss." I touched my face.

"Then let us embrace beauty while we may!" Ciardo pulled me closer to him and began to stroke my unwrapped hair.

That night we claimed the final hours before Lent, before that denial of earthly hunger, by satisfying the desire that had seized us. Ciardo's desire, I knew, was for the beauty that the years would one day take from me, and my desire was, perhaps, to show the true affection I had never given him.

23

The Hounds of the Lord

—Spring of 1491 to summer of 1493

*I*T WAS A MEDICI, COSIMO THE ELDER, WHO HAD ES-
*tablished the monastery of San Marco. It was the Medici who had always
sustained it. And yet now they were being harassed by Savanarola, the
friar of San Marco, the Hound of the Lord, a Dominican monk.*

*Hound of the Lord is a translation from the Latin Domini Canis; and
Domini Canis gave us the word Dominican. The Order of the Dominicans
had always been troublesome, with their preaching against wealth and power
and their encouraging of dissent. But none had been so defiant as Fra Giralamo.*

It was shortly after the New Year that I realized I was with child. Ciar-
do's and my break from conjugal chastity had been "fortuitous," his fa-
ther said. Like Ciardo, he looked upon lovemaking as part of the prize
of a good wife. I carried the child with little discomfort, thanks to the
warming earth and sky and fragrant air of Prato; and I took satis-
faction in Lucrezia's progress in the lessons that she took at Casa Van-
nozzo along with Giovanna's older children. She went into town with
Ciardo or one of the male servants, and when I was not too weary to
accompany them, I took Filomena and Vanni with me to visit Mother.

I rarely wore Cortesia's cloak now that I was busy with the affairs of
Villa Tavola. It remained in my wardrobe, but later was folded and

placed at the bottom of a wedding chest I would one day give to Filomena. It seemed only fitting that the cloak should go to her, considering that her birth was linked to my first sight of it.

I heard little from Florence that spring or summer except for the news that Fra Giralamo Savanarola had been elected Prior of San Marco. Apparently Lorenzo de' Medici had called at the convent to congratulate him and offer a contribution to the church, as he always did with appointments of the clergy, but the friar had refused both the gift and the audience. Fra Giralamo had said he intended to be "a better watchdog than the preceding friars who merely looked the other way because a thief had thrown them a bone." Lorenzo gave his offering instead to the procurator of San Marco and went his way, recalling the words of his grandfather, Cosimo: "The state cannot be run with rosary in hand."

Lorenzo's family had always been generous in support of the Church and had made numerous commissions to decorate its temples. In fact, he had just conducted a competition to choose a design for the façade of Santa Maria del Fiore. Several Florentine masters submitted their ideas, including Sandro and Ghirlandaio and even Filippino, who sent his ambitious entry from Rome. But Lorenzo had given each of them such high praise that he was forced to abandon the matter to avoid the embarrassment of rejecting any one great artist.

Thus, Florence's great cathedral went without hope of a suitable exterior when it welcomed the throngs of Fra Giralamo's eager congregation. They could no longer fit inside San Marco. For those who had been unsuccessful in hearing him, a written account of each sermon was made available by various chroniclers, which served to spread the word of Fra Giralamo beyond the gates of the city. By now, the friar was entirely unabashed in his attacks on Lorenzo de' Medici. He called him "a tyrant who is wont to occupy the people with shows and festivals in order to have them think of their own pastimes and leave the reins of government in his hands." He spoke of Lorenzo's "incorrigible pride and ill-gotten gains," and said that the only hope in converting the "weak and wayward Florentines" was the death of Lorenzo, which he now prophesied to occur within the next year.

One would have thought that a man who had waged war against the

Pope was not about to ignore the insults of a local cleric, and many people marveled that Fra Giralamo would want to tempt the wrath of the Medici. But Lorenzo had lost a great deal of his fiery spirit, and it was known that, because he suffered considerably from gastric afflictions, he had been spending more and more time at his hot springs or at Careggi. He was content that his daughters were married and his oldest son, Piero, had reached his majority.

Those who questioned the friar's motives were apt to criticize the Pierfrancesco brothers for not befriending Lorenzo more in his hour of need, but pleasantries between the two branches had subsided a decade ago, when it was discovered that Lorenzo had squandered the Pierfranceschi's rightful funds. Semiramide even mentioned in one of her letters that she had tried to encourage her husband to align himself with his cousin and consolidate whatever Medici power remained, but Lorenzino saw greater advantage in taking the side of the friar and the citizen's unrest. She also mentioned that Amerigo was glad to avoid these "troubles" by returning to Spain, a country, as he had told her, "that has its own turmoil with the Infidels and the Jews."

"Amerigo is convinced that the future of all trade and navigation lies in Spain," she wrote, and when I read these words to Ciardo, I believe the worry of commerce weighed heavily upon his mind. Still, the Ciardi's wool continued to pass easily through the harbor at Pisa and on to the carders and weavers and mills of Prato and Florence. The summer was prosperous as I watched the ripening of the olives and the fullness of the life within me.

In October I was delivered of another son, which brought Ciardo untold joy. He would be the last child that I would bring into the world. We named him Ricciardo, although we delayed his christening until after All Saints Day. Then we received another generous gift from Semiramide and Lorenzino.

I had not seen Sandro since that Carnival night, nor had I seen or heard about my cousin Cortesia. But both of them were often in my thoughts, so I decided I would go to Florence after Ricciardo was weaned and Filippino had returned from Rome. Ser Vannozzo reported that his house at Via degli Agnoli was well cared for and that the tenants no longer feared the visitation of any "Neoplatonic idlers."

"And who would wish to advertise such an occupation in the climate set by Fra Giralamo?" Ser Vannozzo observed on his return from Florence.

The climate was indeed set, for as the New Year of 1492 was upon us, a terrible rainstorm came up just as Lorenzo de' Medici fell gravely ill and retreated to Careggi. His physician was summoned and prepared for Lorenzo an elixir of ground pearls, which were thought to carry the healing elements of the sea. The friar assailed "the tyrant" for having so much greed that "he was wont to consume jewels for a mere stomach ache."

Poliziano was present throughout Lorenzo's ordeal and wrote an account of how noble his patron and friend bore the pain: "Whenever his son, Piero, went into his father's room, Lorenzo put on a brave face so as not to increase his son's sadness." Poliziano himself returned to his own room and burst into tears.

The pearls only served to weaken Lorenzo's condition, and in the darkest hour at Careggi, lightning struck one side of the cathedral in Florence. Lorenzo inquired in which direction the bricks had fallen, and when he was told it was on the side nearest Palazzo Medici, he perceived it as an omen of his imminent death. He sent for the prior of Santa Maria degli Agnoli to give him his final sacraments. The man was called in and Lorenzo went to him on his knees.

But Lorenzo wished to be absolved by the one religious who had maligned him most: Fra Giralamo Savanarola. "Bring me the Dominican," he told Poliziano in his failing voice. "Bring me this Hound of the Lord." Thus the poet sent a messenger to bring Fra Giralamo in haste to Careggi. The friar consented to see "the tyrant" upon his deathbed and offered him his precious absolution on the condition that if he, by the grace of God, recovered, he would restore liberty to all of Florence and give a voice to those who could not vote. Before Lorenzo could answer, however, he had turned his head to the wall and his spirit departed.

Poliziano declared Lorenzo "twice absolved," and the friar returned to San Marco saying nothing about the fate of Lorenzo's soul. The physician was so distressed by the failure of his pearls that, rather than face the accusation of witchcraft, he threw himself down the well of another villa.

In the days that followed Lorenzo's death, the friar's sermons receded so that Florence might mourn its "tyrant." The funeral cortege worked its way from Careggi to San Lorenzo, where Lorenzo was buried next to his brother, Giuliano. At the city gates, Poliziano wrote, the many artists who had served him met the cortege; Sandro was prominent among them. Members of the Academy walked in front with Marsilio Ficino, Pico della Mirandola, Giorgio Vespucci, and the most sorrowful Angelo Poliziano. It was said that the poet mourned his friend and patron more than any man has ever mourned a wife or mistress.

From that time on, Lorenzo de' Medici was called "Il Magnifico" whenever anyone spoke of him. I do not recall if I grieved much at his death, for I was unable to attend the funeral; but I am wont to think of him as a man who commanded order and elegance and was stubborn in all of his pursuits. He had brought both terror and fortune to Tuscany, as witnessed by my brother's career of painting hanging corpses and glorious frescoes. Aside from this, I would always remember my first encounter with "Il Magnifico" and the feeble voice and countenance that belied his regal form.

In the season that followed, I wrote to Semiramide to convey my condolences, and she replied that, in truth, her husband only mourned his cousin's passing "for the incompetent heir he had left to direct the fate of Florence." Filippino was still in Rome when Piero Medici was sent as ambassador to congratulate the new Spanish pope, Rodrigo Borgia, and he wrote that "Piero's arrogance was an embarrassment to all Florentines residing here and should be for the city as well, which his haughty wife refers to as 'a nation of shopkeepers'!"

By now the "barking" of Fra Giralamo was heard as far away as Rome, and his chroniclers printed his response to Rodrigo's taking the pagan name of Pope Alexander VI. He had called this honoring of the Ancients "only a minor symptom of that moral disease which is wont to afflict occupants of the papal chair."

These reports were of some interest to Ciardo and me, but by summer we were more enthralled with Ricciardo's crawling and pulling himself up to different pieces of furniture. His grandfather,

who had been ailing, said his little Ricciardo was "as strong as Hercules," and I could not help commenting on the sculpture of Hercules that Michelangelo was said to have carved in honor of Il Magnifico. Indeed, the Ancients were too much with us to be condemned or trivialized by Fra Giralamo.

But while our summer was dominated by our active babe, Florence was becoming more and more dominated by the "watch dog" at San Marco. The people continued to throng to San Marco or the cathedral to hear him preach. His compelling sermons caused the congregation to weep and shudder, and his followers were soon referred to as the *piagnoni* or "weepers." Skeptics of the friar maintained that the interest was purely "theatrical," a means of escaping the summer heat in a cool church. But his supporters answered that Florence had "many cool pulpits to entertain the masses on the Sabbath." The people had chosen Fra Giralamo as their spiritual leader.

At the end of that summer, Semiramide wrote with news she and Lorenzino had received from Amerigo. The Genoan called "Cristibol Colon" had convinced the King and Queen of Spain to invest in a caravel of ships. He, inspired by the maps of Toscanelli and the reports of Portuguese navigators who had sailed on these seas, planned to pilot them west from the coast of Portugal in search of India. Amerigo reported how "those who did not rejoice, shook their heads at the folly of this Italian and believed he might have been influenced by the drinking of 'Satan's wine,' that dark beverage called *caffe*, which the Moors often prepared in their meetinghouses."

Although I was privy to these foreign developments, it was not common knowledge among most Pratesi. Surely a woman's interest in such affairs would appear suspicious, so I spoke little of Semirade's correspondence except for her reports on Florence.

That winter, tensions between San Marco and Palazzo Medici grew stronger through Piero Medici's lack of diplomacy and Fra Giralamo's continual forboding about the ruin of Florence. A son had been born to Piero and his Roman wife, and many of Piero's advisers had suggested he approach the friar to bless the child. But Piero balked at the idea and proceeded with the baptism in the Baptistry of San Giovanni.

Ciardo, upon returning from his most recent visit to Florence, said it had become a joyless place. Fra Giralamo railed against the trappings of fashion, festivals, and games: all of the elements that had brought the city to life in the past. His followers now went about destroying or hiding their "hollow, worldly goods" or "evil ornaments." What once brought people pleasure now brought them shame.

Boccaccio had written that "a man without possessions is but a mere beast," yet even great literary works such as his were now going the same way as lace, pearls, and the game of chess. Only the plainest, coarsest fabrics were considered acceptable if one wished to join the friar's congregation. He preached inevitable death and doom to whomsoever did not heed his admonitions against luxury and wealth. And upon the death of Il Magnifico, many of Fra Giralamo's followers had begun to call him "The Prophet of the New Jerusalem."

Indeed, we could not ignore the friar's influence even in Prato. Ciardo noted a decline in his sales of finer wool, although the market for coarse wool continued. Semiramide reported that their silk trade, while improved in Spain, was suffering in Tuscany because of the friar's sermons against the use of luxury cloths and finery. And although the Medici's appetite for festivals continued, that year's Carnival season was more subdued than usual. Piero himself refused to be intimidated by Fra Giralamo and his *piagnoni*, but it was clear that many other citizens were, and they cautioned him against putting on showy tournaments or banquets.

In February, Mother and I received the sorry news of the death of Sandro's sister-in-law, Mona Nera. We attended her funeral with sadness and respect for a woman who had always managed her home with affection and frugality. She was laid to rest in the little cemetery of Ognissanti, not far from the graves of Sandro's parents. Sandro received us fondly and appeared more tired than grieved. "She was a fine lady," was all he could say.

A month later, her husband, Giovanni—our beloved "Botticello"—was taken up to God. He had not survived his grief over Mona Nera nor the advancing age that afflicted him. The loss of these two souls was very difficult for Sandro. Even the acclaim he had received from the Spanish court, thanks to the good words of Amerigo and the

commission of a panel for Queen Isabella, could not cheer him. The queen decided on the melancholy scene of *The Agony in the Garden* —hardly the sort of magnificent, mythological theme that had impressed the Spanish dignitaries who visited Amerigo and Lorenzino at Castello.

Not long after the New Year of 1493, little Filomena fell sick with fever. It came suddenly in the night, but she had none of the swellings that signified *la moria*. Fra Giralamo had foretold a return of the black plague as Florence's punishment for vanity and greed, but Ciardo blamed the fever on the tutoring Filomena now received with other children at Casa Vannozzo.

"She sees too many people!" he bellowed, as his father was wont to do when feeling helpless.

"But so does Lucrezia, and she is well."

This argument served only to illuminate my private fear that Filomena's fever might be some retribution for my sin with Niccolo. Although she resembled me and had much of Ciardo's manner, I could see that she was clearly Niccolo's daughter. Now the error of that magical night with him beat savagely within my breast. I remained constantly at her bedside and prayed for her recovery. Ciardo suspended Lucrezia's lessons for fear she would be next.

Then Mother arrived one morning with some willow bark that she had purchased from an apothecary. She asked the Ciardi's physician if there were any harm in using it, as it had helped my father whenever his injury brought him fevers. The physician did not appreciate her interference, but eventually he conceded that an infusion of willow bark was sometimes helpful. Filomena drank three bowlsful of the tea; and our faith was bolstered the next morning, when she suddenly sat up in bed, her fever broken, and requested food!

But no sooner was my gladness for her recovery expressed in song and dance than I became afflicted. My body and soul were truly wrestling with the sins of my past. Madonna Ciardi attended to me when Mother could not, in spite of her own advancing age and weakness. In my delirium, I came to see her as a confessor and began to utter apologies for my many transgressions and shortcomings as Ciardo's wife.

"But you have been a fine wife to Ciardo, Sandra. You have borne

him beautiful children and you have occupied his brain with loftier thoughts than wool!"

It was at this juncture that I was able to realize the affection that she had always seemed to withhold from me, and I from her.

After two days and nights of my strange visions and dreaming, Madonna Ciardi agreed to give me Mother's same infusion of willow bark. She decided that she had been blessed with the humility "to concede to the wisdom of Madonna Lucrezia." Happily, I recovered almost as easily as Filomena.

But that season was not to be without grief. The same fever that had afflicted us had overtaken one of Filomena's classmates—the daughter of a lace merchant who also traded in fine cloths. The *piagnoni*, who had now invaded Prato, spoke of the girl's death as "God's punishment on those who peddle ornaments and finery at the expense of children's souls!" It became increasingly difficult now to ignore the friar's continual predictions of doom and suffering.

24

The Bonfire of the Vanities

—Summer of 1493 to winter of 1494

*T*HE DOMINICANS TOOK THEIR NAME NOT ONLY *seriously but literally: they saw themselves as the watchdogs of God, sniffing out vanity and greed in all its forms.*

Vanity, indeed, was their triumph; and a day would come, they fervently intoned, when all vanity would be purged in a holocaust of fire. So would jewels and satin gowns, every form of luxury, and the images of pagan painting. How could anything that was not "of God" survive the friar's fury?

Filippino returned from Rome in June and spent two weeks settling back into his house and bottega and arranging for the scaffolding to be built in the Strozzi Chapel. Filippo Strozzi had already died, which made the completion of the chapel all the more pressing. My brother came to see us in July, bringing tears of joy to Mother and Vincenza. He brought me news from Via Nuova, as he knew I was wont to inquire about Sandro. Sandro's brother, Simone, had returned from Naples to reside again in Florence, and he and Sandro were planning to purchase a villa outside the city. Filippino suggested that Sandro needed the solace to finish his drawings for the "Paradiso" verses of *La Commedia*.

"He has so far only depicted Hell," I recalled. "But then that is, perhaps, of more interest to people."

"To be certain, the good friar of San Marco has described so many ways by which we are to see it!"

Filippino reveled in the affection of his nieces and nephews and was quite taken with Filomena, who was now seven. Mother hoped that he would give more serious thought to marriage, but there was no woman in his life. Filippino would say nothing on the matter of an heir and I was wont to think, in my most private ruminations, that perhaps marriage was as remote a desire for my brother as it had been for my godfather.

However, upon his return to Florence and his diligent work on the Strozzi Chapel, Filippino attracted the attention of the Pierfranceschi. Lorenzino had invited him to Castello to discuss decorating another villa, and it was here that Filippino made the acquaintance of Messer Piero Paolo Monti, a friend and agent of Semiramide's brother, Jacopo. The Monti now resided in Florence and managed the sales of iron from Piombino and Elba. Piero Monti had encountered much difficulty in dealing with the young patriarch, Piero Medici, and had approached Lorenzino and his brother, Giovanni, who, he assumed, had some say in their late cousin's investments.

Filippino said he had felt awkward amidst the family tensions, but had found the introduction to Piero most fortuitous, for not only did he procure a commission from Piero Monti, but he also, through his pleasant demeanor and talents, impressed the father of his future wife!

Semiramide wrote to me of these developments before Filippino ever did. She also mentioned Amerigo's amazing report that the Genoese pilot, who had set sail the year before, had returned to Seville "with a parade of cinnamon-colored natives and strangely colored birds." The people had cheered, especially Amerigo, who had believed in Toscanelli's theories about the existence of lands beyond the Antipodes. But new knowledge such as this was not needed to stir Florence's soul. The city had its prophet, Fra Giralamo, who had already predicted that Florence would fall to a foreign power as its punishment "for rejecting Christ."

Autumn passed easily for us with the next harvest of olives. The Ciardi groves had expanded slightly, and we were forced to order more nets for picking and more *orci*, the huge earthen jars that held the

different pressings of oil. Ciardo and his brother, Gio, alternated their travels to Pisa to oversee wool shipments from an increasingly unfriendly France. Piero Medici had succeeded in offending his father's ally to the north by making a new alliance with Naples and Rome; and eventually it came to pass that the lilies of France, which the Medici had so proudly borne alongside the round palle of their family herald, were removed as the friendship dissolved into discord.

That winter King Charles VIII ordered all the Florentine counters to be closed down in France. All exports from Marseilles, as well as exports overland, were prohibited in retaliation against the arrogant Piero. The cloth guilds were losing their markets through Piero's folly and Fra Giralamo's exhortations against vanity; and Filippino wrote that "the whole of Florence now trembles at the feet of the friar and at the sporting hand of Piero."

Fortunately for Ciardo, there were still shipments of raw wool from Germany and Flanders. With Amerigo's assistance, Lorenzino had procured two Spanish suppliers to sail to Pisa so that his investment in the Ciardi ships would not be lost.

At Epiphany, Filippino took time to send us his good tidings and to report on the mounting tensions in the city. He wrote that "the friar's followers leave San Marco every Sabbath, cursing and crying in rage at the occupants of Palazzo Medici. I can hear them from my house!"

At the same time, Semiramide wrote of her husband's recent overture to Fra Giralamo. "He had gone to San Marco to show his support, unaware that Piero had sent his agents there to spy on him. Lorenzino and his brother have called themselves 'the natural replacement for Il Magnifico and Giuliano.' Is it not wise for them to appeal to the people's memory of a more harmonious Florence?"

I could only respond with my good wishes for the coming season, for I knew the likelihood with which any letters to this branch of the Medici might be intercepted by agents of the other.

But the New Year of 1494 did not prove fortuitous for any part of Tuscany. Before Holy Week had passed, Ciardo was forced to terminate the services of the tutor who had been coming to Villa Tavola. By now, we could not afford even the less costly lessons for the children

who met in town. Thus I became my children's teacher, which was sufficient for their reading and writing skills, but I was not prepared to instruct the mathematics that Giovanni and Ricciardo would need to carry on their father's trade. The idea that one of them might follow in their uncle's or grandfather's artistic footsteps had thus far eluded me.

Early in May, near the time of the showing of the Holy Girdle, we learned of the events now shaking Florence. Lorenzino had made overtures to the King of France via Lord Ludovico in Milan. There had been a plan by the Pierfranceschi to overthrow Piero, but Semiramide did not disclose much more than a general knowledge of it. The plan had been discovered and her husband now faced prosecution. Lorenzino and Giovanni were called before the Council of Eight to answer to charges of conspiracy. By his own wit and wisdom, Lorenzino defended his brother and himself by saying they had desired to protect the Florentine treasury and to seek restitution for the mismanagement of their rightful funds.

The Council rejected Piero's demand of harsh punishment and decided to confine the brothers to their respective villas of Castello and Cafaggiolo. "A delightful exile, to my mind," Ciardo scoffed.

In May I was surprised to receive a letter from Sandro, an invitation for Mother and me to visit his new villa and farm outside the gates of San Frediano on the slopes of the Bellosguardo. "Bring your lovely children," he urged me. "And your comely husband as well!"

When Ciardo next had business with the guild in Florence, we set off for Sandro's new villa on Via di Monte Oliveto. It was Mother's first trip in a long time without her faithful Bello, who had died a few weeks earlier. He had been replaced by another mule, but it was not the same.

Sandro greeted us eagerly, having never met little Ricciardo. In recalling his conception, I mentioned that I wished to visit Cortesia at Santa Maria Magdalena if the convent allowed visitors. Sandro said he could arrange it with the Prior the next day when he went into town. He seemed pleased to watch the children, who liked to run amongst the fruit trees and chase the chickens, while Mother and I were content to become reacquainted with Simone, who was as engaging as his brother and even more loquacious. He seemed very interested in

Mother's former life inside the convent, for he was a religious man, and indeed he said that hehad been so moved by the preaching of Fra Giralamo that he had made a practice of chronicling the sermons. Simone enjoyed the friar's "simplicity," and since his return to Florence he had been to San Marco four times.

"And do you weep?" Mother was curious.

"Not openly, but in my heart I do." Simone smiled piously, and Sandro defended his brother's interest by agreeing with the friar's assertion that "the poor pay all the taxes, while the rich only contribute in their commission to the arts."

"But that is *your* livelihood," I reminded him.

"And, at times, to my chagrin." Sandro's countenance was very solemn, much to our surprise.

"Will you be going to San Marco on the coming Sabbath?" Mother asked Simone.

"Most definitely. Would you like to accompany Sandro and me?" He looked at both of us in earnest.

"Sandra?" Sandro touched my arm.

"I had best stay with the children at Filippino's."

"Bring them with you!" Simone exclaimed.

"Oh, but the boys are too young, and I fear the friar's allusions to Hell would frighten Lucrezia and Filomena."

"I have heard enough Masses in my day," my mother interjected. "Let me watch the children and you go with them." So it was decided.

The next afternoon, Filippino and Mother and I took time to go across the Arno to the convent of the Magdalenas, where we had an audience with Cortesia. She looked elegant, even with her covered hair and strict habit, and Mother marveled at how much she resembled her father. Mother's sister, Margherita, had died two years earlier, and Cortesia mentioned how deeply her mother had regretted not finding her sisters in Prato.

"Mother knew she had been negligent, but I think she feared you would rebuke her." My mother only smiled, so Filippino stepped into the void.

"If only I had known you were in Florence and that you knew Sandro. All the time I lived at Via Nuova and I never saw you!"

"I do not believe I met Sandro until after you had finished your apprenticeship. You had your own bottega by the time I started coming around."

"Sandro owns a fine villa now up in the Bellosguardo," I told her.

"Ah, it is just as well he has it now. It would have been too far for me to go to teach him Greek!" She made no reference to the other services she had rendered him.

"Why did he feel a need to know Greek?" Mother inquired as we prepared to take our leave.

"Did he never speak of his regret at not having finished his schooling when he was with you in Prato?" Mother shook her head and shrugged. "Ah, Sandro had all the airs of a lettered man and was perhaps as learned. It pained him to paint for members of the Academy and not be considered one of them. I suppose he felt my instruction put him on their level."

It was then I realized that my godfather had been as proud as he was clever. He had shown his vulnerable side to Cortesia but not to anyone else.

The next morning, as Sandro and Simone escorted me up Via del Cocomero toward San Marco, I was struck by the number of people who filled the streets around us. Sandro and his brother had left their horses in Filippino's stables, for few people ever rode to San Marco. The size of the congregation spilling out the doors of the church prohibited the livery of horses, and any servants who came were liable to abandon watch over the animals when overwhelmed by the voice of Fra Giralamo.

We managed to install ourselves in one of the last rows, while those around us stood in every aisle and against the walls. Not a single space was untaken. There was a great commotion of voices until we all leaned forward in a desperate hush as a swarthy, stooping figure in a coarse woolen robe approached the pulpit. When he began to speak, his voice and countenance assaulted us with such force that I half expected flames to burst from his mouth. He condemned Piero's thoughtless actions against France and hailed "the justified invasion of Charles and his army in order for our evil nation to be cleansed!"

When this tirade was concluded, Savanarola deftly moved on to the subject of vanity and greed and the evils of ornamentation. "Cast off your trivial belongings, for there is no joy but the joy of righteousness! Destroy the pagan trinkets that amuse you! Blot out those decorations in which our Holy Mother has been painted like a harlot!" He looked straight into my face and did not blink. I wanted to look at Sandro, but I did not dare. Was he embarrassed, I wondered, or amused?

At first I had been transfixed by the friar's pointed face and the animation of his mouth and body, as though he were indeed a hawk about to take to flight above its prey. He was exalted by the picture of these sombre creatures before him dressed in their common wools, and he spoke of "the beauty of the spirit that makes itself known and glows neither from gold nor pearls nor finest cloth but from the true raiment of a righteous soul."

I wanted to whisper to Sandro that I hoped God was great enough to recognize the righteous no matter what they wore, but at that moment we could only glance at one another. And I recall, as I looked upon the graceful contours of Sandro's aging face, that the friar's voice seemed to pour over it like oil and varnish over canvas. His words painted a terrible vision, but it could not take form there.

After Fra Giralamo had retreated to his cell, Simone told us that he had arranged to have an audience with the friar and asked if we wished to accompany him inside the monastery. Sandro heartily agreed but I was hesitant, fearing that the friar would find me too adorned with the inlaid comb I wore in my hair. Sandro secured my mantle over my head to hide it, and urged me to go with them.

"Are you not curious to see what he thinks of such natural beauty?"

"If he has seen your Madonnas, then he will think of me as a harlot!"

"I suppose we are blessed that he has yet to visit Castello!"

We mounted the stairs cautiously to the floor of the Dominicans' humble cells, from some of which I could hear the low murmur of prayers. Fra Giralamo's was on a slightly higher level at the end of the small corridor. The door was closed. A monk emerged from one of the cells when he heard us, and Simone explained his disposition. The monk nodded, stepped up to the friar's door, and knocked.

"Simone Filipepi, the chronicler, is here to see you," he whispered

through the tiny window. "He is with two guests, a man and a woman."

The word *woman* seemed to hover in the air above us, and I learned later that Fra Giralamo never spoke privately to women. Some say he had never recovered from being rejected as a young student by a maiden he had fancied in Ferrara. Others say he found women "base creatures" who only sought to instill lust in men. (He made exceptions for feeble matrons or very young girls.) I was prepared for any reception I might get behind that stark, white door.

"Enter, please," Fra Giralamo commanded as he opened the door.

He nodded some vague recognition of Simone and even Sandro, but his thick eyebrows moved higher and his eyes grew wider—and then narrowed—when he looked at me. Simone made the introductions, naming me Madonna Sandra Ciardi to avoid the controversy of the Lippi name. The friar could offer us nothing more than a small bench, but fortunately Simone said we preferred to stand.

"You are recording my sermons, I understand," the monk began rather plainly.

"Yes, Fra Giralamo. It pleases me to move the words of God from your mouth to my quill."

"You plan to distribute them, then, now that we have the devices for printing many copies?"

"My brother and I both know a printer here in Florence. It would please me to have your sermons set in type, for then all who wish to hear you might."

"And you, Maestro Botticelli. I have heard you are the pride of Florence with your *decorations*." The word slid from his tongue most deliberately. "I also have heard that you are best at painting Madonnas and mythological goddesses, as though they were one and the same!"

Sandro's voice did not falter as he responded. "I believe beauty is the same to God in any form. My paintings are allegories for sacred ideas. Madonna Ciardi, here, has sat often for me as the Holy Mother, because of her sublime countenance."

I was waiting for the friar to speak of harlots or some such thing, but instead he leaned forward, as though inspecting me. "Is it so important that our Lord's mother be young and comely for her Grace?"

"But she *was* a young woman when she conceived the holy . . . " I

faltered under Savanarola's unremitting gaze, but Sandro barely blinked an eye in coming to my rescue.

"Would you have me paint her as an old hag?"

To this even Fra Giralamo smiled, and then he turned to me again. "Have you repented of your vanity and cast off the sins the world brings to comely women?"

I felt my words catch in my throat and then upon my tongue. "I . . . I once was guilty of vanity, I suppose, but I cast it out when I became a mother . . . because I had neither the energy nor the time."

Sandro began to stifle a chuckle, but Simone looked to me in all seriousness.

"I suppose the labor of raising children is penance enough," Fra Giralamo said more gently now. "Is their father alive?"

"Yes."

"Then why is he not with you?"

"Sandro is Madonna Ciardi's godfather," Simone explained. "We felt he was a suitable escort. Madonna Ciardi wished to hear you preach. Her husband is at home with the children and their grand-mother."

"He is not a religious man?"

"No," Sandro answered. "But he is very righteous."

"Indeed . . . to be a nursemaid on the Sabbath!"

I must confess I was surprised to find this glimmer of wit in the much-feared friar. We took our leave and thanked him for the brief audience, which had caused me grave discomfort.

After the friar's sermons at San Marco, people were known to crowd the piazza outside and hurl epithets in the direction of Via Larga and Palazzo Medici. As we approached the piazza and headed for Via degli Agnoli, a man in the crowd began to shout at us.

"See there, good citizens! It is the painter Botticelli who exalts the obscene gods of the Medici. And there with him must be the whore he uses for his profane Venus and even our Holy Mother!"

My first reaction was to wonder if this were some prank arranged by Sandro, although I saw no amusement in it. But suddenly a hail of stones and rotted fruit descended upon our heads, and we began to

run, leaving Simone behind. I pulled my mantle across my face, which had once aroused so much admiration and envy. Sandro ran beside me and held out one side of his cloak to shelter me. We were both like the adulteress, persecuted in the name of beauty.

When at last we escaped harm in Filippino's doorway, Sandro paused to wipe the tears from my cheeks.

"That man must have seen the Venus at Castello," I began.

"Or perhaps he was a visitor at Via Nuova for some reason, or perhaps he knew one of my garzoni. People do speak about their work." He shrugged and then squeezed my arm in reassurance.

Sandro accepted Mother's offer of a light meal, but I had no stomach for food. I excused myself to look for the children, who were engaged in a game of tag in the courtyard. The sound of Ciardo calling to them soothed me as I climbed the stairs to our chamber. Soon my troubled spirit would be distracted by the cleaning of capons and the stuffing of ravioli for the Sabbath dinner. But for now, I required the escape of sleep. As I lay on the bed, listening to the voices of my beloved children, I slipped into reverie, and another voice filled my ears.

It was the voice of Fra Giralamo, piercing the air as his face emerged from its dark hood. I was seated before him amongst a congregation of course wool while I huddled in the stark purple of Cortesia's cloak. I trembled in shame for my arrogant attire while the friar called out, "Alessandra! Cast off this mantle of sin. There is no glory in the colors of the Medici. There is glory only in God!"

At this I rose and pulled back the soft velvet hood until my hair fell down around my shoulders and back. In my dream, it shone more brilliantly than the gilt of Sandro's Venus rising from the sea, and it was more yellow than the saffron with which I often treated it. Then I slowly became as the center of the crocus itself, a veritable stigma in the rich petals of a purple cloak.

The thumping of my heart against my ribs awoke me, and I heard new voices. I rose to fix my hair and went downstairs, assuming that Sandro and his brother were still with us. But they had gone, and in their place we had Filippino's guests: Piero Monti, his wife, and their daughter, Maddalene. Maddalene bore a striking resemblance to her mother and looked to be no more than fifteen. She was mature for her

years, but took a kindred interest in Lucrezia and Filomena, who were pleased by the older girl's attentions.

My brother escorted Messer Monti into his bottega to discuss the painting he had commissioned with his daughter posing as St. Anne. Mother and I showed Madonna Monti the courtyard and garden, while Maddalene was suddenly quite eager to join her father in the bottega.

"I had best see where I shall be passing many hours of my summer!"

When I informed her that most painters do their fresco work in summer to avoid the heat of their studios, Maddalene turned to me curiously. "I supposed you preferred such a climate when you modeled for Maestro Botticelli's Venus . . . the one at Castello."

I was taken aback but also amused by the boldness of her remark. "Indeed. But I was assisted by more than climate for that figure."

Later, as we dined, Filippino and Messer Monti discussed Loren-zino's and Semiramide's confinement at Castello and the news that King Charles had intentions of invading Naples. Messer Monti had heard on his last visit to Castello that Amerigo had written again to Loren-zino from Seville. Apparently the pilot, Cristobol Colon, had en-trusted the care of his natives from the New Indies to Amerigo and another Italian, but our friend reported that the natives were "willful" and made poor slaves.

Mother responded by saying, "Let us pray that Amerigo will dem-onstrate to them the mercy and compassion of our Lord."

"You speak as if these savages had souls!" Messer Monti scoffed while choking on his wine. Madonna Monti struck him soundly on the back to clear his throat—and, perhaps, the blunder of his words.

"If they are in our image, then they must be of God's world."

Maddalene smiled broadly without comment on either her father's thinking or my mother's logic, but before the Monti family left that evening, Filippino had promised to finish their panel by Christmas, and Maddalene agreed to come sit for it in early September.

As they gathered their horses and prepared to leave the house, we could hear the distant rumblings of a crowd. This soon grew into a cheer that we could not ignore. Filippino took a torch, and he and Ciardo followed the Monti down the street towards San Marco. I ran

after them into the night despite Mother and Francesca's appeals to remain inside. As soon as Ciardo saw me, he called to me to turn back, but I refused.

"It must be some trouble with Fra Giralamo!"

A trail of smoke rose up into the dark sky, and we could see the glowing of a fire on the piazza of the church. A crowd surrounded the burning mass, and a terror seized me: was someone being burned for sodomy or witchcraft? The men of Il Magnifico's Academy were ever mindful of Fra Giralamo's condemnation of the pleasures of the flesh, particulary "unnatural" ones, and I feared now for their lives.

But as we worked our way into the circle of followers, who both cheered and wept as the blaze continued, I saw that there were no bodies on the pyre. Instead there was a pile of garments, various ornaments and wigs, "wicked" books (according to one man), and questionable paintings—anything that had recently adorned the bodies and houses of the faithful. The assortment of once-valuable belongings now melted together into an immense charred mass.

"But why?" I called out as one woman tossed her jewelry into the fire.

"These are the trappings of our vanity!" She displayed tremendous enthusiasm for her sacrifice. "This is our tribute to Fra Giralamo for showing us the error of our ways. A bonfire of vanities!" The woman's voice cackled like the flames before her.

Upon our return to Prato, we passed an anxious summer with Florence at the brink of war. The influence of Fra Giralamo spread further than ever, and even permeated the ranks of the Academy. The young sculptor, Michelangelo, said to have been moved by the ferocity of the friar's sermons, left the patronage of Piero Medici for the less tumultuous city of Bologna—although the rumors also suggested that he was a victim of the "unnatural desires" believed to have been bred in many artists by their study of anatomy, and was actually fleeing the scrutiny of the *piagnoni*.

Strangest of all conversions were those of Angelo Poliziano and Pico della Mirandola. The poet had succumbed to the word of the friar, intrigued by the great images he conjured up in his sermons; and the scholar abandoned the earlier claims of his *Oration on the Dignity of*

Man and yielded to the supreme glory of Christ. Of course the friar's followers exalted in this triumph over the followers of Plato when in truth San Marco was as much the church of the Medici's Academy as it was of Fra Giralamo and the Dominicans.

In September of 1494, Poliziano was suddenly afflicted with a fever believed to have been brought on by his amorous swoonings over a new pupil. He did not recover, and the *piagnoni* saw it as fit punishment for the poet's unnatural desires. Nevertheless he was eulogized by Fra Giralamo for having blessed the Latin language with his gift of poetry, thereby assuring the spread of God's word to all literate men. He was buried at San Marco, his final request of a world that had been, perhaps, too ignorant of beauty.

By November, King Charles had crossed the Appenines and was received in Milan with every honor. From there he sent ambassadors to Florence to reconcile with Piero. The French requested a friendly passage through Tuscany to Naples, but Piero refused. The citizens agitated against Piero, and according to Filippino, who had seen the clamor at first hand, the headstrong Piero panicked and went in secrecy to Charles without permission of the Signoria. In an attempt to negotiate as shrewdly as his father used to do, Piero ceded to Charles the city of Pisa with several Tuscan territories plus two hundred thousand florins to assist with his campaign.

"The Signoria was enraged and sent its own negotiators in haste to salvage the claims of the city. Among them was Fra Giralamo, the most influential, who persuaded Charles to pass peacefully through Florence 'as was the will of God.' But there was no peace for Piero, who returned to find the doors of the Palazzo della Signoria locked to him. He wasted no time in fleeing the city, while Palazzo Medici was duly sacked. From my bottega, I could even hear the cries of the people as they claimed its riches 'for the people' or for their bonfire of vanities."

As I read Filippino's letter to Ciardo, I could not but wonder if the crowd had destroyed any of Father's or Sandro's paintings. It pained me to think so, but Ciardo, who was now more concerned with the loss of his ships in Pisa, tried to reassure me that their masterpieces would be recognized as more than "mere ornamentation" and would be salvaged.

276

My next fear was that the *piagnoni* would move out of the city and invade the villas of the Medici, even the Pierfranceschi's, and find the paintings at Castello. *Venus Arriving on the Shore* and *The Forest of the Hesperides* would surely not survive the *piagnoni's* wrath. But the Pierfranceschi, having aligned themselves already with Fra Giralamo, were not subjected to his followers' scrutiny. Indeed they saw these developments as their opportunity to dissolve their exile and claim the city. Semiramide wrote to me that "Lorenzino entered Florence under a banner of a red cross on a silver field and declared himself 'il popolo,' the people's man."

I confess that I rejoiced at this triumph because it meant that Sandro's greatest paintings would be safe at Castello; and Filippino soon reported that Simone Filipepi's good graces with Fra Giralamo had brought a measure of protection to Sandro's bottega.

A few days after the expulsion of Piero, King Charles made his way towards Prato en route to Florence. We prepared for the worst, and some families sent their daughters to the convent of Santa Margherita to secure them against the rape and pillage they expected. For ourselves, we sat contained at Villa Tavola with all the Ciardi men and servants armed. We brought Mother and Vincenza's family out with us, but Giorgio insisted on guarding the house at Via delle Tre Gore.

You can imagine our surprise when the French army bypassed us altogether! They entered Florence through the southwest gates of San Frediano, and Sandro said he could see the troops from his tower at Monte Oliveto.

"It was a sight to behold the long halberds of the Swiss infantry gleaming behind the royal canopy," he told Filippino.

The story then circulated that when Charles crossed the Ponte Vecchio and proceeded to Santa Maria del Fiore, he dismounted and everyone could see what a small and unattractive man he truly was. One of Filippino's neighbors had said, "Is this the little weasel who is to rule Florence?"

But he did not remain long enough to rule, and Florence was freed for the price of one hundred twenty thousand florins. By Christmas, the Signoria had been reformed into various Councils and Fra Giralamo called upon the new government to pardon Piero's sympathizers

in order to bring unity to the city. At the same time, the friar had expanded the sumptuary laws, arousing another form of discord.

"There is no pardon for those who would enjoy a tavern after six or a velvet cap!" Filippino wrote. "And all trade must cease on any of the Saints' days, which means I cannot accept a commission or receive payment on those days. There has also been decreed an end to the sale of luxury fabrics, which have cut the profits of the cloth guilds by half."

Indeed, there were no common uses for silks or taffetas, satins or brocades. Wool was still necessary, but the laws now determined the weave and what style of cloak or tunic or gown was appropriate. A man who donned a velvet cap or multicolored hose, or a woman who ventured out in a trimmed surcoat or with adornments in her hair, could be severely fined. And there was punishment for entertainments of a verbal nature. Anyone caught uttering even the most subtle blasphemy or comic hint of it might have his or her tongue pierced by one of the friar's patrols.

Gamblers were imprisoned under the new order, and the roving *piagnoni* patrolled the streets, sometimes entering homes without knocking in search of dice or cards. Courtesans, of course, were outlawed, but they were difficult to identify because they were so numerous! The old sodomy laws were now stricly enforced, and anyone found guilty of "unnatural relations" would surely expire at the stake.

"It seems the friar wishes to rid Florence of all its artists!" Sandro told Filippino in his usual jest. But in truth the suspicion of such infamy was about to fall on him.

Filippino himself began to worry about his long bachelorhood, although by now he usually appeared in the company of Maddalene Monti. But Sandro, to avoid the rumors that had descended upon him regarding his pursuit of handsome youths, now found himself residing more at his villa on Monte Oliveto, away from the tensions of the city.

"Florence has become divided between the watchers and the watched," Filippino declared.

Unfortunately, Prato was not far behind.

Over half the trades of Florence were ruined by the new sumptuary laws, and the question began to arise: How did Fra Giralamo expect the people to pay taxes or

leave anything in his offertory? The answer, perhaps, was that they were supposed to embrace poverty, so he was only helping them on their way.

Eventually a second question would arise: Is it the churches and governments that wreak havoc, or the people who seek to have them do their bidding?

25

The Calumny of Apelles

—Winter of 1494 to spring of 1498

THERE WERE NO CARNIVAL EVENTS THIS WIN-
ter of Fra Giralamo's "New Republic." Instead there was only
the lonely pyre of vanities burning on the piazza of San Mar-
co. Filippino said he watched it sadly as the flames were encircled by
children of the *piagnoni* dressed as angels. Fra Giralamo never appeared
to bless the fire he had inspired. He stayed alone in his cell and prayed
for the deliverance of those who opposed him.

"Yet they are the very souls who would pray for a return to a more
jocund season!" Filippino wrote to Mother. It was his good fortune
that his letter was not intercepted by one of the friar's patrols.

Still, Mother did not lament the lack of games and processions
before Lent. She thought some good had come of outlawing sports, for
with them went the more cruel spectacles.

"Who finds pleasure in pitting a boar against two dogs or watching
two pigs bashing each other to death?" she said to Ciardo and me one
evening.

Ciardo, who was not a man of blood-sports, agreed with her, but he
did not hide his opinion of how the friar's sumptuary laws had devas-
tated the cloth trade.

During Lent it was customary for citizens to make whatever com-

plaint they wished against another citizen in order to expose some un-seen crime. The complaint was called a *denunzia* and could be made anonymously by dropping a written statement in a special box at any church. Of course this invited false accusations as well, and that Sabbath of Lent a *denunzia* appeared in the box at San Marco, as well as in Santa Maria del Fiore, declaring that the painter Sandro Botticelli had committed sodomy with one of his garzoni. The accuser had not had the courage to leave his *denunzia* at Ognissanti, I suppose, for fear that he would be recognized by Sandro's many neighbors and asked to produce some evidence.

Fortunately Amerigo's uncle, Giorgio Vespucci, was one of the canons of Santa Maria del Fiore and dismissed the *denunzia* in haste. But Fra Giralamo, as the Prior of San Marco, was less resolved regarding Sandro's innocence. Certainly he had Sandro's brother to speak on the falseness of the accusation. Simone told the friar there were many artists who envied Sandro's talents and acclaim and wished to damage his career. Or perhaps some angry youth who had not been accepted to work in Sandro's bottega was merely making trouble for him. Fra Giralamo dismissed the charge eventually, but not before the news went to one of the city magistrates. Filippino was forced to appear before the man and relay his own experiences and observations as a garzone of Sandro Botticelli.

"Of course I dared not mention the matter of Betto, the garzone convicted of pederasty. But that was on his own time, outside the bottega, and he was already an odd fellow," Filippino told Maddalene Monti, who later told me.

Still, the *denunzia* greatly disturbed Sandro, and whether or not he had any private guilt regarding "unnatural relations," neither Filippino nor I in our lifetimes could tell. As a result, however, Sandro chose to stay at his villa, away from the tensions of the city. During the rest of that winter he worked on a small panel as a tribute to Apelles, the Greek painter with whom Botticelli was often identified. Apelles also had suffered a grave denunciation from a rival painter, and been imprisoned. He was freed after a conspirator stepped forward and told of his innocence. Apelles had painted an allegory of the evils of false accusation, and now Sandro wished to do the same. He depicted a

beautiful maiden as Calumny attended by her handmaidens, Fraud and Perfidy. She was led in the composition by the dark and sinister figure of Rancor. A Venus-like personage portrayed the Naked Truth, and the scene was set against the elaborate architecture of a Roman temple.

The *Calumny* was smaller than most of Sandro's panels. Filippino said this was because it was a work of personal inspiration and not commission by any patron. He had not wished to invest his money in the normal quantity of supplies most larger paintings required, but he did not hesitate to invest a great deal of his time. "Sandro has never been frugal with his talents," Filippino declared when he saw the finished panel.

But very few people saw the panel who should have, especially those responsible for his month of anguish over the *denunzia*. He ended up giving his *Calumny* to a friend, Antonio Guidi, who later took it to Rome. It was the last secular illustration he would ever paint and his last truly exquisite portrayal of the female form. Sandro was beginning to change: not because he saw any evil in his "pagan decorations" but because he saw the wisdom in avoiding controversy. He had not the energy or "courage," as he said, "to deal with the calumny of living in a changing city with changing sensibilities."

The New Year of 1495 brought more uncertainty. King Charles had claimed Naples, and the Signoria of Florence was altering the membership of its Councils. For Mother and myself, the singular joy was the betrothal of Filippino to Maddalene Monti. Their *impalmatura* was signed at his parish church of Santa Maria Visdomini. The Monti hosted a betrothal dinner that Semiramide and Lorenzino attended in Florence. As we ate and drank, I could not help noticing how our plain, matronly mantles had replaced the fanciful ribbons and jewelry of our youth. And because of Fra Giralamo's sumptuary laws, neither of us wore the colors that were so becoming to the female face. Although the New Republic had brought more democracy to Florence, it had also stolen a measure of grace and beauty from its women.

By November of 1495 the dreaded *moria* had returned to Florence and claimed many lives. It also fueled the friar's prophecies regarding "the cleansing of the wicked city." Those who could afford it left the

bad air of Florence for the country. Semiramide fled to the villa of
Cafaggiolo and bade Maddalene's family join her. Filippino was sick at
heart, but decided it was better to be separated for a short time than
for eternity! He chose to stay in Florence, but made regular visits to
Prato, where we felt relatively secure. Most of Sandro's family re-
treated with him to his villa at Monte di Oliveto.

La moria struck sinners and the righteous alike, and it was by this mis-
fortune that the friar's patrols ceased their invasions of homes and tav-
erns. At the same time, Fra Giralamo had received an interdict from
Pope Alexander to cease his preaching at San Marco and subordinate
himself to the Dominican vicar general. One would have thought this
might result in much indulgence and carousing, but most Florentines
and Pratesi were cautious now: the new sumptuary laws were still in
place.

The *piagnoni* sent emissaries to Rome to implore the Pope to re-
move the interdict; Alexander complied in time for the friar to take the
pulpit for the first Lenten Sabbath several months later. But his con-
gregation could no longer be accommodated by San Marco, so he now
preached at Santa Maria del Fiore. He continued to have a charismatic
hold over the people as he spoke of "the moral lassitude of Florence"
and "the harlotry of the Church in Rome." The written copies of his
sermons now circulated in Prato, and their true meaning was subject
to lively debate.

"I cannot go to market without encountering some squabble over
Fra Giralamo," Mother lamented. "He is either a prophet or heretic
until both sides come to blows!"

This news made me glad of my seclusion at Villa Tavola, and I sent
Lucia more often into town. I continued to tutor Giovanni and Ricci-
ardo and found Lucrezia ready for Boccaccio and Filomena ready to
read Dante. But these were "wicked" authors, Madonna Ciardi had to
remind me, for she feared an invasion from the *piagnoni*. I was forced to
hide the leather-bound *Decameron* and *La Commedia* in my old wedding
chest.

By summer of 1495 an attempt was made by Florentine troops to
recapture Pisa, but the valiant Pisans drove them off. Ciardo was no
longer concerned about saving Pisa: Piombino served as an adequate

port for Spanish wool, although it took longer to arrive. But Ciardo and his father, now infirm with age, knew there was a false security in relying upon a port so close to Siena and Volterra, two cities long in dispute with Florence.

"With Florence and Prato growing poorer, the cloth guilds can no longer sustain the banks. What an irony that Fra Giralamo must now appeal to the rich to support his republic!" Ciardo observed this with a bitter chuckle.

His brother, Gio, was losing interest in wool and beseeched Ciardo to trade in other goods. But any item, Ciardo argued, could be targeted as an "evil luxury" and would be a risk. He remained content to stay with both raw and woven wool, but had long abandoned the finer weaves or any of the "luxury" hues, such as reds, purples, yellows, and bright blues.

With the passing of *la moria* that summer, the Monti returned to their house in Florence and Filippino announced that his wedding was set for September. He had recently finished three major commissions, including an *Adoration* panel abandoned by Leonardo da Vinci, and now had time to devote to a wife. The Monti celebrated their daughter's marriage with as much splendor as the sumptuary laws might allow. A lace mantle lined with pearls and the silk bodice of her gown were evidence that Maddalene's trousseau had come from Piombino. None of the friar's patrols was present at the ceremony to ruin the day. As I watched her meet her new husband at the altar of Santa Maria Visdomini, I recalled my own wedding day and realized that I had not radiated the same joy so apparent in the face of my brother's bride.

After the banquet at Via degli Agnoli, Maddalene returned to her parents' house, as was the custom in honoring the sacraments. This gave Mother one last night with her much-distracted son. In the morning, as we set off for Prato, Filomena resisted our early departure for want of seeing Maddalene's arrival in her new home. But before I could explain, Lucrezia had taken her sister aside to impress upon her their uncle's need for total privacy.

Filomena was much encouraged then to leave. "We shall have cousins soon!"

Ciardo laughed. "Only if your uncle's ardor is as strong as his sister's

willfulness!" With that, he cast a knowing eye my way—one filled both with the joy and the frustration his own marriage had brought him.

As autumn cooled into winter, we gave thanks to God for the health we had maintained, and I began to see those changes that mothers do not always observe in their children. Giovanni and Ricciardo displayed a good aptitude in math and Latin, whereas Lucrezia and Filomena were avid readers and writers. Filomena, who was nearly ten, had a particularly lovely script and desired to pursue her artistic talents in less than conventional ways. She enjoyed stitchery and other needlework and often made very unusual designs, which she had drawn herself on the cloth. She began to take a great interest in drawing and painting, and when Mother found some unused vellum and parchment that Father had left at Via delle Tre Gore, she gave them to my daughter along with a few charcoals. Filippino had provided her with a drawing quill and silverpoint pen before the wedding, and upon seeing this, Sandro had followed suit with a gift of a used leather binding for carrying her supplies.

"Better to tap the Lippi blood in Giovanni or Ricciardo!" Messer Monti had cautioned.

But Sandro agreed with me that Filomena had showed the most promise and that her pursuits were "harmless for a girl her age." I could not but wonder if Niccolo's as well as Father's spirit lingered in Filomena's keen eyes and dexterous hands.

By Christmas of that year, Filomena had filled her sheets of vellum with a profile of her sister, four sketches of her brothers at play, a study of her ailing grandfather asleep in his bed, and Nonna Ciardi checking her olive oil jars. While I marveled at her talents, Ciardo held back his praise, for he was anxious about her meager dowry. The losses in his accounts provided no hope for increasing her dowry before she was fifteen. Lucrezia already had an adequate fund.

My husband knew nothing about Sandro's generous contribution to the Monte delle Doti in Filomena's name, so I thought it time to reveal the news at last, thinking it would bring him good cheer at Christmas time. Instead he acted as though I had performed the services of a courtesan.

"But Sandro's fees to me were no less honorable than what he paid his other models."

"And did Filippino pay Maddalene when she sat for him? Did your father pay your mother?" Clearly his pride had been wounded.

"But they were wives ... or lovers. I was never that to Sandro!" I could barely say the words, and my lips began to quiver mercilessly, threatening to reveal the feelings I had pent up inside for so many years.

"And so your affection and affiliation to your godfather has been *bought*."

"You have made too much of this, Ciardo."

"Is it too much for one man to paint the breasts and belly of another man's wife? For many a tongue has wagged that Ciardo di Ciardi was cuckolded by the brush of Botticelli!" Ciardo's rage now rose into his eyes and nostrils, and he actually frightened me.

"It was another woman's body he painted! He would not allow me to disrobe for him! But I would have. I would have done so for the sake of *beauty*, for I was beautiful then. More beautiful than you ever noticed!"

"Do you think I never noticed your perfect, prideful countenance?" And with that he struck me across one cheek and then the other. I raised my hands to cover my face, but he pulled them away and struck me again. "Why do you think I married you? It was to prove you were not too good for me, a mere merchant, even if you were a celebrated painter's daughter. Yes, I even agreed to let you be the harlot of Maestro Botticelli's paintings so that I could have you, for you were the prize of Prato. The prize!"

Ciardo took my arm and squeezed it so hard I feared he would break my wrist. Lucia heard the noise and came running into the courtyard where we stood.

"No, Ciardo! No!" she cried as she tried to pull him from me, but he turned to her with scorn.

"And I suppose you have told your lovely mistress about us?"

"No!" She violently shook her head.

"All those nights of marital chastity that I actually spent with you, my pretty Lucia? At least your beauty is *mortal*!" He pushed her away brutally and left us together in the courtyard as he went for the stables and his horse.

Lucia ran to embrace me. "No, Madonna Sandra, I did not want to. He forced me to. He said you were too beautiful for him, and I was real!"

Suddenly, with her words, a great weight was lifted from my heart, and I stroked her hair to comfort her. "You have been a faithful servant to me, Lucia. I forgive you."

After that, I spoke no more to Ciardo of Filomena's dowry, thinking he would be thankful for it later, when it was needed. And somehow I was glad of Ciardo's revelation, for it released me from the fear and guilt I had carried since Filomena's birth. Whether or not his unfaithfulness had been in retaliation for some knowledge he might have had about Niccolo, I did not choose to inquire. I only knew that I refused to let him break my spirit, the spirit that had never truly left Sandro and his bottega at Via Nuova.

As the next Lenten season grew near, there were factions in Florence that opposed Fra Giralamo and wished to return to the old celebrations of Carnival. But this caused all the more fury in the *piagnoni* and their patrols.

"No one's door was spared, not even ours!" Filippino wrote to us. "Boys and girls not much older than your Giovanni went into even the most venerable homes and demanded whatever 'vanities' could be seen. They would not leave empty-handed. Maddalene bade them take their leave, saying they had no right to search other people's souls or houses. I feared some repercussion owing to our proximity to San Marco, but one of the older boys told his cohorts, 'Leave them be, for this is the home of the painter, Filippino Lippi, and he only does devotional works'!"

As for us, one of Fra Giralamo's loyal assistants, Fra Domenico, had organized a youth patrol for Prato as well. Fortunately they did not venture beyond the city gates, but they did approach the door at Via delle Tre Gore. Mother would have preferred not to answer, but Vincenza greeted the two young zealots by refusing to contribute anything to Prato's "Bonfire of the Vanities." When one of the boys pressed her further, she spat on him. "There are no 'vanities' here, only things of beauty that prove a love of God!"

Nevertheless there were ample wigs and masks and gowns and playing cards, "wicked" books and ornaments to stoke the bonfire that burned that night on the piazza of San Stefano. The *piagnoni* rang the bell from Palazzo Communale as the enormous pyramid beneath the pile of vanities was lit. Many country peasants came to watch the burning of those things that poverty had denied them, and they were mildly amused by the "folly of Prato's citizens." An even greater fire was provided for Easter.

On the Monday after Holy Week, the Piazza del Mercatale returned to its usual trade of goods, for the Pratesi always delighted in the market of the new season. I went into town with the children and Luigi, our servant who handled the selling of our surplus olive oil. The vendors on the piazza nodded as we passed, and Luigi set up his cart to display our oils and a few of Madonna Ciardi's cheeses. It was at the moment when I was bending over the cart that I felt the presence of a body close to mine and a tugging at my hair. I stood up to see a boy no more than ten running away, and I recognized the luminescence of my mother-of-pearl comb flashing in his hand. At first I thought it was some friend of Giovanni's playing a prank, but when I realized it was one of the friar's patrols, I heard myself cry out in alarm.

"God sees all seductions! You cannot hide them!" the boy called back.

A man in the crowd saw what had happened and yelled after him, "And God sees all transgressions and offenses!"

The worst of this violation was not the loss of the comb but the loss of its sentimental associations, for Sandro had given it to me years ago.

Not long after this incident, Filippino wrote to us that there was new dissent growing in Florence against Fra Giralamo. His followers argued that the friar should not be judged by "the actions of his impetuous patrols," but his continuous tirades against the Pope had finally reached the ears of Alexander, who now summoned him to Rome. The friar claimed illness and remained at San Marco, yet his silence brought no peace to Florence. Some members of the Signoria actually argued for the return of the exiled Piero Medici! A plot was headed by Lorenzo Tornabuoni, the once-young groom who had inspired Sandro's wedding frescoes. He was discovered and dragged through the streets by the *piagnoni* to his execution.

"As we heard the screams of Lorenzo Tornabuoni, all of Florence shut its doors and windows to keep out the stench of the unforgiving!" Maddalene wrote to Mother. Such passionate dissension abounded that year in Florence.

By the winter of 1497, Fra Giralamo's party had even turned against the Pierfranceshi, who once supported them. Those against the friar, called now the *arrabbiati* for their rabid anger, made no move to silence him because they hoped to let him hang himself with his slander of the Pope. Semiramide wrote to me only once that season, saying that Lorenzino had taken down the *Venus* and *The Forest of the Hesperides* for fear the *piagnoni* would invade Castello and confiscate them for their pyre of vanities. "They are too great as works to be destroyed!" she wrote, and her unclear script was proof of her desperation and fear.

Later, Filippino came to Prato and confided that Lorenzino had told Maddalene's father that he had sent the paintings to his villa at Trebbio because the house there was more fortified. En route, Lorenzino's servants encountered one of the friar's patrols, who asked about the contents of their low, flat cart. They had thought to say they were panels of wainscoting for someone's villa, but knew that even this simple decoration might be suspect. Finally the men lied and said they were carpenters transporting pieces of a scaffolding for the construction of a new chapel in some obscure church beyond the Mugello valley.

The removal proved to be fortuitous, because two days later the more strident members of the *piagnoni* audited the Pierfranceschi's inventories, which were on file at Palazzo della Signoria. They were about to go searching for any painting or ornament whose description was not "devotional," but fortunately Lorenzo had had the foresight to strike all the pagan and secular entries, including Sandro's *Venus Arriving on the Shore*, *Venus and Mercury*, and *The Forest of the Hesperides*.

Shortly thereafter Lorenzino and his brother, Giovanni di Pierfrancesco, fled to an undisclosed destination, leaving Semiramide and her children at Castello. Although she was relatively safe, she wrote to no one, for fear her letters would be confiscated in order to glean some news of her husband's location. I did not hear from her for two years, when she remarked that she wondered "if she would ever see the painting of the Venus ever again."

In the Lenten season of 1497 Lucrezia was betrothed to the Van-nozzo's tutor and we prepared for her a very modest trousseau. Filo-mena did all the embroidery for her tablecloths and linens with her own designs. They depicted the gates and house of Villa Tavola above a profile of Lucrezia's delicate face, and the future groom's family marveled at her talents. After this, I arranged for her to travel to Florence to assist Maddalene with the delivery of her first child, an event that brought much anticipation to everyone. Filomena found this fortuitous because she long had desired to observe the activites of Filippino's bottega. I could only call to mind the memories of the wondrous skills on display as they had unfolded before me at Via Nuova.

Filomena was at Via degli Agnoli for the New Year of 1498, and by now Fra Giralamo had been silenced by the Pope from public sermon-izing. The friar, in response, called for "a Council of all the Catholic Nations to appear before to make its claims against the godless Alex-ander." The town crier in Prato proclaimed the friar's prophecy that "a miracle would prove the truth of Fra Giralamo!"

As a result, the Franciscans, who believed the Dominicans had dis-torted their vows of poverty, challenged the friar to perform his mira-cle and walk through fire "unscathed." Fra Giralamo rejected the chal-lenge, but his faithful Fra Domenico accepted it. Two large pyres were erected on the Piazza della Signoria the Saturday before Palm Sunday for one Dominican and one Franciscan to pass through. Maddalene and Filippino felt some misgiving in subjecting Filomena in her tender years to "the current tribulations of Florence," but they wrote that no miracle was seen that day. Rain had fallen to extinguish the fire!

"But the *arrabbiati* were not to be cheated out of some spectacle to defame Fra Giralamo. On Palm Sunday they entered San Marco and set upon the friar, Dominico, and the *piagnoni*'s leader, Francesco Sil-vestri. We could hear the shouting of the crowd as they arrested the trio and then led them to Palazzo della Signoria."

The three remained imprisoned there, and I do not recall having felt very much sympathy for them. By now Sandro's brother had fled to Bologna to stay with their brother, Antonio, and avoid the new antag-onism towards the friar's followers. I knew little of Sandro's senti-

ments regarding Fra Giralamo now, but he had to be relieved that the *Venus* and his other paintings had been saved—although Filippino said Sandro never spoke of them after they went into storage at Trebbio.

"Perhaps they are as much destroyed by hiding as they would have been by burning," Sandro had told Filippino after the friar was imprisoned.

Filomena wrote most faithfully, and her letters arrived in a timely fashion now that couriers were able to travel easily through Tuscany, unfettered by the confiscations of Giralamo's patrols.

"I have passed one week exclusively with Maddalene in order to learn her desires in the kitchen and her keeping of the larder, but Francesca, bless her, has always some extra instruction for me.

"Next week I am to accompany Filippino to Santa Maria Novella, where he is touching up one of the Strozzi frescoes, and later I will go to Via Nuova to eat at Maestro Botticelli's well-laid table!"

After this visit to Sandro's bottega, Filomena wrote enthusiastically about observing the mixing of pigments, oils, and varnish, and likened this to "the intricacy of stirring and concocting the finest sauces." The boiling of the ash and lime for gesso reminded her of "the leavening of flour into dough or rolling the thinnest pasta. But, dear Mother and Father, I imagine that most painters would take offense at having their trade compared with the labors of a kitchen maid!"

She also did not hesitate to mention Sandro's nephew, Mariano, the son of Antonio. He was "handsome," she wrote, "but has not his uncle's talent for painting drapery or anatomy. Still, he is Sandro's best garzone for workshop pieces that are not by the hand of Maestro Botticelli."

When next she wrote to us, all of Tuscany was reeling with the death of Fra Giralamo. No one had expected such an ignoble fate, except for the party of the Compagnaccia who had examined him. One of these was Doffo Spini, a frequent "idler" of Sandro's bottega. Sandro had asked Doffo what sin the friar had confessed to and Doffo had answered, "Indeed, not one venal sin, save the sin of pride. But by now the people wanted some spectacle. If we had sent him on his way, they would have torn us to pieces. There was no other way to silence the friar but execution."

The friar and his two companions were hanged and then burned on the piazza of the Signoria, much like the Bonfires of Vanities he had inspired. All of Florence came to watch, except for the infirm or faint-hearted. "Fra Giralamo was correct in saying that faith is as fickle as fashion," Filippino wrote of these events, "for the children who had once done his bidding now threw stones at the pieces of his body as they fell into the fire. The friar's ashes were thrown into the Arno so that no ground would be sanctified by his martyrdom."

During the friar's last hour, Filomena chose to stay inside with Maddalene, who feared that such a disturbing sight would harm her child. But three days later, Filippino wrote the sorry news that Maddalene had begun her travail too early, and the child delivered had not survived.

I had not expected to go to Florence until the child's christening, but now I felt it my duty to go to Filippino and Maddalene and comfort them. Ciardo accompanied me in the polite silence we had learned to keep. Filomena greeted us weeping, and I held her more tightly than I ever had before.

26

Sorrow and Joy

—Summer of 1498 to autumn of 1509

*L*UCREZIA AND HER BELOVED FREDERIGO, THE
tutor, were married late in August of 1498 at the newly built
church of Santa Maria delle Carceri in Prato. Mother assisted
in the wedding banquet because "Nonna" Ciardo was almost wholly
occupied with caring for Ciardo's ailing father. Filippino and Mad-
dalene stayed in Prato for two days, as Filippino had been working on
a panel for a tabernacle at Palazzo Communale. A crowd gathered for
its dedication, and no one was more pleased than Mother to see her
son accepted and acclaimed so many years after his scandalous birth.

I asked Filippino, before his departure, if he would accompany me
to Castello on his way back to Florence. Maddalene did not oppose
the detour, so I sent a courier a day ahead of us to announce our
arrival to Semiramide. I had hoped that Filomena could accompany
us, but then I realized that the *Venus* would not be there for her to
view, and if any of my children were to see Sandro's magnificent
canvas, it should have been she.

I was unsure how Semiramide and Lorenzino would receive us,
especially Lorenzino, who had recently returned from his exile. He was
still grieving the loss of his brother, Giovanni, in an uprising near

Imola. His only consolation was that Giovanni had secretly wed during his exile, and his widow was about to deliver a child.

Semiramide, as gracious and welcoming as ever, apologized for the bare walls of the grand salon as we entered the villa.

"It is strange to live here without you, Sandra."

"*And* your Aunt Simonetta . . . and Lorenzo." This was a reference to the other figures in the absent paintings.

"Yes, but you always had such a *presence* here."

"I would think Sandro to be more of a presence than I."

"Perhaps, but it was not Sandro that my husband wanted to be reminded of. It was *you*." She said it as though she were confessing a long-held secret, although I should have guessed it years ago. I was humbled as much by her honesty as by her unwavering friendship with me.

That evening, while we dined, Lorenzino mentioned the letters he had recently received from Amerigo Vespucci and explained the voyage that his absent agent had undergone in search of more "new worlds" after his fellow navigator, Cristibol Colon. Amerigo titled his letters "Mundus Novus" and described in detail the customs of the natives, "the women who went naked and swam as well as fish," and their propensity "for roasting and eating their enemies!"

After marveling at Amerigo's adventures, we left the next morning feeling not much safer in our own little corner of the earth.

That winter, Ciardo's father saw his last Christmas and Epiphany. After his soul had departed to God, Nonna Ciardi confessed her relief that his suffering had ended. Ciardo bore his father's death better than I had expected, for they were much alike. I was uncertain how I might best console him, as we had not slept as man and wife since his outburst the previous Christmas. Lucia avoided him also, although I assured her that she had nothing to fear. He had more remorse, I imagine, than the two of us together.

We did not observe Carnival in February, but gave thanks at Lent for our health and the accounts that had been restored to the Ciardi's wool trade. In March, Lucrezia felt the first discomforts of her pregnancy, and we were happy for her and Frederigo. But my joy in that season was matched by my grief for the loss of Sopraccigliotto. The faithful horse had not been injured, which is common in the deaths of

many such animals. He merely expired. My sadness was perhaps more for myself than for this fine black steed, for he represented Ciardo's first affections for me and his apparently noble courtship.

That summer, Filippino announced that Maddalene was again with child, which caused us to look forward to the new century with greater hope. He wrote that Sandro was back at Ognissanti, frescoing the final bit of wall space in the Vespucci chapel. He and Giorgio Vespucci had settled on the theme of the conversion and martyrdom of Saint Denis, probably because it reflected Giorgio's own conversion from Platonic scholar to moderate Dominican.

Three weeks after the New Year of 1500, a courier arrived at Via delle Tre Gore with the news that Maddalene had delivered a healthy son named Roberto. He was reported to have "much hair and the countenance of a Lippi." The child's christening was postponed until late April, when we hoped Mother's health might improve. But she preferred to remain in Prato and sent her blessings with me and Filomena, who went eagerly in the hope of also seeing Mariano Filipepi.

Roberto was both fair of face and robust, and, before his christening, he would not be quieted until he saw the sight of Ghiberti's bronze baptistry doors. Sandro was in attendance and murmured to the wriggling infant, "Be still, my little Lippi. Your father was once quite fascinated by these doors and could barely speak when first he saw them!"

"And I am speechless still today!" Filippino's joy over little Roberto was clearly written on his countenance.

At the baptismal supper, Filomena questioned Sandro about his progress on the illustrations for Dante's *Paradiso* and ended by inquiring, "And how fares Mariano, who is Paradise himself?"

"Such unabashed confessions from these Lippi women!" As Sandro smiled in my direction, I fear I blushed as much as a maiden with a fluttering heart.

Filomena eagerly accepted Sandro's invitation to Via Nuova, and Filippino accompanied her there the next day. These were Sandro's last days in the bottega before he retreated to his villa for the remainder of the spring. Mariano would be assigned to oversee the workshop pieces and any new commissions, which Sandro now took more reluctantly. Filomena gave freely of her opinions on the various panels

in progress, and Sandro jested that perhaps he should employ her as his first garzone!

"Ah, but there is another way she might remain in Florence," Mariano said. His eyes sparkled towards my daughter in a way I had always wished Sandro might look at me. "I see no harm in having a female assistant to mix pigments, for women surely do as well at dying wool or mixing confits!"

"Or stitching a design!" Filomena was thrilled. I confess that I took great pride in her tenacity.

Thus it was decided that she would remain in Florence and assist Maddalene with the new child, while spending part of her day at Via Nuova. Before we departed, Sandro wished to show us his studies for a new painting he had planned as a tribute to the martyrdom of Fra Giralamo, for he believed that the friar's execution had been too severe a punishment for "an overzealous cleric." The composition was a Nativity scene with a perplexing array of angels above the Holy Family's stable. Undearneath, three angels embraced the three martyred men crowned with olive branches. The allegory was more obscure than Sandro's usual illustrations, and for this reason he called it his *Mystic Nativity*.

Below the painting, he planned to add a Greek inscription that he had composed with the help of my now-cloistered cousin. A burst of jealousy coursed through my veins, but I hastened to subdue it. When we asked him to translate, he said, "It is a warning to all Florentines and the nation of Italy, for we cannot afford to be divided and conquered for very long."

Indeed it was a "mystical" inscription as well, referring to the horsemen of the Apocalypse, the invasion of the French, and Fra Giralamo's execution. Filomena frowned most of the time while he read it. Afterwards, she said she was even more disappointed by the "stiff" and "primitive" style he had used to depict his Nativity.

"It looks the way men painted centuries ago! Does he mean it to be that way?"

But Filippino later pointed out that Sandro had recently suffered from considerable swelling in his hands and fingers, as well as failing eyesight. His designs and preliminary cartoons revealed these afflic-

tions, and his paintings suffered further when they were completed by less-skilled assistants. This saddened me as much as any shortcoming of Sandro's. He was a childless man now forced to relinquish his creative powers over the only offspring he had ever known: his paintings.

For the rest of that season I was occupied with the care of Nonna Ciardo while trying to give support to Lucrezia in her pregnancy. The boys spent more of their time with Ciardo, who was also softening with age. Mother was becoming more frail along with Vincenza. It was as if her life's blood and Mother's had intermingled in their advancing years.

Just before Christmas, Lucrezia was delivered of a healthy son, but I somehow felt an intruder beside her bed even in her travail, when she called for me and reached for my hand. The child was christened Frederigo Ciardo, but Mother was unable to attend the event.

On the evening of Epiphany, I was at Via delle Tre Gore with my sons and went to Mother's bedside. She bade me recount the blessings of her life. I told her she had triumphed over her brother's parsimony and the scandal of Filippino's birth. She had known the kindness of the Abbess Bartolommea and the consolation of her dear sister Spinetta. She had been united with the man she loved, and she had been united with her niece, Cortesia. She had known spiritual and earthly pleasure, and she had rejoiced in both.

Then, in her most eloquent and final breath, Mother said that she had "borne a son who could carry on both Lippi's and Botticelli's gift for painting, and a daughter who had left a legacy of grace and beauty for all the ages."

I could only protest these acknowledgements. "But it is *you*, Mother, who have left the legacy of grace, not I."

She smiled and turned her face gently towards the flickering candle, and then her soul was lifted up to God. In the molten light that fell upon her, I saw that same, ageless beauty that had so captivated my father at Santa Margherita. It was the same beauty as Simonetta's: one that prevails even in death.

Her body was borne across the piazza of San Stefano to the little cemetery near the convent. Those who had once scorned her were now more dust than she. Many Pratesi lined the streets to watch the small funeral cortege pass by. Children reached up to touch the bier on

which she lay in order to say they had touched the Virgin of the Sacred Girdle. After her death, those pilgrims who came to Prato's Cathedral were wont to inquire about the portraits of "the beloved Lucrezia Buti," and the priors would direct them to the chapel of the holy girdle or Father's frescoes of Salome dancing before Herod.

Filippino and I had yet to recover from our grief when Vincenza, too, departed unto God. Her death had followed Mother's by only four weeks. My brother made arrangements for the leasing of the house at Via delle Tre Gore because Riccardo was eager to join his son, Giorgio, in another household where he might pass his final years. I implored him to come to Villa Tavola, but he declined most graciously. These two deaths weighed heavily on me, but I was consoled by the peace in which Mother had died, and the knowledge that her faithful Vincenza had joined her in Heaven.

Before the New Year of 1501, Ciardo and I saw the betrothal of Filomena to Mariano Filipepi. When we went to Florence for the *impalmatura*, I brought Cortesia's "wicked" purple cloak to be added to her trousseau. Although I never reported to Filomena how closely linked her birth was to my first encounter with that commanding, velvet garment, I told her it was fitting that the cloak should return "to the address where it had first appeared around the shoulders of Sandro's elegant tutor."

Ciardo never spoke of his suspicions regarding Filomena's birth. She looked less like him and more like me and now thrived under the generous dowry from Sandro Botticelli. Filomena was Ciardo's as much as Lucrezia and his sons, and he never wavered in his affection for his "unconventional" daughter.

Ciardo's mother did not live to see Filomena's marriage to Mariano. She was interred next to her husband, and our hearts were heavy. Ciardo wept more for her than he had for his father, and that night we slept together for the first time in over three years. In her stead, I became the true Madonna of Villa Tavola, presiding over the house I had never felt was mine.

At the end of the year, Filomena announced that she was with child even as her sister wore the gladness of a second pregnancy. Their

brother, Giovanni, who had almost completed his education under his Uncle Frederigo, now joined Ciardo and Gio in the family importation of raw wool. They also exported the surplus raw silk from Lorenzino's mulberry farms in the Mugello. Amerigo's duties along those lines had been preempted by his continued voyages to the New World and his great fondness for Spanish life. Ricciardo, who had shown an interest in math and ledgers, began an accounting and notary apprenticeship with his uncle, Antonio di Vannozzo. Antonio had taken over the duties of his own Uncle Piero, our dear "Ser Vannozzo," who had been the protector of my youth. His passing allowed me to close that chapter of my life at Via delle Tre Gore.

In 1502 Maddalene delivered another son. When Filippino sent this news, he also mentioned the now-acclaimed sculptor, Michelangelo Buonarroti, who had returned from Rome.

"Angelo has received a commission for the Operai del Duomo to carve a figure of the David to represent the new government of Florence. He was given a discarded block of marble. What a challenge! He is being honored by the Councils of the Signoria with a new house and workshop near Santa Croce. How ironic that the figure of a male nude should arouse such gratitude from the same men who would prosecute a charge of sodomy!"

In May of 1503 a courier from Castello arrived at Villa Tavola bearingthe sad report of Lorenzinodi Pierfrancesco's death. Semiramide was much too grieved to take up quill and ink to write to me, so her sorry news was delivered through a less intimate medium. I attended the funeral with Ricciardo and Filippino. Sandro, who now walked with a cane, was unable to participate in the cortege from Castello to San Lorenzo. But he waited in the city, by the tomb where Lorenzino would lie beside his cousins. I heard him say to Semiramide, "I might never have had the vision of the Venus or her realm without your good husband."

"But Sandro, I am certain you would have found some other patron interested in your tributes to Simonetta and the beauty of Alessandra Lippi."

It was only after Lorenzino's death that I learned of his love for me. Semiramide had no choice but to accept it and my presence on their

villa walls. Perhaps it had been a private blessing that they had been forced to hide the paintings at Trebbio. It was "a quiet affection," she assured me, but one expressed in every commission that had fallen into Sandro's skillful hands. And all the while, my unrequited love for Sandro was unaware and flourishing in its place!

I knew not what to say to comfort Semiramide. I called on her at her house in Florence just before she was preparing to return to the fragrant groves of Castello.

"Lorenzino was a good husband. And you, Sandra, have been a good friend and correspondent." As she smoothed the black mantle against her gently graying hair, I could only reflect on how our association had endured the years better than our flesh. "Perhaps I sought your friendship as the only way that I could bear to know you."

We wept in each other's arms—I for my thoughtlessness and she for her hidden jealousies. Sandro had once said that God's gift of beauty "is useless if it serves to arouse fear and envy instead of hope and love."

Before the New Year of 1504, Maddalene gave birth to another boy, christened Filippo Luigi. He was Filippino's last child. My brother's letters had become more sparse, so I now depended on Filomena or Maddalene's reports from Florence. Filomena wrote that Sandro continued to paint "but with difficulty" and that Mariano was assisting him on a series of panels on the *Life and Miracles of San Zenobi*, an early Florentine bishop.

Sandro and Filippino were also occupied with serving on a committee to decide the location of Michelangelo's completed *David*. The decision finally went to the sculptor himself, who settled on the site of the piazza in front of Palazzo della Signoria. The great statue was moved in May and took, according to Filomena, three days for several strong men and oxen to pull it on a special cart from Michelangelo's studio near Santa Croce.

"And then," she continued, "when it was finally in place, a few disgruntled citizens threw stones at what they considered to be 'a shameless nude,' which served as no amusement to the sculptor nor the committee nor, as Sandro says, 'any other thinking man!'"

But Filippino did not live to see the *David* put in place. In March, Maddalene had written to me about Roberto's illness of congestion,

fever, and "a very painful sore throat." Filippino was still working his usual long hours on too many commissions, "always trying to please," she wrote.

By April, he had taken on his son's ailments and was forced to stay in bed. Ciardo was to go to Florence the second week of April and planned to stay at Via degli Agnoli and check on my brother's health. But the night before his departure, we heard a horseman outside the gates of the house, and Ciardo went out to greet the unexpected visitor. It was a special courier from Florence, out of breath, for he had made his journey in haste. The alarm upon his face foretold the anguish of his message.

"Alessandra, wife of Ciardo dei Ciardi?"

I peered out from behind Ciardo's shoulder to receive him.

"I must report most regretfully . . . your good brother, Maestro Filippino Lippi, has died in Florence."

I walked behind Filippino's bier with Ciardo, Maddalene, and the children. Her nurse held little Luigi, for Maddalene had not the strength. The shock of Filppino's death had drained her of all color, and I feared she might collapse before we reached San Michel di Visdomini. For myself, I felt more numbness than grief and more disbelief than any aroused by Amerigo Vespucci's fantastic letters.

All the shops along the Via dei Servi remained closed in honor of its quarter's most beloved citizen. I was moved by the numbers of residents who wept for my brother. But it seemed as if the pomp and esteem of his funeral came too late for a man who had, in life, sought the approval that had been denied to him as a child. As my brother was laid to rest, he was finally regarded as more than "the scandal of Fra Filippo Lippi" or "Botticelli's most successful pupil."

While Filippino's body lay in state, the canons of many churches came to pay their last respects. So many people visited throughout the day that the chapel at San Michel di Visdomini could not contain them all. Sandro, who now had great difficulty mounting a horse, arrived by litter with his nephews. He said nothing to me then, as though he could not fathom that the youth he had once taken under his wing had died before him!

Filippino was interred in the Santissima Annunziata, where the guild of the painters provided a stone carved with this epitaph:

> Design has perished with Filippino
> Flora mourns beside the weeping Arno.
> While from him and all painting shall depart
> This lost style of his invention and art.

In the next six years he was to live, I saw Sandro only twice. I had little inclination to travel to Florence because Filomena and her children were so dutiful in their visits to Prato. Maddalene visited seldom and was considering moving into the house of her aging parents.

Filomena and her family eventually moved north to Bologna, where Mariano united with his brothers in the family printing business. He had taken an interest in designing books and had tired of painting for a less capable Botticelli, whose "new style," according to Filomena, was actually attributed to failing faculties and the loss of his compelling charm over his bottega.

As I settled into my life as "Nonna Ciardi" to Lucrezia's lovely children, I prepared myself for whomever Giovanni and Ricciardo might take as wives. The running of Villa Tavola consumed my time and energy as I, too, felt the years tugging at my breath and bones.

In the autumn of 1509 I traveled to Florence with Ciardo and the boys, for Giovanni was matriculating into the Wool Guild. It was also a good occasion for visiting Maddalena and her sons, and I was impressed by how articulate they had become. Roberto was nearly ten and had inherited Filippino's penchant for keeping a notebook full of writing and sketches.

"When I am older, Mother says she will let me have the sketches Father made in Rome along with his studies for grandfather Lippi's tomb in Spoleto!" He seemed proud to tell me this.

I realized, then, that I possessed very little of my brother's work and even less of my father's. Mother had given almost everything to either Maddalena or the artistic Filomena. Consequently, I was compelled to ask if there were any extra drawings that Maddalena might spare me. She found a self-portrait of Filippino as a young man along with one of Father's studies of Mother before she left Santa Margherita. There

was also a small ink profile of a young girl—no more than six or seven years old—which I did not recognize as being by the hand of a Lippi. Maddalene said Filippino had told her it was a sketch by Sandro. Upon further inspection, I saw that it was, indeed, an early Botticelli, and that the profile was my own!

"And have you any news of how Sandro fares at Monte Oliveto?" My eyes remained fixed upon the drawing.

She told me she had only occasional reports from La Compagnia di San Luca, the confraternity of painters. Filippino had often made jest of Sandro's continual debt with them: he had always been remiss in paying his dues.

While I was still at Via degli Agnoli, an elder of the confraternity— one who knew Sandro—arrived with salted meat as part of a benefice to Filippino's widow. When he saw me at her table, his eyes were filled with a certain recognition.

"Is it Madonna Alessandra? Ah, you are the Venus even yet!" He smiled, while Maddalene's sons took great amusement in the man's assessment of me.

"Tell me, Messer, does La Compagnia have any news of Sandro? Is he well retired at his villa at Monte Oliveto?"

The man shook his head sadly and replied, "Retired, yes, but not well. The hospital of Santa Maria Nuova recently sent a physician to call on him."

Upon learning this, there was little else to do but go the next morning with my son, Giovanni, who escorted me up the slopes of Bellosguardo to Botticelli's "casa da signore." There we were received by Sandro's nephew, Amide, and Amide's wife, who were attending to Sandro's needs. Amide poured a goblet of wine for Giovanni and then led me to the garden.

"He will be pleased to see you, Madonna Sandra."

I found my way past the central tower to the place where Sandro liked to sit among his fig trees. He barely looked up, and yet he felt my presence and seemed to welcome it.

"Sandra mia! It has been too long!"

As he turned his face towards me, I could see the now-clouded eyes that searched for mine.

"I have been with Maddalene and my nephews. A member of your confraternity brought the news that you were ill."

"Ah! Be not alarmed. It is only La Compagnia di San Luca making good use of my money after finally receiving it!" I was pleased to see that the vigor of his wit had not yet left him.

"Have their physicians administered to you well?"

He rose and took a cane, whose wood was as gnarled as the hand that grasped it, and pointed towards the vineyard in the distance. "The wine we make works as well as any medicine for pain."

"Are you in pain, Sandro?"

"Is there any man my age who is not?" he answered with a laugh that became a cough.

"Maddalene found a drawing you had made of me when I was just a little girl. It was a lovely likeness."

He reached for me with one hand, saying, "And how could it not be? You were a lovely child and woman . . . and, I trust, you do remain so."

I realized by his remark that he now saw by instinct and not acuity, and I reached up to touch his wrinkled but noble face.

"Ah, Sandra. You know the painter's eye is never blind, no matter how old or clouded it becomes. By your years, I imagine you are more matronly and your hair perhaps is silver and not gold."

I reached to touch the edge of my mantle and the comb that held the coils of graying hair.

"Your vision is still keen, Sandro."

"If it pleases you, I have received more than enough praise for one lifetime. But then I suppose you have, too!"

"My praises were only for the beauty that you glorified."

"Well, there is so little beauty in our world. It is best to glorify it."

He smiled and took my arm, and a silence fell between us. I felt a distant longing rising in my breast, but it was not the same. Finally I spoke the words I had always meant to say to him.

"Did you know I wished to love you as a wife, or did you find my affection unnatural for a goddaughter?"

He sighed and smiled sadly. "Your love was pure and thereby natural, Sandra. Besides, who was I to judge another's affections? Your affection for me was, perhaps, the greatest part of your beauty,

part of that graceful melancholy I sought to capture in your eyes."

"If you had shown me the least encouragement, you know I would have given myself to you!"

"As you did with young Niccolo? A convenient recipient for your unrequited passion." He nodded slowly and shrugged. "If only I could have been the kind of man to return that passion."

His remark left me all the more confused.

"And so, the funds for Filomena's dowry were for my folly with Niccolo and your part in it?"

He shrugged. "Perhaps. Perhaps not. She was more than a Lippi, and certainly not a Ciardi. And whenever I watched her in the bottega, I saw a glimpse of both your father's skill and the sincerity and tenacity of that young garzone. Had she been a man, she could easily have have become a master artist."

I placed my hand on his, and his crooked fingers showed the stains from years of touching charcoal, ink, and pigments. I recalled the times I had wished for their sweet caress. Our fingers intertwined like the dance of the Three Graces.

"And what of Ciardo?" he asked.

"He protested the funds, at first, and was suspicious . . . of us, mostly. But then his wool trade suffered and I believe he was glad for them. If he ever suffered in his heart, it was for that true affection that I withheld from him."

"He has been a good husband."

I could not tell if this were a declaration or a question, but either way, I did not respond. I could not speak of Ciardo now.

"I could never have been a good husband to you, even if it had been acceptable. I was married to my work, and my mistress was not so much Cortesia as the intellectual life I wished to be part of."

My tears flowed freely and I embraced him without restraint. "But was I ever more to you than a replacement for Simonetta?"

"Ahh, Sandra! You were part of my beginning and of my ending as a painter. Do you remember *The Madonna della Melograna*?"

I smiled in recollection of Filomena on my lap, holding the juicy pomegranate that had stained my gown.

"That panel marked the final splendor of those days of painting you."

I reached around the back of his neck, and the rich curls I had once squeezed as a child were a thinning patch of hair against the collar of his cloak. His clouded gaze moved across the horizon towards the valley of the Arno.

"All the trappings of success are behind me now."

"Would that I might have been one of them!" My words came in the voice of a maiden no more than fourteen.

"Be assured, Sandra. Whatever you desired to be for me, you became to every other man who saw you." To this I gave a startled laugh. "I do believe you may even have turned the head of the righteous Fra Giralamo—that day we went with Simone to San Marco."

Sandro laughed, and his body shook with every breath.

"Sandro," I wept softly, "let me tell you now how much I love you."

We embraced and watched together the Tuscan sky turning the palest tone of pink on the horizon. It was the same color as the blush of Venus landing on the shore.

Epilogue

SANDRO BOTTICELLI DIED ON MAY 17, 1510, AND was buried in the cemetery of Ognissanti in Florence, not far from the grave of Simonetta Vespucci. His nephews ordered a simple stone marking the family arms and graves of "Mariano Filipepi and sons." The cemetery has since been built over, but the church of Ognissanti stands, along with Botticelli's stunning fresco of *St. Augustine in His Study*. All that remains of the Vespucci chapel there are the frescoes by Domenico Ghirlandaio and an inlaid marble circle marking the memory of Amerigo Vespucci.

Sandro Botticelli's celebrated *Venus Arriving on the Shore* remained at the Medici villa of Castello until 1761, when it was transferred to the Guardaroba (dressing room) of the Grand Duke of Tuscany. It did not appear in the gallery of the Uffizi until 1815, when it acquired its current title, *The Birth of Venus*. It is now displayed behind protective glass in the Uffizi's Botticelli Room, which is said to be "the greatest collection of art by one master in any museum anywhere."

The Via delle Tre Gore in Prato is now the Via Magnolfi. The house of Fra Filippo Lippi is on the corner near the piazza of San Stefano and bears a plaque that marks it as the birthplace of Filippino Lippi. It makes no mention of his sister, Alessandra.